Parenting Together

Parenting Together

Men and Women Sharing the
Care of Their Children

DIANE EHRENSAFT

University of Illinois Press
Urbana and Chicago

Illini Books edition © 1990
© 1987, 1990 by Diane Ehrensaft

This edition is reprinted by arrangement with
The Free Press, a Division of Macmillan, Inc.

Manufactured in the United States of America
P 5 4 3 2 1

This book is printed on acid-free paper.

Library of Congress Cataloging-in-Publication Data

Ehrensaft, Diane.
 Parenting together : men and women sharing the care of their
children / Diane Ehrensaft.
 p. cm.
Includes bibliographical references.
 ISBN 0-252-06137-3 (alk. paper)
 1. Parenting. 2. Sex role. 3. Dual-career families. I. Title.
HQ755.8.E36 1990 90-10768
649'.1—dc20 CIP

To my parents, Edith and Morris,
and my family, Jim, Rebecca, and Jesse

Contents

Preface to
the Paperback Edition

It is a warm October morning, 1989. I am sitting at my desk, looking out at the Golden Gate Bridge, thinly veiled in a layer of fog. I have just closed the cover of Arlie Hochschild's new book, *The Second Shift: Working Parents and the Revolution at Home*. I muse at the title, wondering if the publishers inadvertently left out two words. Shouldn't it read, "the *Call for* Revolution at Home"? For the reality is that the "second shift," the work of household and child care that follows a full day of work for two-job families, falls inordinately in the laps of women. To the degree that mothers actually work an entire *extra month* a year, compared with fathers.

Yet, there in black and white, Hochschild impressively demonstrates that without a doubt relationships are improved when men and women share in the tasks of home and family. It did not even matter what couples thought or believed about gender equality or male and female roles. Couples were simply happier when men participated more in the second shift.

Those are exactly the kind of couples who are the subject matter of this book: men and women who share the care of their children. Shockingly, they are a rare lot. In fact, when I first began this project a decade ago, wanting to find out what really goes on in the lives of mothers and fathers who decide to do shared parenting, many of those closest to me questioned why I would choose to study such an esoteric phenomenon at all. There were more pressing and important social problems to spend our time on than a small group of intellectual elite still committed to the 1960s, who were thought to comprise the entire cohort of co-parenting couples at the time.

I wish I could say I was a soothsayer of history, but it would be truer to say that it was sheer stubbornness. I knew in my heart of hearts that the issue of men moving in to pick up half the care of

children would prove to be more than a passing concern. A decade later I stand vindicated. The men and women who share the care of their children may still be few in number, but they are critical to the "call for revolution" at home that I do not believe can wait another minute, for the sake of couples' happiness, women's sanity, and children's well-being.

In August 1989 a national poll conducted by the *New York Times* revealed that women in this country now see the balancing of work and family as their critical and pressing concern. Class and racial lines become blurred as women join hands in demanding, "Who will raise the children?" While politicians and corporations scramble to come up with child care programs and funding that demonstrate their sensitivity to the pressures on working parents, this effort, though necessary and important, is only half the solution. It is also time to start aggressively challenging what people do at home under the confines of their own roofs. It is time for mothers to move over to make room for fathers in the work at home, and, more significant, it is time for fathers to recognize that their time has come to do this.

I hope that by reporting the actual experiences of eighty men and women who have been successful in sharing the care of their children, this will not seem such an impossible call for action. We have been inundated by studies, articles, and books that address why people do not or cannot shift their gender roles within the family. Yet almost no one has stopped to take a look at the, albeit exceptional, cases when people *can* and *do*. This oversight stems not just from a conservatism that binds us to the study of traditional norms and avoids investigation of any phenomenon that might prove a harbinger of social change, particularly in the deeply ingrained arena of mother and apple pie. It is also a reflection of people's pessimism about the possibility of gender alterations. And it is also a message about people's subliminal internal resistances to such change.

For a revolution at home in which women and men fully share the responsibilities of hearth and family will have to be, at least in part, a psychologically based one. More than what one does, even what one thinks and believes, it is also about what one feels deep within, both at a conscious and an unconscious level. By clinically interviewing men and women who have embarked on the project of "mothering" their children jointly, the goal of this book is to provide insight into the very deepest internal feelings and conflicts that make the redistribution of parenting responsibilities easier said than done, but done.

As job responsibilities increasingly cut into family life, experts and

policymakers have become increasingly alarmed that our children are suffering from "undercare." At times it appears as if we have a new generation of sons and daughters raised solely by "fathers," that is, people, both men and women, who are at jobs all day and then spend a bit of time with their children in the evening, when work pressures permit. This is a dangerous direction to take. It reflects a repudiation of the traditional acts of mothering that have heretofore been women's domain and are necessary to children's healthy development. At the same time it blocks the promulgation of "maternal thinking" that Sarah Ruddick in a compelling book of that name identified as the road to a more nurturing and peace-loving society. It is imperative that mothering, the daily acts, concerns, and sensibilities that go into the nuturance and rearing of a child, does not become obsolete, but that society makes room for mothering to extend to any combination of adults—women and men, women and women, or men and men— who are committed to raising a child together.

In other words, it is time for mothering to become a genderless affair. Whereas the tales of the men and women who comprise the subject matter of *Parenting Together* will tell us that parenting still remains a gender-divided experience, the accounts are definitely groundbreaking in their demonstration that some men and women today can and do "mother" together.

Acknowledgments

I would like to open this book by first thanking the people who gave of themselves to make this book possible. These are the men and women who took time from their already overburdened schedules to talk to me about their experiences and bare their inner lives as they revealed the realities of being a sharing parent. Their names remain anonymous for purposes of confidentiality, but you all know who you are and I would like to extend my deepest gratitude for teaching me about shared parenting.

Then there are the people for whom I can name names. These are my close community of friends with whom I have bonded over the years in our common experience of being shared parents. We have shared with each other the trials, tribulations, and joys of our family and personal lives. With their insight, friendship and support I have truly been guided to the depths of what it means for men and women to parent together. To Elli and Robby Meeropol, Joanna Levine and Marc Stickgold, Joan Skolnick and Randy Reiter, Nancy Chodorow and Michael Reich, Gail and Barry Kaufman, and Anne Bernstein and Conn Hallinan, I offer my deepest gratitude.

I would like to thank Nancy Chodorow, whose book, *The Reproduction of Mothering,* planted the seed for my own investigation and who has shared with me a personal and intellectual dialogue over the years on gender and parenting.

To Susan Bernadett-Shapiro I express my appreciation for assisting me in the interviews and sharing with me her clinical insights on the men and women to whom she spoke.

To Anne Bernstein, Jim Hawley, and Barbara Waterman I offer special thanks for reading drafts and giving me the feedback and critique that have helped me give birth to and shape this book to what it grew up to be.

There is one person in particular to whom I want to give special recognition. To my close friend and colleague, Lillian Rubin, for all the hours in restaurants, evenings on the telephone, and detailed and intricate feedback on each word I wrote I extend my deepest gratitude for sharing her intellectual and emotional self with me and being such a true friend throughout the writing.

My publisher, Erwin Glikes, at The Free Press, has given me his encouragement about this project and the excitement that launched this book. His feedback and guidance has been invaluable in bringing final form to the book. I would also like to thank Eileen DeWald, managing editor, for her editorial work and for monitoring the manuscript's progress, and all the other people at The Free Press, many whose names I do not even know, who have worked with *Parenting Together*.

My agent, Marion Young, deserves special thanks for her ongoing encouragement, for reading and giving feedback on the manuscript at its many stages, and for being there every step of the way.

I have saved for last a special dedication to the three people in my life who have been the soil and fertilizer of this project. First, my two children, Rebecca and Jesse Ehrensaft-Hawley, who have taught me through their warmth and patience how to be a mother and who through their beaming faces are the daily proof that shared parenting indeed works. They have had to live through the contradiction of having a mother who has been less available because she was writing about the very problems of mothers being available for their children. For their understanding I will never be able to give enough gratitude.

My final thanks go to my husband, Jim Hawley. He has lived this project with me from beginning to end. An editor, a critic, a consultant, a lover, a co-parent, and the most intimate of friends, he has offered me the intellectual stimulation and the love and support that no book should ever be written without. He has also brought me to the deepest realms of the shared parenting experience just by doing it with me. Through parenting together *Parenting Together* became possible.

<div style="text-align: right">Diane Ehrensaft, Ph.D.</div>

Oakland, California
March 15, 1987

Parenting Together

1

The New Mothering Duet

Mommy, Mommy, what am I going to do? How am I ever
going to be a zookeeper and a daddy at the same time?

This was the distressed wail of a four-year-old boy confronted
with a terrible dilemma. How will he balance his career aspirations
with his firm plan to become a father? Strange he should be so
distraught. With mommies to take care of the children, many daddies
have become zookeepers, and certainly zookeepers have become dad-
dies. Women, not men, are the ones who are supposed to face such
agonizing choices.

Strange, that is, only until you discover that *his* mommy and
daddy are not like that. He is a boy who knows that his mother
spends no more time with him than his father does. He is also a
boy who is aware that both his mother *and* his father struggle to
balance the equally intense demands of career and family. He is
also a boy who has learned not just to worry, but to delight in the
notion that he will be both a daddy *and* something else. He is also
not just any boy. He is my son.

Nine years before he spoke those words, I sat at my desk chair,
a budding developmental psychologist and a budding (or, more accu-
rately, bursting) mother-to-be. An active participant in the feminist
movement, I was also out of synch with my peers, birthing many

years earlier than my post-thirty-five baby boom friends of the 80s. I contemplated the commitment my husband and I had firmly made to fully share the responsibilities of parenting. We were going to demonstrate the possibilities of a 50–50 family. But I had just returned from a doctor's appointment where I was informed I might be having twins. Waddling home stunned, I anticipated the shattering of my work plans, chanting to myself, "My God! 50–50. Twins. That means *100–100*. Just wall-to-wall parenting."

Although carrying twins was just a false alarm, it set me thinking about the vagaries of family life, about the difficulties in planning one's future. I began to think more critically about my own family choices, my insistence that the only man for me was one who changed the diapers as many times as I did. It was in this context that I embarked on my investigation of the shared parenting family.

I posed for myself a set of questions I felt warranted serious responses. Can a man really "mother"? To challenge a universal and time-honored system in which women are the primary caregivers for young children is a serious matter. What about the immutable gender barriers of breasts and uteruses? These are certainly biological impediments to true equality in parenting. Is there organic growth—or, on the contrary, "nuclear fallout"—when the nuclear family does radical rearranging? We can hope for positive results, but we cannot ignore the possibility of damage to either parents or children. Whatever do the balancing acts of a man and woman look like when they have to juggle work and family both within themselves and vis-à-vis each other? Would such new arrangements fertilize marital harmony, or be just another line in the litany of contemporary family crises?

As I first grew interested in the topic, I specifically looked at situations wherein both men and women consciously perceived themselves to be the primary parents of their children, with responsibility for childrearing divided equally between them. In the early 70s, such an arrangement was considered a privileged choice available to a small group of middle-class professionals or "radical life-style" folks with flexibility in their work lives and an ideological commitment to break down sex-role typing and arbitrary gender divisions, at home and elsewhere. It was viewed as an outgrowth of the women's movement and of 1960s counterculture values.

In fact, at that time shared parenting as a self-conscious project probably *was* a privilege. But for those of us going through the experience, it felt far more like survival, the only way to go given

what we knew. Many such parents dreamed of an expansive yet relaxing life in which part-time work for each parent could be combined with part-time parenting. As fate would have it, this would give the children the equivalent of what they could have had in the traditional nuclear family, the sum total of one full-time parent and one full-time breadwinner. The only difference would be that each of these "ones" would be divided between two people. Supplementary day care services would certainly also be used, but ideally, not full-time out-of-home care. Such were the visions of the first sharing parents to whom I spoke.

And such were the visions with which I first started to write this book in my head. Yet my search was motivated by more than an autobiographical interest in making sense of my own experience over the last fourteen years as a mother in a shared parenting household. An analysis of larger social and psychological aspects of the experience was in order. I wanted to discover the realities of two people living together, a woman and a man, who try to divide the traditional tasks of mothering between them—as well as, simultaneously, the tasks of breadwinning and household management.

Ironically, in the intervening decade, times have quickly changed. The shared parenting household I just described, though less than fifteen years old, is already quasi-obsolete. With increasing economic pressure, it is a rare household, indeed, in the mid-1980s that can adequately support two adults and one or more children on the equivalent of one full-time income. The laid-back, semi- or even anti-professional attitudes of many of the late-60s, early-70s shared parenting pioneers have been washed away by the influx of career aspirations and renewed respect (or at least tolerance) for professionalism in the 1980s. The pioneers now find themselves in the same boat as the newer generation of shared parenting families, facing a harried schedule of full-time work for both adults, juggling of parenting responsibilities, and the pressures of a life with just too much to get done every day.

It is not just the shared parenting household that has gone through twists and turns over the last decade. Look at the larger context of family changes. In the past fifteen years, stacks of articles by social scientists, policy makers, and mental health professionals have crossed my desk decrying the deterioration or breakdown of the American family. Another stack of articles, by more radical thinkers, has applauded this same development. They look forward to a better day, free—as they put it—from the reins of the "oppressive nuclear

family." Staring at the piles on my desk and reflecting on my own clinical experience working with families, I think to myself, "The American family has neither died nor self-destructed. But it certainly looks different than it used to. So what are we referring to when we speak of the 'family'?"

The nuclear family described and analyzed so eloquently in the 1950s, in which Mother stayed home with the children and Father went out to be breadwinner, is now a statistical minority in the United States. That family of the 1950s carried on a distinctive tradition of modern Western history, in which men have been expected to have only minimal involvement in the daily care of their young children—to be, at most, "helpers" to their female partners. Overall, this tradition had held firm regardless of whether both the man and the woman had to work outside the home or the woman had the option to stay home and devote her time to childrearing.

Thirty years later, the 1950s family model that greeted us each night on prime-time TV ("Ozzie and Harriet," "The Donna Reed Show," "Father Knows Best") has become a nostalgic anachronism on two counts. First, the number of single parent households has increased enormously, doubling from 12.9% of all American households in 1970 to 25.4% in 1984. Second, the percentage of intact families with *two* working parents has also risen markedly, to over 52% by 1980. By 1986, less than 20% of the time could we expect to walk into an American home and find Mom tending to baby while Dad is off at the workplace. And if Mom and Dad divorce, which will happen about 25 to 33% of the time depending on what state you live in, there will likely be a period of singleness followed by remarriage.

As these shifts have occurred, a striking phenomenon appears: to wit, the paradox of both more and less participation by men in childrearing. As late as the mid-1970s to 1980s, estimates of American fathers' involvement in basic child care tasks ranged from 1–½ to 3 hours per week.[1] This is not very much time. Yet it is a lot more time than characterizes the women-headed households in which there is *no* father involvement at all.

The recent attention given to fathers hunted down by their estranged wives after failing to provide child support payments reflects the extreme case, in which some men have turned their back on their children. Others become, at best, weekend or once-a-month visitors after a marital dissolution in which their wife maintains primary custody of the children. After leaving the home, some men

grow discouraged of ever developing a meaningful relationship with their children and give up visiting altogether. Others throw in the towel because it is either too costly, too inconvenient, or too threatening to their present life-style.

Women, on their side, have also contributed to decreased father involvement. Some have made a conscious choice to have a child on their own, either because they choose not to be with a man or cannot find the right man to be with. The stigma of the unwed mother and the child born out of wedlock, although still present, has diminished significantly, making it easier for a woman, if she so chooses, to pursue the option of the fatherless family.

Other women actively block participation in childrearing by the father of their children. This is most commonly found in those messy divorce and custody proceedings in which the child becomes a football. Because the usual presumption, and the general attitude, is in favor of the mother's rights, the mother usually wins this game. A woman may block her ex-husband's participation because she perceives him as an unfit parent or as disruptive to the children. She may also deny the father access to his children if she has been deserted and if the children are all she has. Walking out on her is tantamount to walking out on the children; his punishment will be the loss of his children. She will also not let him use his demands for joint or sole custody as a bludgeon over her head if she fears his intent is not fathering but, rather, securing financial and emotional control over her.

It is ironic that all this should be happening at the same time that media and child development experts address more and more attention to the father's importance in a child's life. No less than the *Wall Street Journal* has been writing about men packing their children's lunches and taking them to doctors' appointments. And indeed, in many households throughout America, men are in fact packing lunches, making doctors' appointments, changing diapers, and doing all sorts of childrearing tasks out of character with their traditional fathering role.

Some of these men belong to households like my own, in which a man and a woman have made a conscious decision to share both the daily tasks of raising their children and the economic support of the family. Others are post-divorce fathers who share joint custody with their ex-wives and have their children part of each week or month or year. A handful of men are even becoming single fathers, either through adoption or by gaining sole custody of their children.

We have heard a great deal in the recent past about the effects of father absence. What about the effects of father presence? This is the question that excited my interest and led me to do research on shared parenting households. It is not just that the father is more present in these families that makes them unique. It is that the traditional divisions between men and women in the family are turned topsy-turvy. Men come closer to the hearth, typically women's domain. And women step aside to make room for them there. What happens to the man, what happens to the woman, and what happens to the children when they all live together in such a household?

The shared parenting family is no doubt the exception rather than the rule in the mid-1980s. Although there are no polls or government statistics to guide us, it is safe to estimate that these families represent a small percentage of the population. So why would we want to bother looking so carefully at a small, unrepresentative corner of American society?

To begin with, parents of this generation are confronted with harsh economic facts that make the shared parenting family model of more than academic interest to them. The changing realities of the job market and the financial pressures on American families make it nearly impossible to adhere to a traditional family pattern wherein Mom stayed home and Dad went to work. As we have seen, the traditional nuclear family has become the exception rather than the rule. What will be taking its place as more and more women with small children in intact families leave home to enter the paid work force?

The new reality facing young adults in all these families is that they enter their childbearing and rearing years not making a choice between work or career, on the one hand, and family, on the other. Instead, they are forced to maintain a precarious balancing act between the two. For a small handful of couples, dividing up both the parenting and paid work responsibilities equally between them seems the optimal solution. But for the majority of couples, old ways die hard and we find an endangered family situation, particularly for the women in the family. The deeply entrenched ideology that Mother must be the one responsible for hearth and home means that these women are faced with the backbreaking task of doing two days' work in one. They go to work, and then come home to be a housewife and mother. Or they stay home to be a housewife and mother, and then go to work at night. For many wives, this places their weekly workload at two to three times that of their husbands, whose primary task remains breadwinning.

Common sense, and many clinical hours spent with distraught, overworked mothers, has taught me that such an inequitable state of affairs cannot exist indefinitely without a major breakdown, or breakthrough, somewhere in the system. More and more women tell me they are either unwilling or unable to carry out full-time parenting responsibilities with little or no outside support or involvement. They have been affected by the spreading consciousness of the women's movement, which challenges the immutability of gender-divided roles and positions in the family and in society. They have begun to recognize the untenability of a life-style wherein a woman devotes herself primarily to her children and the man primarily to his job. Yet they are still plagued by a gnawing *internal* script to the effect that mothers should be home with their children—reinforced, in the 80s, by a rash of media ideology and propaganda touting the importance of an all-the-time mommy for the health and welfare of her growing child.

What are such women to do? Some read the contemporary child development and popular literature on the other side of the argument and recognize the trend in our society toward more acceptance of father involvement in parenting. They go to movies like *Kramer vs. Kramer* and *Mr. Mom* and are encouraged by the growing recognition of the ability of fathers to "mother." If they are lucky, they live with men who begin to think in the same direction. They rethink and make changes in their family structures.

Other women stay put with their 90-plus-hour work week. They both bring in a paycheck and change all the diapers. The toll on both themselves and their families is tremendous. There is just not enough energy to go around within each of these women—not enough to be, all in one, an effective parent, an effective worker, and a giving lover. Someone, either themselves or another family member, gets short shrift. The husband-wife or parent-child tensions can mount to crisis proportions. The final result can be the breakup of the family.

The majority of intact families today have two working parents. But, unfortunately, the reverse is not true: The majority of these families do not have two workers parenting. This had led me to rethink the notion of "privilege" as it is applied to the shared parenting model. If the alternative and more common solution is the double work week for women, how can we consider shared parenting a luxury? If it actually works, the family in which a woman and a man "mother" together will be the needed antidote to the overstressed, overworked nuclear family. It will remedy a potentially

explosive family situation by taking the burden off Mother and shar-
ing the family workload more equitably between adult family mem-
bers.

But can it work? To answer that question, forty families involved
in a shared parenting arrangement were selected for in-depth inter-
views about their experience. In seeking these sample families, I
discovered that as small and as new a phenomenon as the "50–
50" family is, it has actually subdivided into two basic types.

The first type comprises parents who share by choice, like the
early-70s "pioneers." These are the mothers and fathers who have
made a conscious and often belabored decision. For personal, social,
or political reasons they will raise their children in a shared parenting
household because that is what they strongly believe to be best for
both themselves and their children. They are most likely middle-
class. While I found that the woman is the one who often initiates
the negotiations leading to such an arrangement, it is typical for
both the man and the woman to be strongly invested in the sharing
of their children's upbringing.

The second group is made up of parents who share parental roles
by necessity. Precisely as a result of economic demands, job pressures,
and work schedules, these mothers and fathers engage in shared
parenting either because of expediency or efficiency, or as the only
workable means of juggling their paid work and household responsi-
bilities. Within this group I found both middle-class and working-
class couples.

In this group we find the growing numbers of overworked mothers
who have finally thrown down the diaper pins in disgust and
screamed to their husbands, "I can't do it alone anymore! You're
going to have to pitch in." The timing of the arrangement often
differentiates these parents from the first group, who *choose* to parent
together. The "choice" group usually embarks on shared parenting
from the day of their first child's birth. The "necessity" group has
more latecomers, people who have already had children for awhile
and have lived within more traditional parenting patterns.

There is often less of a sense in the latter group of a mutual
investment between mother and father in the shared upbringing of
their child. These parents' primary goal is not to break down obsolete
gender divisions between girls and boys, but to get through the
day. Because day care services are unavailable, exorbitantly expen-
sive, or frowned upon, these parents may instead adopt the "split
shift" shared parenting arrangement: One person parents while the

other person goes to work, and then they alternate shifts. Not only, then, does the couple seldom get to see each other, but their children seldom get to see them parenting together.

Commonly, these parents, if given a choice, would go back to the old way, and many consider their present arrangement temporary. Some dream of the time when the father will be able to earn enough to support the household and the mother can quit her paid job and go back to her preferred position as full-time mother. Others, particularly the men, find the simultaneous pressure of work and parenting responsibilities unbearable.

Just recently, the *New York Times* reported an incident in which a Home Box Office TV documentary on missing persons inspired a man to return to his family after having deserted them two years previously. Why had he fled the family with not a word for two years? Because he could not cope with a split shift parenting arrangement, in which he worked nights, his wife worked days, and they alternated the care of their infant and toddler, leaving him with only a few hours sleep.[2]

Yet, there are other parents who, once "forced" into shared parenting by work schedules and financial necessity, could not imagine going back to the "old way." What started as a matter of necessity has now become for them a matter of choice. These fathers would find it emotionally intolerable to disengage from their children. The mothers would never be willing to take the entire childrearing burden on themselves again.

My major interest in this book is in parents who "mother"* together because they *choose* to and not because they *have* to. These are people who willfully and with careful forethought violate contemporary Western norms of childrearing. They are making a social statement: that a man as well as a woman is capable of raising a child, and that a child can do quite well, if not better, with *two* primary parents. As mothers and fathers, they are raising their children in a way totally opposite from how they themselves were raised.

If the changing economy dictates that more and more families will find themselves with two working parents, this small group of parents, unbeknownst to themselves, may be the wave of the future. But that is not the only reason to study them. They provide a superb laboratory in which to investigate how far we can stretch gender

* "Mothering" is used here to refer to the social and psychological acts that are done by the primary caretaker, regardless of the gender of the person doing them.

boundaries in the family. They afford us a window into the possibilities of changing the generally accepted form of the family and still ending up with healthy, maybe even healthier, people. And they tell us a great deal about the malleability of the human personality. The women and men interviewed were themselves brought up within a more traditional framework, in which boys were groomed to be breadwinners and girls to be mothers. Now grown up, they are challenging these notions of adulthood. Are they indeed able to switch midstream and become a different kind of adult as they enter their childbearing years?

Other writers have also been stimulated by the phenomenon of the shared parenting family. Recent research has been done on these households to discover what motivates the couple to co-parent, who does what tasks, how decision making is done, how much time each parent actually puts in, and what social stresses impact on the family. The popular press has been particularly interested in describing the "how-to" of the "50–50" household: a day in the life of Ms. and Mr. Smith (Joe gets up in the morning with the baby; Betty feeds him breakfast; then Joe takes him to day care; then Betty picks him up; etc.). These are all very valuable contributions in analyzing the shared parenting household and whether it can work.

Yet, another important piece of the puzzle has been left virtually unexamined. We do not know the interpersonal and inner psychological experience for each of the people in these families: the man, the woman, and the children. From the very beginning of my search, and out of my own personal experience, I always suspected that shared parenting between a man and a woman would be easier said than done and involved more than met the untrained eye. To understand how such a family works, we cannot merely peer within the walls of the family home, describing what we see. Instead, we need to look both further in and further out. We must weave a tapestry from three major threads: the pressures and realities of the job market and the extrafamilial world in which the couple lives; the values and beliefs of the culture; and the psyches of both the woman and the man as they join together in the parenting relationship. Only by incorporating all three threads will we get a full picture of the shared parenting experience.

As my search began I held onto all three threads but felt particularly tugged by the third one: the inner psychological experience of each family member. I knew full well that the fathers I would be

talking to would most likely have been brought up to be breadwinners first and fathers second—and certainly never "mothers" (primary caregivers). And the mothers would have been raised to be mothers first and paid workers second, if at all.

Reading and clinical experience told me that such a legacy of experience and upbringing are not easily shed, and not just because of habit or external pressures. Each of us as an adult has internalized a specific way of being, an understanding of who we are in relationship to other people in our life. Depending on who we are, either female or male, these notions and understandings of self and others look quite different. Yet they are also a crucial psychological underpinning of the capacity and manner in which we will parent a child. Logic would dictate, then, that unless a particular man and woman could successfully shake off their personal history and development as they undertook shared parenting, their efforts at parenting might be equal, but their experience and behavior would certainly not be identical.

That thought intrigued me. It turned around the questions I was posing about the shared parenting family. It seemed too simple to ask, "Can a man mother?"—a question that leads us more toward considerations of biological capabilities than anything else. No doubt this is critical information to know. We have already been provided with enough data to say, "Yes, he certainly can. In fact, any human being who can provide psychological and physical nurturing and respond appropriately to a child's signals can 'mother.' "[3]

A more compelling question is whether we can possibly consider "equality" in childrearing between a man and a woman. We are talking about two people who have been raised and treated very differently in their lifetime, two people with completely different preparations for parenthood, two people who have developed such different senses of themselves, just because one was born a boy and the other a girl.

Given these differences, I began to think that we might be wiser to investigate the possibility of "separate but equal" as we study women and men "mothering" together. Separate are the things they do, the thoughts they think, the emotions they feel as they raise their child together. Might we even favor this separate but equal mode over the androgynous mode—where, with the exception of pregnancy, birth, and breast-feeding, Mom and Dad do everything the same? Do we feel it is better to preserve some differentiation between what men and women do in the family, so the children

are not confused about their being a boy or a girl? Or do we want a situation in which a man and a woman are virtually interchangeable in their parenting capacities? This latter possibility implies that it matters not at all whether you are male or female when it comes to parenting, and we must seriously wonder if such a "wish" is possible even in reality.

These questions tormented me and convinced me that to answer them I needed to crack the mystery of the internal drama for each of the parents in the sharing household. This is a drama that unfolds not only within each parent but also in the relationship between them and between them and their children. To sleuth in this area touches on a very sensitive human subject. Both the phenomenon of parenting and any act of stepping out of what is traditionally expected of us are deeply emotional experiences which stir up our earliest memories, hopes, and fears. They carry us across the map of our competencies, anxieties, convictions, and conflicts, and the journey they describe is made especially poignant by the partners' violation of the norms of the first categorization of ourselves that we ever learned: namely, that we are either male or female. This delicate situation is exactly the one I chose to probe in this investigation.

To parent in this new way requires the external supports of social institutions, cultural attitudes, and family networks. No less essential are the inner resources required to successfully raise a child together: the ability to nurture, to open oneself up to another human being, to have trust in one's parenting partner, to have a harmonious and integrated sense of oneself, and to stay committed in a relationship. The combination of "inner" and "outer" resources was my major focus in setting out to study the shared parenting family. It is the "inner" that particularly caught my eye and will be highlighted in the pages of this book.

The "inner" domain not only reflects the experience of the father and mother, but also spills over into the development of the children they are raising. All eyes are riveted on the children as either the lucky recipients or the helpless victims of this new parenting experiment in which both a father and mother are actively involved in daily care. We know that children are our legacy and our investment in the future. Wrong ingredients in the childrearing recipe will bear bitter fruit later in untoward consequences for the offspring as they themselves move into adulthood. I turned to the mothers and fathers themselves to ask them to reflect through their own eyes on how

they saw their gardens, their children, growing. I also looked within myself and considered my own clinical experiences with children.

In so many ways, this is an account in the oral tradition of people telling their own stories. And the stories of the many men and women I spoke to tell me that the essence of the shared parenting experience lies in their inner discoveries of themselves and their partners, in the bonds they formed with their children, in the level of closeness or distance they experienced with each other, in the struggle they underwent to balance the different parts of themselves into one whole, in coming to terms with who they were as men or women. I would like to bring the voices of these experiences to life in asking again, "Can a woman and a man mother together?"

2

Candidates for Sharing

A Profile of the Parents

If you walk into the Hoffmans' house any late Tuesday afternoon, you will trip over a Fisher-Price toy in the living room and maneuver your way around the playpen in the dining room before finding a seat at the table. Sarah, the babysitter, will be putting on her coat to leave. Ellen, the mother, will be racing in from work to relieve her, one arm still in her coat and the other outstretched to retrieve squirming baby Jonah from Sarah's lap. Neal, the father, bolts from his upstairs study in a mad dash to the day care center to pick up their four-year-old, Judith, before closing time. Racing out the door, he yells over his shoulder to Ellen, "Don't forget to turn the stew on, and would you make sure Judith gets her medicine?" Ellen yells back, "You were supposed to bring in Judith's registration form for Swim and Gym yesterday. It's got to be in by tomorrow."

At the Rand-Greens' house, I am sitting with Maureen in her home office, interviewing her about her experiences as a shared parenting mother. Graham, the father, is strolling right outside her door with fidgeting Michael, their seven-month-old. The cries grow louder as Michael grows hungrier. Graham finally interrupts us, sheepishly, to announce that it is Michael's feeding time. Maureen, with a sigh, takes Michael and breast-feeds him as we proceed, somewhat distractedly, with the interview. Feeding done, Maureen signals Graham to come relieve her of Michael. Michael sails off on Graham's shoulder and our interview continues.

A brief snapshot, then, in the lives of two shared parenting couples. Ellen and Neal and Maureen and Graham look like many other people in their mid 30s to early 40s; they are part of the post-war, baby boom generation. They are college educated, live far away from their own parents, and are presently engaged in either white collar or professional jobs, or enrolled in graduate school. They tend to have one to two children, and many of them have waited until their early to mid 30s to have their first.

Finding the Families

The Hoffmans and the Rand-Greens are just a few of the many families whom I came to know. As with all the other mothers and fathers in the study, their names and occasionally their physical features or exact nature of their job or profession have been altered to preserve their anonymity.

Although the majority of parents interviewed, by myself or by an assistant, were from the larger San Francisco Bay area, I also spoke to parents from Boston, New York, Philadelphia, Chicago, Washington, D.C., Los Angeles, and Ann Arbor, Michigan. What they had in common, then, was not that they came from one geographical area, but that they were all situated in large urban centers or in liberal, academic communities.

The snapshots of the Hoffmans and the Rand-Greens do provide a peephole into the distinctively "untypical" daily lives of these people. They do not have a traditional division of labor, like their own parents did. They seem always to be on the run. They do not know who to list as "head of household" on labor market surveys. It is never quite clear who is in charge. They run the gamut from looking like the ultimate in participatory democracy to resembling the worst in unstructured anarchy. The link among them is that they had, all of them, chosen to share equally in the rearing of their children.

To qualify for my sample, a couple had to meet one simple requirement: They both identified themselves as the primary caretaker in their present family. It was in this definition of self that I believed I could pinpoint those couples who were determined, because of internal desires rather than external pressures, to "mother" together. A strict 50–50 division of physical parenting labor or time involvement was not necessary, although the time division could not wander too far from an equal parenting arrangement. In percentage terms,

it could look like a 60–40 or perhaps even a 65–35 dividing up of responsibilities.

A couple could *not* qualify if one parent indicated they "helped out" in parenting. Helpers take a back seat to the boss, the other parent, who calls the shots. They are not primary parents, even when they do a generous amount of helping. Not surprisingly, they are also almost universally men.

I had also decided only to interview parents who were both the biological parents of the children living in the home. I knew there were many step-families or blended families in which shared parenting occurs, particularly if the father is the biological parent of the children. But with these parents I would be left sorting out the additional complications of family reorganization and adjustment that inevitably occur. That, as well as a study of families in which the parenting was shared by the biological mother and another woman, seemed a more advanced task, for a later time.

Through word of mouth and my own personal contacts, I began to generate a pool of people who fit the bill of two people, a man and a woman, sharing the position of primary parent in their family. I had no trouble finding *potential* couples to talk to. People told me eagerly about friends or friends of friends, and I soon found myself generating, both geographically and socially, an arena well beyond my own circles. Although the pool of shared parenting couples is not a large one, my goal was to cast my net as wide as possible. I was lucky, of course, in that I began my search in an area of the country liberal in both values and behavior and overrepresented with just such "nontraditional" families.

Yet enough popular magazines, journals, and newspapers have been addressing the issue to suggest that people all over the country, not only in liberal communities like the San Francisco Bay area, were beginning to talk in much greater numbers about men's increased involvement in childrearing and the reorganization of men's and women's responsibilities in the home. The *Wall Street Journal,* for example, declared that "today's ideal middle-class father is supposed to change diapers, go grocery shopping, be as emotionally involved with his children as his wife and help her juggle her work schedule and the babysitter's—all without shirking any of his duties at work."[1] In fact, I discovered through my expanding networks that couples in many other communities around the country, couples who fit similar profiles to their California counterparts, were setting up households in which men and women were "mothering" together.

Where possible, I also included these couples in my interviews.

For the most part, people I contacted were more than willing to spend the time to be interviewed. I actually had several individuals call *me,* requesting to be part of the sample. They had heard about the study and wanted to be interviewed. They hoped I think, to learn something about themselves through reflecting on their experience with an interested listener. As is often the case with people pioneering in new directions, they also very much wanted to make their story public and get credit for the gratifying but extremely difficult feat they were accomplishing. One woman contacted me several times by phone before we connected and then passionately explained, "We're doing this, it's damned hard, and I want people to know about it."

Only one major impediment prevented people from participating in the study. Ironically, this was the same impediment that I was later to find out made shared parenting itself so difficult: To wit, people just did not have the time. A phone call to one man produced an amused, but firm response: "Gee, I'd love to help you out. But it's the very thing you're studying that makes it impossible for me to participate. Between taking care of the kids and going to work, Margaret and I just don't have the time for anything else."

Those couples who did have the time or made the time to be interviewed were indeed a very homogeneous group: predominantly white, middle-class, and professional. Their homogeneity was even more exaggerated because I focused only on families who had willingly chosen a shared parenting arrangement. I suspect there would have been a great deal more variety in life-style, ethnicity, and socioeconomic status if I had also included families who had formalized a shared parenting arrangement solely as a matter of expediency or necessity. But the particular psychological questions I was pursuing convinced me to limit myself to the first group.

There was, however, one dimension with respect to which the families I interviewed were not at all homogeneous. This involved the era in which they became parents. Along this dimension the group was not only stratified but, indeed, bifurcated.

On one side were the parents, now typically in their mid-thirties to forties, who had their children in their mid-twenties to early thirties, ten years or more before my research began. These were the pioneers I referred to earlier, and they saw themselves as already an historical anomaly. As one mother, who had her only child in 1972, phrased it, "I can't believe that I'm a grandmother to my

own generation. My friends call me for advice and ask me about the old days when I had a small baby. It's astounding that so much has changed in such a short time. I guess the 80s really are different, and it's sure clear the 60s are over." She meant that she had her child at a time when shared parenting was a "revolutionary" idea, part and parcel of the social ferment and excitement of the time. This sense of communal daring, of a shared confidence in the possibilities of social and personal change, no longer fueled the parenting efforts of the friends now seeking her counsel.

This newer group of parents made up the second side of my bifurcated sample. These were, indeed, the over-35 "baby boomers." Their children were quite young, usually under five. While the first group was busy having children in the early 1970s, they were going to school, establishing careers, and sometimes wondering if they would ever have children at all. Rather than being part of the "revolutionary" experiment of the last decade, this set of parents was swept up more by the biological clock ticking away and the realization that it was now or never for having children. And for a number of reasons, they, like the early-70s pioneers, decided that the best way to raise those children was in a shared parenting household.

Why Did They Do It?

Time and time again, when I give lectures or talk informally about my work, a voice chimes up, "But what makes people want to share parenting? I bet it's because she makes him?" or, "It's really just a matter of expediency so they can both develop their careers, yes?" or, "Wouldn't it have something to do with the messages they got from their own parents when they were kids?" To find out what makes someone do something is in itself a very complicated process. It is particularly complex when that "something" has to do with the very large and intimate portion of a person that is his or her parenting self. Nonetheless, I, like my listeners, was intrigued by the same set of questions.

Asking the parents themselves why they "chose" to share parenting was a bit like asking them what makes them breathe air or wake up each morning. Looking at me askance, they responded first with great puzzlement, "Well, I don't know. I mean, how else would we do it?" But with a nudge and a gentle reminder that most people certainly do not parent at all like they do, a flood of thoughts and associations poured forth.

Revolution Begins at Home

Responding to my prompting, a great number of the parents, both men and women, spoke first of the large impact that the women's movement and the political activism and social milieu of the late 60s and early 70s had had on them. Prior to giving any thought at all to whether they would have children or not, these parents had begun to grapple in their early adulthood with the issues of sexism and inequality, both in the larger culture and in their personal lives. They came from a spectrum of society that was socially aware and wanted to make sweeping changes in the way things were. As one mother put it, "Both of us were of the groups that were going to change the world."

And their belief was that one way to change the world was to start at home, by changing the way women and men relate to each other and challenging the expectations assigned to them on the basis of their gender. Not to change was to accept the status quo of inequality, in which woman was on the bottom and man on the top. The man carved a space for himself in the public world. The woman had to stay home and be the live-in domestic. These parents wanted none of that.

Needless to say, it was typically the women, more than the men, who were hypervigilant with respect to what needed to happen at home in order to make things more equal. Before parenting was even a glimmer in their eyes, they had already paved the way by insisting on sharing housework with their male partner. The men, on their end, typically recognized how necessary their participation in household responsibilities was to the success of their relationship.

By the time a baby came, they were already knee-deep in sharing. The decision to divide up the responsibilities of raising the children was an organic outgrowth of a personal and social commitment to carry egalitarianism between the sexes into the home. Upon the birth of their first child they were not simply starting afresh. The assumption that they would raise the children together evolved "naturally" out of their earlier household arrangements.

What these parents do not know is that many men and women who have successfully negotiated the equal distribution of household tasks do not fare so well when the first baby comes along. Data collected by Carolyn and Philip A. Cowan for the University of California, Berkeley, "Becoming a Parent" project indicate that many parents reverted to a more traditional relationship after the birth

of their child, despite plans to "share" parenting before the birth occurred.[2]

After reading the Cowans' findings, I thought to myself, "Why did the parents in my study have such a different experience?" I know old ways die hard. Years of socialization and a social system that encourages traditional parenting create an uphill battle for women and men attempting to change old ways by "mothering" together. Mom still remembers the dirty laundry better, and Dad still has a harder time taking the day off from work to tend to a sick child. In these precise ways there was indeed evidence of *slippage* in the families I spoke to, but certainly no reversion to traditional ways. The men and women involved genuinely achieved a balance in which both were the primary parents of their child(ren).

We could conclude, then, that a commitment to feminism or the deeply entrenched effects of the cultural upheaval of the 1960s is what differentiates these women and men from the parents in the Cowans' study or the majority of fathers and mothers who never even contemplate dividing up the tasks of parenting equally between them—except that some people I interviewed actively disclaimed any social, political, or ideological commitments underpinning their decision to share parenting. The "anti-ideology" respondents, although small in number, were overwhelmingly men. In our culture, the notion of doing something because of ideological reasons often contains overtones of "following the leader," "being dragged by the nose," or swallowing someone else's regimen. For men to admit to a social purpose underlying their parenting style would be to make a commitment to feminism, to a social movement whose leaders and constituency are women, many of whom, in fact, have complaints about male behavior. These fathers were often, I thought, disquieted at the thought of making such a commitment. They may also have been resistant to the possibility that the women's movement could have had any effect on how *they* live. After all, it's a movement for and about women, not men. Instead, they developed their own notions about how they just happened to be one of those men who enjoy raising a child. They preferred to keep it personal—just between themselves, the woman they love, and their child.

Nonetheless, despite the men's disclaimers, the reality of their behavior and the discrepancy vis-à-vis their wives' reports could mean only that these men were certainly influenced, even if not consciously, by the feminist movement in their entry into shared parenthood. This could occur either through absorption of the sub-

cultural values around them or as a result of direct pressure from the woman in their lives. However it occurred, this particular group of men was ripe for being swayed, even if only at a subliminal level, by the exhortations of the women's movement regarding gender rearrangements.

Dual Careers Means Dual Parents

To be sure, politics (or anti-politics) was not the only force propelling these couples forward into their present parenting roles. These women and men had established a relationship between themselves and the work (or outside) world which strongly affected their sense of how they would incorporate family life into their work life.

From the woman's point of view, she had either established or desired a work or career identity that would be obliterated if she stayed home as a full-time mother. "I had a strong desire not to be the mom. Because I have other fish to fry. I didn't want to sit home raising children. You don't get strokes for doing that. I need the external recognition." Not all women focused only on social acclaim or visibility, however. Most had internalized a strong sense of themselves as professionals, or as people in the world who were on their way to or had established a work identity, from which they received emotional fulfillment.

Whereas their own mothers had accepted the notion that the role of full-time motherhood could be fulfilling, the daughters did not believe this. A few even tried it, devoting the first months of their child's life to full-time child care responsibilities. Their overwhelming response: "I couldn't stand it another minute. I needed to get back to my work. I needed the responsibility to be shared. I needed to be more than a mother."

Obviously the women could have maintained their work identity by employing child care services, a nanny, or an au pair for their children. Most had the economic resources to hire help and did not need to turn to their husbands or lovers for child care. These women, however, were already engaged in egalitarian relationships. They were accustomed to being intertwined with partners in navigating through life, in terms of who did what. It makes sense that those same partners would be the first they would turn to with respect to sharing the burdens of child care.

Furthermore, the women were quite aware that parenting responsibilities transcend the daily child care tasks that an au pair or child

care worker provides. They involve, rather, an emotional investment and twenty-four-hour-a-day psychological availability that only another ready, willing, and able parenting figure could share with them. And so they expect that investment and that availability of the man they make their child with.

The men, of course, were not just waiting passively while the women worked through these inner negotiations. They had their own work-related reasons for becoming involved fathers. First, they were not so keen on the idea of carrying the financial burden of the family alone, particularly if their wife was capable of earning a good living herself.

Consider Donna, the mother with "other fish to fry." Small, dark-haired, and determined, she is indeed a hard worker. Her husband, Jim, fair-skinned and more laconic, is adamant that "I do not want to be the sole money earner. I expected Donna to work." Although taking on parenting responsibilities definitely impinges on their career development, the men, too, like the women, are not swayed by prevailing cultural norms surrounding parenthood. They do not buy the belief of their fathers' generation that a man's primary responsibility is to bring home a paycheck and that the responsibility should be his and only his, not shared or taken over by his wife.

The men I studied want more than to share the financial burdens of the family with their parenting partner. They also want to be fair. Most of these men thought that there was no reason why their work lives and development should take precedence over the women's. One father, a university professor married to a university professor, declared, "Our work lives were so parallel that it reinforced our commitment to sharing. It would be unfair if it was unequal. Our commitment was to minimizing the disruption to work." He believed that his wife's work should be no more penalized by motherhood than his was by fatherhood. If they did not actually internalize this value, the fathers were at least responsive to imagined or real pressure from the women themselves: "I didn't think Naomi would have it any other way. She would say, 'If you want this child, we're going to bear the responsibility together.' She's a self-sufficient person who doesn't want to be exploited."

Even when the men attributed their choice to "external" demands, such as the woman's need for outside employment, they did not speak of their parenting involvement grudgingly, but with warm acceptance. In other words, they did not present themselves as "roped into it" or unduly pressured by their wives' work needs. Instead,

there was a warm generosity toward the women they lived with coupled with an excitement that they themselves were going to have the opportunity to embark on the new venture of raising a child.

Another quirk in these men's work lives might explain why they differ from the fathers in the Cowans' study who do not become primary caregivers. Although the fathers I interviewed came from a broad spectrum of professional fields, a disproportionate share, compared with general labor market statistics, were found in "child-related" fields of work. This included early childhood educators, mental health professionals working with children and families, child development specialists, and pediatricians. In fact, many fathers made direct reference to their line of work as an influence in their decision to share parenting.

One father, a Ph.D. in child development, recalls his early experience as a father: "I had just finished a doctorate. I was enamored with the infant stimulation movement. Sarah's crib was one big sensory overload." This same father, very much influenced by the women's movement, spoke also of his desire to demonstrate in his workplace, a very conservative academic department, that a man could indeed "mother" a child. He remembers with chagrin, humor, and indeed satisfaction the horrified looks and intolerant attitudes of his colleagues, both male and female, when he brought his young daughter to faculty meetings or other work-related activities. His own studies of infant development, combined with his commitment to egalitarianism between the sexes, led to a strong stance that both he and his child would definitely benefit by his equal involvement in her upbringing. Furthermore, he wanted to prove that to others.

Another father, not so evangelistic in his approach, brought it back to a more personal realm. A childhood educator, he recalls that his entry into a shared parenting relationship also "came from my orientation about work. Part of my field is to be involved in parenting and in young children. I have been involved in an infant-toddler program. I also wanted that involvement for myself with my own child."

It makes sense that a man who chooses a field of work involving close contact with young children would also have some inclination to have this experience at home with his own children. Certainly Jean Piaget's meticulous diaries of his own children's development reflect such a carry-over. Yet clearly it was not Jean but *Mme.* Piaget who changed all the diapers and made the doctors' appointments. And any look at the average day of a male pediatrician reveals

that he is typically not also at home as a 50% father. No doubt Dr. Piaget and Dr. John Doe the pediatrician likely fall into the category of "involved" fathers. This, however is very different from the fathers telling their stories in the pages of this book, who are fully engaged in the everyday rearing of their children.

We can conclude that a man's involvement in a child-related field of work increases the probability that he will be interested in taking on the role of primary parent. Other factors, however, must be present, including a partnership with a woman to whom work or career is also important and exposure to the cultural milieu of male-female egalitarianism. Furthermore, entrance into a child-related field may simply be the tip of the iceberg of more deeply rooted reasons, stemming from their own childhoods, that influence these men's choice of both a "nontraditional" profession and a "nontraditional" parenting role. These reasons, which we will come back to later, may well differentiate these fathers from other men in child-related fields who in their home life remain embedded in more traditional modes of childrearing.

A final work-related factor that characterized this group of parents concerned the relative job security of the two parents; it was not a common phenomenon, but nonetheless noteworthy because of its implications. In marked contrast to the situation in the traditional nuclear family, a handful of fathers reported that one reason for assuming half the caregiving was that their wives in fact held better jobs, made more money, or had better job security than they did. For some couples, this was stated simply as a matter of fact, with no expressed feeling of tension or distress behind it; it was just the way things were. But the story of Carolyn and Stuart, a couple each of whom, independently, dwelt heavily on this phenomenon, has a lot to tell us about the reality of this decision for many parents.

Carolyn, stylishly dressed in her professional clothes, sits barely blocking the family photograph propped behind her. I peek in the frame at a three-year-old beauty in her father's arms looking lovingly toward her gentle but animated mother, who smiles back radiantly. This wholesome threesome of Carolyn, Stuart, and Anya did not come to be, however, as effortlessly as the picture seems to portray.

Carolyn brushes her brown curls from her face and begins to unfold her bittersweet memories concerning their family's work-related reasons for co-parenting. She recalls that when she and Stuart first started talking about having children Stuart's employment in the education field was erratic, making him more available to care

for the baby when she was born. In fact, Carolyn thinks that the very structure of their work lives may have been the underlying cause of their shared parenting relationship:

> A lot of things that enabled us to do shared parenting seemed fortuitous. But I don't think that's the full story. For example, how is it that I managed to work at one of the only clinics where you could work part-time? And how is it that we had a baby just at a time when Stuart happened to be underemployed?

Carolyn was not particularly happy with this state of affairs. Unlike some prospective mothers who see their greater earning power as an insurance that their male partners will stick to their part of the parenting bargain, Carolyn was somewhat dubious about this reason for entering into shared parenting. She feared a role reversal around the breadwinning aspect of the relationship. She did not want that double burden: half the childrearing, but most of the breadwinning.

Interestingly enough, Stuart does not remember it quite the same way. Just two days after I have spoken to Carolyn, he and I sit in their dining room, surrounded with papers for work and traces of Anya's after-dinner play activities. A man with a captivating smile and a sparkle in his eyes, he is yet quiet and thoughtful in his demeanor. One could well imagine him as the childhood educator he is. When he thinks back to becoming a father, he recalls that the decision to share parenting affected his work choices, not the other way around.

The story of Carolyn and Stuart teaches us that a shift in the opposite direction from the pattern of the traditional nuclear family can be a determining factor in who will do shared parenting. In the traditional family the rationale for the woman minding the children while the father earned a living was that he had more earning power than she did, so it made economic sense. The same explanation is commonly given in families who have turned back from a shared parenting relationship to a more traditional form or who have settled for a compromise in which the man works full-time and the woman part-time. In a handful of families who choose to do shared parenting, the tables are turned: The woman has more earning power than the man. (If we looked only at the families who do shared parenting by "necessity" rather than by "choice," it would no doubt be larger than a handful.)

That a woman has more earning power than her husband certainly

does not dictate that shared parenting will follow. Looking at American families, we find far more situations wherein the women has more earning power than the man yet still maintains primary responsibility for the children. But in those families who have been influenced by the changing mores of gender egalitarianism, a woman's earning more than a man is often a facilitating factor in promoting shared parenting, or perhaps even an insurance policy that the couple will stick to a shared parenting arrangement.

For both the women and the men, work-related issues are certainly cited as an important factor governing their entrance into shared parenting. Yet when I looked back over my interviews I was struck by how differently the women and the men called forth work factors in their recollections, both in terms of the weight given to them and regarding how they were perceived.

The women more likely uncovered a need *within themselves* to explain their choice of shared parenting. When addressing work issues, they spoke of the need for "self-actualization" and for release from full-time mothering to pursue that actualization outside the home. They turned to their male partner to help free them. Not one woman talked about the external demands of a job situation "forcing" her to turn to the father of her child and request (or demand) his participation.

The men, on the other hand, go on a fishing expedition in search of something that more often lies "outside" themselves to explain their choice of shared parenting. When it came to work issues, they provided one or another essential reason which explained not why they asked their female partner to hand over 50% of parenting responsibilities to them, but why they "accepted" the deal. In essence, they uncovered some reason in the world out there to explain why they had become involved in parenting—"I *work* with kids," or, "she had more job security than me," or, "it seemed only fair to her career."

For the woman, motherhood is delivered to her front doorstep as her expected primary role in life. She has to explain why she is not going to be totally immersed in it. For the man, it is just the opposite: He has to explain why it is that he *will* be involved in "motherhood." The culture's message to him is that he should be a worker, a family breadwinner, and a person who is involved in larger community life. So, interestingly enough, when it comes to justifying how he got involved in shared parenting, that very external world of work and community affairs is what he turns to as an

explaining force. (We might even wonder whether occasionally the man doesn't unwittingly call on a work explanation as a sheepish apology for being involved in what is not traditionally man's work.)

In contrast, the woman turns more to an internal arena, filled with desires and fears and questions of self-identity, to explain her commitment to shared parenting. It would seem, then, that the motivating forces for women are more internal, for men more external, as we assess why these people get involved in shared parenting. But there is a deeper truth than that—namely, that men do not generally become aware of the inner thoughts and feelings that move them into a desire to "mother" until they are actually doing shared parenting. The "inner" is less available to them as they anticipate the phenomenon—which is, perhaps, reflected even when they are doing "retrospective anticipation," trying to recall why they decided to do it. As in many other aspects of life, the "inner" is simply more readily accessible to women, it seems, to talk about.

In the Best Interests of the Children

Beyond the social and political climate and the pressures of work, the well-being of the children was also relevant to a decision to co-parent. Up until now, it would appear as if parents chose a new childrearing style only out of considerations of self-interest: egalitarianism between the sexes, the opportunity to pursue a career, a social demonstration that men are capable of a full range of caretaking tasks. But a strong belief was also expressed that having both a mother and a father fully available would be healthier for the children.

Two major child development reasons were cited again and again as determining factors in becoming a shared parenting family. The first had to do with raising the children free of sex biases. Charles, the father of a three-year-old boy, stated quite adamantly that "there are some things my wife and I both value. One of them is bringing our son up with as few biases as possible about men and women." By having himself and his wife actively involved both in the daily care of their child and in their careers, he hoped his child would learn that both women and men can do many different things, at home and also out in the world. In turn, it was hoped, this would create a child with expanded options, who would be less constricted in his sense of self and freer to develop both the "masculine" and

"feminine" sides of himself. This was an attitude strongly found in all of the shared parenting couples.

The second child development factor cited by many of the parents was a numbers issue. Their children would benefit not just from having a parent of each sex available to them, but also from having *two* primary parents rather than just one actively involved in their daily lives. One mother, who had lost her own mother at age 11, was insistent that "for kids, it's emotionally important that they're involved with more than one person. I want my kid to feel connected to someone other than me, which is also why I believe in child care. So that he feels comfortable." It was the "never put all your eggs in one basket" approach. This particular mother remembers with great pain how ill-equipped her father was to take care of her after her mother's death. Another woman reports an almost identical experience: "My mom died when I was 15, and those next few years I was left under my father's care, which I felt was emotionally lacking. I wanted my child's father to be emotionally there in case something happened to me. My father couldn't get involved because of his emotional limitations."

If only these fathers had been actively involved in their daughters' lives from infancy on, they might have easily taken over as a "mothering" figure without crippling emotional limitations. Not every parent interviewed had to go through a painful childhood loss to conclude that it was better for the building of basic trust to expand the child's sphere of intimate caretakers beyond just one person. But to a person they all agreed this was an important reason to do shared parenting.

To a person this also meant that these parents wanted to raise their children completely differently from the way they had been raised. A father grows emotional as he confides in me: "I felt I wanted to be close to my child. I had a lot of issues about how my father treated me, and I did not consider him a model. My wife and I didn't want to get into a situation where one person would have an important experience with our child that the other person didn't have." A strong aversion to re-creating a family pattern with a father as a scarce commodity in the home was a sentiment expressed by both the men and the women but focused on more by the men, who did not want to replicate the model of their own father's parenting.[3]

Not just their own father's lack of availability, but the double whammy of their father's emotional or physical scarcity and their

mother's unhappiness or overburden was at stake. The way these men and women saw their own parents raising children did not make sense to them. This mother spoke for many:

> Both Sam and I grew up in very traditional families with mothers who suffered from entrapment in motherhood. And we both had overbearing, domineering fathers and introverted mothers who were under the thumb of our fathers. I had a strong need to disidentify with my mother. Sam couldn't understand his mother's role in the family. He felt there was something wrong with his mother's position.

So distasteful was the memory of unavailable fathers and trapped mothers that for a handful of both women and men it led to a period of either spurning parenthood completely or letting it "slide" until they were pushed by their partner.

We all know it is very common for one generation to look back at the one before them and rebel, deciding that they want to do things differently and not in the "old-fashioned" way of their parents. This has been particularly true since the Industrial Revolution, when rapid changes in both the work sphere and the social organization of existence have left each generation with a whole new set of life conditions to grapple with. Yet there is also something unique about this set of adults today. They not only want to do things differently from their own parents; they actively abhor what they saw them do. Yet, dauntless, they are determined to become parents themselves.

Lady and Man in Waiting

We now have a composite picture of our co-parents. They are a group of people who have been deeply affected, either directly or indirectly, by the feminist movement and the cultural milieu of the late 60s and early 70s, in which gender egalitarianism was a cornerstone. Their desire to do shared parenting grew naturally out of earlier negotiations about the division of household responsibilities. The strong commitment of the women to their career or public world involvement, recognized and respected by the men, also dictated that it was "only fair" that child care be equitably divided between them. The unwillingness of the men to be totally responsible for bringing home all the bacon, or their own involvement in child-related careers, also fed into the bargain. For their children's sake,

they anticipate offering them a better world than the one they them-
selves grew up in, a world as free from gender bias as possible,
with two fully involved, caring adults present in their daily lives.

That is what they hope for. Then a baby is conceived. They wait.
Questions pour out. Their confidence is bolstered because they have
already successfully navigated a "gender shake-up" in the distribu-
tion of household work. But as Mother's belly begins to swell, they
grow increasingly aware that children take on a dimension very
different from housework. For some, this is awesome and frightening.
For others, the difference is the very thing that gives them even
greater optimism. As one father mused, "You see, the difference is
that dishes just don't smile back or give you something in return
for your efforts. It's much easier to negotiate around who's doing
what with the baby than it ever is with housework, simply because
there are just so many more rewards."

The men and the women each have their own sets of reasons for
deciding to become sharing parents. They also have different sets
of hopes and qualms as they anticipate the birth of their first child.
The women often remember that it was not so easy, after all, to
establish a fair balance of household responsibilities with their male
partners. They were often the ones who called the shots, or who
blew the whistle when the game lines weren't drawn right down
the center. They are also the ones who will more likely initiate discus-
sions of shared parenting and childrearing issues.

The women approach their imminent parenthood, then, with a
cautious optimism. Overall, they are willing to place bets on its
success. Marsha and Bruce were two parents-to-be whom I spoke
to in Marsha's ninth month of pregnancy. Both tall, stately looking,
and energetic, they were also an even match in stubbornness. Marsha
remembers the struggles around housework, when she would have
to force herself not to count the dishes washed and measure hers
against Bruce's. What pulled them through that time was "having
faith it would even out if we were having a loving, caring relation-
ship." That same faith fuels her optimism that she and Bruce will
rise to the occasion vis-à-vis parenting because of their commitment
to each other.

Carole is a mother with soft, muted features and a doe-like quality
who is nonetheless strongly assertive about her own needs. She,
too, recalls that she was not so confident while she awaited her
child's birth. She had an "I'll have to see it to believe it" approach:
"Practically, I always had the idea that the only way to end up

with anything near 50–50 was to have the man sign up for 80 to 90% of the job, and then *maybe* if you were lucky you would come up somewhere near equal." If the women I spoke to had any doubts, it was about their husbands' emotional capacity to mother and their willingness to put up with the drudgery, tediousness, and intrusion into one's work and personal life that a long-time commitment to a child entails.

Despite their skepticism, these women believed that their partners genuinely *wanted* to share. The harder question they had to ask was, "Did they *themselves* really want to share?" Doubts often surfaced when a woman became a "lady in waiting" and felt the stirring of life within her. Pregnancy is a very special, exclusive experience. Did she really want to share that with someone else? Everyone around her, including the child development texts, was telling her that women have a special bond with infants and that children need their mothers. Did she want to take a chance? Motherhood is power. Did she want to relinquish that to a man?

Despite these qualms, the mothers-to-be kept on track in their commitment to shared parenting. Louise explains it well. Her piercing blue eyes framed by her long mass of chestnut hair, she delivered these words: "I certainly had a very strong feeling from the beginning of not wanting to be strapped with a child. I knew that the impetus to want to share time, to continue to have my own life, was really there and strong."

Meanwhile, the man-in-waiting is an admixture of excitement and squeamishness. He wants to come through on his parenting obligations, as Bruce, the expectant father, puts it, "not because I believe men and women *should* be equal, but because I think Marsha and I *are* equal." The man wants a child as much as his wife does, sometimes even more.

Yet he is already being left out by the very fact that his wife is pregnant and he is not. A great deal of jealousy or envy on this account was expressed by the men I spoke with. But more importantly, their non-pregnant status fueled already existing doubts and fears about their ability to "come through":

> I always felt I would not have the kind of commitment to an
> infant that people talked about. And I was, although I never
> said it verbally, nervous about how willing I'd be to spend 50%
> of the time.

Worries about the pressures of work were paramount in these fathers' minds. To share the dishwashing certainly eats into time otherwise devoted to work or outside activities. But nothing compares with the dent in career or work time made by the responsibilities of childrearing. Rick is a father with a wry sense of humor and a harried style. He remembers very much his concerns about how he would react when the pressures piled up at his job. "Would I fizzle out on the parenting stuff?"

Fizzling wasn't the only problem. It also requires fewer emotional skills to wash dishes than to raise a child. The men, anticipating the birth of their first child, fretted about this. Ben was one of those men. Married to Carole, he complemented her understatedness with his frenetic buoyancy. But when it came to parenting,

> Carole is the one who's empathic, emotional, and whom everyone tells about their stuff. And I'm not particularly interested in that. Carole has a hypertrophied sense of looking out for someone else. That was a standard that I didn't think I could live up to.

The men wanted to share, but could they live up to their promises? Did they have the human relations skills, the empathy, the patience, the endurance for drudgery that have traditionally been seen as women's qualities and are also the necessary components of mothering? The half-read parenting manuals by their bedsides quote the established child development experts, who espouse the importance of these "mothering" skills for raising a healthy and happy child. But they never address the possibility that "Mother" is, half of the time, a man with a beard and mustache. The most a man is told in the standard texts about his own tasks as a father in the early months is to shield his wife from stress and harm and give her love and support so that *she* has the strength to tend to baby.

Even with all their qualms and doubts, the lady and man-in-waiting in the shared parenting family are in a "honeymoon" period. They have made a decision. They are bolstered almost exclusively by a strong belief system, with few models to guide them and certainly no hands-on experience. They know they are embarking on a "social experiment," a way of parenting their children quite different from how their own parents did it and rarely prescribed in childrearing manuals. Their spirit guides them.

These parents are no different from any other couple who anxiously await the birth of their child as a mysterious progression into an unknown world. But they are unique in that no one can definitively answer their questions or reassure them because this is really a very new and unprecedented way of raising a family. Motherhood has universally been women's sphere. No more, for this set of families.

3

"Unto Us a Child Is Born"

Launching the Sharing Family

With no models to guide them and no precedents to inform them, the shared parenting couple plunges into the virgin terrain of co-ed mothering. Their newborn before them, they can only hope expectantly to fulfill the promise they made to each other: to truly share the caregiving of their children.

They may have spent time in households like the Hoffmans' or the Rand-Greens', but they still have only a fuzzy picture of the life awaiting them. A life in which two people will each evening work out the details of who will be doing what with the children the next day. A life in which unexpected events, like their child breaking out in chicken pox, will require an on-the-spot negotiation between Mother and Father to rebalance work and family commitments. A life in which each parent will be exposing intimate details of their inner lives to one another as they try to simultaneously understand and reinforce this new parenting arrangement.

All eyes, then, are on the couples, once their babies are born. Can they pull it off? From within the group of shared parenting families itself, Carole had been the most skeptical of the expectant parents. She was the mother who adamantly believed that the only way to extract anything like a 50% commitment from her husband was to demand an 80–20 or 90–10 arrangement. Yet, sitting on her living room couch fifteen months later, her doe-like eyes still

glazed from those early bouts of baby's nighttime wakings, she marvels, surprising even herself with her own words: "Ben loves to throw this back in my face now because he's so proud, inordinately proud, which does fit your notion of how fully he does his share. And he *does* do his share. I think it's really true that I don't do more than he does."

Carole did not stand alone in her judgment. Again and again, mothers and fathers in every stage of parenthood reported that, despite all the pitfalls and problems, they truly believed they had accomplished some version of a shared parenting situation. Now, we all recognize that "true believers" run the risk of deceiving themselves as they rate their success in their chosen mission in life. These parents are indeed "believers," who placed great stake on the viability of shared parenting for themselves, for either personal, work, or ideological reasons—and all we have to rely on is their own words about their experience. So our task now is to listen carefully to those words, when necessary reading between the lines, and assess how shared the parenting actually is, with all the concomitant household and extrafamilial responsibilities that go with that.

Let us start from the most general and then hone in on the specifics. Join me for a moment as I travel from interview to interview. Here are some comments you would hear. From Francine, the mother of a three-year-old: "You know, it really has worked out quite well. Whoever is around does it. Neither of us feels overburdened." From Dora, now the mother of a twelve- and an eight-year-old: "I can't always say we've worked it out exactly in terms of hours of the day or who does what. That's changed from era to era. But I can say that from the very beginning we have had a shared commitment to the children that has not just been cheap talk but has translated into our activities and behavior as parents. I wish you had had the time to follow us around the house for a couple of years—you know, like Candid Camera—so you could see for yourself."

I have chosen the mothers to speak first because it was far more often the women than the men who had their doubts before the birth of the child. It's not surprising, then, that the men, with fewer initial misgivings about the possibilities, are in accord with the women that shared parenting is actually occurring. Ben, Carole's husband, waved his hand through the air and spoke with great passion as he mused that "I thought it would be much more of a struggle than it is, and I thought Carole would turn out to be more primary, that it would be 70–30 or at best 60–40. It was about six months into Aaron's birth that I flew into a rage because at some point

Carole was suggesting that I wasn't doing 50–50." Carole agrees that she was being hypersensitive, based on her anticipatory fears and skepticism, and reiterated her statement that Ben truly does his share. How did this evolve?

The First Hurdle: The Breast-feeding Barrier

In the Greek myths, the god-given challenges to the mortal protagonist grow increasingly monumental following each successful feat. Not so for the shared parenting couple. Their most ominous fireball is the *first* one hurled at them, starting the day their child is born. The issue is feeding, and the problem is the fixed biological barrier of the breast.

Directly after childbirth, feeding is the obvious first point at which mother and father part ways in their functions. A man simply cannot breast-feed a child, no matter how strong his commitment to shared parenting. So this very first obstacle that the couple confronts in mothering together is also one that is absolutely immutable. If the couple can pass this test, they are over a major hurdle.

One solution, of course, is to make a conscious decision not to breast-feed the baby. Father is certainly equally as competent as Mother in preparing and feeding formula. I have known of a small handful of sharing parents who have chosen exactly this course, with the explicit intention of breaking down any barriers to active sharing. The problem with this tack is that it puts the need to be "equal" paramount above what might actually be best for the child. The modern trend toward "natural" childbirth and childrearing embraces the belief that breast-feeding is healthiest for the child, in both physical and emotional terms. The parents I interviewed were certainly part of this movement. Rather than opting for the bottle under the banner of "equality or die," they all began parenting with an intent to breast-feed.

Interestingly enough, however, a significant number of families, for one reason or another, discontinued breast-feeding very early in their child's life, within the first three months. The likely explanation was that Mother was in poor health or having trouble producing enough milk. But probing deeper, I found a more complicated scenario. On the mother's part, she felt ambivalent or resentful about the amount of time nursing took and the fact that she was left with the entire burden, a burden she was trying to avoid in becoming a sharing parent rather than a traditional mother.

On the father's part, he may very well have colluded with his

female partner's "failure" in nursing. Eleven years after his daughter's birth, Jeff scratches his graying beard and easily recalls: "Louise was not very successful in her nursing and I was sort of glad, so I could have more involvement. It was an area I really did feel some jealousy around, sensing the level of intimacy that was taking place."

Jealousy was central for the fathers. They were left out of the mother-infant nursing dyad and could not do what their wives did. It was one thing to be jealous of your wife's pregnancy, with the baby still an abstraction. It was yet another to have that biological tie thrown in your face in the concrete reality of the intimate physical relationship between nursing mother and child. Certainly one solution was to implicitly or explicitly "encourage" your wife's failure at breast-feeding. This, however, was the exception, rather than the rule. More commonly, the father either compensated for, denied, rationalized, or was sobered by the experience.

To compensate is to find something to do instead. Dad often changed diapers and clothes, retrieved baby from cradle or crib, or walked and burped baby after Mom did the feeding. One father chuckled as he remembered what a great rocker and cuddler he became during his child's breast-feeding days. Another form of compensation, a compromise, was to intersperse bottle and breast-feeding. Fathers would even make a point of feeding their babies barechested in a nursing position, so as to replicate the body closeness and face-to-face gazing of the nursing pair.

A male "stoicism" also cushioned the men against the breast-feeding exclusion. A tone of "Nope, doesn't bother me" belied an underlying denial and defense against feelings of inadequacy stemming from the close, intimate contact the mother was able to establish through nursing. Bernard, in general, is a reserved man, brought up in a family in which free expression of feelings was not encouraged. But even so, he was extreme as he stifled all feelings and reported:

> When Eileen was breast-feeding, Nadine was still pretty attached to me. I didn't feel left out. When Nadine was breast-feeding, I couldn't calm her down. Eileen could pacify her by feeding or holding her. If I picked her up, I couldn't soothe her. But that didn't shake my confidence. I recognized that Nadine wanted to be close to Mother, that she needed a breast.

No one asked Bernard if the experience had shaken his confidence. Yet he felt compelled to assert that it had not.

Other fathers took a different approach. They summoned theory and philosophy to soothe their feelings of exclusion:

> Well, it's good for the child to be nursed. And I just do not want to interfere with that process. It's just something beautiful and natural between a mother and child, and who am I to question it? In those early months it was clear my main role was to sit back and not interfere.

The "philosophers," such as this father, were adept at rationalizing away the problem. They were also more likely the ones who strayed somewhat from a true 50–50 relationship.

There was an equation. The more a father expressed jealousy or rejection in the breast-feeding situation, the more likely you found a couple exhibiting a true equality in parenting. It makes sense. If you are truly committed to full equality, anything getting in the way will be a major thorn in your side. If you are not that totally committed in the first place, an immutable obstacle such as breast-feeding either gives you an "easy way out" or is just not such an irritant. Men are used to being in control. Breast-feeding is one area in which a man who mothers is up against an absolute limit. The mechanism of denial or rationalization is necessary for some fathers to allow them to pursue an equal parenting relationship after immediately running up against a physiological barrier.

David was probably the father who had resolved the conflict in his feelings most thoroughly. A man in his mid-thirties with a three-year-old child and another on the way, his beautifully chiseled face showed no trace of tension as he admitted:

> Nursing was a clear example of biologically differentiated parenting. We never made an issue that we're going to do it equal so we'll both feed the child, not nurse. I think it's good for a child to nurse. I wish I could have nursed. I felt a little let down. The kind of closeness that develops with the mother, it's good for the child. I didn't feel I could give him that kind of closeness and comfort. I think just because of the way I am, it is more difficult for me. But I know if I'm there I can give him that emotional support.

David is sobered by the exclusion from the closeness between nursing mother and infant, a barrier to parenting equality caused by the mother's breast. But knowing he still has emotional resources to offer the child gave David and many of the other men the bolstering

for sharing which far outweighed the inequalities dictated by the physical limitations of the nursing experience.

The physical dictates of breast-feeding take a toll on the mother, too. Already I have mentioned the burden felt by those women who threw in the towel early in the breast-feeding experience, owing to their own conflicts around being stuck with doing it all. One could speculate that these were mothers who also had difficulty establishing intimate contact with their child and were emotionally threatened by the physicality of nursing and the absolute dependency involved. One could go even further and make the argument that this fear may be the underlying motive of a great many women who choose to share mothering with their male partners. However, there is nothing else in these women's reports that would indicate such a conflict. It is not fear of intimacy that plagues these women, but rather the same irresolvable dilemma for the shared parenting commitment that aggravates the men when confronted with breast-feeding—the fact that it cannot be totally equal.

The great majority of the mothers, however, rather than feeling burdened, availed themselves of the special opportunity for closeness (and for demonstrating their own competence) provided by breast-feeding. Rather than shying away from intimate contact with the child, the mother seemed to bask in it, despite its implications for gender inequality, of which she was well aware. She might even find herself tending to take over, to reach for the baby, because she possessed the special object that could soothe and comfort while at the same time feeding. "Nursing puts you in that position. You are the one that stops the baby's fussing. I knew that Rick felt jealous. He felt I had something that could stop Matthew and make him happy." Pam was correct in her perceptions. And she was none to unhappy with this state of affairs. She liked being special, being number one.

I mentioned the equation between nursing jealousy and commitment to shared parenting in men: the greater the jealousy, the greater the commitment. Could we formulate a parallel nursing equation for the women: the stronger the appreciation of her special connection to the baby, the lower her real commitment to shared parenting? No, it appears not.

Certainly, we see glimpses here of the woman delighting in "taking over" and laying claim to primacy vis-à-vis the child, to a "feminine" domain of power. And why not delight in being "number one"? However, the lactating primacy was offset by the women's hypervigi-

lance against being left with the major burden of parenting. Armed also with respect for their mates' desire to be equally involved, the women, along with their male partners, were able to defeat the gods of biological dictates and emerge victorious in their commitment to mother together.

Minding Baby: Female Empathy and Male Bravado

One's commitment to parenting is often greatly influenced by the degree of competence one feels as a mother or father. Beyond breast-feeding, the test begins on Day One, with all the tasks and responsibilities of caretaking. The issue of relative levels of competence between these women and men had a whimsical twist. My general hypothesis when I embarked on this study was that women would report greater feelings of competence than men, particularly in the early months of parenting.

I assumed that this would be the case even if both the mother and the father were greenhorns with a newborn. Inexperience, after all, is often the norm in our culture, where adolescents and young adults of both sexes are often completely divorced from the world of young children until suddenly delivered one of their own. Simply because females will have had more training, even at a subliminal level, and are "supposed" to know more, they would experience themselves, I suspected, as more competent.

Men, I imagined, might easily grab the opportunity for self-enforced helplessness and relinquish expertise to the woman because, of course, "she knows more." Men, I figured, would look for a wedge to bow out a bit, while the women grabbed at the chance to maintain their domain of power in the mothering sphere.

Much to my surprise, competence was an area of questioning in which I found the greatest wealth of statements attesting to sharing and equality. Ken is the father of a two-year-old boy. He is an easygoing, low-keyed man, almost boyish in both appearance and actions. He told me a beautiful story about the cooperation and respect that can obtain between two people committed to sharing parenting. The mother in this family is an expert in the early childhood field, her profession of many years. Ken, on the other hand, having had little experience with young children, reported himself feeling totally incompetent upon the birth of their child:

> One of the things Nancy was great at was when she would criticize me she would do it in a constructive way. The first

night he came home from the hospital, Sam woke up in the middle of the night, got fed and changed, and was still crying. We both agreed I should keep Sam until he stopped crying, rather than have Nancy take over. . . . Our approach was that there was nothing Nancy could do for him, except breast-feeding, that I couldn't do. The way I got to be the expert was by Nancy not taking over.

Two years after Sam's birth, Ken announced that he no longer defers to her automatically. "I trust my own instincts as much as hers."

Nancy and Ken went to greater extremes than most to assure mutual competence in an initially very unbalanced situation. They were typical, though, in that Mother, rather than Father, more likely had the greater feeling of competence in the first moments of parenting, whether she was trained in an early childhood field or not. The most immediate influence on her was the experience of childbirth itself: "I felt more competent around him as a newborn than I thought I would. I don't like newborns. But I had great confidence because I had delivered a child. The physical aspects, childbirth and nursing, gave me feelings of confidence." Even if a mother felt all thumbs with her baby, as Francine did, she still felt an initial edge over the father of her baby: "I remember feeling totally incompetent the first week after Jason was born. But I still felt more competent than David."

That the woman bore the child was not the only factor bolstering her confidence vis-à-vis childrearing. She also typically had extended time in the hospital to tend to the baby, time when the father was not necessarily there or, hospital practices being what they are, when he was not expected or encouraged to "practice," as was the new mother. One could understand how the initial commitment to sharing could easily be undone right in those first moments after birth. Not only is the mother catapulted into an immediate physical relationship with her child, particularly if she is breast-feeding; she is also being called upon to exercise a general set of attributes she is at least vaguely aware of as the key components of "good enough mothering," as the psychoanalyst D. W. Winnicott put it.[1]

The women in this study recalled the patience, the frustration tolerance, and the empathy they drew on as resources in those early days, even if they knew nothing of changing diapers:

He [the father] would lose it sometimes. I was more *patient*. So I did feel more competent.

In the beginning I felt very competent along the lines of *empathizing* with a child. I didn't feel so competent about how you do certain things. I hadn't been around many babies, none of my friends had babies.

These abilities are called to the fore among these mothers because they have been raised in a culture which stresses these qualities in women and puts much energy into a gender-specific inculcation process. It is also explainable because all of them had themselves been raised by women. Nancy Chodorow, in her book *The Reproduction of Mothering*, poses a theory that little girls, raised by women who are the same gender as they, never develop a full sense of separateness from their parenting figure. Mothers, on their part, who perceive their female children as like them and even as an extension of themselves, will have greater difficulty in "letting go" of their little girls. The result is that a little girl grows up always experiencing herself in the context of connectedness with another person. Out of this sense of connectedness comes the "relational" abilities that will in turn make girls good candidates for mothering: empathy, nurturance, "intuition" about other people's thoughts and feelings.[2]

Little boys, on the other hand, according to Chodorow's theory, follow a different course of development, precisely because they, too, are typically raised by a woman, who, for them, is an *opposite-*gender parenting figure. The mother perceives the boy, quite early in his life, as very different from herself. Particularly if she is in a culture like ours, where men are traditionally absent from the everyday lives of women and children, she very early on rears her little boy as an "other" to relate to.

The little boy, for his part, has a hard task ahead of him, as he has to disengage from his mother, who is there all the time, and turn to a not very present father to establish his sense of self as a male in the world. The boy in the traditional nuclear family, then, with little access to his father as a daily presence, grows up not experiencing himself as connected, but rather as very separate from his major parent, Mother. Out of this separateness, and his need to individuate from her daily influence to become a man, comes an entirely different set of personality attributes. Rather than empathy, nurturance, and "intuition," the male in the female-raised culture develops the more "rational" traits, such as thinking clearly, being analytical and objective, keeping one's emotions in check. These attributes prepare him for the world of work and public affairs, rather than the world of relationships and intimacy.

If this theory is correct, the fathers in this study, all raised by women themselves, must come to parenting with a distinct disadvantage in the area of parenting competence—which, according to Winnicott, involves, particularly in the early months, the ability to be connected, to identify with one's infant, and to give support just when it is needed. What does happen to the new father's sense of competence in the shared parenting family as his female partner gets the added benefit of time in the hospital, a more physical relationship with the child, and the freshly tapped resources of "feminine" nurturance, empathy, and patience to enhance her sense of "expertise" as a parent?

Some of the men were quite conscious that their first tendency was to let Mom take over; after all, "She must know what she's doing; she's a mother." David recalls, "There were times where slips came out: 'Women can do this better,' like around changing diapers or doing the shitwork." In Ira's family, these feelings were further complicated by the fact that his wife had medical training:

> Since she's a doctor, there's been a tendency to assume she
> knows about all sorts of things that she doesn't necessarily
> know about. It comes up when Joshua is sick, or has a physical
> problem. I expect her to know what to do.

It is not just because Karen, Ira's wife, is a physician that he turns to her. The reverse was not true: When the husband was a doctor, the wife still called on her "intuitive" sense of what to do. Karen was called on by Ira no more than Francine, who had no medical training, was called on by her husband, David. Ira turned to Karen not just because she was a physician, but because she was a woman. This should confirm, then, my initial hypothesis that men will tend to let women be the "experts."

Well, yes and no. Because following David's initial statement, he adds, "I repented fast"; and Ira goes on to explain, "That has changed over time. There's lots of times when I turn to her for confirmation of things and then realize that is completely unnecessary." I want to accentuate how much both the women and the men were consciously aware of the initial tendency toward an imbalance of assumed "expertise," which I had predicted and which did indeed exist. Yet, as exemplified in the story of Ken and Nancy, this imbalance was not accepted as the status quo, but was struggled against in the push toward "equality."

In addition to the commitment of both parents to strive toward comparable competence, the men additionally had two advantages

on their side to weigh against the women's biological and gender-specific personality accoutrements of parenting. Ironically, both of these advantages lie in the very same realm of biology and personality.

Precisely because a woman giving birth to a child enters parenthood via the route of nine months of pregnancy and a labor and delivery, she is often exhausted and worn out from her long journey. The baby's cries and the 24-hour on-call status of breast-feeding can further deplete her. Whether biologically based (due to a radical shift in hormones) or psychologically based (due to the physical rupture in connectedness when the baby leaves a mother's womb or fear of the symbiotic tie with this new little being who might drain her of her resources and identity), some women do experience what has become known as post-partum blues.

By coincidence, two of the women I interviewed had both suffered an identical post-partum thyroid condition, which went undiagnosed for several months but was experienced as heavy fatigue and depression. These were the extreme cases, but in many of the families the story was not dissimilar: Dad, not depleted by the childbirth experience, was able to be the more energetic and active parent during the early months. Through his activity he developed a sense of competence and even "superiority" to his wife in the daily tasks of infant-rearing, such as bathing, diaper changing, rocking, and soothing. Exactly *because* he was freed from the biological aspects of childbearing and physical nurturance, he was able to transform his relatively higher energy level into childrearing activities and skills. Mom may be "maternally preoccupied" or absorbed in the foggy aftermath of labor and delivery, but Dad, in these families, often proved to be more clear-sighted and efficient. This is certainly a gender-specific form of competence, but nonetheless an attribute that keeps Dad in the running and in fact provides baby with a more well-rounded set of parenting behaviors and styles.

Biological exemption alone was not the only factor working in the father's favor. A particularly male personality trait, which for want of a better term I shall call "bravado," was actively in play for this group of men. Suzanne sized it up quite well when she remembered that "when Kira was a newborn, I felt totally incompetent. Gary had a better veneer. He looked like he was more on top of it." *Was* Gary more on top of it? In Gary's own words, "I figured I'd rise to the occasion. I had never held an infant before. I was sure I was going to collapse. It wasn't so bad, I got into it."

"Rising to the occasion" hits it on the mark. In our society the

Marlboro man, tough and self-assured, holds sway as a cultural image. Even when a man enters the more "feminine" sphere of babies and diapers, he carries with him his male sense of pride and efficacy. He is not supposed to look vulnerable or incompetent. We all know jokes about the man who presents himself as all thumbs in the kitchen in the hope that some woman will take care of him. But once a man decides that a certain endeavor is important for him to master, as these fathers have decided about mothering, they will be damned if they are going to let someone, particularly their female partner, show them up. So, says Paul, "I think I probably felt somewhat more self-assured than Laura, but I don't know if it was false assurance." Probably it was artificial, particularly in contrast to the leeway given a woman to admit when she is feeling vulnerable or overwhelmed.

Ironically, this sense of male pride, which masks vulnerabilities and often does not stand men in good stead in developing a truly intimate relationship, has quite the opposite effect when it comes to getting a shared parenting relationship off to a good start. The greater sense of ease that comes to the woman in taking on the parenting tasks is balanced by the man's determination and achievement motivations and results in the growth and development of two competent parents.

And over time, the consensus among my subjects was that even if there were inequalities at the beginning, the pattern smoothed out over time to create a very comfortable balance of relative competence. The most common explanation for a shift over time toward equality was that the man became more competent. This was particularly voiced on the part of the women: "He learned so fast, I was so proud of him"; "I used to feel more competent, but now I'd say he's grown more competent than he used to be, so now we're equally competent, at least around physical tasks." Embedded in these statements are two critical pieces of the pie. First, it is the woman who is still somewhat the overseer in the parenting relationship. Second, "at least around the physical tasks" suggests that in other areas competence may not be equally matched, a point we will return to later.

Clocking In

With love relationships, it is an age-old adage that "It doesn't matter how much you feel; you also gotta take the time." The same is

true of parenting. Equal feelings of competence won't make a world of difference unless they are translated into relatively equal *practice*. Over time, the men develop more competence. If practice makes perfect, this can happen only if men are putting in the necessary time.

The baby is born and comes home from the hospital, and time marches on. And for these families, time, if anything, was one area in which the expectant parents had expressed misgivings: Would Father-to-be really be willing to put in the time it takes to care for a child?

Studies of father involvement in child care or of shared caregiving families have closely scrutinized the amount of hours actually put into child care, and the stability of the arrangement over time.[3] They generally reveal that mothers tend to put in more time than fathers, and fathers tend to bow out after a period of years. If we simply count the number of minutes and hours clocked in, the words of the men and women in this investigation do not completely belie these assessments.

Most of the couples reported their time commitment as being very close to 50–50. Yet, more often than not, if there is an inequality in time, it is in the direction of the woman taking up more of the slack. The furthest it ever fluctuated from a 50–50 mark in the parents' eyes was to 65–35. Universally, there was total agreement between the mother and father in reporting their time divisions, even though they were asked in separate interviews. And almost universally, the parents stressed that these time figures, if unequal, were not permanent, but rather an outcome of some situational factor in their contemporary life. They in no way saw the fathers as "bowing out."

The most often-cited reason for a shift from 50–50 was financial. "He can make more money than I can, so when one of us had to cut back from work and do more child care when the second child came, it made much more sense that it be me." This could be either a mother's rationalization or a legitimate explanation for the times when she does more. In fact, it is a combination of both.

Certainly for this group of parents, as for any other American household, raising a family is increasingly costly and good child care decreasingly available. Families are required at times to put necessity above principle. If the family needs money and the father has a high-paying job while the wife doesn't (which labor market statistics will tell you is most likely the case even if the husband

and wife work in the same field), the commitment to shared parenting may well go by the wayside. This is particularly true if the alternative is giving up their primary source of income.

But the part that may be rationalization is revealed as we look at the two other major explanations offered for time inequality. They had to do with career expectations and the biological components of mothering. Dad was not around as much right now because he was in the last stages of writing a book, or his employer had requested overtime. Mom was around more these days because she was still nursing or recovering from childbirth, or pregnant with their second child.

No doubt both these explanations, like the financial constrictions, do point to external factors impinging on shared parenting. The work force is hardly sympathetic to working mothers and even less so to working fathers, who are not supposed to change diapers anyway.[4] And the biological component of motherhood cannot be denied. Nursing certainly ties mothers to their children. Pregnancy and childbirth (regardless of what people argue about women in the fields dropping their babies and going back to work), can be a physically exhausting and enervating experience in our culture, with time needed for recovery and relaxation at home.

But there is still something suspicious. The continual refrain was that if things were not 50–50, it was only transitory, until the wife finished graduate school, or the baby finished nursing, or the husband was finished with his current project. Last on the list of reasons, even for a "temporary" imbalance, was that women tend to take on more child care than men, regardless. Each family saw itself in isolation, not in a larger context. As we will see again and again, when the mothers and fathers talked about their experience, it was difficult for them to recognize any larger gender-specific patterns that would explain the particular arrangements of their own household. Instead, they rationalized some personal or situational factor.

Bruce has not even become a father yet, and in fact his wife has a much higher earning potential than he. Yet he anticipates spending less time with the baby than his wife, because he "needs" to make money for the family. Sandra, working in a high-power profession, "needs" to drop everything and spend all her time with their son when she and her husband return home from work. She feels that "I'm the mother he's entitled to. Before I was working, and now I am home. So I should be with him." Her husband works similar hours, but feels no such *internal* pull. He looks forward to spending

time with his son, but is also worried about his career and "needs" that evening time to make work calls and catch up on business mail.

Even I, as the interviewer, did not catch on to the larger picture until I reviewed the interviews and saw the repeated pattern. In this case it was that women pick up more of the burden than men if there is a time differential in sharing between them. The reason is quite simple, and goes beyond external exigencies. Both their training and their inner psychological make-up will pull women and men toward traditional gender roles in the presence of any external catalyst, like financial or career pressures. Work demands easily tip the time scale off balance when trying to raise a child together— but certainly more so when aided and abetted by the internal pulls *toward* mothering by women and *away* from fathering by men.

The woman is still saddled with the myth of motherhood, embedded deep within her, that whispers to her that she is damaging her child by not being there. The man is internally driven by the work ethos and by expectations that murmur, "Salary first, son second." Result: Mother clocks in more parenting hours than father.

More than Role Sharing

It was certainly my belief, when embarking on this study, that if a family strayed too far afield from an equal time arrangement they would not be doing shared parenting. Even though I recognized that good parenting was more a function of quality than of quantity, it seemed obvious that if one person was clocking in significantly more time, the other would inevitably be reduced to the level of a helper. Whereas no family I interviewed ever strayed into that realm of a time-differentiated primary parent–helper relationship, this set of parents did educate me on the follies of reckoning shared parenting within the static framework of time alone. Adjustment to breast-feeding had already alerted me to the creativity of the parents in orchestrating ways to balance out the immutable gender gap of lactation. If I were to have evaluated the equality of these couples' mothering arrangements along the dimension of time alone, I would have completely missed the more poignant expression of the true shared quality of their relationship in the fluidity and flexibility that prevailed between them.

I interviewed David while his wife was partially bedridden as a result of a pregnancy complication with their second child. Because

of that, he was now doing most of the household and child care work. As he mulled this over, he came up with a fine description of shared parenting at its best: "That's a good definition of equality. It's not always 50–50 in time, but it's the willingness to take over roles when necessary."

I would go further and say it's not simply a willingness to "role share." To enter a role is to adopt the external behaviors, responsibilities, and attitudes of a particular social position, in this case that of primary parent. Instead, David's vision of equality is based on the underlying premise that each of the parents, at a very *internal* level, fully identifies as a primary parent and is therefore ready and able to take over or pick up the slack for the other at any time. Traditional fathers have clearly demonstrated the ability to fill in when a wife has fallen ill, died, or deserted the family. But as frightfully as Dustin Hoffman botched up his first batch of french toast in *Kramer vs. Kramer,* these fathers suffer extreme stress and alienation as they are forced to step into their wife's role. David showed no such stress, because mothering was already an indelible part of his core identity as a parent. He not only had prior training. It also just came "naturally" to him to take over.

It did not take the extreme of a parent taking to her bed for these families to recognize the centrality of flexibility to their parenting relationship. I had just asked Ira, whose child was now three, whether he saw a tendency for him or his wife to take over in the parenting:

> I can't think of any situations where one of us takes over.
> Except to help the other one out. When one of us is having a
> particularly hard time, the other one will step in. That's mutual.

This quality of comradeship and mutual respect is a key variable in the success of women and men mothering together over time. It is what will help the couple navigate through all the stresses and tensions that inevitably arise when they get back into the particulars of who does what and why. Whereas Ira put it in a day-to-day, even moment-to-moment context, the larger sentiment was that over the course of months and years the couples were flexible enough and committed enough to each other to recognize that sometimes things would be lopsided, with one person doing more than the other, but over time it would come out even enough. This is not to deny that the reality of the lopsidedness often falling to the woman's side would cause rancor and resentment. But more importantly, the

couples would be willing to accept or grapple with such limitations if they felt they had the larger context of fluidity and flexibility between them.

Pete, in fact, balked at my question about whether he and his wife had a 50–50 arrangement. He and his wife and his two daughters are all active participants in a sharing household, even though they live in a community which hardly supports their family style. His eyes narrow and he shows signs of irritation as he responds, "In therapy we came to realize that a meticulously accounted for, exact 50–50 arrangement was an obstacle. Instead we accepted an approach to childrearing that not everything was going to come out even, but that we were committed to each other."

The issue of commitment is central here. But before delving into that, let me pause to read between the lines. By this point it may have become obvious that the parents who spoke of defining shared parenting in other than time terms were all men. We also know that any shift from a 50–50 arrangement is more likely to be in the direction of the woman doing more. Herein lies the first loophole of shared parenting.

Although time equality is certainly not the only criterion of shared parenting, it is nonetheless a signal of something deeper. Men move to a more "global" interpretation of sharing because, in the largest sense, they are "in there" as much as the women. It is when we break it down into microscopic parts, which we begin to do when we talk about time, that gender differences begin to surface.

No doubt the men will be more eager to define shared parenting in other than time terms because they know somewhere within them, albeit not necessarily at a conscious level, that they stand to fall short on that dimension. And they know that for themselves it is very important to perceive the relationship as truly shared, even if they are having difficulty translating that into equal time commitments. Carole summed it up well when she said of Ben, "I think in some way Aaron matters more to Ben than anything in his life, but not in terms of how much of his day he wants to spend on him." Ben's work and extrafamilial activities will claim priority on his time, more so than on his wife's. Once again, the internal "tugs" demonstrate that shared parenting is easier said than done.

Yet done it is when it comes to the question of commitment. By "commitment" I am referring to the level of emotional investment and involvement in parenting, and to one's identification as primary parent as constituting a consistent core sector of the self. Commit-

ment embraces the behavioral activities of parenting but also transcends them. Men hold on to the importance of commitment as a measuring rod of shared parenting because here they stand up much better than on the time dimension. Each of the parents was asked to re-evaluate their estimates of sharing not in time terms, but along the lines of commitment, as just defined. Here the percentage terms reached much closer to 50–50 for all the families.

Emotional commitment goes beyond lists on the refrigerator of who does what and if they've done it. It is something larger than the "role" of parent, with all its attendant duties, functions, and obligations. It extends beyond moral compunction. It is a reflection of one's inner feelings, desires, and longings, of the anchors in life to which one attaches her or his soul. No doubt if someone completely ignores the list on the refrigerator any statement of shared emotional commitment will ring hollow. But not one woman or man in this study fit that category. Dividing up the tasks of mothering was not always easy and many a gender-based battle was fought in that arena, sometimes along lines of very subtle inequalities or differences. When it came to commitment, however, the men and the women weighed evenly in their involvement in their children's lives, the centrality of their children to them, and their intention to remain a "mothering" figure to their children throughout their parenting years.

The Family Who Fails

It begins to sound like shared parenting is a shoo-in, that anyone who ever contemplates doing it will have an automatic success. Certainly the parents interviewed, particularly the women, ended up feeling that shared parenting is not simply a choice, but an imperative. In one mother's words, "I can't imagine parenting any other way, in the sense that there's no way I could do what I do and do any more child care."

Those who do entertain fantasies about going back to the "old way" are more likely to be men. For they could much more readily "do what they do" if they had not taken on the added burdens of child care, which were not their prescribed "lot" in life. So Ken admits:

> Sometimes my son gets me when I don't want to be with him. He gets my resentments. In conventional families men are with the children when they *want* to be with them.

And although Craig assures me that "it's not a big deal," he sets down his teacup and leans forward as he acknowledges that with traditional parental roles, he would have more freedom. Sometimes resentments bubble up inside him because of that. It would be so nice to stay home and work, rather than have to tend to Daniel.

But despite the fantasies, Craig and Ken come to the same conclusion as Bernard:

> If I wasn't committed to Nadine, it would be a lot easier, in terms of my work. For example, if I was away during the day, I wouldn't be concerned. I wouldn't feel my input was very valuable. I have a friend who's a non-involved father who thinks it's easy to take care of a child, because he's only doing it on weekends. Would I go back to a traditional parenting situation? Not if I can help it!

Yet some couples cannot help it. We have heard only about the success stories. But not everyone "makes it." Janine and Brett are a couple that started out with every intention of sharing childrearing. Participants in the gender-egalitarian social movements of the late 1960s, they could imagine doing it no other way when they discovered Janine was (unexpectedly) pregnant. But they had not quite worked out how that was going to mesh with Brett's entrance that fall into a grueling, time-consuming graduate program. Or with his growing commitment to a professional identity after a "counterculture" stance of several years.

Nor did they recognize how Janine's loss of her mother in childhood was going to affect their parenting arrangements. Unlike the other parents who had lost mothers in childhood and wanted to ensure that their children had more than one primary parent to depend on, Janine was to discover a different way of working through the loss. When her daughter was born, an intense merging occurred. If she lost her mother, she was determined to hang on to her child. For many years she was loathe to let her daughter from her side. Or to let someone else be number one.

Unbeknownst to both Janine and Brett, there was an underlying pas de deux in which each played their complementary part in guaranteeing that a sharing arrangement would not occur. Janine's unconsciously motivated claim to her child as a mother substitute and Brett's new work drive, strongly supported by his original family's Protestant ethic, pirouetted them both into a more traditional parenting arrangement.

There are, in fact, warning signs of when a sharing arrangement may fail. We have already identified economic exigencies, such as men's greater earning power or the lack of flextime or job sharing possibilities that would allow both a woman and a man to take on some of the daytime responsibilities of childrearing.

Lack of community support can have a further dampening effect. Pete was one of the most committed fathers I met, yet he still did not involve himself equally in certain "mothering" activities. Living in a conservative community on the East Coast where a sharing family was a rarity, he avoided these activities out of "necessity," in order to avoid shocking people in the community:

> For example, the babysitting co-op has a secretaryship. No man has ever called up. When it's our family's turn to be secretary, the pattern is for a woman to call and ask for my wife. It would be uncomfortable if they had to talk to *me*.

The desire to live comfortably within one's own community can often take precedence over the principle of sharing. One survival technique is to search out the few families residing there that *do* have the same parenting arrangements. Yet even with that minority support, the situation of being a "different" kind of family can be a lonely experience:

> Something about our shared parenting sets us apart from the few people we see. It highlights the value difference. We'd be better off if we knew more people doing shared parenting.

A mother whose close friends are traditional moms, this woman feels the tension between her and her old friends. The alienation has become so intense that she is considering trying to make a whole new set of friends more compatible with her and her husband's family style, a style that now governs so strongly not only what they do but who they are. The alternative approach to killing the pain of loneliness would be to adapt more to the style of her friends and other people in her community, drop the commitment to sharing, and go back to the old way. Some families do this, particularly if goaded on by the criticisms or skepticism of close extended family about this silly new way of doing things that just makes life harder.

There is yet a further impediment to sharing: when the internal work-family tensions that pull the woman toward the mothering end of the balance and the man toward the work identity end have not been sufficiently worked through. If either the man or the woman

is not truly committed to the sharing process, we can anticipate sabotage. Short of almost blind commitment, it can indeed be tempting to throw in the towel.

As the prime impetus toward shared parenting appears to be the woman pushing (with the man responding), the determination of the woman is probably even more central than the initial commitment of the man. But if she pushes and gets nowhere, the result in some families has been not just a failure in launching shared parenting, but the break-up of the marriage itself.

Commitment, flexibility, and competence have proven to be the cornerstones of the successful shared parenting arrangement, both at its inception and over time. Without them, the original biological hurdles of lactation could never be overcome. Whereas numbers of minutes and hours clocked in is a highly relevant factor, it becomes secondary, as long as it remains within certain bounds of equality. Louise and Jeff, married for eighteen years and veterans in the sample group, with an eleven-year shared parenting relationship, speak for all the parents in their reflections on their past decade, a decade filled with tensions and struggles, but also with pride and accomplishment:

> Louise: I think there's been a consistency in terms of loving, caring, nurturing—the real primary basis of parenting. I've never felt that Jeff could not take care of Rachel. In terms of the emotional aspects of parenting, I feel we have divided it up very equally. I've never had any question of the sharing of the emotional responsibilities, the sharing with Jeff. Again, the nurturing, the emotional, the psychological have been completely shared from the very beginning.

> Jeff: Louise and I now have a real respect for the arenas which we have evolved over time and what we're good at and what we are more comfortable with, rather than thinking we can be the all-around parent separately. And we have a tremendous amount of respect for each other's abilities to parent. Louise is a very, very good parent. I've really learned a lot, and modeled on the ways she has acted with Rachel. And I think that's true of her toward me.

Jeff is correct: Louise *does* feel that way toward him. The bets are placed, and Jeff and Louise are among the unexpected winners.

It is not cheap talk: They truly experience themselves as fully involved in a shared parenting relationship. Neither the mother nor the father has thrown in the towel, reneged, or sabotaged.

Yet, men shirk from using time as a measuring rod, and women make reference to competence being equal if we limit it to the "physical tasks." We begin to get the feeling that in the more specialized psychological and behavioral intricacies of day-to-day parenting, there may well be hidden gender gaps or inequalities between the mothers and the fathers.

4

Day-to-Day Sharing
Easier Said than Done

Basic to the partnership of shared parenting is an agreement to equitably divide the job responsibilities of childrearing. Two parents can do this by saying, "You do this and I'll do that"; or they can strive for the "interchangeable parts" approach in which each person is a Renaissance Parent, who can and does do all the parenting functions when "on duty." Two parents can also discover that the task of dividing up the work equally is virtually impossible.

Theoretically, once past the initial hurdle of breast-feeding, both Mother and Father should be equally equipped with all the necessary physiological equipment to provide for the child's physical needs: feeding, dressing, bathing, physical protection. But the daily caretaking of a child extends well beyond the physical into the realms of empathy, emotionality, play, and nurturance. Childrearing skills in these areas require more than able-bodied adults. They depend also on one's psychological make-up. Both theoretically and empirically there is a wealth of evidence that for whatever reasons, men and women are very different from each other in that make-up.

Logic would predict, then, that the psychological experience of shared parenting might well be dissimilar for the mother and father. "Dissimilar" does not necessarily mean more or less, or better or worse. Perhaps "separate but equal" is a better concept for understanding how a woman and a man experience, and behave in, a shared parenting situation.

Parenting competence is a perfect example. As one mother expressed it, "We're both equally competent, but with 'expertise' in different areas. I rely on my husband for the medical stuff, particularly given his medical training. But I feel I know more about childrearing, from an instinctive rather than an 'earned' position. He reads texts. I'm ideologically opposed to doing this.*' Instead, I assume in the realm of emotional care that my instincts are right."

Over and over, the women and men in my sample made the assessment that neither of them was more competent than the other; they simply had different spheres of expertise. They were referring not just to a set of behaviors, but also to a range of feelings, a way of being. For example, a consistent note sounded by these couples was that women were more patient with the children. More generally, the theme was that women were more likely to tend to feelings and emotions, while men were often more efficient in implementing the daily or physical tasks of childrearing, such as setting up the baby's room or attending to health needs.

The separate but equal phenomenon is quite clearly gender-based. It suggests that the only way shared parenting may be possible in this generation is by rejecting the notion of complete identity between the man and woman doing it. They themselves have grown up in a setting which strongly differentiated male from female, and in which their own fathers were but peripheral figures while their mothers were the daily mainstays of their emotional life. This heritage is not erased when they enter the parenting arena, even when they are committed to discarding many of the "shackles" of debilitating gender restrictions and actively violate sex role expectations by mothering together.

The tales of the men and women I spoke to indeed reveal a very different mode of existence for the shared parenting father and mother. Yet many of these differences are often unbeknownst to, or only subliminally experienced by, the couples themselves.

Each mother and father was asked to enumerate who did what with the children. They often strongly subscribed to the Renaissance Parent approach in their initial response. "Oh, we both just pitch

*This couple was very unusual with regard to reading childrearing books. In most families it is the mother who reads the childrearing manuals and studies, while the father relies primarily on Dr. Spock, if he reads any childrearing book at all.

in and do everything that needs to be done. Whoever is around, does it." Even when each parent was requested to think very carefully about any special activities one parent did with the child(ren) that the other did not, it was not uncommon for the response to be a blank stare: "No, nothing I can think of."

I had a strong suspicion that these initial responses, typically occurring early in the interviews, were a product of both idealization and emotional defensiveness. Indeed, the constrictions placed on the "coed-mothering" experiment by the separate but equal phenomenon will crystallize when we scrutinize specific areas of division of labor between the mother and father in the shared parenting household.

Do Clothes Make the Baby?

I myself had some hunches about particular caretaking activities that might reflect gender splits in parenting. When I followed those hunches by actively probing each parent about a set list of childrearing responsibilities ("But what about ———, who does that?" or, "How do each of you do that?"), I indeed found a remarkable consistency with respect to a specific subset of related activities in which mothers as a group behaved very differently from fathers as a group.

Dressing and wardrobe purchase was the first such activity, and the differences could not have been revealed more clearly than when Ben and Carole talked about their baby boy. They live a harried life, in which each of them must be out of the house by a certain time each morning. Carole observes, revving up for a much longer discussion, that "we dress Aaron probably almost an equal number of times, because of our arrangement around the morning. The difference is in what kinds of dressing take place."

What does she mean by *kinds* of dressing? Carole moans and cradles her forehead in her hands. "First of all, the kinds of outfits we put together are radically different, and secondly, how completely he's dressed is quite different. I will dress him completely. Usually it's clothes that if they don't dramatically go together, don't dramatically clash." She goes on with an impish chuckle, "Ben, on the other hand, will change his diapers and leave him with his pajamas halfway on and halfway off. If you put a blindfold on, you couldn't come up with more unlikely outfits than Ben will pick out."

If it is not just any morning, but a special occasion, "not dramati-

cally clashing" is far from sufficient. For these events, "if I want Aaron to look good and I'm showing him off in a particular way, then I know exactly which outfits are attractive outfits. I'm very particular about colors, and I'll put on the colors I think he looks best in."

What is Ben doing while Carole is obsessing about color coordination for special events? According to Carole, not much. Ben agrees. "I don't notice these things. On a day-to-day basis, I just don't find it as important as she does." Ben and Carole agreed this is not restricted to how they dress their child; it is also an extension of how they are about themselves.

Carole is wardrobe manager. Ben has little expertise and gives Aaron's clothes little attention. How do they feel about this state of affairs? According to Carole, "I sort of enjoy it." According to Ben, "Around appearance, it's OK. It's how Carole is in all situations."

Again and again, women and men agreed that mothers had a much greater stake in how their children looked and therefore in the clothes they wore. Women did inordinately more clothes shopping for the children than men, regardless of their child's gender, and fussed more about clothing coordination and appropriate dress for the occasion.

And the women were pleased with this state of affairs, enjoyed the sense of superiority over their male partners, and wouldn't have it any other way. Not one woman spoke of feeling oppressed by this extra burden.

The women derive greater pleasure from dressing their child because, as stated beautifully by one mother, "I have more of a vested interest in how my daughter presents herself to the public, out there in the world." And the fathers see it the same way: "Denise likes to pick out the clothes that Anya's going to wear. Denise buys her clothes. She puts more emphasis on clothes. Because she pays more attention to detail, to projecting a public image."

Training in our culture makes a girl more sensitive to the nuances of physical attractiveness and wardrobe appearance. Clothes may make the man, but they *are* the woman. When we bring this into the realm of caretaking, females begin by dressing their dolls and end by dressing their own children. The closest the boy may have come to this in traditional culture is attiring his G.I. Joe doll, and this more for the sake of power and conquest than for the sake of physical beauty.

The contrast between the fathers' lack of concern toward dress and appearance and the mothers' preoccupation with it was quite remarkable. Ben was not the only father who "just didn't notice these things." The other fathers stand behind him like a Greek chorus:

Nancy loves to try different outfits on him, like he's a doll. To me dressing him is a necessity. Nancy cares more about how he looks. She takes great pride in how he looks. Me, I don't give a shit about his looks.

Audry does most of the dressing. She chooses the clothing. I really don't care.

When it comes to buying clothes, Karen does much more. She's in charge of, takes responsibility, keeps track of what Joshua needs much more than I do. How Joshua looks is not very important to me.

So we have here the first clear-cut gender difference that goes beyond immutable biological barriers: Women put a great deal of thought and energy into how their children look, and men do not. But there is more to this behavioral and attitudinal difference than, as it were, meets the eye. Who picks out the children's clothes in the morning is not just a result of women being generally more concerned about appearance than men. The psychological explanation for the gender gap in clothing runs much deeper.

Carole, like the other mothers, is more preoccupied with her son's physical appearance because she experiences that child as an extension of herself in a way that Ben never does. How Aaron shows up at a birthday party will be a direct reflection of who Carole is as a person. This is both an objective reality and, more importantly, her subjective experience.

People do indeed make judgments about mothers on the basis of how their children look and behave. Particularly in the case of physical appearance, the cultural assumption is that a woman is completely responsible for this aspect of childrearing. Therefore, shared parenting mothers are bound to feel this external pressure more than the fathers will. No one expects fathers to be responsible for their children's clothes. It's no reflection on *them* if their child is dressed funny.

The more significant subjective experience for the mother is that the boundaries between herself and her child are fluid. Where the child stops and she starts is not always clear. This would be true whether that child was male or female. "It's an issue of wanting to have a beautiful child. I was conscious of this since before he was born. I tend to look at Matthew as a product of me more than Rick does. With Rick it doesn't seem quite the same kind of reflection of self."

In the beginning, a mother, whether she is going to share parenting or not, has an experience the father never has. Her infant comes directly from her womb. Before birth, this child was actually a part of her. For the father, his part in producing that baby is a more abstract phenomenon. He cannot see his sperm meet up with the ovum, nor does he experience the movements of a child within his own body.

This biological factor only primes the parents for a differential experience that is already cultivated in very gender-specific ways in the man and the woman. The mother's focus on clothes, her perception of the child as her product, and her experience of the child as an extension of herself all grow out of mothering's being deeply embedded within her as a core part of who she is and a prime determinant of her worth in the world. These mothers, themselves raised by women in a culture that strongly emphasizes the role of women as primary caretakers, cannot escape from the internalization of the close connection between how their children function in the world and their own worth as persons. Not only are women supposed to mind the children, but the mothering mystique in our society glorifies childbearing and childrearing as their most sacred missions in life.

Futhermore, recall Chodorow's observation that generation after generation of females mothering results in women passing on to their daughters a personality style that includes relatedness to other human beings and a permeable psychological membrane between themselves and others that allows the maintenance of emotional connectedness.[1] That permeable membrane is what sensitizes these mothers to how their children look.

In contrast, it is the man's "thicker membrane" between self and other that allows him to "care less" about his child's appearance. It is not just because he has been raised in a culture that teaches males to value comfort and physical practicality over aesthetics and attractiveness in clothes and appearance. And it is not only because

no one will point fingers at *him* if his child is dressed inappropriately. Within himself, he is clear that he and his child are very separate people. Again, this is understandable within Chodorow's framework, because these fathers, raised by women, have incorporated a sense of separateness and more generally a way of being in the world that values instrumentality and autonomy over relatedness and emotional connections. This sets the stage for fathers experiencing their children much less as an extension of themselves than mothers do.

Even more surprising than these mother-father differences is the subtle but present "gender warfare" that is alive and well in the shared parenting family and becomes visible with respect to so mundane an issue as wardrobe management. Listening very carefully to the words and intonations of the men and women as they discuss the clothing issue, you can discern an unmistakeable undertone of hostility or competition.

The men speak with perplexity and exasperation about their female partners' near-obsession with such a frivolous matter as clothing. After all, dressing is just a matter of necessity or comfort, say the men in rather self-righteous, superior tones. They are "above it all" and "have more important things to do."

These are men immersed in a subculture in which woman's work is taken very seriously and the traditional patriarchal and even misogynist attitudes toward women are scrutinized very closely. Yet not every aspect of being female feels comfortable to a man. Particularly as they recognize a very traditionally "feminine" attribute of their female partners, which is both foreign to them and highlights a difference in their mothering styles, they defend themselves by "laughing it off." They are defensive not only regarding the difference in parenting style; they squirm about the difference in *amount*. Mother does *more* in the area of clothing than Father does. He may feel a need to account for that.

Father may have some very legitimate complaints about his partner's preoccupation or even obsession with the child's looks, particularly if he perceives it as smothering the child or inculcating wrong values. With a girl child he may worry that the mother is reproducing debilitating sexist practices, turning the child into an object, a doll. With a boy child he may experience discomfort at the "feminization" of his child.

Yet none of the fathers voiced such overt criticisms toward the mothers. Instead, they spoke more in innuendoes. Their remarks

had much more the flavor of the gender tensions that Dorothy Din-
nerstein describes in her book, *The Mermaid and The Minotaur*.[2]
Men ward off their fears and feelings of alienation toward women
by belittling them or reducing them in importance. This was in no
way the overall attitude of these fathers toward the women with
whom they lived; yet, one can detect subtle traces of it in their
teasing or barbed comments about the perceived gender differences
in wardrobe management.

The women, for their part, were decidedly more overt in their
humorous antipathy toward the men on the dressing issue. Given
their avid commitment to shared responsibilities, one would have
expected some rancor about the men's cavalier attitudes or their
lack of equal involvement in dressing the children. Yet we recall
that Carole actually enjoyed this state of affairs, and so it was for
other mothers, too: "I wouldn't want Ken to dress Sam. I don't
have bad feelings about that. I actually wouldn't like it any other
way." This is Nancy, the same mother who ensured equality in
competence early in their infant's life by stepping back, letting Ken
perform, and not lording her child development professional skills
over him. Why should she have such a different attitude when it
comes to clothes?

The most obvious reason presented by the mothers is that they
think the men are bad at it and not to be trusted. This was expressed
again and again in humorous stories recounting their chagrin, upon
returning home, to discover that their husband had let the kids visit
grandma in pajamas and boots or sent them to school wearing patri-
otic regalia of stars and stripes with a little plaid thrown in for
good measure. With their own measure of superiority and self-righ-
teousness, they dismiss or belittle their male partners' capabilities:
"I do more of the clothing because it's my acculturation as a nice
Jewish girl. Besides, when he does it, he dresses them funny. Because
he doesn't know from girls. I've got a sense of how kids should
look."

The women simply do not trust the men to competently dress
the children. And they are also perfectly willing to carry the major
load themselves. This is in decided contrast to other activities, like
meal preparation or scheduling appointments, in which the mothers
grow extremely irate if the father slacks off in his duties. The reason
is quite simple. The women do not want the men to encroach
on a mothering activity that has a great deal more meaning for
them than is reflected in the time and energy allotted to it. This

activity is so important that they do not want to share it with men.

Besides which, of course, they are accurate. They *are* better equipped in this activity than the men, even if the children involved are boys. Interestingly enough, some of the fathers of girls imagined that they might be more involved in clothing if they had a boy. The reverse, however, never occurred: The mothers were not less involved if they did have a boy, and not one mother of girls imagined that she might be less involved if she had a boy. Furthermore, the fathers of boys were still less involved in the child's dress than their female partners, though they might be a tad more involved than the fathers of girls.

Yet in other activities in which the woman had a headstart on competence, she was quite willing to relinquish some of her expertise to the man. With clothes this would be risky business. If her worth is measured by her child's appearance in the public eye, she cannot ask the social world to put away the tape measure while her husband learns how to dress children. Because she has been raised female, that yardstick has become very important to her. Her jest about her "bumbling" husband who cannot put tops and bottoms together masks an underlying resentment that he might botch it up, leaving her holding the bag. The children will be judged poorly and so will she, and *he* will have been the cause of it.

The mother's disdain toward her husband's clothing crassness cues us in to her desire to maintain a position of superiority to her husband in some of the traditionally feminine aspects of childrearing. What begins to become apparent is that any arena of childrearing that touches on the permeable boundary between mother and child and reveals the more opaque boundary between father and child will be one fraught with imbalances.

Baby, You've Been on My Mind

Whereas "compensatory" work is a quite effective means of acquiring gender equality in many arenas in which women may have a headstart on mothering skills, a few areas are almost beyond such adjustment. They are resistant because they are based on attributes so deeply engrained in the psyche of each parent that they are either not even recognized as differences to be grappled with or are so invaluable to either parent's center of existence that one or the other parent would be resistant to intervention.

"Worrying" is just such an arena. In every family, there was always one parent who worried about the children more than the other—and it was almost always the mother. In the Cranston household, Bernard and Eileen are both energetic and highly involved in their toddler daughter's day-to-day affairs. But Bernard still feels that "Eileen tends to worry about Nadine more, carry Nadine around in her head more. She tends to worry more about things that could happen. I tend not to think about things until they occur." At the Sanders' house the story is the same: "Pete wouldn't remember certain things on his own. He doesn't worry as much as I do. Pete, he doesn't worry about their lives. For example, I worry about my daughter's relationship with her friend at school. There's no slot in his life for such worries." And the Kleins are in total agreement that one of them worries more than the other about their son: "Donna worries more than I do. She calls home from work. I never do. When I'm at work, I'm at work. I never think about Daniel."

How do these families explain why one of them is more the worrier than the other?

Pete: Stephanie's more of a worrier. She comes from a long line of worriers.

Karen: Both of us would worry about a problem with Joshua. It would occupy me more as a conscious preoccupation. The next day at work it would still be with me. I figure that's just because our personalities are different.

These women and these men are not misinformed when they attribute their different worrying styles to personality factors. They do not, however, recognize this as a difference transcending the long line of worriers in one of their families or the temperament of the particular person they chose to marry. In fact, the root cause is a culturally generated personality difference between women and men that cuts across all these families and makes "mothering" a very different experience for women and men.

Women worry more and men worry less for the same reasons that women are more involved in children's attire than men. Donna worries more about Sammy than Craig does because "I probably would be worried that it was something I would be doing wrong. Craig would be able to put it aside." David has exactly the same

explanation about his wife, Francine: "Francine worries more, in the sense of 'Did I do the right thing?' If Jason had a bad day, or did not get invited to a birthday party, she'll worry."*

Just as with clothes, if things are not going well for the child the mother experiences it as a reflection on herself: "I must be doing something wrong." Even harder for the mother, she experiences her child's pain as her own. This goes beyond basic empathy, in which a mother puts herself in her child's position and imagines what it feels like for him or her. Instead, it involves a stronger *identification* with the child. When the child's skin is pricked, she feels it in her own arm.

Because the child is both a reflection and extension of the mother, and because most women experience motherhood as a core component of who they are as a person, the mother will tend to carry the child around in her head, even when the child is not with her. This can be referred to as the psychological "labor" of childrearing. It embodies thoughts, feelings, and even obsessions about how the child is doing.

The father, in contrast, even in the shared parenting family, appears to feel more separate from his child. He does not worry about his child or carry the child around in his head as much as the mother; he can "put it aside," where it will not gnaw at his insides. It is difficult, however, to "watch" a mother worry more or a father worry less. The "hidden" quality of psychological labor indicates that some imbalances in parenting between men and women are intangible, immeasurable by the naked eye or in terms of behavior alone. They are imbalances which reflect deep-rooted differences in the inner life of men and women.

The couples themselves often did not see it that way. Time and again a mother or father reported that the father was less prone to worrying about the child because the nature of his job, rather than any psychological predisposition, prevented him from worrying:

At work, my wife would be thinking about our daughter more. In my work, I can't be distracted by anything. I do photog-

* Birthday parties were repeatedly mentioned as events around which mothers, in particular, experienced concern or anxiety. Birthday parties represent early symbols of children's presence and acceptance in the rituals of their peer social world. First, they need to be invited. Then they need to present themselves in proper form at the festivities. For the parents, these rituals provide signposts for how well their child is measuring up.

raphy. This involves split seconds and complete darkness. I have to know where everything is. I have to pay attention to minute details.

If there was a problem with our daughter, I think my wife would be more likely to worry about it the next day. In my work, I have to think about thirty kids every day.

Men no doubt tend to gravitate toward different jobs or are able to get different jobs than women. A glance at the gender divisions in labor market statistics easily tells us that. There is certainly some truth, too, to the notion that positions primarily reserved for men require the man to be on his toes and on the job and not allow his mind to wander. Yet the explanation that the external demands of work are what prevent the man from worrying more or carrying his child around in his head as much as the woman does just does not hold up under closer scrutiny.

The father who runs a program for thirty children neglects to take into consideration that his wife, a psychotherapist, is also in a field that requires intense emotional involvement with six to eight patients a day. Yet she has time to worry. The father who is a photographer forgets that his wife is in a high-pressured business position that requires constant attentiveness throughout the day. Yet she has time to worry more. The division across couples regarding who worried about the child more at work was always the same, regardless whether the woman was a doctor and the father a psychotherapist, or vice versa: The woman worried more than the man. Not the nature of the work, but the nature of the *men,* makes them worry less than women. "When I'm at work, I'm at work." Men seem to have an easier time drawing boundaries between work and family and preserving those demarcations. Perhaps, too, parenting as a core identity defining who they are in the world just may not be as central for men as for women.

Not only are the men able to prevent "spillover" between work and family; they are also able to establish firmer demarcations between themselves and their child. They do not experience every failure of their child as casting an aspersion on their own self. Because of that, one mother explains, "there's no slot in his life for such worries." Fathers can even, then, be as casual as Bernard, who tends "not to think about things [with Nadine] until they occur."

These differences in "worrying" once again remind us that parent-

ing even when shared, breaks down along gender lines. In the case of clothes, we were surprised to find that overt tensions did not erupt between mothers and fathers because of the perceived imbalance. With worrying, the dynamics were not quite the same; most parents were not so magnanimous in their acceptance of the "worrying imbalance." Clothes is a very circumscribed sphere of caretaking activities. Worrying, on the other hand, permeates all childrearing functions, and consumes a great deal of emotional time and effort. Whereas two people cannot as easily *both* be in charge of choosing a child's party wardrobe, they can easily share "worrying" without encroaching on the other's emotional space. There is room enough for both.

Suzanne and Gary live in a small, cozy home with their five-year-old daughter, Kira, a lively, but demanding child. Suzanne complains that when it comes to worrying about their daughter, Gary asserts that he "just doesn't have time for that." Gary retorts that "I think Suzanne gets obsessed with a problem. She'll talk it to death. Suzanne carries Kira around in her head much more than I do. Suzanne criticizes me about that. My response is that I have confidence in my way." Suzanne, for her part, feels "ripped off." She muses that "something about what we feel about our relationship with Kira is just different." The implication is that she feels more and Gary feels less.

There were some families in which mother-father differences in worrying were as readily accepted as the clothing disparities, but they were the exception rather than the rule. Stephanie and Pete have a relatively conflict-free relationship. When it comes to the question of worrying, Stephanie explains,

> I'm the worrier. I also have a map in my head about certain things, like toilet training. This gives me the right to decide. It's tacitly agreed on between us. I don't feel ripped off, it's OK. I don't feel he can do these things as well as I can. Pete wouldn't remember certain things on his own. He doesn't worry as much as I do. Pete, he doesn't worry about their lives. For example, I worry about my daughter's relationship with her friend at school. I do not feel ripped off. I feel grateful. The division of labor we have is OK.

Rather than assuming that she could impart her "expertise" in worrying onto Pete, Stephanie would just as soon maintain superiority in this realm. Worrying is a difficult trait to teach someone else and

also an arena Stephanie covets for herself, because as with clothes, it allows her to maintain a connectedness with her child that may override the importance of sharing and assures her she is not "doing anything wrong."

Again, as with clothing, we can detect a gender tension resulting from the imbalance, whether the couple accepts the inequality or not. Differences in worrying reflect that women and men mother differently. Some women want the men to mother more like they do; when a father worries less, they see it as a sign that he is not as involved as they are in parenting. And some fathers resent being pushed to worry more to prove their commitment, and feel compelled to assert that there are other ways to "mother" than the female way; maybe women worry *too* much, rather than them worrying too little. Indeed, the greater distance that men can maintain between themselves and their children may be healthier for the child, or at least balance the mother's very close involvement.

Worrying is directly connected to the third arena in which large differences in parenting between my sample's mothers and fathers were consistently true. This third arena is like clothing management, in that it is hard for two people to be doing it at the same time; but, like worrying, it is not very visible to the naked eye. It is the "psychological management" of childrearing. It is what Stephanie refers to as "having a map in my head about things."

In every family someone has to make sure the children are bathed, fed, scheduled for their pediatric appointments, and so forth. It is not a question of who actually does these tasks, but of who oversees them. In every family in my sample, the response to the question, "If one of you has a tendency to 'take over' more with the children, who would that be?" was the same. In one form or another, "she" did.

In the early years, it looks like this:

> I direct certain things. I definitely direct the clothing. I direct the organization of where things are going to go in our son's drawers. I decide where things go in the kitchen, too. And my husband decides *not* to learn where they go. And the same thing in Aaron's room. I also take over around babysitting, arranging schedules, general management around the house. I think I take over a little more in general.

And then, as the child gets older:

> If there's stuff around Rachel taking showers, getting her hair washed, getting nail cuts, hygiene, I take much more

responsibility. Around clothes, making sure Rachel has those kinds of needs met always has been more my responsibility. Getting her lessons together, the management. I think I carry that stuff around much more.

Mom is the overseer, the organizer, the list maker, the keeper of inventory. Beyond overseeing practical activities, she is also able to look out for and interpret patterns and rhythms in the child's daily life and respond to them accordingly. She also tends to "boss around."

What is the father doing while all this female organizing is going on? In this group of families, men either deferred to the women, taking the back seat, or remained oblivious or unconscious. Bob is a deferrer:

Generally speaking, I guess I see myself as a subordinate to Audry's expertise. I handed over, relinquished decision making. I guess I perceive her as the expert. I think about it as it's happening. I'm this incompetent male. With Audry, having that kind of authority over kids is something she does well. If I say, "What should she eat?" she'll rarely say, "You decide."

Rick "checks out":

I let things slide. And I'm more able to take little spaces, when I just sort of blitz out.

A very carefully choreographed pas de deux transpires between shared parenting mother and father in the "taking over" ballet. Both the Warner-Sterns and the Kleins described it well. Francine is adamant that

David would much rather I took over emotionally. He has a tendency to want to hand over parenting to me. He is much more likely to do it to me than vice versa. I recognize it, it's almost instinctual, and I call him on it. There's also a tendency [on my part] to take over. For example, if the three of us are trying to get out in the morning, and David is spaced and stressed, I'll take over.

Are men really so "checked out" when it comes to attending to the children? David, Francine's husband, sees it differently. "Francine puts out more for Jason than I do, even if we're both there. He tends to turn more to Mommy. When we first became parents, Francine was more managerial, she took the lead, but I was also putting

in a lot of effort." Mom may tend to run the show, but Dad stands up for himself. It's not that he is not doing *anything*, or is preoccupied with other things. He is just not as zealous—and besides, what is he supposed to do if the child keeps turning to mother instead of to him?

In the Klein household, Donna agrees that her husband has a tendency to defer, but she is more explicit than Francine about her own dynamics of taking over. "One day Craig was getting Daniel dressed. Daniel tore up a book. Craig was taking care of it. I walked in and took over: 'Daniel, why did you do this?' " Donna was critical of herself for this behavior, knowing perfectly well that Craig was capable of handling the affair on his own. But because she is "the organizer," and because Craig allows her to take over, she has difficulty keeping her fingers out of the pot. Craig lets her take over "just because she is better at management."

The mothers took over, the fathers deferred. Why should this be? As with clothing and (a bit less so) with worrying, some families turned to personality or individual differences as an explanation. David thinks that Francine takes over more just "because of her lower tolerance for chaos. It's a relative thing." Donna, too, thinks Craig defers to her because of personality differences between them, and Craig thinks Donna takes over simply because "she had more practice, with two younger sisters in a family-oriented household."

Yet, the majority of parents turned directly to gender differences to explain this dynamic. Many saw it as just reflective of how this society operates. Barbara says cynically, "I'm the social secretary, which is typical in this culture." Nancy concurs: "I do the managerial tasks. That's just one of the sexist divisions of labor that I'm beyond struggling about." Even though in the job market women rarely make it into actual managerial positions, both at home and at the workplace "women's work" is to keep things going and make sure everything is in place. At her workplace, historically, a woman may do this from the sidelines; with her family, however, she has traditionally been in the center. Without her, the day-to-day functioning of the household would grind to a halt.

The women in these co-parenting families have relinquished their center spot in the household, handing over half of it to the fathers. Yet they still take over. The sociological explanation attributing their persistent managerial position in the family to the role of females in the larger society is not specific enough to unravel why this occurs. Instead, we have to enter the households and focus

inward, on the dynamics *between* men and women who parent together which create or underlie the gender difference in psychological management.

For both the men and the women there is often a powerful, deeply engrained message that says, "After all, she is/I am the mother." Karen is open in admitting that "in the beginning, for me it was kind of difficult not to be the overall parent. I just couldn't accept that Ira might be 'number one' with the baby. I thought *I* should be holding that spot." "In the beginning" should be underscored, for many of the parents who were quite conscious of these inner pulls also saw them as much more prominent in the early stages of parenthood.

As Karen goes on to explain, "I've done a good job of restraining that tendency. At present, I don't feel the same tugs." With time, the parents "worked on it." Also with time came the changing demands of parenthood, changes that might tip the balance in a different direction. Childrearing duties that have a more "masculine" flavor, such as discipline, can certainly put the father more in the driver's seat. Paul reports that when it comes to overseeing their twelve-year-old son in doing his household tasks, he is definitely the one to take over. "I'll often discount my wife's authority with Zach because I don't think she impresses on him what needs to be done. She's more casual." As the children get older, their needs and demands sometimes create situations in which the men rather than the women take over, further weakening the assumption that women should be the "overall" parent.

What did not change over time, however, was that the parents remained consciously aware of the deeply internalized ideology they were challenging in becoming men and women who mother. They readily picked up the signs when that belief system, that women were "made" to mother, showed up within their own selves. Yet they were still unable to totally eliminate the pattern of women continuing to take over, even as the children grew older, despite all their conscious attentiveness to the effects of these "tugs."

One reason is that their behaviors seemed to be governed by yet another underlying psychological tug, about which the men and women were neither as aware—nor, therefore, as hypervigilant—as with mothering ideology. That pull was the male-female dependency relationship. Bob readily admits that in this arena, "she takes, and I relinquish. I need that kind of nurturing, being taken care of." So Mother is taking care not only of her child, but of Father as well.

How do mothers perceive this? "I'm always organizing—making lists. Jim's the kind of person who will leave it for tomorrow. It's just part of our general agreement. Jim is dependent on me, but he could do it if he wanted to." The women almost accept the dependency as second nature. These fathers were no different from many other men in this culture who turn to women for emotional bolstering and support. When it comes to management of the children, especially, they let women take over. It is not just that they are lazy or uncommitted. At some very deep level, having been raised by mothers themselves, they depend on women to do those things, both for themselves and then, as an extension, for the children.

This dynamic is exacerbated by the fact that sometimes the women, again impelled by the message that "women are made to mother," do not actually trust the men in particular situations. All the commitment in the world to equalizing competence is still not enough to counteract these pulls. Pam and Rick spend many hours together with their year-old son. In personality, Rick is definitely the more assertive, imposing person; yet Pam, with her quieter, low-key style, is the one who takes over with Matthew. She explains: "If Matthew is crying, I will take over. I'm afraid that Rick is not doing something right." Pam thinks this pattern was set up in the early months, when she was nursing and discovered that that was the best and sometimes the only way to stop the baby's fussing.

When it comes to day-to-day soothing of the child's ills, this may be true. But it does not explain why women should carry the children around more in their heads, make more pediatric appointments, or write more lists. A better explanation is that women "need" to be more in control to reassure themselves that everything is going right in the mothering arena, and men "need" to rely on women in order to feel loved and supported.

The dynamic of woman as overseer takes its toll on both the women and the men. The women can end up "screaming," "calling him on it," or struggling to bite their own tongues. Yet the dis-ease seems even greater for the men, the relinquishers. Rick agrees that he lets Pam take over. He is the same father who "takes little spaces," "blitzes out." His happiest moments are not these times, however, but when he has the opportunity to exercise his own autonomy and efficiency in managerial tasks:

> I love the times when Pam is away. I'm much more efficient
> around the house. I can't blitz out. And when I do, I find out

things still go fine. I've actually had wonderful times with Matthew.

A dissertation study conducted by Rick Sapp on shared caregiving fathers found that men became more competent caretakers if their wives were physically not present while the fathers parented.[3] Studies of single fathers indicate the same phenomenon. The best way to ensure effective co-parenting, then, is to give the men ample opportunity to "solo." That is how Dustin Hoffman learned to make French toast. The implication for these shared parenting families is that the "all hands on board" household, in which parents are more often both present with the children at the same time, may not be as effective in breaking down gender imbalances in parenting as "split shift" parenting, wherein each parent alternates times home with the children.

Clothing, worrying, and psychological management are three discrete components of childrearing, then, wherein the sharing of parenting is clearly easier said than done, despite equal levels of overall commitment. It is noteworthy, though, that women and men are most complacent about the clothing differences between them and most disturbed by the gender division in the "mental baggage" of parenting.

Earlier we were alerted to the possibility that any arena of childrearing tapping the fluid boundaries between mother and child while exposing the firmer boundaries between father and child would be a locus of gender imbalance. Now the caveat is added that such an arena will be particularly prickly if it either permeates all of one's parenting moments, as does psychological management, or touches a dependency issue *between* the woman and the man. Piecing this together, we begin to suspect that the *inner* experience of parenting must surely be very different for the woman and the man in the shared parenting household.

We now know two things. These fathers and mothers are very different from most other men and women in the culture in that they truly share the everyday tasks of parenting that have traditionally been considered "women's work." Yet they do not do that work in the same way; the mothers do it as females and the fathers do it as males. They are completely atypical, but when it comes right down to it, in some arenas she parents "just like a woman," and he "just like a man." How can we explain this?

5

The Roots of the Sharing Experience

The Childhood Gender Gap

The fathers in this study look like a thousand other men walking down the street. The only difference is that a good part of the week they stroll along with a baby on their back or a child skipping alongside. The mothers I interviewed could also just as easily blend into a crowd of women in their mid-thirties to early forties—except that, a good part of the time, they stroll childless because their husband is home minding the children.

According to how they were brought up in their childhood, this is not how it was supposed to be. A girl learned from a Little Golden Book that "I will be a Mermaid when I grow up and live in a castle under the sea. There I will serve ice cream and tea. You could be a Diver and visit me," or that "when I grow up I will marry a Baker. He will bake cakes every day for my friends and for me." While little girls were dreaming about eating or serving food and meeting up with their men, a little boy was being instructed that he really "ought to be an Astronaut when I grow up. I will go to the stars and Venus and Mars. I will land on the moon," or be far away from home because he would be "too busy being an Explorer, you see. I might live in the jungle when I grow up and spend all my time exploring."[1]

Why did the co-parents I interviewed not "buy" the traditional messages with which they were brought up? In their very decision

77

to split up the tasks of mothering between them, they violated the basic assumptions of what a boy and a girl become when they grow up. Yet why are they also similar to other men and women—in that, based on their gender, they do not parent the same? We now know about their adult decisions to reorganize the distribution of work and tasks in their families. But taking a longer journey back, there must be earlier factors from their childhoods which further explain why they end up so differently than their childhood peers, and yet why in some ways they are just like them.

Some years ago I was addressing this very question while presenting work in progress at a professional meeting. A discussant on the panel grew agitated and objected to the generalized statements I was making on the basis of a very small group of "sissy men and headstrong women." His ire was fueled by the fact that the fathers I interviewed had consistently remarked on their alienation from "boy" culture in their youth or young adulthood, and the mothers consistently spoke of their ambivalence about traditional motherhood and their strong determination to be something "more" than a "wife and a mother."

Years later, having had additional opportunities to explore in greater depth the childhood realities and personality factors that culminate in a shared parenting experience, I have learned what I knew all along. These are not a group of "sissy men and headstrong women." Instead, they are merely a group of people who acted on their alienation from their own childhood in creating an environment and structure within which to rear their children. Central to their own childrearing philosophy was a disavowal of gender expectations. Either cast off or balked at was the saying, "Boys will be boys . . . girls will be girls."

My interviews took the mothers and fathers back to their early experiences. I was particularly interested in their answers to two questions. The first was more general: "Is there anything in your own childhood or background that could explain your desire to share parenting?" The second, more pointed question was a derivative of the first: "How was it growing up as a girl or boy?"

The second question produced a startlingly clear set of responses. Both the men and the women, albeit in very different terms, spoke of a parallel phenomenon: a discomfort with the norms and expectations pertinent to their gender. The men repeatedly and spontaneously brought up that in one way or another they did not feel comfortable with the male culture they grew up in or had to live

in now. The women, almost with one voice, repudiated the notion that a woman should be above all a wife and a mother. They spoke of the confusion or ambivalence they experienced in their growing up years in trying to balance the expectations of motherhood against their inner desires to "be something"—i.e., to have a career—when they grew up.

Growing Up Male

The men in my sample came from a variety of backgrounds. Some had grown up in upper-middle-class homes and were the sons of professionals; others came from lower-middle-class families. They were all currently in a professional occupation, many in the area of human services (medicine, psychology, education). The vast majority had grown up in large urban areas. And they had one important thing in common: Their experience as a boy growing up was coming back to haunt them, either as "veterans from childhood" or as "adult initiates."

The first group of men, the veterans from childhood, spoke extensively about *never* having fit into the norms and expectations of male culture. These were the boys who were never good at sports, who were often the "eggheads" at school, who did not like physical aggression or male backslapping. Their own words speak more eloquently than anything I could say:

I was short, dumpy, and bad at athletics, and I wet my bed. I was marginal, and was oppressed by male culture. . . . I was on the effete margin.

I absolutely abhor young boy culture and have since I was a young boy. I really do not like that kind of teasing, aggressive boys' play. . . . As a kid, it was really hard to relate to boy culture. I never really understood. I used to be very hurt by kids teasing other kids.

This is not to imply that these men are "losers" or misfits. Looking at them now, one gets the impression of competent, self-assured men: They have meaningful work, friends, a stable relationship with a woman, and strong connection to their children. It is not even to imply that they were losers or misfits in childhood. The significant event is that they *felt* out of place in a world of cops and robbers

and Sunday baseball. They grew up in the 40s, 50s, and early 60s, when sports and "he-man" culture were far more emphasized than today as a central badge of worth for a male youth. Many of these men knew how to go through the motions of "making it" in that culture, but felt an inner alienation. Others experienced the dilemma of straddling two worlds, the masculine and the feminine. For many years they carried the pain inside themselves, only to be relieved of it by the explosion of feminist consciousness in the late 60s and early 70s and the subsequent permission given them to challenge traditional gender stereotypes.

Why these men felt so alienated in the first place is another story. Either they pulled away from a father figure they disliked, or they were pulled by their mothers into a feminine sphere that contradicted the development of socially prescribed masculine traits. In addition, as boys these fathers simply were not endowed with what it took to "make it" in American male culture. They were intellectual instead of athletic. They were artistic instead of aggressive. One father, raised alone by his mother with no father figure in the house, recalls:

> To some extent, I always felt inadequate as a male. I think it was a result of how I was raised. I was a neat boy in a white shirt. I was discouraged by my mother from physical roughhousing. I had little or no athletic ability. I was never encouraged. I did finally make the Junior Varsity basketball team. But I was encouraged to be a good boy, to be an intellectual.

For many of these men, it was not just the uneasiness with male culture they remember, but also their attraction to "forbidden" female culture. They recognized in their childhood selves a strong feminine component, which could take the form of liking girl's activities, liking to play with girls, or being interested in caretaking activities that are usually ascribed to females. They apparently got this proclivity either from a close identification with their own mothers and with what girls got to do, or from observing their own fathers as the carriers of "feminine" attributes.

One father poignantly recalls his immersion in "girl" culture as a child:

> I had very few boy friends. I knew lots of men who have women friends to tell their tales of woe to. Mine's a very different experience. I had only little girl friends. . . . I played

house a lot. I was a sissy. I really related mainly to girls. I hung out and played hopscotch, and Tuesday nights was hanging out with the girls and watching Milton Berle, and getting into pajamas and having milk and cookies and playing with dolls. I played fantasy stuff around being a parent.

Other fathers remember not fantasy games revolving around being an involved parent, but their actual observation of and identification with the caretaking activities of their mother or father. Fathers made particular note of this if it was their own fathers they remembered in this role, perhaps because it was such a rare phenomenon. One father, definitely the more primary parent in his present shared parenting household, recalls a similar version of this experience in his own childhood, an unlikely occurrence in the 1940s.

As a child, I very much expected to be very connected with my kids. I always expected it would be natural that I would be someone who did traditional, so-to-speak, women's work. . . . My father was my only parent [meaning that his mother was not capable of parenting]. Most of my conscious, aware feelings of softness, emotionality, femaleness, if you will, caring for and about someone, come from my father.

Striking here is that fathers' memories of their own "feminization" in childhood came not just from associating with females but also from "feminine" components in their own fathers or in other males around them.

Many fathers spoke not only of their alienation from male culture, or of their attraction to female activities, but of their more pervasive feeling of being "out of it" in their peer circles. One father remembers growing up in a missionary environment that "made me feel different. . . . This difference led me to expect I would not fit in. I felt the tensions between the family values and those of the culture around me. At school I felt envious of the easygoing, materialist culture. I was brought up with the value of nonaggressiveness." Another father speaks of his involvement in radical politics in high school, and remembers that even earlier he had been set apart from other children because of his parents' involvement in the anti-war movement.

We already know that this group of fathers is unique in making a conscious choice to raise their children against the grain of what is usually expected of men and women as parents. It is no surprise, then, to find that they might themselves have come from families

who were living "against the grain," so to speak. What is a surprise, however, is that no one mode of being "different"—such as having radical parents, or high father involvement—was the determining factor in producing gender disaffection. Instead, it was some quality of their childhood that, either because of estrangement from peers or because of family values that ran directly or indirectly counter to mainstream norms of maleness, left them feeling on the outskirts of "boyness."

Whereas these fathers speak quite openly of what they abhor in male culture and what they respect or admire in either feminine or feminist values, they are also quite accepting of themselves as men. For the "veterans of childhood," this male identification might be directly linked to a phenomenon occurring in their adolescence and early adulthood—a time when they often reported "coming into their own."

From preschool through middle childhood, the rules are often indelible and written in blood as to how you can and cannot behave. By the teen-age years, however, the proscriptions and regulations loosen up as young people scramble for an identity and a sense of self. It was often in high school that these fathers for the first time discovered other boys like themselves, boys more intellectually or academically oriented. Particularly if they came from a middle-class or upwardly mobile background, achieving good grades and being college-bound were suddenly emphasized. Many of the men were "tracked" into schools or programs where academics were stressed and there were no longer "jocks" to be in awe of.

Often they found other youths who were also interested in radical politics or nonmainstream ideas that up until then had left them feeling estranged. At this stage in their lives, the overwhelming majority of these fathers had no future vision of shared parenting. If they thought about parenting at all, they imagined that they would probably do it something like their fathers did. What they *were* aware of was finding some niche in "nontraditional" notions of maleness which felt comfortable and certainly would be a precursor to their willingness and ability to take on an active "mothering" role later in life. One father's bittersweet memories of his childhood are telling:

My brother used to make fun of me. He was five years older and he was good in sports. He called me "Little White Body" or "Frail Carrot Head.". . . I always liked girls. I remember a scandalous relationship with a girl in first grade. After about

second grade, I wasn't successful with girls until college. First of all, I was always smart. Second, I was a communist. Neither made me particularly popular with anyone. In high school, things got better. I got into a liberal, Bertrand Russell crowd.

The "veteran from childhood" pattern is the more likely one for fathers who end up in shared parenting relationships. It is also the pattern that makes people anxious and elicits retorts like, "But what about George Jones? He's an involved father and he was Mr. Super-Jock and Mr. Outdoors and is clearly a 'man's man' and always has been since I knew him as a kid." There are no doubt George Joneses among the pool of shared parenting fathers. In the fathers I interviewed, these were men who remembered always liking or excelling in sports, being in the "in crowd" at school, and growing up surrounded by traditional male values of aggressiveness, assertiveness, and competitiveness. What sets them apart is that either in adolescence or in early adulthood they experienced a transformation—a "conversion," if you will. These are the "adult initiates."

For the same reasons that some fathers in what I call the "veterans" group came into their own in high school, some of the "adult initiates" experienced a change during their high school years. The loosening up of injunctions and the search for identity (and probably the effects of raging hormonal activity in adolescence) left these men experiencing some disjuncture vis-à-vis their earlier days as a boy:

> I was a normal boy, played all the cops and robbers games, all those games I hope my kids *don't* play. At puberty I became more introspective. Something happened when I was 12. By high school I discovered that the emphasis was on Yale and Harvard and intellectual sports.

Other fathers in this second group continued being "normal boys" straight through high school and even beyond. Only later did they look back on their own childhood and dislike what they saw. Influenced by the women's movement and the cultural milieu surrounding them, they wanted to make changes in both their attitudes and behavior concerning men and women. Often, shared parenting itself was part of this project.

Ironically, the very fact that they had never been "sissy" boys caused them remorse now. As happened with many soldiers who went to fight in Vietnam and came back pacifists, these fathers no

longer saw the value of being competitive or aggressive or of denying the nurturing, caring parts of themselves. They particularly dwelled on this in discussing the values they wanted to impart to their own children:

> I was always heavily involved in sports. I had a lot of outside role models. I have a legacy of male role models. My father was Irish. There was a remnant of the Irish Catholic tradition of rousing, drinking behavior with the wife at home.

This man is now in a traditionally female occupation and has been involved in a men's group for several years, in which he is attempting to explore new ways of being male. When talking about his own preference for a male or female child, he revealed his discomfort about his legacy of Irish Catholic maleness:

> I had no preference, but I guess I thought I would be better with a girl. I had a lot of questions about what it meant to be male. I couldn't be a good enough role model with a boy. If I have a boy, I'm going to be into him being into sports and achieving. I didn't want to be that kind of traditional father. But I also had visions of batting balls. The conflict was that I would be spending too much time on the male competitive side and not spend enough time on the soft, nurturing side with a boy. With a girl, I felt the feminine part of me was fine. I could do well with girls.

The real concern, then, was that the culturally valued "masculine" traits would squeeze out the more affective "feminine" traits, both in the father himself and in the male child he might rear. Both groups of fathers, the veterans and the adult initiates, worried about this squelching of the feminine by the dominant masculine traits. In fact, of course, the two groups really make up a continuum, rather than being mutually exclusive. The overlap is particularly noticeable in adolescence, when the boys in both groups grappled quite consciously with what kind of man they wanted to be.

Another gender-related childhood experience also links the two groups. Not just when looking forward to raising their own children but also in looking back to their own fathers, the fathers grimace about maleness. With the exception of one father, who remembers his father as the warmer, more nurturant parent who in fact "mothered" him, the other men perceived their own fathers as negative role models. It was not a question of disliking the personal character-

istics of their fathers. More specifically, they were distraught about what their fathers, in their male family position, did not give to them.

Frank, the father of two children, remembers poignantly that "I felt a lack of closeness to my father that can be traced to his lack of involvement. He was the breadwinner, came home, and fixed things. I felt emotionally we didn't have a lot going. I don't feel my father spent much time with me. I decided to remedy that. That was a lack. I wanted a strong emotional connection to my kid."

Frank speaks for the majority of fathers. They perceived themselves as the *victim* of their father's gender position. If being male in 1955 meant you brought home a paycheck, did instrumental tasks around the house, and were either emotionally reserved with or unavailable to your children, then from Frank's point of view as the son he saw himself as having missed out on a lot.

As Sam Osherson points out in his book *Finding Our Fathers,*[2] many men today think back with pain and sorrow about what they did not get from their own fathers. What sets Frank and his fellows apart is how they acted on those feelings. If being male meant fathering as their fathers had done, they wanted nothing of it. They would instead be "mothering" men.

In seeking to be a different kind of father to his own child, Frank is not just offering what he thinks is better for his child. He is also "reparenting" himself, making up for what he himself lost out on because of the way his father was a male. Spencer, the father of a two-year-old boy, has memories similar to Frank's. Although his father was very committed to the family, "he was not a model of one-to-one as to how to relate to another human being. He was neither supportive nor in touch with his feelings." Spencer has himself spent many years in psychotherapy and makes a point of expressing his feelings and encouraging his son, Gregory, to comfortably inhabit his own developing verbal and nonverbal spheres of emotion. Spencer made a promise to himself that Gregory would never have a father like he had had.

We can all probably remember from our childhood some transgression our parents committed against us and our subsequent vehement promise to ourselves, "Someday, when I'm a parent, I'll never do that." And then someday we do grow up and become parents. We discover that although we are unable to keep all those childhood promises about what we "would never do," we indeed find ourselves trying to make some reparations with respect to our own children.

We do this by putting ourselves in their shoes, imagining we are them. In that process we often project onto them what we remember from our own childhoods. Through just such projections we soothe old wounds. We cannot undo what has already been done to us. But in identifying with our children we can at least partially remedy the things we did not like about our parents by compensating for our parents' errors—by parenting in a different way. We then "reparent" ourselves by reliving our childhood again, in a new way, through the vehicle of our child's experience. In a funny way, this involves comforting ourselves through experiencing ourselves as our own (better) parents, as we regress and imagine looking out from our children's eyes. For men who are sharing parents, such a corrective experience is accomplished by attempting to provide their offspring with the closeness and attention they themselves never received from a man.

The fathers' discomfort with the domination of competitive male traits and their displeasure with their own fathers' parenting, then, were two strong precursors of their subsequent embrace of shared parenting. These men are not "sissies." They are very strongly identified as males and at the same time spend much time focusing on the effects their maleness may have on themselves and on another human being. Before ever becoming parents, they have repudiated those aspects of traditional or stereotypical male gender roles that they deem destructive. Simultaneously, these men recognize quite consciously, and with little ambivalence, that they possess a "feminine" component in their personality. Upon their becoming fathers, the repudiation of stereotyped maleness and the acceptance of the feminine in their psyches translate into a strong emotional commitment to and involvement with their children.

Growing Up Female

We now have half the picture of the childhood background of the shared parenting couple. But what kind of woman will this type of man likely join up with? In contrast to the men, the women who become sharing parents have a more complicated tale to tell regarding their defection from traditional female culture and their present position as a woman who abdicates half of the mothering of their child(ren) to a man. The men speak more of *repudiation* (of traditional maleness). The women, too, speak of repudiation, but more

pointedly about *ambivalence* (toward traditional femaleness). They want to be mothers, yet they don't. They were identified with being a girl when they were growing up, yet they weren't.

Going back to these women's childhoods, we do find one remarkable similarity among all of them in their memories of their own mothers: We hear one single, very loud cry of protest and disavowal. They want to be nothing like the unhappy people they perceived their own mothers as being. If there was one aspect of female culture they were clear was not for them, it was traditional motherhood.

It was more typical than not for the fathers I studied to think very little in childhood about impending parenthood. It was just not included in their panorama of hopes and dreams. Even those fathers who played house as small children rarely incorporated those fantasies into their own future role aspirations. Their arena of gender concern consisted of sports and the development of competitiveness and aggressiveness. But the parallel arena for girls *was* motherhood, beginning early in life with their first doll. And in parallel fashion to the pain experienced by the men as they sought to navigate their male arena, so, too, the women reported pain in theirs.

Whereas the men were repudiating a set of values, attitudes, and behaviors when they talked of their disaffection with male culture, the women were repudiating a set of external constraints, along with an internal unhappiness, that they perceived in the females closest to them, their own mothers. In contrast to the men's feelings of gender discomfort while actually going through childhood, the women's insights into their own mothers' unhappiness did not often come until adulthood. Yet parallel to the men's reported uneasiness with childhood male culture, these insights permeated their contemporaneous feelings about their childhood and their plans for their own journey through womanhood.

It did not matter if their own mother worked outside the home or not; motherhood still trapped them. The women movingly lamented their own mothers' fate. One "grew up with a 1950s housewife—bored"; another remembered her mother's telling her "never to have children. She didn't like her role as a mother"; a third flatly recoiled from her mother's perceived fate: "I couldn't see doing what my mother did. I felt like my mother gave her all to the kids. And she also worked at a job, came home, did the cooking. It was her adamant insistence that she do it all." If their mothers stayed home, they were frustrated. If they went to work, they were con-

flicted—guilty about being away from the children and liking it, burdened by a double load of domestic and occupational responsibilities.

Some women did recognize that working outside the home was a way out for their mothers, giving them added meaning and fulfillment in their lives. But they also assessed that the unhappy aspect of their mothers still remained their parenting self. Again and again, I heard statements like the following:

> My mother would only take a job that would let her out at 3:00. She only took work that gave her flexibility to be home with me. And my mother really enjoyed working. My mother would have gone to work much earlier if my father had allowed it. My mother was never a particularly happy housewife at home. She always wanted to go to work.

For the females growing up, it was not a matter of fitting in, as it was for the boys in male culture, but a question of being squeezed too tightly into a box, with no room for movement. These girls did not experience constriction themselves, but only vicariously, through their mother's experience of womanhood. This is in keeping with David Lynn's notion that boys learn from abstraction, because they have no readily available close identification figures, while girls learn from direct imitation and the examples of mothers and other women easily available to them.[3] It is also in accord with the psychoanalytic notion that girls experience themselves as an extension of their mothers and that there exists a sense of boundary confusion between mother and daughter.

The difference here is that these daughters were not *learning* by example, but rather *unlearning* by example. Their worst fear was to be that extension of Mother, to be just like her. Instead, they wanted to sever the cord between them by being anything *but* what their mothers were.

Many of the women went to extremes in their childhood to sever that tie. One mother exclaimed, "As a child, I didn't want to get married, I didn't want to have kids, I didn't want to be a homemaker." Another mother remembers, "As a child, I did not think about being married and having kids. I thought more of having a career." As we will see shortly, the girls' vision of a career parallels, in a way, the boys' affinity toward "girl" things and female culture.

Other women did not go to this extreme in their childhood imaginings, but they did carry into adulthood a fear about their own entrap-

ment in motherhood. No doubt they did not have to look back to their mothers but simply at women around them to know the frustrations full-time motherhood could bring. They needed only pick up their local newspaper to read the national statistics that men's mental and physical health improves within marriage, women's outside of marriage.

But their reference point was most often their own mothers. As one woman expressed it, "I wanted to have children with a father like I had, but a life nothing like my mother's."

Their particular fear was that motherhood would "eat them alive" and leave nothing of their own selves—nothing for other activities, work or personal. They knew all too well from their own childhoods that motherhood could be a life with no boundaries or few rewards. Barbara, whose own mother had warned her never to have children because it would ruin her life, explains that "I had ambivalence about having kids. I was afraid of getting lost in the shuffle of being a housewife." Francine, who saw herself as a "tomboy" in childhood, recalls that as she got older she "saw being a mother as a very negative role. TV and literature put women in a passive, insipid position. I didn't want to be a happy housewife, ruffled apron, giving cocktail parties." Specifically, she did not want a life like her mother's.

If these feelings were so strong, and were often so deeply embedded in childhood experiences, then the question remains, "Why did these women ever choose to become parents at all?" The answer lies in the fact that you have just heard only half the story. These very same women, who did not like what they saw in their own mothers and feared the entrapment of motherhood, also harbored strong desires to mother a child. Their feelings were either already apparent in childhood or crept into consciousness later in adulthood. As we describe "the other half of the story" of their feelings about motherhood, you will see a clear illustration of the ambivalence, rather than the repudiation, that the shared parenting mother has experienced about her gender from childhood on.

One woman, a latecomer to parenting, certainly feared the entrapment of parenting, and identifies herself first as a professional, second as a parent. Yet she also recalls from her childhood:

My favorite book was *Cheaper by the Dozen*. I planned to have children no later than age 18. I was going to have four of them. It didn't occur to me that anyone wouldn't have children. It was

out of the question. I was very good with children. I was very much a little mother. I was going to marry a prince and live in a castle.

Another mother expresses feelings of guilt that she is not a mother like the one she had, one who gave her all to the children: "Sometimes when I think back to what my own mother did for us, I feel sad, and I think, 'I'm not the one who does this for my child. I'm just not a 'cookie mother.' " Other mothers spoke of the possessive feelings they have toward their child at times, their wanting to claim an exclusive entitlement as Mother: "I found that much more than I expected, I was feeling resentful about sharing the parenting. It was a bother to have to discuss it with Gary. I had to give up feelings, not always conscious, that as a mother you have the right to decide."

"I should, I don't, I want to" often vie with each other as these women work out old and ongoing issues of gender-based roles, expectations, and concepts of self, particularly revolving around motherhood. The important point here is that ever since childhood these women have been grappling with the personal reality of being female. They neither repudiate a "feminine" position nor accept it. They rarely talked about feeling "out of it" as a girl in childhood female culture. Although some spoke of their tomboy days, they predominantly experienced themselves as entrenched in female culture. What was difficult for them was the confusing messages they received from *within* that culture.

Many of the women did report that as a child they did not feel like a "girl's girl." "As a child, I didn't play with dolls. I read. I just wasn't interested. My sister played with dolls. I had no particular professional aspirations, but I knew I would grow up to be something." It sounds like this mother saw her aspiration for professional success as a repudiation of femaleness. But when this same mother goes on to say that "I was conscious of discrimination against women when I was growing up. And I felt like I had to fight it," we realize that this woman is talking about something very different from repudiation. From childhood on she recognized that things were not fair for girls. Rather than wanting to disavow female culture and join the boys, she in childhood was already a "pre-feminist" who wanted expanded options for herself *as a girl*.

Certainly most of the women were not such "pre-feminists" in their childhood. But many did talk about their discomfort with being

a girl. They did not feel the same alienation that the "veteran" fathers expressed; their overall stance was that they enjoyed being a girl. It was just that there were some contradictions in the experience.

Nancy eloquently expresses the dilemma: "It was a funny combination. I was a real active kid. I was definitely into my dolls. I was always smart. I definitely picked up that it was not OK to be a smart girl. I remember being annoyed by that. There were certain things about being a girl I didn't like. But I liked being a girl. I was into girly things. And I also understood that being a boy was better."

The grass seemed greener as they envied what boys got to do that they did not. Recognizing that being a boy was better did not translate into defection to "forbidden" boy culture, but instead remained a longing from the other side of the fence, as with the mother who remembers that "as a child, I longed to be athletic, aggressive, like my brother. I didn't have a sense of that as a girl. That was because my mother was so protective with me." If there was any direct action taken by these women in their childhood, it was unlikely to be hanging out with the opposite sex, as some of the fathers had done. Instead, these females would act by demonstrating that they could do things boys did or that they did not need a boy's help: "When I was a child, my father taught me to do handy work around the house. I never felt I needed a man." Beyond handy work, thinking ahead to a career was certainly another such action.

Regarding their gender histories, then, the men felt alienated, the women conflicted. What is identical is that neither the fathers nor the mothers liked what traditional boyhood and traditional girlhood, respectively, had to offer. That this disaffection was experienced differently by the men and the women can best be explained by the norms and values of the larger culture, which in turn stem from the social expectation that women stay home and mother while men run the public world.

We all know from our childhoods that being a sissy was far worse than being a tomboy. A higher value was placed on male activities than on female. For a boy to step outside those more highly valued norms was both a discredit to his gender and a reflection of something gone seriously awry, that he would choose a lifestyle less valuable over one more valuable. Thus, he had little room to move in if he did not like the rules and norms of masculinity. From this came his alienation.

For a girl to go outside the bounds of girlhood was not nearly so remarkable. Who would not want to seek out activities and behaviors more highly valued in the culture? Not only did the women recognize at an early age that to be a boy was more valued. They also recognized from their own mothers' experience that to grow up female was not so easy and did not often come with great rewards. They escaped some of the discomforts of traditional girlhood by taking advantage of more elastic boundaries that allowed them, with at least a modicum of social sanction, the leeway to explore expanded options *as a girl*. Yet these particular women had gotten enough gratification from the experience of being female that they in no way wanted to repudiate it, but rather to integrate it with something else.

As with the men, we can now say there are two strong developmental precursors for a woman entering a shared parenting relationship. The first is the experience of conflict about female gender roles, particularly motherhood, and the dilemma of how to "do it all." The second is the determination to carve out for herself expanded options that leave out neither work nor family. Once these two things are in place, shared parenting seems like an almost inevitable solution to her gender dilemma. In one mother's words, "We're products of this particular historical group and movement that validated this shared parenting project. It let my husband do something that he wanted to do anyway, raise a child. And it gave me space in fact, too, to *not* have to do something I always thought I had to do so completely, mothering, and therefore has certainly made it more enjoyable to me."

Shared parenting fathers and mothers did not grow up like ordinary boys and girls. Their discontent with traditional male and female culture may well be the strongest precursor to their adult decision to "mother" together. Yet the decision and commitment to co-parent does not translate into an identical set of feelings, thoughts, or behaviors in men and women. Despite their discomforts, these fathers certainly grew up as males and these mothers as females. There must be some element in this growing up experience that explains why, even when they fully commit themselves to mother together, the "inner experience" of dual parenting is so different for each of them.

6

Doing vs. Being in Parenting

The shared parenting family is a self-proclaimed 50–50 household. The concept of "separate but equal" allows us to accept some overall framework of mutuality and equality between the men and the women who share parenting. But it still does not mitigate or erase certain imbalances in the actual parenting—and the gender tensions they give rise to.

The three areas of mother-father parenting differences we've explored—dressing the children, worrying, and psychological management—all, as we have seen, reflect a common underlying dynamic: namely, how separate or connected the mother and father feel toward the children. In every incident we studied, the father was more separate from the child, the mother more connected. In each of the three areas the result is not simply that the parents do something *differently,* but that the mothers are *more* involved in the activity.

Childhood is the locus of explanation for this gender phenomenon. Let us return to the work of Nancy Chodorow, who contrasts the more flexible or permeable ego membranes of the female with the rigid ego boundaries of the male. Based on the experience of being raised by women, "The basic feminine sense of self is connected to the world, the basic masculine sense of self is separate."[1] Recall that Chodorow argues that this basic difference in personality prepares females for the responsibilities and relationship of mothering, while

leaving males less prepared or predisposed toward the primary identification, empathy, and connectedness that are the basic requirements of mothering.

The group of men and women to whom I spoke do not fit the categories of men and women that Chodorow addresses—that is, women who mother and men who do not. In a sense, they are trying not to *reproduce* mothering, but to reconstruct it. The men have turned not away from, but rather toward, mothering; the women do not want to do all the mothering themselves. Yet, like the men and women in Chodorow's thesis they, too, have all themselves been raised by mothers, even if they did not like it that way. It seems obvious that the contrast between the feminine "connected" self and the masculine "separate" self coincides with the mother who worries more and sees her child as an extension of herself vs. the father who leaves his parenting worries at home and experiences his child's appearance as constituting no reflection on him.

The differences in the way that shared parenting mothers and fathers parent are related to their upbringing, their socialization, and their internalization of early family relationships. Like any other man or woman, they enter parenting with the baggage of their background and developed personalities. Consequently, the gender-differentiated aspects of their histories, even when they did not feel comfortable with them, are not easily shaken to create two sharing parents. The key variable is the feeling of "connectedness" vs. "separateness." And the outcome is very much that women "are" mothers while men "do" mothering.

Being vs. Doing

A Father: I don't think we're equally invested. If Sam died today, Nancy would want to kill herself. I would be destroyed. I wouldn't want to kill myself. Her being, her essence is more tied in with him than mine is. For me, parenting is something I do.

Being vs. doing as a female-male difference has been a repeated theme in psychological and philosophical literature. D.W. Winnicott, the psychoanalyst, writes in *Playing and Reality* about the female and male elements of personality.[2] The female element he calls "being." It occurs very early in human development and is first situated in an infantile experience. It involves a period when baby and parent (or other) are felt as one. In other words, a merging occurs in which

parent and child have no separate identity. It is described by Winnicott as the simplest of all experiences, and the source of the true continuity of generations. It is also labeled by him as "feminine."

Doing, by contrast, is, according to Winnicott, the "male" element of personality. It follows "being" in development and presupposes a separateness between baby and parent. The infant can begin to recognize that the person who takes care of him or her is "not me." The infant can then start to act on its environment. To do this requires an advancement in mental structure beyond that of birth, whereas being can begin immediately. Doing is therefore more complicated than being, and Winnicott labels it as "masculine."

Winnicott posits that all of us in fact have male and female elements within us, so that doing and being are part of both men and women. "The male element *does* while the female element (in both males and females) *is*."[3] It seems likely, however, that when women are the exclusive early figures in the child's life the male element will be enhanced in little boys while the female element will be dominant in little girls. Chodorow, through clinical example, and Dr. Gloria Lawrence, through empirical interviews with mothers of sons and daughters,[4] demonstrate that mothers perceive their daughters as less separate from them than their sons and instill more independence in their sons than in their daughters. Fathers collaborate in this process by being the purveyors of "sex typing" with both boys and girls and encouraging the separation of the son from his mother. The result, again, is a "connected" sense of self in the girl and a "separate" sense of self in the boy.

This outcome carries over into adulthood, into the different personality styles of women and men. Lillian Rubin's book *Intimate Strangers* provides strong documentation of the continuing presence and impact of the connected-separate dichotomy: "A woman remains more preoccupied with relational issues, gives herself more easily to emotional relationships, and reaches for attachment and emotional connection with an insistence and intensity that often startles her as well as the man in her life. . . . For men . . . the problem that plagues their emotional relationships is their difficulty in allowing another to penetrate the boundaries to establish the communion, the unity, that's necessary for a deep and sustained intimacy with another."[5]

Conceptually, the connectedness-separateness distinction is parallel to Winnicott's being-doing. I come full circle, then, back to the proposition that women *are* mothers, while men *do* mothering. For

women, parenting is her very "being, her essence." For men, "parenting is something I do." Even in a population in which the "feminine" component is relatively highly developed in men, it will still not be as dominant as it is in a woman or operate in the same way.

Doing vs. Being in Action

A father shifts uncomfortably on the couch as he remembers back to two "life and death" incidents from their daughter's early life. In one, their infant was about to fall off the changing table. Both he and his wife were present, but she lunged to catch the baby. In the second, their car slid off the road in winter. The father emerged from the car, dazed; his wife went straight for the infant. Soberly, he reflects that "the reality, the inner connection of taking our daughter as part of ourselves was different for my wife and for me. She was much more a part of my wife's life, and some of my stuff was much more romantic, much more objectifying."

Another parent, a mother, says reproachfully that when it comes to their child, her partner always first thinks about what *he* needs, while "I tend to start from 'What does our son need?'" She feels that she should "be" there much more, while the father feels they can get other child care providers to *do* a great deal of the daily caretaking tasks.

Time and again there was a "nine to five" quality to the men's attitudes toward parenting responsibilities which clashed with the women's more amorphous, "all the time" sense of being "on duty." Denise glanced wistfully at the idyllic picture of herself, Stuart, and three-year-old Anya on the grass. But rather than smiling, she scowls as she describes her displeasure with her husband on days when Anya is in child care long hours and she is at work. She would like him to pick their daughter up early whenever he can; he experiences this as an impossible demand. Denise does not think Stuart has any appreciation of the more emotional tie she has to their child. She does not see him feeling the same pressure to be a "good father" that she does to be a "good mother." Stuart, on his side, experiences it "as a source of tension when more demands are placed on me and I see it as an infringement." He feels he is certainly *doing* his share, and what Denise is asking for goes beyond the call of duty.

Denise absorbs the "extra" demands of parenting, or pushes Stuart to recognize them, because parenting is a more internalized part of

her self. She feels a connection to her child, and to her own mothering, in the very central core of her being. In contrast, Stuart's sense of himself as a parent is more bounded. His parenting responsibilities have clear limits and are not as deeply internally grounded as Denise's.

These vignettes are discrete examples of the being vs. doing difference in the "mothering" provided by women and by men. They are all offered within the framework we've established: to wit, that indeed both the men and the women passed the qualifying test for "good enough mothering," to use Winnicott's term.[6] Within acceptable bounds, both the men and the women are able to provide the empathy, identification, and attentiveness that are required if one is to "mother" a child. The point is that for women mothering is a form of existence, a way of being. For men, mothering is a set of activities they are doing, defining a relationship in which they are involved, but which does not reside at the very core of their being.

The distinction is, as we have seen, never more evident than in the ability of the men and the women to draw boundaries between themselves and their children. For example, consider the very concrete ability to get two things done at once, to ward off or screen out so-called intrusions from the children. Imagine being at home with a magazine article at your side that you are dying to read. Then imagine you are "on duty" with your four-year-old child, who is playing energetically at your feet with a new toy. What would you do?

If you were one of the fathers, you would have found a way, if humanly possible, to do both. Ken explains why: "I'm not willing to let Sam intrude on me." If you were one of the mothers, the magazine article would have fallen by the wayside. "Nancy," Ken reports, "is much more likely to allow the intrusion."

Although there were exceptions, in the typical household Dad was able to manage taking care of baby and doing something else at the same time, while Mom looked on either admiringly or critically. Louise is a genuine spokeswoman for most of the mothers when she muses, "If there's an area I always felt I did feel jealous around Jeff it was his ability to hold Rachel and to do work. He was more capable of structuring time for himself with Rachel than I was. When I was at home with Rachel it was hard for me to structure time, to figure out how to do things for myself."

So it looks like men can juggle two things at once and women cannot. Yet, we protest, "What about the image of the woman vacu-

uming the floor and stirring the soup with baby slung on hip, a veritable time-management miracle? And what about our stereotypical picture of the man, frazzled and discombobulated, soup boiling over, vacuum eating up toys, and baby leaking through an unchanged diaper?" It is true that often when it came to the simultaneous management of *household* chores and childtending, women were better able to cope than men. Men either got overwhelmed by too much going on at once or let the household tasks slide, giving full attention to the more engaging activity of child care. The "two things at once" that men could do better than women did not involve home management tasks—"women's work"—but rather the coordination of work, or "doing things for myself," with parenting.

Within the family, women are highly tuned into their child's presence and feel almost compelled to intervene. Men maintain a distance: Their child does not "penetrate" or get to them as much. This was especially true if the child was fussing or demanding attention: "Rick can tolerate Matthew's crying and screaming much more than I can. It drives me crazy; I feel like I absolutely have to do something." From the father's point of view, the solution is quite simple: "I'm more willing to let her cry."

It is not that women are fragile or on the verge of nervous breakdowns that makes them so susceptible to their children's crying or so attuned to their mere presence. It is not that men are hard-hearted, hard of hearing, or stylistically "macho" that allows them to let the children cry it out or leave the children to their own resources. It is simply that mothers are connected while fathers are separate.

A woman has a terrible time disengaging herself from her child, not just because she thinks she "ought to" do something for the child but, more deeply, because she has trouble not "being" a mother. Regardless of what else she does with her life, as a result of being a woman raised by a woman in a world that assumed that women mother, she has strongly internalized the empathy, the identification, the "at-oneness" with her child that makes her "be" a mother. These are the very qualities that make it difficult for her to pick up the coveted magazine article if her child is in the same room. To vacuum would be acceptable, because it is part of caretaking. Structuring time for herself, on the other hand, removes her from her child, and threatens her existence as a mother. It comes so "naturally" to her to remain connected, because of her personality structure, that she cannot understand why it is so hard for her to create boundaries between herself and her child, and yet so easy for the man she lives with.

The "tuning out" that makes the man less of a psychological manager is the same "tuning out" that allows him to more easily work and tend to baby at the same time. Father is much clearer than Mother as to where he stops and where baby starts. He is so aware of this that he grows agitated when his child's needs encroach on his. How different this is from the experience of mothers, who have a hard time even sorting out their own needs from their children's: "I can't tell if I'm picking her up to make her feel better or to make me feel better."

Listen to the story of Ira, a very devoted father. He wants to be an involved parent; he also wants to be able to pursue his own endeavors. He agonizes, "When am I ever going to get to play the piano? I expect Joshua to take a nap so I can play, and then he doesn't. And I'm so resentful." Take Father out of the script and replace Mother, and you would more likely hear how guilty she felt for even having these feelings, for wanting to get rid of her child. Parenting is a discrete part of Ira's larger existence; it is not the essence of his being. When the things he does as a parent encroach on the other things he wants to do, he feels constricted, hemmed in. Since parenting is something he *does,* it is also something he can *stop* doing, or at least integrate with doing something else as well. If Joshua could sit quietly at the foot of the piano while Ira played, he would probably take advantage of the opportunity to play. His wife could only do so with guilt dripping from her fingers and with repeated attentive glances to her son.

If this is the situation when the child is in the room, you can well imagine the gender differences when parent and child are physically apart from one another. Fathers simply put a hold on their parenting functions when away from their children in a way women rarely do. Stephanie and Pete were one of the couples who had most successfully negotiated a congenial shared parenting arrangement. They have minimal gripes or complaints, and they truly equalize the daily tasks of parenting their two young daughters. Yet, when Stephanie mulls over the way she and Pete handle the coordination of their professional and family lives, she has this to say:

> Pete can compartmentalize. When he goes to work, he's off. I can't do the "on and off" stuff. It's like my children are with me throughout the day. I don't think Pete does that. I envy it but I don't want to change it.

Stephanie couldn't be more on target about Pete's dynamics. In his own words:

For me, out of sight is out of mind. At work, I might think
about the kids for five seconds. For Stephanie, at work at 11:00,
she'll start thinking, "Are the kids OK?" At 1:00 she'll think,
"Did I pack Sandra with her clothes?" I have no more thoughts
of the kids through the day. As for Stephanie, well, it's her
funeral.

Yet, Stephanie could not imagine it any other way for herself.
Living and breathing are things we just take for granted; so it is
for many women in the case of mothering. It permeates their entire
self, sometimes to the point that it feels stifling, but most often
with an inner propulsion and rhythm that takes its own course
whether the woman wills it or not. Her mothering self is intermingled
with all the other parts of her. As we have already seen, the expecta-
tions of the external world that in contrast to men she is Parent
first above all else (Why else would we have only the term "working
mother," but never the term "working father"?) both influence and
mirror what is already going on inside her. Not necessarily that
she is mother *first*, but that she is mother all the time.

A man looks at what he experiences as his wife's obsessive preoccu-
pation with the child (and her complacency with this state of affairs),
and he scratches his head. He feels neither envy nor guilt that he
does *not* intermingle, but rather compartmentalizes, his life. It comes
"naturally" for men to do this because they have something women
do not: a capacity to maintain a distance between themselves and
their child and also between different parts of themselves. The man
understands full well that it makes things easier for him, leaves
him less overburdened, and he cannot fathom why his wife wouldn't
"choose" the same mode for herself.

She doesn't choose the same mode because she is governed by a
very different set of internal dynamics than the father. The "out of
sight, out of mind" relationship to the children more common in
men when they go off to work does not prevail simply because
work is more important to them than it is for women; these men
and women talked with equal intensity about their work involvement
and identities. Instead, it is because men do different "balancing
acts" within their psyches than women do.

"Sometimes I want to rush back to the day care center, scoop
him up, and take him home. Other days I wish I could just barricade
myself in my office." This mother, like many others, is continually
plagued, in a way men *never* expressed, by the tensions between

her familial and extra-familial identities. Marsha, who has not even had her baby, predicts that she will be in the same boat: "I have nightmares about it. I want the work, I want myself, I want the kid." And the question of course, is, "How can I have all three?" It is an easier question for the man, because it seems more possible for him to *do* all three than it is for the woman to *be* all three. It reflects an ambivalence that is not the sole domain of the sharing mother, but pertains to all women who attempt to "be" mothers while maintaining some other identity.

Buttressing that ambivalence is a powerful sense of mother guilt, a guilt which is totally unparalleled by anything one could call "father guilt." Because motherhood is so centrally embedded in a woman's psyche, any movement too far away from the primacy of mothering in her life comes with pangs of guilt. Recent polls indicating that, in one case, 59% of all women, and 44% of all men, think that employed women are equally good mothers or better than those who do not work outside the home[7] do little to alleviate the woman's angst about being a "good-enough" mother.

Barbara has two small daughters and works in a business profession that takes her away from the home for long stretches a few times a year. It is not easy for her:

> I feel guilt. I am so intense in terms of my work. I don't miss the kids because I am so involved in what I'm doing. I'm just exhausted. But I do feel guilty, particularly with our older daughter, because I was pushing her aside.

Her husband, a very committed father, has less flexible working hours than Barbara's and in fact works many miles away rather than in a home office as his wife does. Yet he never expressed any such guilt.

And so it comes to pass that the mother's inner experience is so different than the father's. Here are two parents who are both full-time professionals. But listen to the difference in their experience as described by the man:

> My wife feels guilt not about her competence, but about her ambivalence regarding time away from our child, in a way that I don't. It would never be remotely possible for me to stay home full-time. But of course, there is the expectation that women do. Because of her guilt, my wife puts up with more from our son. She'll let him go too far out of a need to compensate for her absence. Then I have to jump in.

It is this mother guilt that makes it so much harder for women to deal with placing the children in day care for long hours, going to work when their children are ill, or spending too much time on themselves. It is part of the "being" of parenting that gnaws at women in a way it never does at men when it comes to balancing different parts of the self.

So when Ben, a father, says, "If Aaron is not doing so well, I wouldn't take that as me. I would say that's in Aaron, and that's too bad," he is demonstrating the male balancing act. With that level of autonomy between himself and his child, Ben is free to go to work and leave his parenting burdens behind. He has fulfilled his parenting responsibilities, and the rest is up to Aaron. The inner capacity that allows him to remain a clearly separate person from his son is the same capacity that allows him to put up firm dividers between the part of himself that is parent and the part that is worker or some other non-parenting self. To be able to maintain a separateness between self and other is the prerequisite for Winnicott's male element of "doing." This element appears much more highly exercised in men and allows them to separate child from self and parent from worker because they are not hampered by the "merging" or "being" aspect that is so much more fully developed in women.

Play

It has become almost a cultural axiom that women and men play very differently with their children. In the traditional nuclear family, Father arrives home from work, tosses the little ones in the air, wrestles with the older ones, and runs through the living room playing tag. He roughhouses and has all the fun with the children, while Mother cooks dinner and reprimands him and the children for getting too wild. If we look a little closer, however, we discover that it is not that women don't play with their children but that they do different kinds of activities with them: more sedentary than physical, more cerebral than motoric. Will this be true also in the shared parenting family? If it is, is there any way we can make sense of it as a "test" of the doing vs. being differences in men's and women's mothering?

Donna and Craig both derive great enjoyment from the leisure time they spend with their little boy, Daniel. But, as Craig explains it, "Donna is a little better at playing with Daniel. She is more creative at finding activities to do together, particularly stimulating

creativity in his play. I go to the zoo a lot with Daniel. And I rough-house with him. Donna doesn't do that at all. That physical kind of playing." In another city nearby, a mother who shares parenting reveals the same dynamic at work—or play—in her household. "I tend to be more sedentary. I read stories, play with our daughter. I play with dolls, talk on the telephone, play with water, let her help me cook. My husband is more physical with her. He chases her around on all fours, carries her on his back." Whether the child was a boy or girl, little or big, the scenario was always the same. Even in families where women and men embark on parenting with a commitment to sharing and equality, their play styles, like their concerns about dress, are consistently different.

Co-parenting women engage in activities with their children that involve role-playing, apprenticeship, or the quieter moments of life when two people just "are together." They are also intent on stimulating their child's creativity, "making things together, like cooking, or Valentines, or a present for someone." Comparing themselves to the men they live with, they perceive themselves as more "intellectual," more "sedentary," and more "quiet." When it comes to play, they are more apt to focus on songs, learning the alphabet, learning numbers, playing board games. And, relative to the children's fathers, they more often stay home with the children than take them on outings.

In every household but one, shared parenting fathers absolutely had the corner on the market for roughhousing. Sometimes the families were consciously aware of this and made a pointed effort to change it, by having the women be more physical with the children, but it just didn't "come naturally." Most families just let it be and accepted that the fathers were more boisterous, more "physical," more "rough-and-tumble." Some even felt that this contrast came from the children rather than from their own differences as parents. A father of a three-year-old boy explains that "I definitely do more rough-and-tumble play. Jason likes to approach *me* for that." Perhaps because Jason sees his father as bigger and stronger than his mother, or because Jason watches television and knows that only the male stars roll around on the ground, he turns to Dad for that. But most fathers believed that this came more from within themselves than from anything demanded by their children.

The image of the mother who watches over the stove and family with no time for play and the father who is the more "exciting" parent does not evaporate, even in the family that does co-parenting.

In one household after another, I heard allusions to the belief that men were the more "playful" parents.

Stephanie thinks that Pete is merely "more playful. That's just his temperament. I'm more apt to *talk* to the girls. Pete is more apt to play with them." If play is defined as rough-and-tumbling or going on outings, Stephanie is correct. But why doesn't the "talking" she does with the girls count as "play"?

Jeff reports that his wife is more involved in organizing the material parts of their daughter's life and setting up schedules, and that mother and daughter rarely play together. He sees himself as having a degree and intensity in his play with his daughter, a "fantasy space," that is just not existent for his wife. But why isn't the room rearranging or shopping sprees that Louise and Rachel engage in also "play"?

Francine worries that her relationship with her son Jason is just not as exciting as Jason and his father's. "With Dad Jason is moving out from the house, with more discovery of the outer world than I'm likely to initiate with Jason. I feel a sense of slight guilt that I don't give him these experiences." But why isn't the "inner world" that Francine explores with Jason through stories and fantasy play equally as exciting?

To answer these difficult questions we must look at the very constricted and limited notion we have of what constitutes play. We live in an activity-oriented culture in which playing and "doing" are an exact equation. Without "lights, camera, action," it just isn't any fun. We have an image of play that is outer-directed. It is also a male-dominated image. Think of two little boys in a kindergarten class. "Yecch, I don't want to play house. That's not *doing* anything. Boring, boring, boring."

The kinds of activities women characteristically engage in with children, even having a talk, are absolutely modes of "play," if one considers play to be the creative interchange that occurs between two people when there is some fusion of reality and fantasy.[8] If play is a bridge between one's inner, subjective life and the outer, objective world, the sedentary, cerebral, or "relational" activities of mother and child are equally as "playful" as the rough-and-tumble play of father and child.

The critical difference between Mother's and Father's play is that hers has to do with "being," while his is decidedly "doing." Or, as Audry puts it, "Bob is more physical with Valerie. Romping around. I'm much more intellectual. I do counting, alphabet, songs. I'm more

of a watcher than Bob. Bob does, I watch." To watch is simply to "be" there. Being is a state of relaxation and quietude. It is the "female element." Doing is "exciting." And it is the "male element."

Fathers do not do more boisterous play with the children simply because males tend to be more physically active than females, although this certainly could be a component of the phenomenon. They rough-and-tumble more because the male element is more developed in them than in women and they are accustomed to acting on their environment rather than sinking into it. They also respond to such physical play because it underscores the separateness between themselves and their child. Tossing your child in the air is moving your child away from you. It is an expression of the two of you as two separate "objects" that collide in space and have their own unique force of weight and gravity. It is also one of the few forms of nonsexual physical contact acceptable for men in this culture.

Psychological studies document that beyond roughhousing, fathers are generally more *physical* in their play with children than mothers are. They pick them up more, make more physical contact in their games.[9] Such observations, however, may very well overlook the physicality inherent in more subtle forms of "play" that are not as exciting or activity oriented. For a woman is no less physical than her husband in the play she does with her child, if we take into account a more expanded notion of play. Her physicality involves molding and merging. It is the cuddling or sitting on laps that so often accompanies reading and quiet activities. Later on, it is the close physical *proximity* of intimate talks or mutual cooking projects. It is very much a physicality of being rather than of doing.

We see that men and women in shared parenting families are no different from those in more traditional households in the male-female division of play modes. Because of their own upbringing and resulting personality structures, women's play has more to do with being, while men's play is part of their doing. These mothers' and fathers' commitment to shared parenting does not break down this distinction.

Separations

If men can more easily enter an "out of sight, out of mind" mode, it seems only logical that any extended separations from the children that actually occur will be easier on the fathers than on the mothers. I will leave for a moment the question of which parent is more

desirous of being apart from the children, for that is part of the drama we have yet to unfold about the shared parenting family. Instead, I ask the question: Once a separation is already a *fait accompli,* who has an easier time, Father or Mother?

> The first time I spent a night apart from him I didn't sleep the whole night. I was a basket case.

> The first time we left Nicole, I was a basket case. She was seven months old, and she had a wonderful babysitter we left her with. I knew she was going to be alright, but it was like this primal thing, "How could we leave her?"

Two mothers, two basket cases. Particularly in their early months as a parent, the mothers in these shared parenting families were completely thrown out of kilter by a physical separation from their child. It didn't matter if it was for hours or for days; the feeling was the same.

A mother of a three-year-old brought tears to my own eyes when she told this story. "The first time Jason was in child care, in my own home, and I had time to myself, I felt very confused. I had no place to go. Every magazine had said you have to have free time. I felt empty and confused." I remembered my own experience the first time I left my infant daughter with my brother so my husband and I could go out together. Stifling feelings of panic, I was like a freed slave who should feel liberated but desperately wants to run back to the plantation. I did not want freedom. I needed to stay connected.

Without the children, we women feel empty and confused. No doubt this is primarily manifested in the *early* months, when we have just given birth and are physically connected to the child through breast-feeding. The feeling is mastered or dims over time, but it does not completely go away. It is not a feeling that in any way *prevents* us from actually being separated from our children, living active lives outside the home, or even having a good time. But it is a feeling that often makes separations from the children more painful for us than for the men we live with, despite living in a household where both share the caregiving.

The physical rupture between mother and child leaves the mother feeling as if a part of her is missing. Time and again, women patients have sat in my office, tearful, struggling to express through words

the "hole" or the "empty space" they feel inside when separated from their babies. No doubt, some of their pain derives from their worries about how their children are doing. Tracey, the mother of two daughters, goes so far as to call home every time she leaves the house to make sure the girls are alright in her absence. Bob is quite convinced that separations were harder for his wife because "she wondered how our daughter Valerie was doing. 'Should we phone? Maybe she'll be confused.'"

Mothers also feel *guilty* about separations. First, they worry about being "good" mothers. Good mothers should not abandon their children, not leave them with strangers. They also project onto their children raw feelings of abandonment and pain:

> I felt guilty about leaving her. It didn't happen very often. The first day of day care I left her for two hours. She had such a look of betrayal on her face. I felt terrible about it.

The mother is, indeed, highly attuned to every nuance of her child's reactions. She might also imagine some that are not there. Whether the child's perceived reactions are fact or fancy, the stark reality is that mothers believe they have inflicted pain on their child, leaving their child confused in the same way they themselves feel confused by the breach in contact. This real or imagined suffering is even more emotionally charged for them than the internalized social proscription that mothers should not leave their children, and is the strongest source of guilt.

Mothers, then, often project onto their children the very feelings they themselves are experiencing about the separation. Or mother and child may simply mirror each other, both having identical feelings of being confused or lost. The mirroring, like the projection, occurs as a result of connectedness. Mother either intuits what the child feels or experiences herself, albeit unconsciously, as being one with the child. She experiences the separation as a "hole" or "empty space" because indeed a part of her, her child, is missing.

The pain of separation from the children was especially true if the children were female—thus underscoring the mothers' separation experience as a product of connectedness. Chodorow theorized that mothers will feel more connected to their daughters than their sons, and will view them as less separate. Lawrence then demonstrated that mothers indeed had a harder time with separations from toddler daughters than from toddler sons.[10]

The emptiness that the new mother experiences upon separation,

then, derives from her feeling depleted when her child is removed from her. And the greater the connectedness with the child, as with a daughter, the more threatening this emptiness becomes. Although this particular group of women successfully mastered this set of feelings and were able to live happy, fulfilling lives involving significant amounts of time spent away from the children, this sense of depletion, though reduced, still lingered over time.

In fact, the strong connectedness that the woman feels with her child is the very reason some women coveted physical separation from the child. Because the woman has such difficulty drawing boundaries between herself and her child and circumscribing some individual "space" for herself, the only barrier that works is one composed of time and physical distance. Pamela is just one of those mothers. She cannot stand her infant son's crying, finds it nearly impossible to screen him out for more than a minute when they are together. How does she feel about leaving her son?

> It's been great to be separated from Matthew. I don't think about him, or walk around thinking about him all the time. The first time I left I was upset not to take Matthew—Who would I be without him? But I found out that that was not true. The last time I went away I had a great time.

Who would I be without him? I *am*, then, as much as I am a mother. Pamela is no different from the other mothers in this regard. But the sigh of relief and gratitude that accompanied her revelation of having had "a great time" was the discovery of a reprieve from the No Exit experience of blurred boundaries between self and child in his presence. She was so overconnected that physical separation was her only escape from wall-to-wall, twenty-four-hour child.

While mothers struggle with separation from the children, men are certainly not breezing through the experience indifferent or unscathed. Fathers, too, wrestled with feelings of emptiness, loss, and anxiety when apart from their children. "When Donna [his wife] and Catherine were gone," says Jim, "things felt empty. I thought I would like it in anticipation. But they had become part of my life." Stuart leans back and reflects, "What's it like to be separated? I intellectualize about it. How young our daughter is, does she understand it? On a real level, I just miss her."

In Jim's case, the emptiness was caused not just by his daughter's absence, but also by his wife's. It is the discomfort of being alone, by himself, rather than the experience that a part of him is actually

missing. Being part of his life is a bit different from being part of *him*. And for Stuart, it is simply a clear-cut matter of feeling the absence of his three-year-old daughter. He just doesn't like not having her around. For the men, we see that another person closely related to them is not accessible rather than "a piece of me is missing and I am incomplete."

Jim and Stuart, like most other fathers in the study, admitted that as hard as separations were for them, they were even harder for their wives. In their own words, they think this is because women are just more aware or conscious of their emotional experiences. Initially, Ira has a hard time figuring out whether he or his wife, Karen, has an easier time with separations from their son. First he is tempted to say Karen. But then he re-evaluates. "For me, over time, a certain deprivation builds up, a little colored by guilt, and missing him. It isn't so much consciously worrying about him. Karen is much more consciously aware of missing him, thinking about him." For Ira the "missing" feelings may be background noise; for Karen they are at center stage.

Denise reports in stark detail her own raw feelings the first time she left her daughter overnight. She poignantly remembers crying when she left her and then finally getting over it. Stuart's response to the same situation: "I don't quite remember it." Can we doubt, then, the accuracy of Denise's statement when she adds that "it's hard for Stuart to be away from Anya. He misses her. But the separations are more painful for me"? (Stuart presumes it is just a product of the fact that Denise verbalizes feelings more, not that he does not have those feelings.)

In our culture it is assumed that women are "more in touch with their feelings" than men. In the area of separations, as with many other aspects of the parents' reports, we have to be careful to sort out the greater ability of the women to retrieve and *express* their emotional experiences from the reality that they are in fact having a very different experience from the men. That men cited women's superior emotional expressiveness specifically in the area of separations to explain why their responses might appear different from their wives' is noteworthy. They never resorted to this explanation in the other areas of gender difference that we have so far uncovered. The significance is that the men are probably right. Their experience is closer to women's when it comes to separations than in other gender-divided aspects of shared parenting, and they want recognition of this. Also, response to separations is an aspect of parenting

that has primarily or even exclusively to do with feelings rather than behavior. In that case, when it comes to a comparative measurement of feelings the issue is that men's feelings are just not as accessible to their partners or even to them, perhaps because of intellectualizing or suppression or repression that makes it "hard" to remember.

But they are wrong to assume that this is the *only* difference between them and the women when it comes to separations. It is not just that the feelings are more on the surface for the women. It is still, also, because separation does not, in fact, constitute as great a loss for the men. Not one man talked about his existence being at stake or registered total confusion (What am I to do, Who am I without her/him?) in response to separation. Several women did.

It may also be that women express these sentiments about separation not because of a qualitatively different attachment to the children than the men's, but because the culture *expects* to hear these words from females. The women respond, then, not simply to please the interviewer, but because they have internalized a set of responses that mothers "ought" to feel, to the degree that they actually begin to believe this is what they *are* feeling. The men have no similar cultural prescriptions. On the contrary, it would be "unmanly" of them to have such intense separation responses.

Clinical acumen, however, tells me that this was not the case. The depth and intensity of emotion accompanying the women's words about separation made it clear that these feelings came from deep within them rather than being externally imposed by cultural expectations. Similarly, the men may have been clumsy in expression but were in no way defensive against emotions they were "not supposed" to feel.

The parents' differential need for escape from wall-to-wall child provides further confirmation that the mother-father differences run deeper than social prescriptions. Whereas some mothers felt so overconnected that their only haven was actual, physical separations, not one father had that feeling. In stark contrast, some fathers reported unambivalently positive feelings during the time away: "My first separations from the children I experienced as positive while I was gone. The conflict was when I got home. My wife and I would fight. I would feel guilty, she would feel resentment." He had no qualms about being away and "disconnected" from his children. In fact, his greatest worries were about the reconnecting that occurred upon his return, at least between him and his spouse as she responded to his absence.

A father is more capable than the mother of taking sheer pleasure in his absences from the children because he is *doing* parenting, so he can also *stop* doing parenting without it posing a major threat to his core being. When he leaves his child he stops doing what he was doing. He is still intact—no part of him is missing.

Worrying

Connectedness vs. separateness is the obvious explanation for the fact that women worry more than men about the children. Yet an unexpected quirk in the *type* of worrying occurring in shared parenting families ostensibly belies this concept. Fathers worry one way, mothers another.

Rick, a large, intense-looking man who is still marveling at the wonder of his year-old child, is yet worried a lot about Matthew "being hurt or killed. I've always worried about this since he was born. I worry about that much more than Pam." Paul has already watched one child grow older and now has another just Matthew's age. Both as a brand-new father and now, he is "the one who doesn't react well to illness. So if the baby gets real sick, by and large Laura does much better than I do. She handles it real well. I get real upset and real scared." Ben is even more extreme. Carole explains, and he concurs, that "Ben worries more about all sorts of disasters befalling Aaron than I do. He really worries a lot about Aaron dying, not in a realistic way." Ben is not just a neurotic father. He is like many of the other fathers who had a strong fear, sometimes obsessional, of something horrible happening to their child: that the child might get sick or injured or die, that a *physical* disaster might befall their child.

Audry did not realize what a profound spokeswoman she became for all the families when she stated simply, "Bob worries more about her physical safety. I worry more about her emotional safety. If Valerie had a bad day at school, I'd be the one to worry about it more at a party that night. But if Valerie hit her head, *he* would worry more." Bob, although never hearing these words, agrees with her wisdom: "If Valerie gets a fever and shows some kind of changes in her physical well-being, I'm the first one to worry. Audry is more the first one to worry as to how we're doing as parents."

That women worry more than men about their child's *emotional* well-being makes perfect sense. They, as the "be-ers," are more focused on the relational realm of existence and the feelings and emotions that accompany that realm. Yet why should this relational

gender difference not extend to the arena of health and safety? Women worry more than men except when it comes to physical safety, and then men become the worriers.

There are three related explanations for this. Women's worry about developmental issues vs. men's near-obsession with physical issues is the counterposing of the subjective and the objective. Men are raised and trained to focus on the objective world—to be what Talcott Parsons in 1955 referred to as the "instrumental" male.[11] Theoretically, in our culture a man is traditionally prepared to head a family, focus on making a living for that family, and offer himself as the moral guidepost and representative of the larger world to his children. To do this he must take a relative stance of objectivity. This becomes a cultural metaphor not just in his extra-familial existence, but also in his most intimate relationships at home. It is the way he is trained to "feel."

Men who do shared parenting have opted out of the "instrumental" mode. Yet they grew up in that cultural milieu, and the realm of the objective may subsequently be more comfortable than the subjective as they go about childrearing. They can fret about physical ailments and injuries because they are visible and measurable. There is no comparably accurate thermometer with which to assess your child's emotional ills.

Yet they also fret when there are no actual ailments or injuries to see or measure. Here is where objectivity simply becomes a cultural metaphor for the man. He, like the mother, is very attached to his child. When a parent is firmly attached to a child, he or she naturally wants to protect that child from harm. Each parent recalls the pain to which they themselves were most vulnerable in their own childhood. A boy may have worried more about a punch in the nose; a girl, about hurt feelings. Now grown up, the parent projects the form those worries took onto the child. The man frets more about the physical, the woman more about the psychological. The *root* of the worries is identical: a compelling need to shield the child from pain. It is just the *expression* that is different.

Related to objectivity is the issue of control: control over the environment and control over one's feelings. Men's bravado helps carry them through to a level of competence because they know as men that they are supposed to be "on top" of things. Keeping your child physically fit and safe from harm is a tangible measure of successful control over things. Furthermore, psychological studies reveal that in our culture women tend to have more of an external

locus of control—that is, things are experienced as happening because of factors outside themselves—whereas men have more of a sense of internal locus of control—that is, that they are the ones who make things happen. One way to ensure that you effect change is to keep a cool head, keep your emotions in check, and remain rational.

At a very primitive level there is probably no feeling more distressing or disconcerting than seeing your own child in physical pain and not being able to stop it. For a man, with a belief and expectation that he should be able to effect change, this would be especially excruciating. Paul admits that the reason he gets so upset and scared when the baby gets sick is that "I'm going to get out of control and not be able to handle him when he's sick." He is not only afraid he will be unable to make the baby better. He is also frightened that his emotions will overwhelm him and render him helpless in his instrumental caretaking functions. The fear may be exacerbated by the reality that physical illness or injury is one circumscribed area in which males have been allowed to express their dependency needs and be emotional (even if they are instructed not to cry). Perhaps that allowable emotionality will leak through even though it is the man's child, rather than he, who is sick. If such were the case, he would no longer be able to *do* parenting.

Simone de Beauvoir, in *The Second Sex*,[12] developed a theory which states that historically men were driven to conquer and master the environment as a reaction to having no control over the birth process. Not knowing their own role in procreation, they were both awestruck and threatened by women's capacity to bear children. To compensate for their lack of control over nature, men poured their efforts into creating and controlling culture, a process de Beauvoir labeled "transcendence." Many centuries later, the men in these shared parenting families are quite aware of their role in the procreation of their children. But they are just as out of control as their male ancestors in the birth process itself. They can only watch and help; they cannot do it themselves. We already know that this has particular significance for the shared parenting family, in which a man and a woman are trying to establish an equal "mothering" relationship. This reality provides the third explanation, aside from the issues of objectivity and control, for the fathers' worries about their children's physical well-being.

"If anything ever happened to Kira, I practically would give up my own life. She has never been inside me. I have a strong animal

protective reaction." We find this statement perhaps a trifle exaggerated. Both mothers and fathers agreed that it would be the mothers who would actually be more devastated by the actual loss of a child.

But if we take this father's statement as a metaphor, rather than as an accurate predictor of behavior, we can understand the father's fretting about the child's safety as compensatory, as a psychological defense mechanism. The shared parenting father is engaged in every way, just as much as the mother, in the day-to-day care of his child. But he has never had the experience of carrying that child within him. He has also never gone through the "letting go" process that occurs for the woman as her baby passes from the womb into the world. Many mothers describe that moment as pushing them that much closer to death. They have released the child from within their body. They experience the sadness and the loss that accompany that passage. At the same time, they experience the contradictory feeling that this child has been a part of them and that they have been successful in growing the baby from a fetus into a person. Because they have already experienced a certain "death" of their child as one who once lived within them and at the same time have indeed had physical control over their child's very survival, they need not fret as much about losing the child or not being able to keep it out of harm's way. Actually losing the child would be another story. They just don't need to worry about it as much.

The father, however, is acutely aware of his separateness from the child. Often, to make up for his physical disconnectedness from the child during the nine months of pregnancy, he covets the opportunity to have his child in a front carrier close to his chest in the early months of life. Many a man has joked about his fantasized "external" pregnancy, with corduroy as womb. But a baby carrier is not a womb, and the father has not been provided with the self-assurance that he can successfully grow a child from a fetus into a person. The separateness from his child that allows him to fret less about wardrobes and generally worry less does not work so well when it comes to the child's physical survival. The father's removal from the birth process can lead to compensatory anxiety over the child's physical well-being.

Sharing an Identity

We have proposed a thesis: that the more a particular childrearing arena taps into the fluid boundaries between mother and child vs.

the firmer boundaries between father and child, the more we can expect a gender difference. Now we can recast the equation, substituting new variables. The more an arena of childrearing engages the being vs. doing dimension of parenting, the more we will find a difference between mothers and fathers. Getting children ready for bed, taking turns getting up in the morning, and cooking the children's dinners are not such arenas; responses to separation, play activities, and integrating work and child tending are. A corollary to the equation is that if a particular childrearing arena involves exclusively a "doing" activity, mothers and fathers will share equally in it; but if the activity can be approached by either *being* a parent or *doing* parenting, the result will be gender differences or inequalities in "mothering."

Our new equation again reminds us that "Can shared parenting work?" is not simply a question of divvying up tasks and responsibilities. We are talking, rather, about the sharing of an identity. Focusing on the jobs posted on the refrigerator or the sharing of "roles" only scratches the surface in uncovering the actual success of a man and woman in "mothering" together. At a concrete level it is easy to identify the negotiation of household and caretaking tasks. But how do you talk about the sharing of a *relational* experience such as parenting—which involves the sharing of consciousness, of emotional involvement, of self-concept and "maternal" identification? These are intrapsychic intangibles. They point up the contrast between sharing the "role" of parenting and sharing the "identity" of parenting. They also highlight an area in which we will need to be very sensitive to the dynamics between mother and father as they attempt to share this identity.

Ironically, while I was writing this chapter my daughter was home unexpectedly with the flu. My husband called from work in the early afternoon to find out how things were going. He got a very harried response from his wife: "Well, I'm not getting as much writing done as I wanted. I keep getting up to get Becca something to eat or answer her calls to me." His reply, meant to be supportive: "Just tell her you have to work and she shouldn't disturb you." Just tell her I'm working. He would. I can't. After my first moment of irritation—at him, at myself, at my daughter—I burst out laughing. Sitting back at my desk, it all hit home. Isn't that exactly what I'm writing about? I'm being a mother—with all the connectedness and difficulty in demarcating boundaries that that entails. If the theory fits, wear it.

Theoretically, the "being" of mothers and the "doing" of fathers can nicely complement each other in the co-parenting household. Mother and Father can each learn from each other, through dialogue and example. Mother can observe that it is possible to establish boundaries between self and other. She can work more on "doing." Father can be encouraged to be more connected with his child at appropriate moments and to internalize his child more as part of himself. In the meantime, the child has the advantage of fully experiencing both sides of the human equation, the male and the female elements, by being exposed equally to both his "being" mother and his "doing" father.

Pam and Rick are just such a family. Listen to Pam.

> I tend to Matthew more than Rick does. It used to be because Matthew went to me more. Now it's because I can't seem to not intervene when Matthew is around unless I'm involved in an active project, like house chores. But I can't read or do anything that requires focused attention. This comes from a long history of tuning things out on Rick's part. Somewhere he assumes that I will be there to fall back on. He doesn't feel the same need to jump in.

Things are not all roses for Pam. A note of resentment is easily detected in her voice. But she also admits that Rick is helpful in pointing out to her when she is being *too* tuned in to Matthew, resulting in her depleting herself and getting angry at Matthew. Rick himself notes that he does not think Pam's high intervention strategy is good for Matthew, because he is not learning to be more autonomous or tolerant of other people's needs. If Pam and Rick can hear each other out and come to some happy medium, they will have a nicely balanced relationship wherein he can turn up the amp and she can turn it down.

Most often, however, the parents themselves are completely stumped by the differences between them that erupt because of the doing vs. being dichotomy in parenting. At a recent workshop I conducted on dual career families, a father expressed anguish that his wife was a wreck because she could never just sit down and rest for a minute. He—well, he could just sit back and relax at opportune moments. Why couldn't she?

Another mother who had read some of my earlier work and heard me lecture totally agreed with the doing vs. being gender division in mothering. She specifically sees it reflected in her inability to estab-

lish work boundaries for herself. She envies her husband for his focus on his work and his ability to set boundaries between work and family. Her husband never heard my lecture; he reports that "both my wife and I feel raising a kid is an important part of life, but at the same time not our central focus." He is either unaware of or defending against what his wife keeps emphasizing. Things are *not* the same for both of them. Her being a mother often overwhelms her or intrudes when she attempts to focus elsewhere.

If more men and women were aware of and sensitive to these differences between them, they might be better able to empathize and dialogue with each other about their respective experiences as parents. They could recognize the tensions that do erupt as involving more than "just a personality difference"—as part of a broader, deeper phenomenon. The being vs. doing distinction, however, is only part of the picture. There are also other aspects of the inner experience of shared parenting within each father and mother, and of the emotional dynamics between the couple, that we have yet to explore. One critical issue is the requirements of intimacy vs. the need for autonomy.

7

How Do I Love Thee?

The Parents' Bond to the Child

Growing up is one long process of anticipating and practicing for "the next step." We attend grade school to prepare for high school and college. We have romantic relationships in adolescence to ready ourselves for a permanent emotional commitment later in life. In a culture which values personal control and self-awareness, we pride ourselves in "knowing" what is ahead and accurately predicting our reactions and behavior. But nowhere can this be more challenging or anxiety-provoking than in anticipating our relationship with our child before that child is a reality. All the baby-sitting, playing house, and tending to younger siblings done as pre-parents are no match for the actual phenomenon of producing and caring for one's *own* child.

For that reason, each parent I interviewed was asked to compare what they had *expected* to feel in relationship to their child with what they in fact *had* felt since the birth of their child. If fathers *do* parenting, and mothers *are* parents, then parents' innermost fantasies and experiences with their children should surely be different for men and women.

I Think I'm in Love

I'm absolutely in love with her. Just passionately in love with her. On occasion that's almost frightening.

119

> There's something wonderful looking in his eyes. There's this person there—he's intelligent, he loves you. There's person-to-person contact that's just wonderful. It's especially wonderful because I'm so crazy about this person.

> It was at that moment that I realized Ruthie was the person I was most honest with and who understands me, and was able to look at the lines on my forehead and say, "What are you worried about?" To this day she can read my worry lines.

The sounds of a fine romance, the intimate murmuring of two lovers under the stars. Except that these are three men describing their feelings toward their children. It matters little whether the children are female or male. The sentiments are the same. As one mother of a son exclaimed, "These men have gone 'ga-ga' over their children."

She was correct. Indeed, there was an intensity and effusiveness to the men's expression of their emotional reactions to their children that neither the fathers, the mothers, nor the "informed" interviewer were capable of predicting. The men, in short, ended up "falling in love" with their children.

Ira's story is typical. Before the birth of his son, Ira was anxious and skeptical about connecting with his child. "I thought of the child as much more an obligation and a millstone and someone who would prevent me from doing a lot of things, rather than someone I would prefer to be with." Now Ira often chooses to be with his son over anyone else, even his wife. He goes on to explain:

> I just couldn't anticipate the strength of the bond. I never anticipated how much he would become number one. I could never understand how in newspaper articles, someone could throw themselves in front of a car to save another person. Now that I have Joshua, the kind of bond that could allow that to happen is just obvious. My relationship with my son has been extremely intense, much more than I thought.

Ira talks about the bond he feels toward the child. Ruthie's father spoke of what he thinks, or imagines, his child can do for him. These are different phenomena. But sitting in these men's living rooms, the emotions emanating from each of them felt identical: a euphoric elation about their relationship with their child.

The fathers were completely taken aback by the intense feelings and excitement they experienced about the children who had entered

their lives. These were the same men who had worried about "coming through" before their child was born. They were the same husbands eyed suspiciously at times by their pregnant wives, who also wondered whether these men were indeed capable of "mother love." Yet, they have in reality been swept off their feet, finding their children so much more wonderful than they ever could have anticipated.

But this "love affair" the fathers express—is it any different from the experience of the traditional father? He too can lavish affection and attention on his children when he is around them, precisely because being around them is a special occasion, rather than a daily occurrence. Perhaps the fathers' effusiveness toward the children is simply an extension of what has already been discovered about gender differences in traditional marriages: Men have a more romantic attitude, while women perceive marriage from the vantage point of practicality.

While the less involved and the sharing fathers' feelings may fall along a continuum, the shared parenting father's "love affair" is certainly very different from the traditional father's in one important respect. The feelings he expresses are translated into his ongoing, daily experience of, commitment to, and responsibility for the caretaking of the child. The emotions he articulates are not experienced in the context of minimal actual contact, as with many traditional fathers. If familiarity is supposed to diffuse romantic auras, it was not so for this group of sharing fathers, who are on the front lines every day with their children.

One purpose of shared parenting is to achieve gender equality between the parents. In that respect, Father's "love affair" ought to find its counterpart in Mother's feelings; we would also expect her to be "in love" with her children. The women no doubt loved their children very much, but the contrast with the men's expressed experience was remarkable in two ways.

For one thing, the mothers were not nearly as surprised by the reality of their feelings. The gap between the anticipation and the reality was smaller; it was more of an "expected" phenomenon. Secondly, it was rare for a woman to "fall in love" with her child. A woman would talk about her attachment, her feelings of endearment, her sense of closeness to her child, but not in the language of a love affair. The mothers just had not gone "ga-ga" over the children as the men had.

The men were more skittish in anticipation—and then spoke only in glowing terms about the reality. In stark contrast, the women,

less apprehensive beforehand, were ever so much more measured
in their descriptions of real life with the children. Instead of the
lyric poetry of a love affair, there were prosaic accounts like the
following:

> Although it wasn't a total surprise, I don't think I anticipated I
> would be so totally taken with being a parent, that it would be
> so important to me. Or, somehow I imagined it would be, but I
> didn't see how it would spell out day-to-day. A lot of it was I
> didn't know about the day-to-day reality. I don't think I
> imagined it to be so intense, so much fun, and so draining and
> awful, too.

More often than not, women were more taken by surprise by
the amount of energy and involvement parenting took than by the
feelings they had toward their child. Whenever they did talk about
an unexpected intensity in their feelings, there were no unadulterated
romantic murmurings, as from the fathers, because invariably there
was the contrapuntal strain of the drain and toll that parenting
took: "I didn't imagine I would feel as close to her as I do. You
don't realize how gut-wrenching it is. I wanted to physically hold
her, be around her. Yet, it was also nice to hand her to someone
else." The women, then, have not been swept off their feet. Instead,
they remain very much on the ground, imbued with the practical
wisdom that with every ounce of love comes at least an ounce or
two of work.

Parenting: Intimate or Nurturing?

A father speaks of his child in the words of a love affair. A woman
does not. This is a matter of how the father communicates *about*
his relationship with his son or daughter, not necessarily of how
he actually is with that child. The love affair, then, is a *discourse*,
composed of the parent's thoughts, feelings, and fantasies about
the child.

"Intimacy" is one of those words that has become a central part
of the discourse of human relationships these days. Increasing atten-
tion has been given to the inability of men and women to sustain
long-term relationships, and to the importance of communication
and openness in the strengthening of interpersonal bonds. The word
repeatedly appears in the titles of books about relationships.[1] It is
invoked again and again by therapists and patients alike within the

walls of the consultation room. "What is true intimacy? How can I achieve it? Do I already have it? Do I really want it?"

The same word pervades descriptions of relationships between husband and wife, between two close friends, and between parent and child. The dictionary refers to intimacy as involving a detailed, deep, close relationship with another person or persons, often very private and involving a "union" of parts. In common parlance, one speaks of intimacy in terms of "partners"—frequently meaning peers or equals—and of course the word often takes on sexual connotations.

Yet, writers and child development experts use that same word to describe the feeling of a baby's soft skin against one's own, the sucking of an infant on its mother's breast, the parent-child "private talks" that become part of the bedtime ritual. "Bonding," "attachment," and "dependency" are certainly also words used to describe the deep, close personal relationship between parent and child. But frequently they are all lumped under the rubric of "intimacy."

In the shared parenting family, there is a new element in the traditional bondedness between parent and child. Not only the mother but also the father is involved in the establishment of a primary tie with the child. The fathers' discourse of a love affair gives us a hint that the mother and father experience this bond very differently. When we return to the dictionary definition of "intimacy" we can easily agree that the following statements fit that description:

> When we were alone together in the country there was a kind of chill running through me of closeness, of real loving.

> I go in to look at him when he sleeps. I look at him and all the stress goes away. All this emotion comes up and I feel good. He's so important. It's wondrous to see him.

Again, these are men talking about their children. As I listened to men speak in these terms and tones, I wondered how they themselves made sense of their relationship and feelings toward their children. Would they describe their relationship with their child as "intimate"? And would that characterization be different from the mothers' description of *their* relationship with their children?

If intimacy, as the definition suggests, is a *mutual* opening up, and if that is how the man in fact perceives his relationship with his child, a puzzling question arises. How could it be that such a thing could occur between this tall adult and this short child, obvi-

ously two *un*equals? Is it mythical to speak of the relationship between parent and child as "intimate," rather than as involving "nurturance," or "attachment," or "bonding," when equality between the partners clearly does *not* obtain?

On the other hand, perhaps the term "intimacy" actually has multiple meanings, which need to be teased out. Does intimacy necessarily require mutuality or equality between partners? For example, a relationship in which one person facilitates the "opening up" of another might very well be perceived by the second person as an "intimate" relationship. Is this not what the patient-therapist relationship is about—a connection referred to by many as "intimate," but certainly one that does not enjoy the mutuality of the relationship between lovers or best friends? This example of a "facilitating" relationship may in fact be very apt for the parent-child relationship.

These are not merely abstract questions, but compelling issues to be pursued in understanding the nature of "relatedness" in the shared parenting family, with its reorganization of gender roles and redistribution of "bonding responsibilities" between men and women. Men's comments about their children, besides having the flavor of a love affair, also resonated with tones of "intimacy." Women were more practical; they spoke more of a love based on the commerce of daily life, in contrast to the men's expressed affair of the heart. I wondered if the parents themselves actually perceived a difference that way. I chose two words, "intimate" and "nurturant," and asked each parent which of the two, if either, more aptly described their relationship with their child.

I knew "nurturant" might be a loaded word for some. In the 1960s, feminists confronting the traditional and debilitating stereotypes of women found the ascribed attribute of nurturance objectionable. Woman's traditional role, stemming from "nature," was to nurture, to take care of others, to put herself last and others first. No longer, said feminists, was that to be women's assigned mission in life.

But with time and changing circumstance come different contextual meanings of a word. By the 1980s the term has been freed of its gender-stereotypic implications. Mothering has regained respectability within the feminist community. This, coupled with the explosion of birthing on the part of the post-war "baby boomer" generation and the increased involvement of fathers in the parenting process, has put the word "nurturance" in a new light. Rather than implying women's restriction to caretaking activities,

it has been neutralized, referring more to the ability of any person to care for another.

But to avoid imposing any external meanings on either of the terms "intimate" and "nurturant," I relied on parents' *own* associations to each of those words to structure their responses. Although men certainly referred to a nurturing component in their relationship with their child, the overwhelming majority spoke of the compelling *intimacy* in the bond. This meant, as one father put it, "that I know him really well, he knows me, and there's something really enjoyable about being in his presence." With intimacy, they strongly associated the words "emotion," "connection," and "closeness." They relegated "nurturing" to a secondary category or excluded it altogether, because they typically associated "nurturance" with "taking care of," "helping to grow," or "giving," all of which they felt less adequately reflected their emotional relationship with their child.

The mothers' overwhelming choice of word, on the other hand, to describe their relationship with their child was "nurturing." They were constantly aware that they were taking care of another human being who was smaller, less powerful, and less articulate than they. Intimacy was summarily dismissed as the primary characterization because they saw intimacy as a relationship between two equals, which this was not. The primary way women used "intimate" as a description, if they used it all, was to identify the *physical* closeness they felt with their child.

Karen's green eyes softened as she thought back over her three years as a mother. Then she came up with a statement that captured it all beautifully:

Intimacy has more to do with being known as much as
knowing. I certainly feel being known by Joshua as his mother,
but not in the same way my husband would know me.
Nurturing has a lot more to do with the emphasis on *giving*
rather than taking. Expecting certain of my own needs to be
watched out for, that's more in intimacy.

Nurturing implies a distance that intimacy does not. It involves being on a different level from your child, looking over him, as it were. The women found that soon after birth it came "naturally" to them to take care of their child, but they spoke of the relationship in terms of "watching over" or "protecting," of the child's "needing a grown-up to help her grow"—all descriptive features of *nurturance*.

The Child Feeds a Man's Hunger for Intimacy

The fathers choose "intimate," the mothers choose "nurturant" to describe their relationship. The choice of adjective is directly related to their gender-specific answers to another question in the interview, "Can you identify anything unique in your emotional relationship with your child that is experienced nowhere else?"

What the fathers discovered as unique in their relationship with their children explains beautifully why they would gravitate toward the description "intimate" rather than "nurturant" to label that relationship:

> Kids are so spontaneous. No layers of social conventions. You can laugh, make silly jokes. You can't do that with adults.
> There's a physical closeness, a spontaneous thing you can't do with adults. With children, you can be a child with them.

The fathers, then, discovered that they could be free to be frivolous, carefree, childlike, and completely uninhibited with their children. The opportunity to relate to their child opened up avenues to them that heretofore had either felt closed or been too risky.

Women in our culture are apt to accuse men of being inaccessible, closed, uninterested in emotional interchange. (Lillian Rubin has documented this thoroughly in her book, *Intimate Strangers*.) This indeed may be the behavior women meet up with in their relationships with adult males. Yet that behavior must be separated from the desire behind it. Given the right circumstances and environment, the man in fact can open up, will open up, yearns to open up emotionally. The key requirement is that the environment feel safe. This group of men found that safe environment in the company of their children.

The fact that men *did* parenting and women *were* parents did not negate the obvious reality that these fathers were bonded like epoxy glue to their children. Women, too, were strongly bonded to their children, but the substance that held the men to their children was of a unique variety. It was composed of the newfound delight of being able to melt into another human being and to "play" in a way they had not allowed themselves to since they were small children. It responded to what I saw as their "hunger for intimacy."

These are men who have actively disaffected from their own gender in mothering a child. Yet they are no different from the vast majority of men in the culture who were forced to repudiate the very early,

pre-verbal merging between mother and child as they move on to be a gendered "other" who will ultimately relate to women not as caretakers but as objects of sexual desire.[2] In subsequent years the boy develops an ambivalent relationship toward women as he both desires to re-create the early intimacy and fears engulfment by maternal figures. He develops more impermeable boundaries than his female counterparts. But he never gives up the longing for close intimacy.

For this particular group of men, that hunger for intimacy finds fulfillment in their new-found opportunity to mother a child. They take the regressive longing for intimacy with their earliest caretaker that they share with many men in our culture and turn it into part of themselves, *becoming* a "maternal" parenting figure in another child's life.

We have discussed the school of contemporary psychological thinking, including the work of Dinnerstein and Chodorow, which argues that because of past socialization and family structure, males do not develop the same capacities for mothering that women do. But these capacities are something quite different from the desire for a relationship. That desire, expressed in a focusing of attachment and commitment and in the shared parenting father's growing "love affair" with his child, brings him one step closer to the feminine sphere of "being." As stated by one father, "I must say I felt that way [totally in love with his child] from early on, before his personality developed. So part of it has to do with this hunger I've had for a kid for so long."

The hunger is fueled by the fact that men in this culture have been "starved" for relationships and emotional closeness for most of their growing and adult years. Their developmental task has been to thwart the desire for merger and to generate, instead, autonomy and individuality. Our society's family structure and social mores, forces in the labor market, the media—all reinforce the movement away from the development of "relational" capacities in men. So when it comes to parenting, they ought to have a more difficult time with what Margaret Mahler refers to as "libidinal availability,"[3] with what Winnicott refers to as the "holding environment":[4] with being able to make their own inner self available to both the inner life and behavioral needs of the child.

Yet within the discourse of the love affair, it is this very emotional giving and responsiveness that, both parents agree, the shared parenting father is able to both experience and express. He can do this

despite his relative shortcomings either in concrete childrearing tasks, such as wardrobe planning, or in the psychological management of daily activities (such as knowing the three best pre-school programs in town). The explanation for the "unexpected" phenomenon of the father's intense emotional involvement with his child can be found in his relationship to the earliest experiences of his own childhood.

Recall the recent psychological studies which posit that anyone who can provide frequent and sustained physical contact, soothe a child when distressed, be sensitive to a child's signals, and respond promptly to a child's distress can mother a child.[5] Let us take this one step further. Beyond these immediate behavioral indices, anyone who has personally experienced a positive parent-child relationship that allowed for the development in his or her childhood of both basic trust and individuation has the emotional capability to parent.

According to Chodorow, "the early relation to a primary caretaker provides children of both genders the basic capacity to participate in a relationship with the features of the early parent-child one and the desire to create this intimacy."[6] Shared parenting fathers, to their own surprise, have been able to open up avenues of intimacy with their children. They, like the mothers, can be "relational." If this is so, Chodorow's theory, in positing the socialized inhibition of mothering capacities in men and their extension in women, underestimates the importance of this earliest, relatively "genderless" mother-child relationship that all infants, male and female, experience.

Because of acculturation into "manhood," that experience may lie dormant or repressed throughout much of a man's childhood and early adulthood. Nevertheless, he is able to successfully evoke it as he chooses to "mother" a child himself. These capacities, in other words, are indeed squelched throughout childhood, but they resurface given the opportunity to "mother." And because many of these men held tenaciously to a "feminine" component within themselves throughout their growing years, the squelching may have been only partially or even minimally successful, so that the capacities already lay quite close to the surface. The right circumstances—in this case, the availability of a child to love and the willingness of the man to participate in primary caretaking—can unleash these "basic capacities" in the father.

In his quest to fulfill his desires for relationship in the parenting of his child, the shared parenting father is really not very different,

is he, from the traditional mother? Indeed, many a mother who is a sole primary caretaker has sat in my consulting room speaking of her blissful love for her child in terms very different from the women in this study but not that dissimilar from the "love affair" described by these co-parenting men. For those women, their central inner focus in life often becomes their experience of mothering. For these men, who are anxious in adulthood to evoke the "mothering" capacities at least partially denied them throughout their growing up years, their internal focus, too, can become their new-found "mothering" existence. By reclaiming those early capacities, in their hunger for intimacy, they come closer to what has been the women's legacy, the "being" of parenthood.

Mother's Nurturing Quenches Her Thirst for Autonomy

The particular uniqueness that the men identify in their relationship with their child is unmatched in any of the mothers' reports. Instead, the very "mother henning" implicit in their choice of "nurturance" over "intimacy" was what they thought uniquely characterized their relationship to their child. Rather than the fathers' delighted discovery of the opportunity for experiencing closeness and emotional spontaneity when with their child, the women held as precious the protective bonding toward a small, helpless human being:

> My relationship with my daughter is unique partly because she is so little, and therefore so vulnerable. She looks toward her parents to protect her, to interpret the world for her. I can protect her. With my friends, or my husband, they're all more able to take care of themselves. A little kid can't do that. They need a grown-up to help them."

This awareness led the women right back to their assessment that if watching over this little person was what was so special in the relationship with their child, surely the relationship must be a "nurturant" rather than an "intimate" one.

Their choice of "nurturant" also divulges a defensive (albeit unconscious) strategy. The main struggle for shared parenting mothers is to maintain autonomy and separateness, so they are not swallowed up by mothering. The mother, herself raised by a woman, faces in her own life a struggle for independence that stems from her first boundaryless relationship with her own mother. If a woman has a fear of "boundarylessness," there is no situation more ripe for the

flourishing of this fear than a close or intimate relationship with her child, as depicted so poignantly by Jane Lazarre in *The Mother Knot:*

> His mouth, vulnerable and innocent at other times, grabbed my nipple and sucked it into himself with a ferocity, a knowledgeability, which was awesome in its purity. . . . As he drew the milk out of me, my inner self seemed to shrink into a very small knot, gathering intensity under a protective shell, moving away, further and further away, from the changes being wrought by this child who was at once separate and a part of me. Frightened that he would claim my life completely, I desperately tried to cling to my boundaries. Yet I held him very close, stroked his skin, imagined that we were still one person.[7]

Sharing mothers often feel perched on a precipice. The slightest push, as in their male partner's unwillingness or inability to "come through," might send them over the edge, back into the position of being a *single* primary parent. The push can also as easily come from within. After all, the woman has from early on incorporated a sense of self as "mother" or has had to spend much of her childhood resisting the vision of full-time motherhood that the culture offered her.

When it comes to having a child, these particular women are in a unique position. They are no different from many women in this culture who feel ambivalent about traditional mothering and all that it entails. But the shared parenting mother consciously expresses her ambivalence and also has the opportunity to act in a different mode yet still be a mother. She strongly believes that her new arrangement offers her the best of both possible worlds. Most significantly, the shared parenting mother has another available and capable partner to fall back on and the privilege of sometimes "stepping out" from the institution of motherhood, a privilege she at times allows herself even more than the shared parenting father. As one mother freely admitted:

> I might want to escape from family for awhile. There's no flexibility in my life. There's no spontaneity. I always have to account for my movements. Everything has to be so carefully premeditated and structured and planned and scheduled. I think he (Father) has less need to break away from family.

The shared parenting father discovers spontaneity *through* his child; the mother fears that that very relationship will rob her of

it. The legacy of her own upbringing leaves her not with a "hunger for intimacy," but with a "quest for autonomy." Merging, so strongly associated in her own mind with intimacy, she has already had plenty of; separateness is what she often lacks. Maintaining a bounded relationship with her child, as a separate individual who requires care and attention rather than as a romantic soulmate, is one way to succeed in that quest. Couching that relationship in terms of "nurturance" rather than "intimacy" reflects that quest.

While the father is making his great leap forward in opening up to his child, the mother is carefully traversing a balance beam, parenthood on one side of her, "selfhood" on the other. The difference in the fathers' and mothers' pacing makes for very different, gender-specific emotional experiences with the child. But inasmuch as she is successful in integrating parenthood with an extra-familial identity and existence, the woman escapes the "being" of motherhood, which overwhelms everything else, and comes closer to the "doing" of parenthood, which entails separate spheres of activity.

The "Privileged" Intimacy of Father and Child

Let us return to the father's intimacy with the child. Again and again, the men talked about turning to their child as the person they indeed felt most comfortable with of anyone in the world. The child's innocence, the child's total love for the father, and the very fact that the child is not making adult demands made the father both willing and eager to test the waters of emotional release and entwinement. One father leans back in his chair and reflects: "I like being with my son a lot. In almost any social situation, I'd rather be with him or watching what he's doing than anything. This is especially true in a large gathering—say an afternoon party." I ask the father why this is so. He quickly responds: "He's fascinating, to watch what he says, what he thinks, his level of understanding, his lack of understanding." But after a pause, the real truth pours out: "He's also someone I can relate to more spontaneously than with most people. I don't feel the same kind of inhibitions when I'm with him that I feel with adults."

A man may feel awkward "opening up" in front of other adults, who might not be able to accept him as anything but an adult, rational human being, and he might feel excruciatingly vulnerable in exposing himself to another person as anything but strong and composed. When with his child, his discomfort is relieved. He and his son or daughter can be peers together in their childlike play.

The child will neither judge nor reject him, but instead will delight in his silliness, his exposure of his inner, primitive self: "This freedom to express myself easily came out in a way with my son that I just couldn't imagine. The anxiety around that ability not being there was around *adult* relationships."*

In essence, a union really does occur between two equals in those moments: the man in his regressed self, the child in his or her contemporary childhood self. So this *is* a form of intimacy for the father, if one abides by the definition of intimacy as an exchange between two equal partners.

At the same time, we see an illusory quality to the intimacy the father expresses. Notions like "he really knows me well" or "she can read the worry lines on my face like nobody else" were heard not from one, but from many fathers. It is puzzling to envision how a two-year-old has the capacity to know a thirty-seven-year-old man "really well," or how a ten-year-old child can even know what worry lines are.

In this respect we can only conclude that inwardly the father elevates his child to adult status in his own quest for a close and all-encompassing emotional relationship. He creates for himself the fantasy of a child who is completely in tune with him. He does this because he is projecting his own feelings of expansiveness, spontaneity, freedom of expression, and, most importantly, connectedness, unleashed in the presence of his child, onto the child itself. In exposing himself and thus feeling so known, he assumes that the object of his expressions, his child, *knows*.

What the father overlooks in his own new-found delight in this "intimate" relationship is the capacity of his child as *subject*. Children cannot possibly have the psychological capacity to interpret another's inner state or actively reach into another's being in the

* Ironically, it is in this very gift of expression that the child gives the man, reassuring him that he can be connected to another human being, that the father, rather than the mother, is the one who loses track of his separateness from the child. One father explains it thus: "Nancy respects our child's autonomy more than I do. For example, I will kiss him, hug him for my own needs, even if Sam doesn't like it." In the father's overzealous desire to bond to his child, he might at times put himself first before the child. In a culture which emphasizes men as subjects rather than as objects, he is particularly vulnerable to "forgetting" that what he wants is not necessarily what is best for the other person. The lack of separateness that results is not in the form of merger, as it is for the mother, but rather involves a mild obliteration of the other person altogether.

terms in which the fathers speak of them. If the child is an active subject in any way in this emotional relationship between child and father, it would be more accurate to say that he or she has the effect of stimulating the father to also act as a child: to be frivolous, nonsensical, free-spirited. In contrast to the fantasy of the child completely in tune with the father's adult self, the *reality* is that the child turns on and tunes into the father's *childlike* self, thus creating a union between two equals.

The elevation of the child to the status of an individual capable of that kind of "knowing" is, therefore, somewhat illusional on the father's part. Yet it remains benign, particularly because it is contained in the realm of fantasy. The father *imagines* that his child is an active partner in this intimate duo, being caught up so much in the warmth of his own internal feelings of emotional expansiveness when in his or her presence. One might even say that the words he speaks about his child are really just part of the "discourse" of the relationship, part of how he communicates his thoughts and feelings about the bond, rather than part of the bond itself—part of how he actually interacts with the child.

In fact, so far as I could tell the fantasy about the child's "knowing" did not translate into undue expectations or inappropriate parental behavior toward the child. Take Ruthie's father. When one hears his words about the ability of his child to read his worry lines like no one else could, there is initial cause for alarm. This does not sound like a healthy father-daughter relationship. As a clinician, I might even begin to worry about seductive or incestuous behavior on the father's part. As it happens, however, I had ample opportunity to observe this father's interactions with his daughter and also to speak to the daughter. I would assess their actual interactions as loving and caring, with the father acting very appropriately in his parental role and in no way making undue or pathological demands on his daughter. This seemed equally true in other families as well.

That the child is raised to adult status only within the father's inner fantasy life and does not get translated into behavior with his child reassures us that it does not impede good parenting. If one believes, however, in the communication of the unconscious from one individual to another, we cannot discount the possibility that these fantasies on the fathers' part will at some level be transmitted to the child. Perhaps the child will feel burdened or pressured to have to "come through" for Dad or to be the sustaining force

in his emotional life. (On the other hand, perhaps the child will simply feel the force of strong love from the father.)

But if Father's fantasy is of an intimate relationship, one between two peers, what happens as the child grows older and loses his or her own childlike state? Will the father withdraw as he loses his own opportunity to be childlike because his child is becoming too old to "play" with him? Or will he grow and mature with the child, utilizing the spontaneity and closeness available in the father-child bond to move to deeper and more adult forms of intimacy? All of these are questions for the future, when the children are more grown up. At this point we can simply earmark them for future consideration.

In effect, while the child is young, he or she is acting as a "facilitator." Just by virtue of the child's being there, small, warm, and all-accepting, the father feels able to open up. He can let go in the presence of this other with little self-consciousness and with the ability to intensely bond to that little other, his child. In that sense, the relationship qualifies as that form of intimacy unique to the parent-child or patient-therapist relationship—or any other which involves a lack of mutuality but a "facilitating" environment.

What we see here is a distinct problem with that concept of intimacy. In the case of father and child, it is based partially if not exclusively on fantasy or illusion. It is also very one-sided. One participant may feel much more "intimate" than the other, or see the relationship in very different terms. Here, the child as an "intimate" other exists more as a figment of the father's imagination than as any reality. We might even refer to it as a "privileged intimacy," with all the contradiction in terms that that implies. To call it a privileged intimacy, with the father as privileged partner who is free to open up without the threat of a peer or equal as recipient of his openness, is certainly to negate it as the "stuff" that adult intimacy is made up of.

Even if we accept that a true form of intimacy can occur between parent and child, we find that although the men invoke "intimacy" to describe their relationship with their child, they still recognize that in terms of actual emotional interaction with their child, something is missing. They may have unleashed heretofore repressed relational capacities, but still, when they look at their wives relating to the children, they become aware that something goes on between mother and child that does not happen as easily for them.

These men recognize that their wives are often more skilled in

engaging their children in emotional dialogue, creating a setting in which the child expresses his or her feelings and seeks the mother out for psychological comfort or support. They envy the women's more developed relational abilities and wish that they came more easily for them, so they could feel more secure in their "intimacy" with their child. Just the fact that they perceive the child as more easily opening up to the women than to them reveals that they are aware of a less lopsided form of intimacy, wherein an emotional dialogue transpires, rather than a unilateral freeing of emotions provided by the presence of the other.

Two Roads to Intimacy

The man describes his relationship with his child as "intimate." The woman instead chooses "nurturant." We have heard the men and women speak their own words in elaborating why this is so and have analyzed the phenomenon in the juxtaposition of the man's desire to open up to the woman's need to preserve boundaries. But there is yet another explanation for this gender difference in choice of words—an explanation not always consciously accessible to the respondents themselves. It involves the bifurcation of intimacy into two types for women, in contrast to a unidimensional mode of intimacy for men in our culture.

For the man, like the woman, the *desire* for intimacy is based on his earliest experience with his own parent. But for a boy, the *form* that intimacy takes is subsequently shaped by the heterosexual norm of intimacy that has developed throughout his childhood. Boys who grew up in this culture were not primed to be "mothers" in the same way that their sisters were. Their major anticipation of intimacy in adulthood has not been with a child but with a woman who will be their lover or spouse. The main discourse of intimacy with which a boy becomes familiar is the discourse of heterosexual intimacy, not just with a love partner but with his own primary mother figure of the past. If he remains heterosexual, then we are talking about one mode of intimacy—that between male and female.

The woman, on the other hand, has a very different history of intimacy. She has grown up in a culture which expects motherhood from her and instills her with the appropriate "virtues" from a very early age. She has grown up with a same-sex primary caretaker who is the source of her first exposure to intimacy. She is accustomed to a bifurcation in intimacy from very early on. There is the kind

you have with Mother and with females and the kind you have with men as you are directed down the course of heterosexual relationships. This dual nature of intimacy branches out even further, so that by the time a female grows up she has developed a repertoire of several different styles of intimacy, both with women and with men.

The fusion of intimacy and sexuality will have different outcomes for different women. Some eliminate the bifurcation by bringing sexual and intimate love together in a relationship with a woman. More often, the woman maintains the bifurcation of heterosexual love relationships and same-sex intimate friendships. She is aware that there is more than one way to be close with someone. She is thus well prepared to divide intimacy between her lover and her child. Each requires a different kind of connectedness, one which she deems "intimate" and the other "nurturant," and she has already had experience in discriminating between two different forms of "love."

Men are not so well prepared. This is not to say that men do not experience intimacy with other men, including their own fathers. However, in the traditional nuclear families in which they grew up, Father took the secondary position in the early mother-father-child relationship. He was meant more to represent the rational discourse of the real world, to disengage the small child from the dyadic relationship with his or her mother and be the embodiment of the outside culture.[8] Men have close relationships with one another, but not with the same quality of merging or intense psychological interdependency that characterize the parent-child or the lover relationship or the intimate friendships experienced between women. Therefore, when a heterosexual man summons a mode of connectedness in his relationship with his child, he has only one mode to call on—the heterosexual intimacy begun with his mother, but transformed into a more mature form wherein the woman is a true "other" and an object of (sexual) desire. He does not have one mode of intimacy for lover and another for child. So if you ask him to describe his relationship with his child, a new kind of relationship in which there is daily, close, very personal contact, he speaks in the discourse of the romantic love affair.

The inseparability of sexuality and intimacy that evolves for the man may be why men, more than women, are conscious of or worry about seductive or sexual feelings toward their children, particularly if the child is female. In extreme, pathological cases, that fusion of

sex and love may account for certain men's actually acting on those feelings—whereas such incestuous behavior happens only rarely between mother and child.

The sharing father who blithely talks of a love affair with his child is no less exempt from or oblivious to the taboo or discomfort associated with experiencing sexual feelings toward his child than is the traditional father. Women, also, become aware of sensual or sexual stirrings toward their children, but because of the bifurcation between sex and intimacy in their development, they are reassured that the strong love they feel toward their child in no way has to lead toward sexuality. Intimacy without sex is an old and familiar tune for them. Not as easily so for men.

It's a Boy; It's a Girl

The bisexual vs. heterosexual modes of intimacy available to women and men, respectively, can also explain another curious phenomenon in the shared parenting family: the desire for a girl child. While somewhat tangential to the central theme of intimacy vs. nurturing, it ultimately brings us back to the same theme of the different forms of child bondedness experienced by mothers and fathers.

In our culture it is generally accepted that males are valued more highly than females, and therefore most parents, particularly fathers, will have a preference for a male child. In remarkable contrast, the majority of the shared parenting fathers interviewed indicated a preference for a girl. They had accessible to them two very conscious explanations for this desire.

Jeff, one of the veteran fathers in the group, with a preadolescent daughter, couches his preference in cultural-historical terms:

> I wanted a girl child very badly. We were caught up in the women's movement. And to have a woman child, a girl child, there was something very exciting, very electric about the prospects of raising a girl child, and for some reason I felt that would not be available if we had a boy child. It was very much being caught up in the rising tide of feminism and how exciting it would be to have a girl child.

This father was strongly influenced by his immediate social context. For some fathers we might even say that they considered it "politically correct" to have a girl. But politics was not the only source of the men's preference for a girl. The men had deeper, personal reasons:

I really wanted a girl. I absolutely abhor male culture and have since I was a young boy. I do not like that kind of teasing, aggressive boys' play. My fear would be I wouldn't be able to relate to it well.

The preference for a girl, then, was very strongly (and poignantly) a desire *not* to have a boy child. Not only would a male child recall for these fathers the pain of their own boyhood and their early alienation from boy culture; the fathers also worried about the management of their own hostile reactions as they watched their male child be aggressive, teasing, or insensitive.[*]

The women, like the men, also expressed a strong preference for a female child. They, too, were excited by the women's movement and by the notion of raising a girl child with nonsexist values and giving her equal opportunity in the world. But at a deeper, more personal level, the desire for a girl had a very different meaning for the women. Women spoke in terms like "a girl seemed more familiar, easy"; "I thought I would understand a girl better"; or "I felt more related to females than to males." One mother neatly summed it up:

I knew girls better. I'm more comfortable with girls. I wanted to relive things in a better way. I wanted to see my daughter physically brave, meaningful, have her have a happier childhood.

For the women, the fantasies of having a daughter started many years before a child was conceived. Uppermost was a strong pull to remain connected to the world of females: "I'm really happy that I have a girl. I was a daughter, my mother was a daughter. I was very close to my mother's mother. And my mother and her mother were very close. And it seems special to be part of that chain." Embedded in that desire is the mother's urge to reproduce her own self, becoming the mother to a daughter, so that she can relive and reconstruct her own history as a daughter, making it up to her daughter for things she has "missed out on," such as bravery or assertiveness. In that sense, she becomes mother to herself. And

[*] Many of the fathers, including the one just quoted, were clearly disappointed by their desire for a female child. Once a male child actually arrived, the desire for an opposite-sex child, no matter how strong, went by the wayside and the fathers discovered great joy and fulfillment in their relationships with their sons.

she also experiences the child as an extension of herself, a form of connectedness that is simply nonexistent for the man.

Just as many of the fathers wished for a girl so as to avoid having a boy, so did the mothers. They wanted daughters because they could not imagine what they would do with a son. Like the men, they worried about the burdens of raising a nonsexist child in a sexist culture, and fully anticipated that this would be an easier task with a girl than with a boy.

But unlike the men, their deeper fear was not that with a male child they would have to relive a painful childhood. Rather, they just would not know how to handle a boy. They would not understand him, would not know how to feel connected to his inner experience. Even though the mothers ultimately faced an intense struggle around remaining separate from their children, when they anticipated being "good enough mothers," the more emotional connectedness they could envision, the more comfortable they felt. Their sense was that boys would put them at a disadvantage.

Although this feeling waned over time, women sometimes did have trouble at first if they were told, "It's a boy!" I remember my own amazement when my son, my second child, was delivered, as I marveled, "Oh, my God. I made a penis. How could that be?" On a sadder note, one mother recalls with some melancholy that "all my fantasies were about having a girl. When my son was born, there was a sense in which he felt so separate from me. At some basic sense we were different. There was a sex difference."

Unlike the men, the women with sons did not always make an immediate, positive adjustment to their disappointed fantasies about having a daughter. (Though one mother found the birth of a son a welcome boost exactly because she worried about too much connectedness:

> Even though I really wanted a girl, I was glad Sammy was a boy. I don't think he's a me. I just feel like he's an other. I don't feel like he's an extension of me that I know I would feel if he were a girl. I feel I'm a better parent to him because of that.)

As we have seen, the fathers in this sample did not express the same desire for a same-sex child; there was not the same longing to re-create the self. Thus, the shared parenting father we encountered is strikingly different from the traditional father, who hopes for a boy not just to re-create, but to perpetuate, his own self. Perhaps

in defense against his own early abandonment by a woman, the traditional father may devalue girls and turn to a male child in order to confirm his own worth. Instead, the shared parenting father who desires a girl disidentifies with his own gender, rather than desiring to perpetuate it.

The desire of these men for a female child also reveals an unconscious holdover from their childhood years: the desire to hook up with a female in a parent-child dyad. Both these men and these women searched for a re-creation of their earliest attachment, with a female. Only this time, the female is their own infant rather than the mother of their primal memories and dreams.

The men's desire for a girl also speaks to their notion of intimacy with an "other." Psychoanalyst Alan Gurwitt, in writing about fatherhood, cites a clinical case in which a man's desire to have a girl and *not* a boy functioned in his life to avoid activating old conflicts with his father.[9] Given the relationship of fathers to intimacy, there is a more salient explanation. These shared parenting fathers desire an opposite-sex child because heterosexual intimacy is the only kind a man knows. It is much more difficult to imagine pre-verbal intimacy with another male, even though in actuality the fathers I studied were delighted and emotionally involved if that imagined child was in fact born male. The father-child relationship in which the man likely grew up is often referred to as a more rational, verbal one than the relationship with the mother, not (as with the mother) based on primordial fantasies and dreams. And men are not supposed to touch (cuddle, fondle) other males in a way women are given permission to do with females.

The Family as Haven?

The man's desire for intimacy stands in stark relief against the woman's search for autonomy when it comes to mothering. If we focus on the father's emotional relationship with the child, we can certainly see how the family becomes for him what Christopher Lasch called a "haven in a heartless world." In a book of that title, he emphasizes how much the nuclear family under Western capitalism becomes a "womb" and safety valve over and against a cold, uninterested extrafamilial environment predicated on market value rather than on human relationships.[10] In the shared parenting father's "love affair" and experience of intimacy with his child, he indeed appears to have found his haven.

Buttressed by the move toward increased father involvement in the culture at large[11] and the new acclaim accorded such men, the fathers, now feeling like a "chosen people," bask even more in the delights of their home life. It is as if they've opened the door to a room they hitherto have never been allowed in. They are overwhelmed by the sweet aromas and flavors of what lies within, and are drawn toward it, almost in a semi-trance, delusional with the newly given gift to participate in an act from which men have been barred for centuries: mothering a child.[12]

But if we look at the *woman's* experience, Lasch's formulation falls flat. For her, it is the extra-familial world that offers a haven from a family sphere heartless in its ability to rob her of her own self. Suzanne is a case in point. To maintain her psychological equilibrium she has to escape from that "haven" of husband and daughter:

> The best separation I ever had was when I was away from both Gary and Kira. There were whole days when I didn't think about being married and having a child. I experienced a real rediscovery of myself.

Ironically, it was around this very issue of separation that a subgroup of the fathers poignantly demonstrated how much a haven their family had become. Even though men in general had an easier time than women with physical separations from their children, several fathers either admitted or boasted that they never had been separated from their child. They were so "in love" with their child that they could not imagine ever wanting to be apart from him or her; the more of their child, the better. This, of course, did not prevent them from leaving their child for a full schedule of child care on any particular day, but it did make them shy away from any rupture in the emotional bond with the child:

> I've never been away from him [his son]. I thought about it, and it made me nervous. I want to see him, to see his little face. I feel pleased about not having been away from him, sort of as a domestic credential.

A man "escapes" into his family, then, particularly into the father-child relationship, to fill up his inner emotional life and raise his self-esteem. Whereas, to maintain an emotional equilibrium and preserve a self, a mother "escapes" *from* her family—from both the mother-child and husband-wife relationships. As the father calls on submerged, suppressed, or even repressed capacities to "mother"

his child, his inner boundaries loosen and he comes closer to "being" in parenting. He begins to match the profile of the woman who mothers. But as the mother struggles to maintain both a parenting and an extra-parenting identity, she learns to compartmentalize and set boundaries around herself. Thus she comes closer to "doing," the masculine component of parenting.

By moving in these opposite directions, the shared parenting mother and father are actually coming closer to gender equality, with a healthier balance of "doing" and "being" within each of them. In these families we could say that "intimacy" becomes the male element and "nurturing" becomes the female element in parenting.

8

Dual Parenting and the Duel of Intimacy

The shared parenting father has a hunger for intimacy. The shared parenting mother is in quest of autonomy. The men experience a desire to "merge" with another human being—their child. The women avidly work to draw boundaries around themselves and preserve some sense of separateness and disconnectedness from that same human being.

In one sense, we might well imagine that these are marriages made in heaven. He wants *more* connectedness with a child; she wants a bit *less* connectedness than is culturally prescribed for women. What could be a better pas de deux? A mother steps back from her experience and reflects: "We're products of this particular historical group and movement that validated this project and let my husband do something that clearly he wanted to do anyway. And it gave me space, in fact, too—to *not* have to do something I always thought I had to do completely—and therefore has certainly made it more enjoyable for me."

An optimistic prognosis, then—but not enough of the psychological returns are in yet to cast a final vote. The shift from the traditional parenting arrangement has a strikingly different impact on the sharing mother and the sharing father. Their inner emotional experiences both have to do with the issues of connectedness vs. separateness, attachment vs. individuation. And each parent is grappling with

the simultaneous pushes and pulls of both their external and internal lives. But the momentum is in completely opposite directions for male and female, and we could as easily foresee marital discord as harmony when the father's "intimacy" and the mother's "nurturing" needs and personas meet—or collide—in their own couple relationship.

Is There Safety in Smallness?

Before we can measure the health of the relationship between the man and woman under these new parenting arrangements, we must re-pose an old question in new terms. Men turn to their *children* for intimacy. Women do not. Now we ask: Is there anything in the present family dynamics of these shared parenting families (rather than in the parents' past) to account for this?

Let us begin with the men. It is not just that the men choose intimacy over nurturance as a description of their father-child relationship. And it is not just that they do this because children are "safer" than adults in general. It is because children are safer to open up with than one very particular adult—the woman they live with.

I was sitting with Stuart at his dining room table when he explained to me that "the uniqueness of my daughter is just the level of unabashed fun when we're together. I just don't do that with anyone else." I asked him, "What makes it different that you wouldn't do it with anyone else?" He thought for a minute and then offered: "The physical contact, the sort of hugging and clowning and silliness. I don't think I'm that way in relationships. I'm much more reserved in other relationships, including with Denise."

"Including with Denise." The more fathers and mothers I spoke to and the more I thought about the stories of my own patients, both female and male, the more convinced I became that it was not just "including Denise," but *especially* Denise. A father is quite conscious of the "walls" that go up in the presence of the woman he lives with, walls that easily crumble when he is alone with his child. Another father echoes Stuart's experience, even more pointedly:

> There is a closeness with my daughter that I have nowhere else. I really feel comfortable in all my selves in her presence. I don't experience that with the whole world. I'm on safe grounds with

her because I have known her since Day One. I don't have to get through any barriers with her, like I do with my wife.

This father's logic does not make total sense. He may have known his daughter from Day One, but he has certainly known his wife longer. If intimacy is at least in part a product of length of acquaintance, why should his daughter rather than his wife feel safer to him?

Clinicians and psychologists have identified a gender-linked phenomenon in which a red flag goes up for a man in situations where he is feeling vulnerable, emotional, or childlike in the presence of a woman.[1] And men themselves have begun to explore and write about their own experiences with women in the "intimacy" arena:

> "Intimacy" is vulnerability. It's the risk of opening myself up. It means sharing all sides of my self, exposing my sentimentality, dreams, weaknesses, and fears. It is a wonderful, terrible feeling, and one against which I fanatically defend. . . . I am afraid of being unmasked. Deep inside, the shrinks might say, I hate myself. Or desperately need the approval of my mother. Or who knows what? *I* know what: something inside me lives in fear of discovery. Fleeing first saves me from myself; avoiding intimacy keeps away discovery.[2]

Men may actually flee from women. More likely they put up protective shields. Their rationality, their seriousness, their emotional guardedness all serve as a protection against awaited danger.

Yet just what *is* the danger represented, for men, by a woman? The first danger for a man is that he will be rejected, perhaps in the way he first felt rejected when his mother pushed him out of the nest to go off and be like Dad. At a conscious level, he doubts that a woman would be able to accept him if he were too "emotional." Eileen and Bernard have been married for several years, and with time Eileen has learned to decipher the meaning of Bernard's behavior:

> Bernard's very outgoing with our daughter, much less with me. He talks more with her. She doesn't have the ability to interpret his nonverbals, like I do. He's more bubbly, open with her. He's freer to expose himself. He feels safer to do this with her because she's his kid. Old ways die harder with a wife than with parenting.

Embedded in Eileen's statement is the second danger. The man is wary about reactivating earlier fears of maternal engulfment, of being swallowed up by a woman in his state of infantile vulnerability.[3] Ira Wolfson continues, in his confessions about intimacy:

> Come to think of it, I have been emotionally intimate with a woman, and over a long period of time. I *have*. Really. In fact, over my whole life. And boy, have I paid for it. My mother. I love her, you know, but she wanted and needed me too much. I was a little kid, and she held on to me, tightly. I was a husband substitute, a father substitute, more. . . . Here's what my friend Bill recalls: "My mother's love was a trampling love. The intimacy that I had with her was overwhelming, and I've never been able to divorce myself from it." . . . Maybe a lot of us guys have problems breaking away from Mama, and fears of re-creating—or *not* re-creating—that overwhelmingly powerful relationship.[4]

There is a seeming contradiction here. If the theory is correct that men are more "bounded" and separate than women because of an earlier expulsion from the maternal nest, why should they at the same time feel so inextricably entwined with their mothers, the very women who pushed them out, that it feels near impossible to escape? The best way to understand this is to make a clear distinction between ego boundaries, on the one hand, and dependency and attachment, on the other. The boy is often the apple of his mother's eye, and is adored and coveted. She can become his one-woman cheering squad. He can also become the child who can carry out her suppressed "masculine" desires, because he is in fact a bona fide male. This adoration, predicated on the very premise that her male child *is* so different and separate from her, can generate an interdependency, perhaps even a mutual protection racket over the course of the son's childhood, in which mother exchanges her unmitigated love and admiration for son's undying devotion.

In the context of a relationship with a woman, then, a man will tend to feel trapped and struggle to maintain his autonomy. As Dinnerstein pointed out so graphically in *The Mermaid and the Minotaur,* because of their own female-dominated childrearing, men develop a strong ambivalence toward women and toward intimate relationships. Ira Wolfson illustrates how dreadfully afraid a man can be of falling back into the hands of woman's perceived primitive

powers, of an all-encompassing giant who will overcome him and leave him like mush. It is very dangerous to open up to women. Men have spent a good deal of their childhood, adolescence, and adulthood shoring up their defenses against being pulled back into a relationship with a female in which they are helpless, and the woman is the life-giver. But they also *long* for this kind of intimacy.

Enter a child. A young child cannot trap a man in the same way a lover can. Even if that child is female, she will hardly symbolize the overpowering, overwhelming maternal force of yesteryear. A child is vulnerable, malleable, and all-accepting. What is so hard to do with their female partner—to experience a merging, a connection between two unconsciousnesses, the delights of mutual play—is so much easier to do with their child. Their child cannot swallow them alive. In their wildest fantasies, their female lovers can.

An unexpected measuring rod of this phenomenon may be the expression of anger. Anger is one of the more dangerous emotions. It is not uncommon for people to handle their angry feelings in one of two polar extremes: by getting angry either only when they feel safe and know the person really well, or only when the person is a total stranger, so that there is nothing to lose in the relationship. Anger might be a particularly difficult emotion for a man who is alienated from his own gender, because it implies a male-dominant, aggressive style which many of these fathers have found abhorrent, both in themselves and in others. If you allow yourself to get angry, you may unleash your own murderous impulses or, even more significantly, the other person's. With your wife, then, it is safest to remain stoic, monitoring your angry emotions in the face of a woman who has the power, in your most primitive fantasies, to destroy you or make you want to destroy.

Byron, the father of two children, shakes in his boots before he gets up enough nerve to express anger, even at a mild level, toward his wife. Although it has gotten better over the fourteen years of his marriage, it is still an ongoing problem for him. Yet his anger is easily and appropriately directed toward either of the children when they transgress or push beyond tolerable limits. Pete is the same way, although he is not so clear that his levels of rage are appropriate: "Esther [his daughter] can make me angrier in six seconds than any other human being." He says this with a tone of warmth and affection, implying that he is *freer* with this human being than with anyone else in the world.

With a child, fears of engulfment or annihilation are assuaged.

In comparison with a woman, a child is "tame" and calls up no such archaic threats. In one father's words:

> There's no other relationship in which things like anger are so momentary. My son doesn't stay angry at me for more than the situation lasts, and I can't stay angry with him. So I'm not worried about what the impact of that will be on our relationship. That's different if my wife and I get angry with each other. It's much more threatening. The impact won't be momentary—the hurt, disappointment, alienation, grudges, revenge.

A Pandora's box gets opened with a wife. The love is so uncondi- tional with a child that the father can relax, let his hair down, express the *full* range of his emotions without fear of tearing the relationship asunder. He has no such security with his wife, or in any other relationship in his life. With the child it is a case of feeling so close and permanently connected that you can *afford* to get angry.

Strikingly, not one woman similarly referred to the liberating expe- rience of being able to express anger toward her child, or to how much easier it was to be angry with her child than with her spouse. The parents were not asked to speak to the issue of anger per se, but instead the men's comments about the children and anger were elicited in response to the question, "Can you identify anything unique in your emotional relationship with your child that is experi- enced nowhere else?" The men saw fit to speak of anger; the women never even mentioned it.

Most likely, the women took for granted the ability to get angry with their children. That is what women have been doing for centu- ries in the context of a closely bonded mother-child relationship which does not blow asunder just because of a little eruption. The women's movement, which has so effectively articulated the constric- tion of women within patriarchal culture, has argued that women have difficulty expressing anger. In the context of public life, this seems quite accurate. But when we look behind the front doors of the family household, something different ensues.

Here it appears that men may be the ones having difficulty express- ing anger appropriately within the context of a close, intimate rela- tionship with another adult. We certainly know from statistics of wife abuse that some men end up expressing rage in violent and brutal ways when there is no intimacy or as a defense against inti- macy (wherein familiarity breeds contempt). But when it comes to

confronting a woman they love and respect, many men, like Byron, tremble. Women, on the other hand, find the hearth the very safest arena in which to express anger, particularly when that hearth feels stable and secure. In the realm of intimacy, children, and anger, then, we can suggest two things. First, the women in these families do better than men at expressing anger with children and with their spouses. Secondly, these men do better with children than with their spouses because they feel safer in *any* self-expression with a small child than with an adult-size woman.

The father in the shared parenting family may turn from his wife to his child to find solace and comfort in an intimate relationship. His wife, however, does not turn to the relationship with her child as the safest arena in which to "open up," to discover her inner self in the presence of an other. Not only does she not do this; she finds it inappropriate. Children are to be taken care of, provided for, looked after. If it is intimacy she is after, a woman has better outlets than her child to allow her vulnerable, emotional, primitive self to emerge: her husband, her women friends, perhaps her own mother.

Unlike her male partner, she has not had to spend her childhood and later adult years closing up—sealing off vulnerabilities in the quest to become an individual free from the grip of women and adaptable to cultural norms of "rational," "objective" comportment. Subsequently, she has no fear that her emotions will not be welcomed or accepted as the man does. *Her* anxiety concerns putting boundaries around her emotions, to prevent her feelings from sweeping her over. It is no new discovery for her to find that she can be emotional and open up, as it is for a man with his child. And she is not afraid to bare herself in the presence of a man, as is her husband with a woman. Typically, she wishes she would have the opportunity to do this more often, and that her husband would reciprocate in revealing his own self:

> My husband is much more childish with Valerie than with me. When I'm childish with Bob, he doesn't like it. I wish he would be able to do it with me. It's a little repulsive for him when I'm childish. For example, I like to tickle Bob when he's not being attentive. I'm silly. When I'm silly with Valerie, he doesn't like it. He doesn't like it when I'm a girl rather than a woman.

In other words, she would like to be more "intimate" with Bob in this way, but he cannot tolerate it, although this mode of intimacy

is easily accepted and even welcomed by Bob when it is between himself and his little girl. It seems that Audry's silliness evokes feelings in Bob of a relationship "out of control"—one with no boundaries, and that leads him right back to primitive fears of a woman as overwhelming or engulfing.

When such intimacy is not forthcoming, the mother does not turn to her child for this reciprocity, because she is quite aware that she would be barking up the wrong tree. Many women in traditional marriages do turn to their child as the central person in their life, leaving their husband feeling excluded from their central orbit. Particularly if that child is a girl, as she grows up she may become the mother's confidante. If a boy, he may become a surrogate husband in the father's emotional absence. Yet this is not because the mother needs that child's presence so she herself can open up. It is because she needs that child to need *her,* to make her feel validated in the world. She needs someone to *nurture.* Even if she does find herself opening up to that child more than to anyone else, it is in the form of the "privileged intimacy" to which I referred in Chapter Seven, wherein one person's presence facilitates the other's self-revelation, rather than in the form of true reciprocity. For if it is "mutual" intimacy the woman desires, she will look elsewhere.

The New Triangle

A man falls in love with his child and grows euphoric over the ease with which he can open up with that child. A woman loves her child very deeply, but delights more in the feeling of giving to an other than in the freedom to be spontaneous. When this man and woman become parents, an unexpected twist ensues: a convolution of the mother-father-child triangle observed in traditional nuclear families.

In the traditional family a father feels left out after the baby is born. He experiences his partner's unlimited love and attentiveness, which he has grown accustomed to, withdrawn from him and transferred onto the primary caretaking of their child. This is particularly true in the child's earliest months, when the mother demonstrates what Winnicott calls "primary maternal preoccupation" with the infant, the predominant feature of which is the mother's willingness to devote all of her energy and attention to the baby.[5] She most decidedly leaves nothing for Father.

Supposedly, Father's role is to support his wife during this time

so she has the strength to mother. More realistically, as time goes by, Father is increasingly out of sorts. He, not so maternally preoccupied, gets nothing from the mother (including sex). Baby gets it all. Rubin quotes one of her respondents in *Intimate Strangers:*

> I know it sounds awful, but it's like having a competitor. I have to compete with the baby for her time and attention. And it makes it worse because she's so into the whole damn mothering bit—you know, nursing him and all, she really gets off on it.[6]

A parent from my own study expresses this same feeling:

> I wish I could have more of Pat's undivided attention. That's the difference between a child and an adult. You don't expect a child to wait. Pat reasonably expects that I can wait.

The difference, though, is that Pat is the *father*, and a *mother* is speaking!

The shared parenting family, like the traditional family, has a triangle, filled with jealousies and feelings of exclusion. Remarkably, though, the dynamics are exactly reversed in the shared parenting household. Mother is the unhappy one, witnessing her male partner's emotional preoccupation with their child and distressed by her own status as the fifth wheel:

> Craig and our son share experiences I'm not part of. For example, the zoo. The kind of exuberance they have together, it is more theirs. Sometimes I feel left out.

In the traditional family, the father frets upon the birth of his child because that infant is now getting what heretofore has been all his and is now taken from him and transferred to the baby: the mother's intimate love and attention. In the shared parenting family, Mother, not Father, is the complainer, but she balks not just at the loss of what used to be hers and is now directed to the child. Rather, her jealousy and resentment grow as she witnesses Father easily giving to the child something she, too, has always wanted but has never adequately received from him: his intimate and emotional availability. Women long for this very closeness and are troubled in their adult love relationships when they experience their male lovers as withholding or not capable of providing such intimacy.[7] Now they see these same men turn around and eagerly, seemingly effortlessly, offer it to their children.

For some shared parenting mothers, these feelings are evoked by

seemingly petty incidents. The focus is on material goods. Several women squirmed uncomfortably in their seats and laughed embarrassedly before finally admitting:

> When he came back from Santa Barbara, he brought our daughter presents, three presents. He didn't bring me anything. It occurred to me that he could have brought me something.

Or:

> He does not and never has brought me little presents, and he's more apt to do that for our son. I think he's brought me flowers two times, both times since Jason was born. I loved both of them. I would love more of that. It says when he's away he's thought of Jason, and I wonder if he's also thinking about me.

"He could have brought me something," "I wonder if he's thinking about me." These are not spoiled, petulant women, demanding to be showered with gifts by their lover, although this is a bit how they feel as they hear themselves competing with their small children for the father's attention. They are women expressing in a disguised fashion a much deeper problem in their relationship with their male partner. It is all part of what I call the duel of intimacy.

For other mothers these feelings erupt much more forcefully. Carole is close to venomous when she expresses that:

> I have a lot of resentment toward Ben, jealousy issues. I always knew I shouldn't have a girl with Ben, even though that's really what I deeply wanted. I joke about it, but it's really true. The quality of attention he gives to Aaron is only bearable because I don't really see Aaron as a direct competitor, but if it were a girl, I know I would have had a really hard time. Because I also know it would be a more sexist form of attention. I know the way he relates to little girls—of all ages. I know that would be really hard for me on the level of how ga-ga he is over Aaron.

Although Carole disclaims it, she already is having a hard time, even though her child is not a girl. The issue is not one of heterosexual flirtation, as she suspects, but rather one of the male mode of intimacy. The man calls on this mode whether his child is male or female, and he offers it to his child much more easily than to his wife for all the reasons we have already stated.

Suzanne wishes that Gary, her husband, was, with her, more like

he is with their daughter, Kira, which means letting go, being physically affectionate and spontaneous. She receives instead his emotional contrictedness, and that makes her jealous. She soothes her jealousy by standing back and, quite perceptively, analyzing her husband. Kira gets more of Gary's intimacy than she does because "Kira doesn't demand as much from him emotionally as I do. It is an effort for him to have an emotional confrontation. Kira can be demanding in terms of attention and time. But so far she has not been emotionally demanding like I am."

In one respect, the shared parenting mother *does* mirror the traditional father. She, too, expresses jealousy about her partner's transfer of affection from her to her child. Nancy is irate when she complains that "Ken nicknames people a lot. He used to call me 'Darlin.' I realized he was calling Sammy that. And I realized, 'Hey, that's *my* name! How come I'm having to share it with this pipsqueak?' The problem is that he is with Sammy the way he is with me, too much the same. Except that Sammy gets more of the playfulness, and Ken is not playful enough with me."

The shared parenting mother mirrors the traditional father, then, in objecting to the *transfer* of affection, but is radically different from him in the reason for her objection. She operates from the scarce commodity principle. From the woman's point of view, genuine emotional intimacy with a man is not a common phenomenon. What little she gets she wants to hang on to. Already feeling deprived rather than indulged, she does not want to lose what she is hungry for to some child, particularly when insult is added to injury by that child getting what was hers and then some.

The shared parenting mothers make many references to feeling left out of the other parent-child bond. The shared parenting fathers do not. Paul reports a tension in his relationship with Laura because of "her accusation that I was taking over. That I just left no room for her with Zach. That I was the perfect parent and that she couldn't parent at her pace and she couldn't parent in her way, that I just left no room for her at all." It is not easy to give up the power of the hearth to a man. If on top of that you begin to feel squeezed out of an exclusive father-child relationship, jealousy and resentment are a likely outcome.

Gender also rears its head because women in our culture, much more than men, are sensitive to feeling invisible, to experiencing themselves as not as highly valued or recognized as men. The traditional mother can protect herself against these feelings at home by

being the indispensable wife and mom no one can live without. The shared parenting mother does not have this cushion. Her fear of being overlooked or ignored comes to the fore in the intimacy triangle:

> There are moments when Ira comes home from work, and Joshua comes up, runs into his arms and they're off playing train tracks, and I'm making dinner, and I feel, "Nobody's talking to me."

A recent first-person article in the *New York Times* incisively conveys this "down side" of the shared parenting experience:

> I am sometimes jealous of how much Leon dotes on Mara. When he calls her by pet names previously spoken only to me, when he ignores me and pays attention to her, I am sometimes sad at being displaced. Their tie is blood, and mine with Leon is based only on volition. Ours can be broken; theirs cannot. Although their love delights me, there are times when she looks up at him adoringly and I am jealous. That is the price I pay for sharing her equally with him. Women who do all the parenting, or who share it with paid helpers, have a special power that I have relinquished. It is the power of being everything to the child. I am not Mara's everything. She cares as much for Leon as for me. This is most difficult when I walk up the stairs to my study to write, and leave the two of them playing in the living room. He blows me a kiss. She doesn't even look up.[8]

So the mother has lost her primacy, feels invisible, and to make matters worse, in facing the exclusion from the father-child pair also experiences a rupture in her feeling of her child as an extension of herself—for now she painfully sees that her child also belongs to and is identified with someone else. That fantasy is particularly shaken when her child is male and she witnesses the resultant solidarity between father and son and struggles with her own feelings of exclusion. She feels jealous about their connectedness. But even if the child is a girl this dynamic can unfold. Gary and Suzanne both agree that their daughter is much more like Gary than like Suzanne. Gary perceives Suzanne as feeling estranged by having a child who is not her mirror image and who has a more sympatico relationship with Gary because of father-daughter temperamental likeness. A woman, who may tend to confound merging (in the feeling of two people becoming one) and intimacy, could feel doubly jealous, then,

by the sense of her child being her husband's, rather than her, mirror image.

We have illustrated the triangle from the mother's eyes. From the sharing father's perspective, a very different but complementary story unfolds. Not one man spoke of feeling "odd man out" because he lost his wife to his child. More likely, the father is so caught up in the ecstasy of his bondedness to his child that he fails to recognize any problems here for him and his wife. Ben, whose wife, Carole, is close to incensed by the father-son tie she witnesses, has this to say on his part:

Carole is a little jealous of Aaron's greater attachment to me. She keeps it under wraps, but she's jealous. *I* love it, I absolutely love it.

How can he be so gleeful when his wife is so chagrined? It is not that he is callous or sadistic, but that he is completely oblivious. It is as if he has eyes only for his son. Another father is even more explicit in expressing his delight in the exclusionary father-child bond: "I was right there when he came into the world. I had this immediate connection. Nancy was out of it, from the labor. I was the one who focused on him more explicitly. The whole experience set a tone for me." Set a tone for him to have a love affair with his child, which he expresses profusely throughout his interview. A love affair which his partner, Nancy, could be barred from in her half-unconscious post-birthing state.

The fathers who *are* aware of a tension with their wives downplay its significance. Bob knows that Audry often feels left out of his relationship with his daughter, Valerie. He admits that his involvement with Valerie "makes Audry resentful about time away from her. She wants some of my time. She doesn't want to take it away from Valerie. She just wants some of that herself." What she wants is the "physical affection. She would like me to be as physically affectionate with her as I am with Valerie." But he does not really see this as a genuine problem and, in fact, both twists it around and attributes it to Audry's imagined fears rather than to real deprivation. First, he redefines her discomfort as actually having to do with her insecurity that Bob and Valerie have a more loving relationship than she and Valerie do. Then, he protests: "I don't see it that way. I see them as having an emotionally intense relationship that I wish I had."

So the father reinterprets female jealousy as envy, a safer emotion

in their relationship. Rather than Mother agonizing over the loss of him to another person (jealousy), Father transforms it to "She just is feeling insecure about a thing I have with our child that she would like to have with our child, too" (envy).

Mothers may well collude with this process by subduing or obfuscating the nature of their jealousy, reducing it to the insecurity of "He's closer to the child than I am." That is certainly a more "acceptable" feeling than admitting that you are actually jealous of your child because he or she is getting from your husband what you would like.

The man also downplays the woman's jealousy because, projecting his own experience as an enraptured father, it is incomprehensible to him. Any feelings of jealousy or exclusion that the fathers, for their part, do express toward the mother-child pair take on a cavalier tone that stands in striking contrast to the women's anxious or conflicted stance:

> We are jealous of each other. I am jealous of Louise's space with Sarah, when they go shopping and they do these kinds of things, and I do feel like I'm missing out. But I respect it for what it is and I do feel the dance is the dance and you can't break into it at this particular time. And I feel Louise feels similarly. [She does not].

A smugness reassures him that whatever the child *is* getting from the mother that Father *is not* getting at any particular moment is really not a problem, because "I have eternal optimism of infinite perfectability. If I want something in my relationship with my wife, then that can be had. At times I might feel resentful that they're cuddling, but I know I can have that, too." The world is a man's oyster: What he wants he can have for the asking. Filled with his feelings of closeness toward his child, he experiences no sense of deprivation but rather a feeling of more and more to be had. And given Mother's desire for more intimacy with him, he is probably right.

Men also transform women's jealousy into envy not just because it is a safer emotion but because it is more comprehensible to them. It is what they themselves *do* feel toward the women they live with. Recall the men's envy of the woman's "relatedness" with the child. The father feels clumsy and covets his wife's relational abilities so he can more successfully satisfy his hunger for intimacy with his child. It makes him feel badly not that his wife turns to his child

instead of to him, but that his *child* turns to his *wife* instead of to him, because she possesses qualities he does not. This suggests, then, that the intimacy dance does not involve the child feeling closer to the father than to the mother, but the *father* feeling closer to the *child* than to the mother. In other words, the direction of intimacy is from father to child, rather than child to father. And it is where the father is pointed that is so painful for Mother, because his intimacy is directed to child instead of to her.

Although the triangle experience is different, then, for the mother and the father, for both of them it does come home to roost in creating new wants and desires in their adult relationship. I found this out by asking each of the parents, "Are there any ways your partner is with your child that you wish your partner would be more like with you?" The consistent gender differences in the responses were striking. The women wanted very much to be "let in" more by the men. They wanted the physical affection, the cuddling, the playfulness they saw their male partners showering on the children. They wished the men would be close (or open) to them in the same way.

Chodorow argues in her account[9] that women do not necessarily turn to men for intimate connection, because they can as easily or more successfully get this need fulfilled in their relationships with other women or in their role as a mother. It relates back to women's bisexual modes of intimacy. But the women who do shared parenting are in a subcultural group that is challenging the norms of traditional gender behavior and hopes for a reorganization of their relationships with their men and with their children. They have been attracted to men who possess a strong feminine component, and it makes it all the more frustrating when they *still* run up against gender barriers in relating, barriers that Rubin describes like this:

"He doesn't talk to me," says a woman. "I don't know what she wants me to talk about," says a man. "I want to know what he's feeling," she tells me. "I'm not feeling anything," he insists. "Who can feel nothing?" she cries. "I can," he shouts. As the heat rises, so does the wall between them. Defensive and angry, they retreat—stalemated by their inability to understand each other.[10]

This is an extreme. The sharing mothers did not feel a total inability to emotionally communicate with their partner. But they did find the men "constricted," "wary," "closed up a bit." That is,

with *them*. Although they complained that the men were not always as attentive or tuned in to the children as they would have liked, they were more struck by the men's *success* rates in this area. But if this could happen with the child, why couldn't the man open up his inner life with them, too?

In a fashion, the men, too, wanted to be "let in" more by the women, but not via the women opening up her inner life. Instead, they wished there was, as it were, more of a welcome mat. Ira sees Karen bringing to their son "a kind of nonjudgmental problem-solving, an understanding trust." He wishes "that was true more often with me. There's more of a charge in our relationship—hurt, blame gets activated more easily." As the men saw their partners being nurturant, all-accepting of the children, they wished *they* could have more of that, too, rather than the woman's critical, demanding, or antagonistic stance.

The sharing mothers and fathers' wants and desires, stimulated by observing their partners with the children, were in exact accord with Chodorow's, Dinnerstein's, and Rubin's findings. The men wish the women were more loving and accepting with them, as they are with the children. The women wish the men were more open and spontaneous, as *they* are with the children. The man wants to feel less threatened by the woman. The woman wants to feel more access to the man. Seeing it happen with the children makes them want it even more.

"Corrective Emotional Experience"—or Flight

Contrary to both the woman's, the man's, and outsiders' expectations, then, the shared parenting father *is* capable of a strong sense of emotional commitment to and involvement with his child. Although this connectedness manifests itself differently than in the *mother*-child relationship, it does reflect the man's basic relational capability to "mother." Beyond parenting, the optimal personal outcome for the man would be that in experiencing this longed-for intimacy with his child, his fears and defenses against intimacy would get broken down or at least reduced. In other words, he would become more "relational," and better able to fulfill the intimacy needs of his female partner.

Chodorow argues that men do not have the same relational capacity as women to mother. But I have argued that all children, male and female, are afforded the basic opportunity for developing that

intimacy in their earliest relationship with their primary parent. A man, then, *does* have the basic emotional capabilities to mother. It is just that his socialization has run them underground. The capacity is developed in the *earliest* months of life and only later defended against as the boy must separate and become a (sexual) "other." The desire for that intimacy is never lost.

Shared parenting can thus be viewed as a "compensatory" experience. If psychotherapy can cure the neurotic, then mothering could in like fashion be the "corrective emotional experience"[11] that could restructure men's relational abilities, spilling over from parenting to other arenas of life. Unlike other paradigms which argue that it will take at least another generation of males raised in a different kind of society, with both men and women actively involved in parenting, for men to truly acquire the capacity to mother, the "corrective emotional experience" notion posits a *one*-generation phenomenon. Even in this single generation of shared parenting men and women who were all raised by women, we could expect a change in men from traditional father figures to more empathic, intimate mothering figures.

The fact that the fathers demonstrated basic mothering skills, very much beyond a surface level, throws some doubt on the validity of those theories which argue for the importance of the early stages of life in molding future personality and character development. Far from the die having been cast, we witness the *transcendence* of early childhood experiences in the father's involvement in "mothering" a child. Rather than a deterministic model which relies heavily on the first five years to both understand and predict adult functioning (as when Chodorow posits gender divisions in relational abilities), perhaps a "leapfrog" model of development would be more appropriate.

First, there has to be a basic human experience that all individuals acquire: in this case, the love that transpires between infant and mothering figure. Then, there are the intervening years: in this case, the growing-up years when boys and girls are clearly set down different paths of development, based on cultural norms and on who is raising them. But then, later in life, new situations can present themselves which, at least in part, "undo" the psychological effects of those intervening years. In this case, it is the appearance of a child to love and take care of. The stimulus of the child is so strong that any human being, given the appropriate foundation, will elicit "mothering" capacities from within themselves. It as if the individual

"jumps over" those intervening years, by compensating for the suppression or repression of those capacities within themselves.

This model implies a developmental line of personality growth that goes from infancy through old age, and is not "set" at any particular time. The first five years are no doubt crucially important in that progression. But they are not the only years that count.

Now let us return to the implications of the "corrective emotional experience" for the couple. Men can surely mother, but not like women, and with some gender tensions between mothers and fathers. But will the father's new relational capacities be reflected in increased intimacy and emotional openness between the adults as a result of shared parenting?

Or will there be an outcome more grim for the couple? Instead of enhancing heterosexual intimacy, the opportunity for the man to fall in love with his child may serve as an escape hatch. He can now pour all his intimacy needs into a safe place, his relationship with his child, and dodge the more dangerous arena of male-female intimacy struggles. The answer to these questions can be found in the parents' own reports of the additional effects of parenting together on their relationship.

9

How the Marriages Fare

Recently I was asked in an interview to name the major stresses on families in the 1980s. My first response: the dual pressures of work and family. The interviewer then asked for solutions to the problem. One answer seemed obvious. If working women spend two to three times more on housework and child care than working men,[1] relieving working women of some of that work and getting men more involved has to be a stress reducer.

It may be a stress reducer, but that does not equate with being a viable family model for the late years of the twentieth century. Inevitably, each time I speak publicly about shared parenting, an audience participant will grill me, "But what about their marriages? Do they fare well? Are they really happier?" In that moment I long to be the informed social scientist with national statistics to quote. Statistics on the divorce rate, statistics on the longevity of the marriages of shared parenting couples. Unfortunately these families appear nowhere as a discrete category in census statistics. Such marriages have also not been around long enough for us to say how they fare over the long haul, from birth to the maturity of their children.

There are many skeptics. They fret about the untoward consequences of shaking up the "balance" in the family by changing traditional roles. They predict that removing the "complementarity" between husband and wife will create friction and reduce the sexual

and emotional excitement that stems from "differentness." They say that things run smoothly in the traditional nuclear family because each adult has a mutually exclusive set of duties and responsibilities, that pieced together, make a complementary, complete whole. This eliminates two people colliding with each other, competing with each other, or confusing who should be doing what at any particular moment. It just will not work to have two nurturers or two instrumental breadwinners. Even if a mother goes to work—which is increasingly the case in American families, with over 60% of women with children under 18 in the work force—the skeptics argue it still must be kept clear who runs the helm of each of the ships. To preserve marital harmony, it should only be *one* person for each, Mom at home and Dad in the outside world.

What I can tell the skeptics is two things. Divorce rates, reports of marital dissatisfaction, and rates of mental illness in traditional families contradict the myth that all runs smoothly with spousal "complementarity" of roles.[2] In contrast, on all scales of marital satisfaction or harmony the dual parenting families to whom I spoke would rank quite high. Using my own clinical judgment, I would assess these as some of the healthiest male-female relationships I have seen. It is because they are healthy that these couples can sustain a shared parenting household. And it is because they have a shared parenting household that these couples can sustain a healthy relationship.

"Healthy," however, is a fairly nondescript term. It signifies "free of disease" and "growth-producing." When applied to relationships, it also implies "open" and "trusting." It inevitably takes that kind of relationship for a couple to even contemplate breaking new ground in the sensitive area of raising children and trying something new, unheard-of, and often looked at askance by the people closest to them, particularly their own mothers and fathers.* An unstable relationship often buckles under the stresses and strains of a new baby. An unstable relationship would have an even harder time with the negotiating, cooperation, and synchronization required for successful shared parenting.

But "intimacy," more specific than general health, is the measuring

* A great many of the women and men reported that their own parents were either doubtful or downright condemning of their attempts to do shared parenting, and felt very threatened that their offspring were disidentifying from their own ways of raising children.

rod I am applying to these couples. The question is whether equal parenting creates greater bonding, disclosure of self, mutual empathy, acceptance of differences, and the ability to really "let each other in," to share an inner life. The answer lies in the parents' reflections on their own and their partner's feelings about their relationship, and the synchronicity in their responses. If the reply is affirmative, we can rank shared parenting as one strong, viable solution to the gender tensions and disharmony rampant among so many American couples today.

Intimacy vs. Nurturance: From Parent to Couple

The last chapter ended with our wondering whether the intimacy the father discovered with his child serves as a corrective emotional experience in his adult relationships or whether it serves as a deflector from adult intimacy. Rubin, in *Intimate Strangers,* has demonstrated that not just the men but also the women may participate in warding off intimacy in the relationship. The man, as we have seen, is afraid of being eaten alive by the woman. But the woman, on her part, is really afraid that if the man *does* come through in being emotionally open, available, and hence demanding of her, she will lose control. She might lose herself, sell herself out to this man, sacrifice her own identity.

To protect against that possibility with her husband she can call on the very thing that is central to her relationship with her child: nurturance. She can coddle her husband, attend to his needs, generously and selflessly give to him, no returns asked. Since nurturance is the relationship between two unequals, the giver and the receiver, it wards off the threat of merging that occurs when two people mutually open up to each other.[3]

So when we evaluate the effects of shared parenting on a marriage, we must counterbalance the question about the man's intimacy with the child successfully spilling over into his relationship with his wife. We must simultaneously ask whether the woman's nurturance with the child can be contained *within* that relationship to avoid the contamination of intimacy in her relationship with the man in her life. His spillover and her containment in the intimacy-nurturance childrearing split will be the ideal ingredients for an enhanced closeness and emotional connectedness in the shared parenting couple.

"I feel more tied to the world, to other people's lives. Things matter more." The men were indeed deeply affected by the experience

of mothering a child. They learned to be more patient, more tuned in, more sensitive to other people's needs. In sum, they saw themselves as becoming more "relational." As they learned to zero in on their child's needs and wants, they also learned to "listen" more carefully to the women.

So there *is* a corrective emotional experience. But I do not want to gloss over the underside of the phenomenon. Often, the newly discovered openness the men referred to was cast in the most general terms, addressed to "the world" or to "people" rather than to any one particular person, like their wife. The men indeed talked much more than the women about the permanent or dramatic changes parenthood had had on their psyches. Only a small handful of men, however, claimed that it made them a more sensitive or receptive lover or made them want to open up much more with their wives as a result of their new-found intimacy with their child.

The ire of the wives because Father had eyes only for the children gives us a stronger hint that the fathers' spillover is only partial at best. It's safe to say that these men are *in transition*. They are aware something remarkable is changing within themselves as a result of mothering, and they like it. But they remain preoccupied with the parent-child rather than their marriage relationship, particularly in their first years as a father.

The older the children, the more possible the transition of openness from child to lover. As the child matures and demands less and as the novelty of having a child in his life wears off, the father can assimilate the changes toward greater openness and take the next step of generalizing them elsewhere. Gary explains that "in the past five years, I've become a different person. I am more accepting, have gained a great deal more patience, and am a lot more easygoing than before our daughter was born." He goes on to say that "it is very good for our [marital] relationship."

If not spillover, there is at least some "leakage" of the father's increased capacity for intimacy from child to spouse. The women's containment of nurturance within the walls of the nursery, however, is a more complicated story. In contrast to the women, who were openly agitated about wanting more of the men's intimacy, the men had no complaints about their wives being more intimate with the children than with them. Nor did they feel antagonized because they saw the women showering selfless giving on the children to avoid facing the music of an intense relationship with a man. Nor did they feel that the women tried to transfer the nurturing that

came so easily with the children onto the men themselves, smothering them with their "mothering."

Instead, the problem of nurturance containment was a mutual issue for the women and the men. Both were focused on the amount of caregiving directed to the children in comparison to the caregiving directed to one another, and the effects of their mutual caregiving of the child on their own relationship. If the women were guilty of escaping into nurturing, so, too, were the men. It was not a matter of each of them neglecting to turn off the faucet of parental nurturing and then showering it on their spouse, leaving no room for true adult intimacy to develop. Whereas the couples were generally quite satisfied with the status of their relationship, they sat right smack on the fulcrum as they tried to determine whether the intimacy in their relationship had gone up or down as a result of nurturing a child together. For every positive, they could come up with a negative. Which side ultimately outweighed the other, if at all, will unfold in the story below.

Adult Intimacy: A Double Entry Phenomenon

A father sits in his office, gazing out the window, scrutinizing his life as a parent and how it has made his marriage of fifteen years better or worse. He cannot come up with a straight, simple answer. His face lights up as he marvels: "Shared parenting adds a level of discussion which wouldn't exist in a traditional marriage. I would have had no input." But then his shoulders tense. "On the other hand, there would be no room for conflicts in a traditional relationship. With shared parenting comes a new area of potential tension and conflict—differing opinions." Like a fluorescent charm, the very same thing takes on a completely different color, depending on whether you hold it in the light or the dark. Talking is good. Talking is bad. For every line item on the intimacy ledger of the adult relationship, there is a simultaneous credit and debit.

The opportunity to discuss is the first such item. Couples were in unanimous agreement that the negotiating and implementation of dual mothering requires an ongoing and intensive discourse between man and woman. It is not just who is making breakfast in the morning, but questions like what to do when Sally rejects Mommy and only wants Daddy but it's Mommy's turn to take care of Sally. Questions like, "Should we intervene in the way Jeremy is treating his friend Ethan or should we just let them work it out

themselves?" Questions like, "Is your way of insisting that Marnie talk to us about *why* she tore up her best picture good for emotional growth or is my way of letting her talk about it only if she wants to more sensitive to her needs for privacy?"

To have these kinds of discussions requires soul-searching into one's deepest inner corners; it requires delving back into our own childhoods and what was done to, and with, us; it requires a baring of one's psyche to one's partner; it also requires being able to accept mutual differences of experience and perception. The whole process can be short-circuited in the traditional family because usually only one person, Mom, is intricately involved in these intimate details of everyday life. Dad will certainly be around and involved for the "big" decisions regarding the children, but those times can be few and far between. In the meantime, he delegates authority to the wife; she covets this arena of power; and when Father and Mother do get together, their knowledge of and relationship to the child are so different that it can be like comparing apples and oranges to try to come to a common understanding both of their own feelings and of what action they should take.

Not so for the shared parenting couple. They are "forced" into this type of psychological discourse because they are equally committed to those everyday intimate details. This is good for the couple, because it structures a "disclosure" process, plunging them into an arena where they both learn about one another and learn to give and take in a highly sensitive arena, the growth of their child. As they gain experience in weathering their differences in such discussions, self-disclosure becomes even easier because of the enhanced feelings of safety and acceptance with one another.

Interestingly enough, the fathers much more than the mothers stressed how important this discourse was for strengthening the closeness in their adult relationship. As the father of a three-year-old explained to me, "It keeps us honest. There's a willingness to share. We're pretty up front with each other."

It makes sense that the fathers would sense this more than the mothers. As a gender, they, more than the women, have difficulty "opening up" to the opposite sex. At the same time, these fathers *want* to be able to open up more. The opportunity to do this within a structured situation, in this case the discourse of childrearing, will be a particularly welcome facilitator to the father in the potentially scary prospect of allowing his wife into his inner life. This time it is not his new openness with his child, but the openness pressed

upon him when *discussing* his child, that actually enhances the intimacy and inner knowing between Mother and Father.

When Mother and Father discuss and are in agreement, it bolsters their sense of confidence in the solid ground of their relationship:

> It has strengthened some of the things we share. Values that we share. It really brings out a lot of the concordance: similar attitudes about childrearing, child development. And we're both reminded that we both have a big investment in our child.

But when there is difficulty reaching a final agreement, those same discussions become trials, rather than confirmations of the bond between Mother and Father. A mother of a three-year-old has just been telling me how much the empathy between her and her husband has increased as a result of going through the shared intense feelings of loving and enjoying their son. Then her face clouds over. She remembers, too, that "one effect of shared parenting is that the irreconcilable differences between me and him get accentuated and kept in the forefront. We have to come to terms with them, and the fact that they're not going to change."

In the courts, it is "irreconcilable differences" that bring a marriage to dissolution. Not one family interviewed felt that any of the deeply ingrained differences of opinion they had about the children, differences discovered only because of the intensive level at which they discussed their mutual childrearing efforts, threatened their marriages. Instead, they simply identified the childrearing disharmony as a new tension to be dealt with as a result of the microscopic level at which they in concert examined their childrearing. They presumed this tension would not exist if they lived in a nuclear family with a clear demarcation of roles, responsibilities, and decision-making. But they accepted it as a creative, not a destructive, tension, one which enhanced intimacy by allowing each of the partners to more fully embrace each other in both their likenesses *and* their differences. The father gazing out the window concluded his musing with, "But it [the conflict] is good for the relationship. Otherwise, we would be mechanical, stereotyped. Like our parents."

When people devote a great deal of their time together to talking and thinking about a common project in which they are both highly invested, and when they feel they are cooperating rather than competing with one another, inevitably a "team spirit" evolves. Conversely, if there is no team spirit, it is usually because there is competition rather than cooperation, or parallel rather than joint efforts. Rose

Bowl victors could not have had a stronger team spirit than the sharing mothers and fathers cheering each other on in their pooled efforts at parenting:

> It's offered another area where we can trust each other's judgment, have respect for each other. The idea of pinching each other and saying, "We did it!"

Another father echoes:

> The fact that he's been such a good kid makes me respect Donna all the more. We must be doing something OK. It produces respect and congratulations to each other that we have this healthy, bright little guy.

In the traditional family, the parents often grow apart after the birth of their first child. Clinicians working with new parents typically hear complaints like, "All she wants to do is talk teething and formula," or, "When he comes home from work now he wants to talk about a world that has nothing to do with me and the baby." In the co-parenting family the mother and father are sharing the intimate details moment by moment of what it feels like to have major responsibility for a new infant. When she too loosely diapers the baby, with disastrous consequences, he strokes her arm and chuckles, because the same thing happened to him yesterday. At the same time Mother and Father are constantly having to negotiate schedules and routines, childrearing approaches and techniques. In this arena there is no opportunity to drift apart. The common experience and negotiating process solidify for these parents early in their child's life a sense of camaraderie and mutual respect that has remained consistent over their childrearing years to date.

Along with empathizing with what the other person is going through in raising a child, the respect comes from watching each other with the child. The measure of success is a healthy child. But the pleasure for the couple comes as much from *witnessing* each other's confidence, competence, and affection in the act of mothering the child. And the outcome is that "I know a lot more about her and she knows a lot more about me."

The team effort has a particularly salient effect on the couple's intimacy because the very content of this joint project consists not just of activities and schedules, but of feelings, fantasies, and attitudes. In Ken's relationship with Nancy, it brings him closer because "we share the devotion, the interest, the concern with this person."

As Ken and Nancy direct these feelings toward Sammy, the emotions eventually spill over into their feelings toward each other. Again, there is a corrective emotional experience, but this time mutually experienced by both Mother and Father.

Then there is the unity against the new common enemy. It begins in the early months, when both parents are under siege by this relentless, demanding little person who shows no respect for the rhythms of night and day or the everyday courtesies of modern civilization. And then it grows as both parents become humbled by their mothering experience. They come to realize that inevitably they will always be less than perfect parents. And when it comes to withstanding the demands made on both of them by the progeny they have made, the only road to survival is "United we stand, divided we fall." With that realization comes a deeper interpersonal bonding, almost as with privates who have endured boot camp together:

> We feel much more comfortable with each other about things. We argue much less, at least we argue much less in a violent manner. We're willing to cooperate. There is more of a gentleness between us. It's us against him [their son]. We're together as a united front.

The bond becomes so strong it can even mitigate the tension created by irresolvable childrearing differences, which inevitably surface in the shared parenting family. Particularly when a man and woman come from very different cultural, class, or ethnic backgrounds, they often polarize around the question of "how to raise the children."[4] In many families it is parental disagreements about these very issues that cause the couples to separate. One could expect this risk to be especially high in the shared parenting family, where each parent has a high stake in how the parenting will be done. But just the contrary was the case in my sample. Although many of the couples were quite homogeneous in ethnic, religious, and cultural background, for those who were not, the joint commitment to involved parenting spurred them on to override their differences and join hands in the mothering process.

One of the youngest mothers interviewed explained how their daughter really provides a good sense of perspective for her and her husband. It quiets the building pressure they feel with one another when they start bickering over handling their little girl. They remind themselves that they are in this together, rather than against each other. It not only quiets their childrearing tensions. It also puts their

larger relationship into perspective. It goes like this: "Without her [their daughter] we would reach this level of intensity that was ridiculous. A level of negative intensity that didn't make any sense." *With* her: "my husband and I have come together much more just from the simple technique of parenting."

So with "team" parenting comes a feeling of solidarity and unity. But baseball teams, unions, and army squadrons all experience a sense of "togetherness" and yet no one would necessarily call them milieus of intimate relationships. In like fashion, the debit side of parenting suggests that just as intimacy can increase, it can also easily decline. The team effort takes a lot of time and energy, often leaving the parents with nothing for each other. "It's just the whole sense of how absorbing our daughter has been for both of us. Both of us are so tired, there's no time for lovemaking. To some degree it's different than the mother who freshens herself up for her husband. It's a real different thing between us. It's like a corporation."

Like a corporation. The traditional family is a very different kind of team. Each member has her or his own very unique part to play. If every one pitches in and does their individual part, the game works. In the sharing family, both team members are at work doing the same part, coordinating the overlap and synchronization with each other. They are interchangeable parts. They know what the other player is going through. They don't play across from them, but beside them. At one level it seems just as the skeptics said. Particularly with men and women, if you play beside instead of across, it squeezes out the romance and intrigue. Instead, the relationship becomes a joint work endeavor, with the child as the "end product" or work objective. The team effort of parenting fills up the entire space of the relationship, with nothing left for adult intimacy and recreation.

Mark, the father of two daughters, laments that he and his wife have "lost a fair amount of intimacy over the years. There was a lot more before we became parents. We had more physical contact, more time to be alone together. I often see that we deal with each other as parents who run the house. We lose our relationship as lovers and become parents, administrators of the household."

What you have is "wall-to-wall" parenting. Many of the parents quipped that 50–50 parenting is really a misnomer. It should really be called 100–100. Precisely because there is no complementarity of childrearing roles in the family structure, there is nothing to check an overblown preoccupation with the children and with parenting.

In the traditional nuclear family, as in the sharing family, the birth of a child can set the couple into a tizzy as the man and woman feel the pinch in their heretofore child-free existence. But at least in the traditional family the mother's overinvolvement with the child can be held in check by the father's unwillingness to only talk kid stuff with her. In the shared parenting family there are no such checks and balances. Instead, we hear a litany of lamentations like "I don't think having a child has helped our relationship. Parenting swells into the relationship, fills it up." "It's real easy to lose track of the interests we share. Our life is so Anya-focused that it's ridiculous. I don't know what else we'd talk about." The sharing couple cannot anticipate the possibility of that common child-focus being the cement that will solidify intimacy and hold the couple together for many years to come. They can only feel the crunch of the present.

Because mothering is not just a set of responsibilities and duties, but rather an inner, psychological state, it can easily extend to fill one's whole waking (and even nonwaking) day. Even with the gender divisions inherent in the being vs. doing of parenting, this extension can easily occur, as when the father fills up his inner life with the thrill of his new-found love affair while the mother is inundated by her feelings of "being" a mother. The couples who share parenting stand apart from their contemporaries in the very emphasis they put on the importance of how one raises children and their own desire to put effort into pioneering a new way of doing it. This emphasis and desire already skew them toward being very involved parents. On top of that, it actually takes *extra* time and energy to execute a sharing arrangement.

Many collective work groups admit that it would be far more efficient and time-saving if only one person was in control or if responsibilities were delegated to individuals instead of everyone having to be involved in everything. So, too, the sharing couples, particularly the mother, are quite aware it would be a lot "easier" in some ways if they did not always have to negotiate parenting with another person. Given the fact that there are only twenty-four hours in a day and each of the men and women is also trying to balance a career and a family, these couples run the risk of squeezing out from their lives the other aspects that go into an adult relationship: time for adult recreation without the children, sexual intimacy, intellectual or work-related discussion or collaboration.

Father Time shows no mercy for those who do not have enough

of it. In the double-entry ledger of the co-parenting couples' intimacy, time is far more of a debit than a credit. The single positive attribute the men and women could assign to time was that, like discussions, it provided a preset structure in which the couple would have to interact with each other. As the father of a three-year-old explains, "We've had to share a lot more time together because of being parents. That was always an issue before. So that's positive for our relationship."

For couples who wait until their mid-thirties to become parents or get married and for men and women whose lives are full of work and outside social activities, time spent with each other is often pushed aside. As a friend whom I had just invited for dinner with his wife explained, "I can't tell you until I see Peggy on Saturday [this was Wednesday]. You see, for us folks who didn't get married until we were thirty, our life is already so filled with commitments to friends and other things that we have to schedule in time together." Parenting can be a remedy to this "two ships passing in the night" state of affairs. The child brings the man and woman together in time and space. And if the man and woman are doing shared parenting, this is even more true, for, as one mother described it, "When our son gets a bath, it's not one parent who hangs over the bathtub, but both of us. We both just have so much fun watching him splash around that neither of us wants to miss it. So it's always time we spend together." It goes back to 50–50 really being 100–100. Because both parents often dote on the child, they both like being there. Particularly if they work full-time, time at the end of the day and on the weekends involves an intensive regrouping of mother, father, and child. Neither Mother nor Father wants to miss out.

More time is spent together than in independent activities after the birth of the child, but the problem is that "baby makes three." "Just Molly and me" get little time all by themselves—nor does either one alone. Barbara, the mother of two, almost leaps from her seat in her blast against time and its venomous effects on the relationship:

What has the most negative effect on our relationship? The question of time. Before we had kids we had tons of time. Time, that's the biggest enemy. Nobody has any time, so when someone takes time, the other one has resentments. It's much more likely for me to jump on him.

The mothers and fathers speak in one voice as they talk about there being no time for making love; no time for having an intimate dinner, "just the two of us"; no time for an uninterrupted discussion.

Not just the shared parenting family suddenly faces the changes that come when there is a baby where before there was none, so that going out means planning a week in advance rather than hopping around the corner to the local movie theater when the mood strikes you. The sharing parents' complaints could have been declaimed by any group of dual-career households, whether the father is actively involved in parenting or not. As George Gilder explains in his book *Wealth and Poverty* (in which he argues that women should go *back* to the home):

> As families forgo leisure and domestic life in favor of work, there is a point when the scarcest of resources becomes, quite simply, time. As time becomes more scarce, it also becomes more valuable and its loss becomes more costly, more destructive of welfare. The first effect of the woman's acceptance of full-time work is an emotionally stressful time pinch.[5]

Rhona and Robert Rapaport confirm this in their study of dual-career families. They cite one dual-career wife, quoted in a *Wall Street Journal* article, who lamented, "I feel that I even have to sleep fast."[6]

The co-parenting family is just like any other dual-career family, but it is also different. Of all the families I have worked with clinically, the shared parenting couples are clearly the ones who have the hardest time carving out time for themselves. A close friend of mine, a sharing parent with two young children, burst into my kitchen exhausted and blurted out, "The problem with our generation is we're just trying to do too much. We just can't do it all." It is parallel to the Supermom myth, which has made a media splash over the past five years: the woman who can hold a high-power professional job, raise two beautiful children, work out at the gym every week, and still look radiant and ready for anything on a Saturday night. Only this time it is both the woman and the man trying to do it.

We are told that "women, and men, tend to flourish when they play a number of different life roles."[7] But only if they have enough time to do them. The shared parenting family has a particularly hard time because of the synchrony of functions. *Both* parents fill

their life up with parenting on top of a full-time job, in contrast with the dual-career but traditional parenting household, where a microscopic look will often reveal that the "emotionally stressful time pinch" is often much more the woman's burden than the man's. In the sharing household it is mutual, and since rather than "spelling each other" the man and woman are both hands on with the child at the same time, overload easily ensues.

The sharing mother wants to be a parent, and she also wants to have a work or career identity. The sharing father wants to be a parent and also maintain his career identity. As part of the interview process I asked each of the parents to fill out a personal "pie." They were asked to divide up the pie (a drawn circle) into segments that they thought proportionally represented the parts of themselves that were parent, paid worker or professional, lover or spouse, friend, and "other."[8] The men and women were surprisingly similar in their responses. In keeping with the doing vs. being gender divisions in parenting, the women devoted slightly larger pieces of themselves to parenting than the men did, on the average. But overall, both the men and woman gave at least two-thirds of themselves, if not more, to the combined segments of parent and worker. This left very little room for anything else. Both the men and women discovered, some with great chagrin, that there really was not much time left over for their marriage or for their own activities.

This problem was exacerbated in families that practiced split-shift parenting. At least those couples with the all-hands-on-deck approach had the opportunity to lay eyes on each other and experience mutual pleasure and joy in the context of time spent jointly with the child. But families who operate with the "You're on, I'm off" regimen find even less time to spend together as a couple. Rather than two ships passing in the night, they find themselves like two runners in a relay, passing the baton from one to the other. In this case, shared parenting creates not enforced time together, but enforced time apart. We can imagine that this would be a prevalent complaint in the shared-parenting-by-necessity families, where it is usually work schedules, financial resources, and lack of adequate day care facilities which dictate that Mom works while Dad tends baby, followed by a changing of the guard. Some of these families do not want to be doing shared parenting at all; they just "have to" for the time being. The chafing about there being no time for the couple may hit them even harder, as it will not be soothed by zealous excitement in the new childrearing "experiment."

Coming back to the shared-parenting-by-choice families, they have more trouble than the traditional couple finding time because they really do want to do it all. And they do each give their all to the children. The effect is to bring the couple closer: "Because we feel close to our daughter, we feel closer to each other." And the effect is to pull the couple apart: "In some respects we're more distant because another object is getting our attention, our focus. Everything goes to our son and then we're worn out with each other."

We begin to get suspicious. Why is it that these men and women are so eager to give their all to the children at the expense of any time for themselves individually or for themselves as a couple? It has already been documented that the working mother in the traditional family is quite aware that the one thing that "gives" in her life, with little time left after a full week of two full-time jobs, is leisure time and time for herself.[9] But the shared parenting family ought to have it easier. After all, they have equitably divided up the labor between them so that neither should be overloaded. Yet work expands to fill the time available, and that certainly is true for the shared parenting couple, where there is often a duplication of effort. Dad reviews Erica's history report, but so does Mom. Mom gives Frankie a lecture on not teasing his friends at school, but so does Dad. In time management terms, it is not a very efficient system.

Yet something runs deeper psychologically that allows this "inefficiency" to occur. I was stunned to discover that many of the mothers and fathers had *never* been away overnight from their child as a couple, even if their child was well into middle childhood. It took all my training as a poker-faced social scientist not to gasp, "You mean you've *never* wanted to get away from the kids—just the two of you?!" These were families who had both the financial resources and the social support systems to allow them to take a little weekend rendezvous alone with each other, if they so desired. Yet several families did not so desire.

I could only think that these couples were hiding behind their parenting selves to avoid each other; that the avid attention they gave to parenting, to the point of missing opportunities to be off on their own, reflected a mutual preference to fill their time with parenting rather than with adult recreation, sex, or any other "children need not apply" activities. The presence of the child makes things cozy and comfortable. Without the child, things might begin to feel less safe.

In fact, some of the couples who do get away for trips without the children reveal that the hardest part of the experience is not falling into the trap of filling up the time together talking *about* the children, since that is what they are so accustomed to doing. And when they run out of "kid" things to say a lull sets in, for now they are faced with only each other, with no buffer or distractions. As much as the couples complain about how much time they do not have together, it is telling that they also set this up by not making the effort to carve out that space, even in the context of limited time resources.

But it is also more complicated than the couples being skittish about time alone. There is a protectiveness toward the child that is not necessarily in the service of protecting the couple from each other, but does interfere with allowing more intimacy to happen. These are people who are stretched very thin in their lives, trying to juggle quite a bit at once. They do have genuine concerns that their child is the one who suffers the consequences, with not enough availability to a relaxed, unencumbered parent. Out of "selflessness" and a strong commitment to the children, they believe that if anyone should have to sacrifice in terms of time, it should be them before the children. They recognize the price they pay, in terms of the deprivation for themselves as a couple, but they have set their priorities, and the children come first.

At a more subjective, inner level, these parents are also often not just protective, but sometimes overprotective, toward the children. For example, *one* parent might be quite willing to sneak a weekend or more away from the children, as long as they know the other parent is there, in charge. They do not trust anyone else with the children, and cannot sleep comfortably unless they know the child is in good hands. This certainly exemplifies a form of intimacy between the mother and father, reflecting the strong mutual trust they feel toward each other's caretaking abilities. At the same time, the priority given to the child's well-being can be carried to excess, and the distrust toward the rest of the world's being able to carry on in one's absence embraces an unhealthy "us against the world" mentality.

Why these couples get so embroiled in wall-to-wall parenting at the expense of their adult relationship comes back full circle to the gender-specific experiences of the women and men as they attempt to mother a child together. Mothering is very different for the man and woman, but with the same outcome of "parenting first, couple later."

For the man it is not a question of avoiding as much as *forgetting* about "just Molly and me." He is elated by his experience in mothering and preoccupied by the unexpected phenomenon of his new-found intimacy with the child. The thought of breaching that connection by being away from the child makes some of the fathers nervous: "I want to see him, to see his little face." "I have a strong connection with Joshua right now. It is a pleasure to wallow in those feelings right now. I can't leave Joshua alone." If he can't leave Joshua alone, that means he can't find time to be alone with Joshua's mother.

It is true that the love affair the father feels with his child is fueled by the father's experience that the same feelings are so much harder to sustain with an adult woman. At the same time, his getting lost in this love affair is not at a conscious level an escape route from his wife's demanding clutches, but rather a gleeful, and perhaps self-involved, wallowing in the quenching of his thirst for intimacy. For the father, then, wall-to-wall parenting is not *caused* by an avoidance of women, but can certainly *lead* to it if the father does not awaken from his dream of paternal ecstasy.

Mother has no such dream from which to awaken. Instead, she is consciously burdened by the guilt that maybe she is not enough of a mother. She has a career or work identity. She has relinquished half of the childrearing responsibilities to a man, not to mention the additional child care services that fill her child's day. Even though she has adamantly proclaimed that she wants to be more than a mother and wants to share those responsibilities with a man, doubts gnaw at her.

Sometimes she feels she has turned her back on her child. Sometimes she feels deprived, that she doesn't get enough of her child. To compensate, she focuses all her attention on the child when the opportunity arises. She alleviates her guilt or anxiety by reassuring herself that time spent in the house is "good, quality family time." In this respect the sharing mother shares something with *all* working mothers. The only difference is that she has willingly agreed to be only "half a mother," in the sense that she is going to share the role with her husband, rather than claim it as all hers.

Remember that she, more than the man, is already having more trouble separating self from other and drawing boundaries between herself and her child. The result: wall-to-wall parenting. It is not that she is *avoiding* exclusive intimacy with her husband. She, too, is self-absorbed, compelled to include her child in everything to reassure herself that she has not forgotten the child. The central propelling force is her own ambivalence about motherhood, not her fear

of men. But the untoward *effect* is that her wall-to-wall parenting does create a barrier to intimacy with her spouse.

Father's paternal ecstasy and Mother's maternal guilt, then, interfere with quality time for Mother and Father as a couple. Characteristic of this set of parents, and probably underlying their decision to embark on shared parenting, is the central importance they assign parenthood in their own lives. These are all "family" men and women. It is not that they live for their children, like the diagnosed overinvolved mother of the 1950s, but that their relationship with their child and their sense of self as parent are critical to their sense of well-being and happiness. They are men and women with a dual mission: to prove there are alternative ways for men and women to live their lives, and to "re-parent" themselves by parenting their own children in ways very different from the manner in which they themselves were raised. In a sense, we can call them parenting zealots.

If these couples' intimacy is based so centrally on their parenting relationship, then potential danger must lurk when raising the children is no longer the organizing force in their life. The first tension point would be when the children hit school age and no longer require the intensive parenting they did in infancy and pre-school years.

Phyllis and Carl had been together for twelve years. When their youngest child reached the age of six they found themselves with less and less to talk about, and with less and less to draw them together as a twosome. Both their children were involved in their own activities and no longer either needed or would tolerate the wall-to-wall parenting Phyllis and Carl had grown accustomed to. The children were now both in middle childhood, a rather conflict-free period, so there wasn't that much for Phyllis and Carl to mull over or agonize about regarding them. They found themselves released from their parenting duties. Yet rather than rejoicing in their new-found opportunity to spend time alone together, something they had complained about the lack of for many years, they felt somewhat at a loss with each other.

They turned not toward each other, but away from each other. Feeling (both of them) smothered by the 100–100 parenting they had been doing, they sought out emotional fulfillment in areas having nothing to do with family at all. By this time they could see each other only as the intimate *parent* they shared a life with. They began to have outside relationships. They ended up separating, unable to find any other glue except parenting to hold them together. They went through their midlife crises.

The story had a happy ending. After pulling away from each other, Carl and Phyllis discovered that deeply embedded in their relationship was a great deal more than just being good parents together. They had a second courtship and then came back together. They reestablished a close, intimate relationship that no longer revolved solely around the children and in which they promised to carve out time for themselves. But it certainly looked like touch and go for awhile.

The next obvious danger point appears when the children actually leave home and the parents are left with their empty nest. If the entrance to middle childhood is a stressful period for these parents, we can imagine how much more intensified the stress might be after eighteen or more years of parenting together. Given the high involvement of each of these parents in the rearing of their children, they might be out of practice at anything other than parenting.

In the traditional nuclear family, the mother often feels an admixture of emotions when her children leave home: sadness at the loss of her child, insecurity about what she will do next with her life, happiness about the relief from the inordinate burdens of primary parenting and the opportunity to have time to devote to herself. The father, whose daily investment in the child's supervision is much lower, might experience the children's leave-taking as less of a personal loss and rupture. On the other hand, because he has not been prepared for the final leave-taking by the incremental moves toward independence that the mother experiences in her intimate contact with the child, he can be the one who suddenly balks at his family falling apart, when he's hardly had a chance to be with them and just when the children are getting old enough to talk to as real people.[10]

If this is the case, we could just as logically speculate that the empty nest period would be a far easier time for both the sharing mother and the sharing father than for the traditional couple. The mother already has a work or extra-maternal identity developed which is a strong part of her. There will be no insecurities, then, about finding or rediscovering the parts of her that don't mother. The father has been active in the child's life in an ongoing way, so he, as well as the mother, will have been prepared for the child's final leave-taking by the steps toward independence in which he has fully participated.

Yet both mother and father also find themselves in the position of the traditional wife when they look inward at their family life. In the context of the wall-to-wall parenting style they have chosen,

we can easily fantasize that they might feel very much like this woman, in a traditional marriage, who worries:

> It isn't that I want to hold the children here, it's just that I worry about what our life will be like. I don't know what we'll talk about, just the two of us, after all these years.[11]

The problem may be exacerbated, for sharing parents, by the collusion between them in "all these years" to be two peas in a pod, two doting mothers. The woman above is worried, perhaps, because she has not talked to her husband at all, in any meaningful way, during the years she was preoccupied with mothering. The sharing mother and father have talked plenty, but about only one topic: the children.

If the intimacy that comes from that talking and sharing can be carried over from parenting to coupling after the children leave home, shared parenting has a good prognosis for the growth and development of committed, long-term relationships. If the empty nest produces the empty couple, however, there will be trouble in store. Even though the couples long desperately for more time to devote to themselves, they just may not know how to fill that time when they finally get it.

Overall, the prognosis looks very good. These are couples who love and respect each other. I cannot deny that tensions do erupt— not just around childrearing philosophies, but in a subtle form of gender warfare. The woman resents the imbalances between her being and the man's doing, sometimes feeling she unfairly carries more of the load, particularly when it comes to woman as psychological manager. As I said irately to my husband, who had temporarily taken over the household responsibilities and had forgotten to cancel our child's tutoring session, "You may be a wife, but you are *not* a woman."

The man, on his part, feels beleaguered and maligned. From his side, he complains that the woman is simply doing too much, is always on the lookout for his failures, or is not giving him enough credit for what he does do with the children. Such tensions certainly can take their toll on the relationship, but that is nothing compared with the volcanic stresses that can erupt in a family where the woman does two jobs for the price of one and the man remains adamant that "that's the way it's supposed to be done."

Not only are the gender tensions diluted by doing shared parenting; they can also be transformed into a new form of gender har-

mony. The woman has the opportunity to develop her more masculine components, by being out in the world and participating in extra-familial culture. The man has the opportunity to develop his feminine components by mothering a child and turning inward toward family and home. And so, as one mother explained to me, there develops a Yin-Yang fusion: "Bruce is attracted to the masculine side in me, and I'm attracted to the feminine parts in Bruce." It is not the dichotomy of differences, male and female, that cements the attraction, but the similarity in the balance of female and male within each of them that draws them together. Furthermore, as the couple weathers the differences between them that do exist, they grow less threatened of each other and are able to come together in a stronger intimacy, without fear of engulfment or loss of identity.

If we balance the books, we come up with a couple who love each other very much, with mutual respect and sharing around their parenting efforts, and have a sense of getting to know each other better for it. Yet they are a couple plagued with little time for themselves outside of parenting. Are they intimate?

To test intimacy, I asked each of the women and men in the interview to predict how their partner would answer a question, a question that pertained to an individual's innermost experiences of parenting. The men and women had a remarkable degree of accuracy in anticipating the other person's response. Beyond these test questions, I was also struck by the level of consistency between the stories the mother and father told individually. At least when it comes to parenting, the sharing mothers and fathers are deeply intertwined in and aware of each other's inner life.

How they will fare in the long haul when parenting no longer welds them together remains to be seen. In the meantime, the nest is not yet empty. There are children growing. Children growing up very differently from most of their peers whose fathers are significantly less present in their daily care. We are all very interested in how the couples fare. Yet we cannot forget the children, who are the reason for all this reshuffling of family arrangements. So we come to, "And how do the children grow?"

10

The Child with Two Mothers

Bonding and Attachment

> Clinical studies and anthropological studies support the
> relationship between strong attachments to single individuals in
> childhood and the capacity for a limited number of intense,
> exclusive relationships in adulthood. This might simply be
> "imprinting for monogamy," and should be looked at as such.
>
> MARGARET MEAD[1]

The "glorification of the mother" ethos that has permeated both
child development research and popularized notions of parenting
over the last hundred years has been adamant about the centrality
of the mother for the child's well-being. Now, just as the mother-
love concept has begun to lose its solid grip on public favor, the
experts have come to the fore, rallying around the cause. So it is
that Selma Fraiberg, a well-respected clinician and child development
expert, won great acclaim for her book, *Every Child's Birthright:
In Defense of Mothering,* published in 1977. Mothering is the desired
act, but a single person—a.k.a. Mother—is the deliverer of that
birthright.

Yet, there is unrest afoot. In 1971, I found myself in the front
lines of a burgeoning protest movement within the child development
field, when as a graduate student I wrote, fueled by Dr. Mead's
admonishment to Western culture:

> We, along with other Western societies, are unique in the
> exclusiveness of the mother's role as infant caretaker and in our

emphasis on her importance in the development of a child's social attachments. Few non-Western societies exist in which infant care and associated household tasks are regarded as full-time jobs for women.

Yet we have come to a point in history when the single mother-child relationship is beginning to be questioned, and as one psychologist states: "It is incumbent upon the developmental psychologist to inquire whether the matricentric system of childrearing is in fact the one most conducive to the best growth of human personality."[2] With the rapidly changing role of women and the questioning of the traditional nuclear family structure in a highly technological society, it becomes more and more imperative for the psychologist to deal with this exact question.[3]

A decade and a half later, I sit at my desk chuckling at my youthful and earnest sense of moral imperative. But I also chuckle because I have indeed paid heed to it, posing the question of what *does* happen to a child's development when Mother shares childrearing responsibilities with Father. No longer in the forefront of a new social movement, I am now part of the swelling ranks of parents, professionals, and policy makers who really do need to know what is happening to those of our children who are now being raised by multiple caretakers, whether it is Father, relative, baby-sitter, or child care center who serves as the other-than-mother figure. In that context, the shared parenting family becomes a social laboratory enabling us to begin to answer the questions these new childrearing modes have raised.

Up until now my attention has been riveted to the parents and how they fare in a shared childrearing arrangement. But perhaps even more important is the outcome for the children raised in such a family. When the child first springs from the womb in a family where Father is also participating, our first concern involves the *number* of caretakers. What is going to happen to an infant who has two mothering figures rather than one? Then our second concern, about gender, surfaces. What will happen when one of those figures is a man?

Let us begin with the question of number. The key word here is "attachment." In the clinical work I do, with both children and adults, my thinking and understanding are primarily guided by the concepts of object relations theory. I work with both the real and

internalized or fantasized relationships that clients have with the people present and absent in their lives. The underlying premise is that beginning at birth the propelling force in human development is the individual's desire for relatedness to others. Rather than a pleasure-seeking being, the little baby is primarily a relationship-seeking one. It begins its relationship seeking early in life with the bonds and attachments that develop between infant and caretaker.

Our culture puts tremendous importance on those early ties which unite the child with the significant other(s) in his or her environment. Experts view these early relationships as laying the basic groundwork for all future development. Until recently, we have had very set—and, I might add, ethnocentric—notions of how such relationships must unfold for the optimal well-being of the child.

The first organizing notion is that every child needs a paired relationship with *one* significant other in order to get a good start in life. Bolstered by the anthropological observation that mothering is a universal phenomenon, always done by women, the supposition is that the biological mother is the best person for the job.

Further supported by observations of primates, other mammals, and some humans to boot, the second supposition is that infants have a propensity to attach to only one person at a time.[4] In a large-group setting, such as a nursery, or in a small-group setting, such as the family, the little baby will gravitate toward one caretaker and make that person a favorite. Anyone else will be a weak substitute.

For children denied the opportunity to make that special connection, particularly those raised in institutional settings with multiple and frequently changing caretakers, the outcome can be devastating: mental and physical retardation, sociopathic personality development, and hyperactivity at worst; superficial interpersonal relationships, anxiety, and emotional insecurity at best. With the additional knowledge of these untoward consequences when the child is denied a mothering figure, the stage is set for a theory which upholds that *one* person, preferably the biological mother, should be in charge of the young child.

It is assumed that the child in its earliest months is cognitively or emotionally unprepared to deal with more than one person at a time. Attachment, best defined as a unique emotional relationship between two people that is specific to them and endures through time, depends in a child's first year on the availability of a caretaking figure who will be sensitive to the child's needs, learn how to read

a child's signals, respond promptly and appropriately, provide adequate physical and social stimulation, and spend enough time with a child for a bond to develop. On the child's side, he or she will show that an attachment is developing by seeking proximity to the attachment figure; babbling, cooing, and increasing physical activity in that person's presence; smiling and protesting selectively in response to that person's comings and goings; and indicating a preference to be with and be calmed by that person over other persons.

The bulk of contemporary child development literature goes on to state that since the child most likely demonstrates that behavior with Mother more than with any other individual, the child clearly has a need or the capacity for only one caretaking figure, and that person is indeed Mother. But no mention is made of the fact that the mother is typically the only one around for the child to become attached to, or that even within that traditional childrearing context children have been known to choose someone else instead of Mother as their special person, or that some children show evidence of attachment to more than one person. Actually, a careful review of the childrearing literature, both Western and cross-cultural, indicates that a child is capable of sustaining attachments to at least two, if not three, significant others in their early life, as long as those people are salient figures in their care.[5]

The question, then, is not whether the child is *capable* of such multiple attachments, but whether it is beneficial or harmful for the child to have them. When Margaret Mead reminded us that exclusive mother-child relationships may simply be imprinting for later monogamy, she was pointing to a larger reality. Our childrearing strategies and outcomes can be evaluated only if we tie them to our childrearing goals. We must first be clear what we are striving for: what adult world we envision our children entering and how we hope to see them cope with that world.

That is why conservative thinkers become squeamish in response to the enterprise of challenging our basic notions of how early attachment should occur, and more liberal thinkers grow excited. If we want people to remain the same, we should keep the basic building blocks intact. But if we have new visions for how people should be, a rearrangement or restructuring of the basic building blocks offers us expanded possibilities for social and human change.

Whether or not the participants in families who involve fathers in the parenting are consciously striving for such change, they no doubt are actively changing the basic building blocks of human devel-

opment by introducing two primary caretakers, rather than one, into the child's life. In doing so, they join the ranks of the kibbutzim, of utopian societies, and of all other situations in which the caretaking is shared between the biological mother and others. But they are also unique in that the co-parenting position is taken by a man rather than by a woman, and by the other biological parent to the child.

Relying on my clinical experience, personal observations, and the words of the parents themselves, I have sought answers to a specific set of questions about the development of healthy attachments in children raised by both mothers and fathers. Are these children trusting and secure, or do they show anxiety and confusion in their attachments? Do they show a preference for one parent over the other, or is there a genuinely equal attachment to both mother and father? And if the child indeed shows an attachment for one parent over the other, what do parents committed to equality do in response?

Basic Trust

Basic trust, from a very early age, is born of how the mothering task is performed. When the child's needs are well and responsively met, he develops, we think, a sense of trust.[6]

The child development experts who insist on the need for *one* attachment figure to establish basic trust would argue that children raised by more than one mothering figure, as in the shared parenting family, will be confused by the diffusion of early mothering tasks between mother and other. They will grow anxious and insecure, and manifest such symptoms as increased separation anxiety, cognitive lags, hyperactivity or lethargy, and aggressive behavior.

Yet clinical observation and parent reports reveal no such untoward outcomes in children raised by both a mother and father— or, for that matter, by *any* two mothering figures. The mothering tasks are easily coordinated between two people to responsively meet the child's needs, and the child is indeed capable of cleaving to two attachment figures simultaneously. Melanie Klein, in her theory of infant development, asserts that the infant early in life has an awareness of both a mother and a father.[7] If the small infant already recognizes that it has more than one parent, it makes sense that having that second parent come into clearer focus, rather than re-

maining a fuzzy, distant figure, could be a rich and rewarding experience for the baby.

Securing in their children a deeper trust in the world stands out as one of the parents' central goals in embarking on a sharing relationship. Rather than overloading or confusing the child, two parents will, they believe, provide twice as much trust for the child. As one father put it, "Sam has two people that he's really comfortable with that he can go to to get his needs met."

Speaking out of a sense of having been deprived in their own childhoods, these parents strongly asserted that by having *two* highly involved parents, the "Never put all your eggs in one basket" result was the best possible insurance policy against emotional insecurity and ill health in the children. The psychological wisdom of this approach is demonstrated in a father's report of his children's adjustment after the sudden death of their mother. The two sons had both been raised in an egalitarian parenting arrangement. The boys, both under five and one just a year old at the time of the loss, did as well as they did, according to the father, only because they had had such a strong attachment to *both* parents. Father was able to step in not as a stranger or somewhat distant figure to the children, but as their other mothering figure. No doubt the children were bereft, but not nearly so much as if the only mothering figure they had no longer existed.

Another mother to whom I spoke reported a similar situation subsequent to a serious car accident as a result of which she was hospitalized for several weeks when her daughter was one year old. Although the child grew anxious about her separation from her mother, she was reassured because the father, who was also a primary attachment figure, was able to take over. These children did not have to suffer the trauma of having no other mothering figure to count on, as do children who suddenly find themselves with an ill-prepared, "untrained" father when bereft of mother—a trauma that reduces, rather than enhances, a child's trust in the world.

But the "eggs in more than one basket" dictum is not just a mainstay against anticipated tragedy and parental loss. The benefits of their being two active parents for the building of basic trust also apply to the exigencies of everyday life. Nancy's partner, Ken, is not concerned about Nancy dying. He tells me it is better for their son to have two parenting figures because "he is intimate with two people who can offer him different things. It makes him feel more secure in the world, that there's more than one reference point.

The world is a less scary place. It opens him up to experiences because he feels better about the world." It is what another father calls the "existential security" provided by having two people engaged and involved, giving the children the basic confidence that the world is safe. One parent's way of doing things doesn't have to become the young child's only reality.

The world is safe because two people envelop the child with their love and caring. But it is not a sheer numbers question, wherein having two present is better than one. It is also because two people can spell each other. If one is physically exhausted or emotionally depleted, the other parent can step in and be equally adept in mothering the child. Remembering their own "shopworn" mothers and the untoward but unavoidable resentments passed down to them from these women who sacrificed all other identities to motherhood, this generation of men and women did not want to repeat that with their own children. Focusing very much on the child's needs, the solution, in their eyes, was the "fresh blood" approach: "A major advantage of sharing is that the supervision changes hands before resentment builds up. Neither of us is good for parenting over a long period of time non-stop. The advantage is that the children get attention from someone who's not wishing he or she was not there."

"Fresh blood" was often synonymous with a split shift policy— if not in actual time, at least in emotional presence. The parents saw this as particularly beneficial, if not imperative, in the child's earliest months, given the twenty-four-hour demands of babyhood. Even in the traditional family, father will sometimes help an exhausted mother of a newborn by helping out in one or two of the night feedings. But the egalitarian mode of "share and share alike" in the co-parenting family meant that the parents made a self-conscious, studied attempt to carry that burden together, even within the limitations of breast-feeding.

Rather than being confused by having two different figures appearing throughout the day and night, the baby can benefit from two fairly rested parents instead of one full-time, red-eyed zombie. Adults operating at full- or at least medium-level steam are more likely fueled with the interpersonal sensitivity and inner emotional resources that are the key ingredients in bonding and early psychological development.

From the parents' point of view, even after the baby begins sleeping the night and becomes less physically taxing, the ability to spell

each other remains a key ingredient in the child's well-being. Stuart's daughter was pre-school age, and Stuart perceived her as being at the stage when she became easily frustrated and emotionally demanding. By having both himself and his wife actively engaged with her, he thought they were giving her the best help they could in this area: "Sometimes I get exasperated with Anya's stalling tactics. She gets whiny and whimpery. I'll say, 'I can't handle it, will you take over?' It works the other way, too." This arrangement creates children with high levels of trust in the world because there is a greater possibility of someone who can "come through" for them with their fullest self.

Because there are two equally involved parents to spell each other, the arrangement can also be a healthy way for children to deal with separations. Successful adaptation to brief separations is another milestone in the establishment of basic trust: I can be all right even when my loved one is not right beside me.

There is great controversy in the child development field about the meaning of "separation anxiety" for the young child. Somewhere in the second six months of life, the baby is expected to show some kind of distress when removed from a loved one. For at this early age, out of sight is not just out of mind, but gone forever. If the baby never shows *any* such distress, that is a very bad sign, as it demonstrates that the child has never developed a bond with a loved one to care about losing. If, however, the child shows only a weak separation anxiety response, some feel this is a good sign because it demonstrates strong trust in the child's intimate environment and an early ability to both internalize that trust and generalize it to others. Others feel, on the contrary, that the baby who strongly objects to the parent's departure is the one who cares very deeply about that parent and is securely attached.

Many of the parents in the study, both mothers and fathers, saw their young children as adapting very well to early separations from their parents, with minimal stress or trauma. Denise reflects on her daughter Anya's first three years:

> She certainly has mastered our comings and goings. She seems to have a real balanced sense that we both do those things. In general, Anya is on the easy, adaptable side.

But it is not just her temperament that makes the parents' comings and goings so nonconflictual for Anya. Because the children in sharing families have early experienced a transition from one caretaking

figure to another, they are not so traumatized when a primary figure leaves because there is readily another one to take his or her place and be relatively equally gratifying. And it is not just the other parent who serves this function, but also the presence of a child care provider who typically enters the infant's life in the early months because of the parents' work schedules.

Parents who lauded the benefits of having multiple caretakers also perceived no emotional confusion or anxiety in their children, but rather an ease and comfort in letting two or three adults, rather than just one, be the "love" of their life. A weak separation protest was definitively correlated with strong trust in the world, the children appearing to be confident that more than one person could fully meet their needs.

Parents' beliefs were supported by my observations of the young children's equanimity in the face of separations, as when a child care worker arrived and a parent left for work, or a child waved a cheery good-bye to Mother as Father scooped him up to go to the park. I have seen the same ease of transition in my clinical work and in day care consultation with the children not just of sharing parents, but from any familial situation in which more than one person has been involved in the children's care from early on. The attachment to each of the parents appears quite strong, but the trauma experienced upon separation minimal, arguing against the equation that strong attachment equals strong separation response. There are countervailing considerations, particularly the availability of more than one attachment figure.

The parents' own belief system about what they *think* will happen to a child is also a salient factor in what actually does happen for the child. If parents believe it is good for the child to have more than one parent involved, this can become a self-fulfilling prophecy, mediated by the confidence with which the parent presents the arrangement to the child.

I was surprised to find that when talking about the benefits of shared parenting for the children the first thought of the parents was not the gender issue—that is, giving children expanded notions of who males and females are and what they can do. Much more definitively it was the number question—the advantages of having *two* parents for developing greater trust in the world and being exposed to a broader range of personality styles and ways of being. I think this is because the concern about gender is more of an overlay, coming later in the parents' own early life as an issue or a topic of

concern. Before they themselves ever knew they were male or female, they grew to understand that there was only one person who was really there to take care of them. When they look back on that now, it touches some very painful feelings, a sense of having been deprived of two loving parents and of having been precariously balanced emotionally between a monogamous relationship with Mother and the typical psychic absence of Father. It is this that they are most intent on changing for their children.

Because the parents genuinely believe that they are creating a world of greater trust and dependability for their children, they act accordingly, communicating this to their children in both actions and feelings. Just as Rosenthal found that if you expect good performance of children in the classroom, you will more likely get it,[8] the expectation that the immediate world you are creating for your child is full of stability, security, and trust can generate for the child those very feelings.

Overall, theory, observation, and common sense all lead to the conclusion that having two adults actively involved creates in a child a strong base of trust and love in the world. But there are some caveats. Marsha had not yet delivered her first child, and she began to have some worries:

> If there isn't one parent who has clearly put parenting over career, the kid will be insecure. I worry about how the kids are going to feel if we haven't clearly stated that one of us puts our parenting first. What if we're both at a time of putting our career first? I guess the kid'll have to go to both of us.

The fear is that the child will feel unimportant and somewhat shunted to the sidelines, and that both parents will be spread too thinly to really attend to the child's intimate needs. It is the same criticism that the opponents of the arrangement harbor when they say, "Without one person clearly in charge, this will never work."

A small number of mothers and fathers did express concern that shared parenting would introduce two impediments to bonding and the development of trust in their children: discontinuity and unpredictability. The parents wonder if they have put too much stress on their children in the early months by forcing them to be *too* adaptable. A mother reflects, from the baby's viewpoint:

> Life is somewhat less stable and predictable. There is a demand on him to be more adaptable, [more] flexible in relationships.

Early on he doesn't have the basis of continuity in relationships. He has had to adapt to two very different people from the beginning. He has had to accommodate to that.

The child can grow frustrated, for example, when one parent fails to understand a newly acquired word or phrase that the other parent has easily grasped. The parents worry that the demands made on the child might be too taxing, that perhaps the child development experts have a point about the need for continuity in early care and the efficacy of having only one person who really knows the child inside and out providing it.

This is a legitimate concern, and one more often expressed by mothers than by fathers, as mothers are more often skittish about the outcomes of tampering with the traditional arrangements. The lack of continuity may in fact be stressful for the child, to be weighed against the advantage of having two involved parents for establishing basic trust. To mitigate against this strain it is crucial that the caregivers have enough consistency and coordination between them to offer a harmonious, rather than discordant, experience to the child.

Related to the stress of adapting to two styles of parenting is the problem of the "changing of the guard." If predictability and consistency are the cornerstones of successful attachments in early life, the fact that Mother relieves Father and Father relieves Mother might shake loose these cornerstones.

Pete explains that if one person, he or his wife, is on duty for a long time, Esther and Liz, his two daughters, are then reluctant to go to the other parent. From our adult standpoint we think we are doing our children a great favor by providing them with a fresh and eager parent while the worn and used one takes off to refuel. But from a very small child's stance, this is not necessarily the case. Babies and small children can be extremely stubborn and repetitive creatures. What they have they want more of. How many parents have been driven to distraction by their toddler's insistence on their reading the same book for the fifteenth time? Their relief comes from understanding that the quest for consistency through repetition and practice is a legitimate developmental need of young children to help them relate to the world in an orderly fashion.

Just as the children have fallen into a rhythm with one parent and have accustomed themselves to the undivided attention of that parent, in bursts the other parent to scoop them up, expectant with excitement and hungry for baby. The child's response: not the squeal

of glee the parent fresh on the scene anticipates, but a wail of protest and a lunge toward the parent who is familiar and has already been there all day. This is different from separation anxiety, for it is not that one parent has left, but that both are there and the newly entered and refreshed one is being rejected in favor of the worn and weary one. It is particularly hard on mothers who return home from a long day of work, with a gnawing sense of mother guilt from being away from their child so long, only to be coldly greeted as an intruder.

Karen is one parent who has experienced that, but was able to contain her own feelings of rejection and recognize that it was more important to focus on the child's needs for security and stability:

> It has seemed at times difficult for Joshua to make the transition from one parent to the other. Sometimes it's difficult when one of us comes home and he suddenly has both of us. Including the one who's been away.

> He called the one who was home "Mommy" up until he was 15 or 16 months old. And the one who was away was "Daddy." There's still threads of that. It is important for us to negotiate that switch and transition from the one who's with him to the one who has not been.

The baby is faced with an intimate world which periodically changes before its very eyes. There is a lack of predictability and a subsequent lack of accessibility, of no one person always being "on call" for the baby.

Again, this stress can be superceded by the sensitivity of the parents in negotiating transitions and by the benefit of getting love and attention from more than one person. But this will be beneficial for the child only if more really means more. If, instead, less is more—less here being fewer people, and more being more stability and trust in the world for the child—then concerns about inconsistency and unpredictability cannot be dismissed lightly.

In order for a baby to develop an attachment, he or she must first achieve a level of "object constancy." In other words, the baby must be able to hold on to a consistent image of a person, both in that person's presence and as a mental representation of that person in their absence. To do this, the child needs continual exposure to that person over time. If the child is presented with too much inconsistent stimulation, in the form of frequently changing persons, that constancy becomes difficult to acquire.

On the other hand, once that constancy is acquired, it becomes laden with emotional meaning as the baby "falls in love" with the object, and its motivation is to keep that object coming and staying. The "object" in question is the parenting figure. The debate here is whether the young baby is capable of handling two love objects at the same time. Its resolution lies in the investigation of the specific attachments the very young child forms to a mother and to a father when they are both equally present.

Equal Parenting, Equal Attachment?

The worries that the young baby will be overwhelmed by the presence of *two* mothering figures are unfounded. The children show signs of strong and healthy attachment to *both* adults, with no dilution of basic trust or security. But the question remains, "Are the children actually equally attached to both parents or does the child "naturally" hone in on one over the other to preserve a sense of a "one-to-one" relationship?"

Some influential theorists, such as John Bowlby, maintain, as I have already stated, that an infant has a natural propensity to bond to only one person at a time.[9] Other experts have demonstrated through empirical research the existence of multiple attachments in infancy, although they still typically find an attachment to *one* person first, followed by the addition of others to the list.[10] Contradictions among existing studies depend in part on whether the researchers are directly studying human infants or extrapolating from the behavior of other species (particularly monkeys and apes) and on what exactly they measure when they assess attachment. One study might use the preferential smile of the infant, another the protest when the adult leaves the room, another a compilation of a series of factors, including an inference about the infant's inner state.[11]

Most parents never get around to reading such studies. Yet, they can usually tell you quite accurately about the bonds they and their children have developed. And most people who look in on the shared parenting family are eager to know just one thing: "You two may attempt to do everything equally, but surely the child must prefer one of you over the other?" Interesting that this question, next to the concern about the risks of gender confusion, is the one that makes outsiders the most anxious. It is as if a relatively equal attachment with both parents were a form of infantile adultery. And no doubt, given that we have all grown up in childrearing structures

that have imprinted us for monogamy, this might be precisely how we interpret it.

From listening to the parents speak, from reflecting on my own family experiences, and from observations in my consultation room, I would have to state that there is a tendency for the young baby in the egalitarian family to prefer one parent over the other at any particular time. In the words of an older child, "I can't help it. I like Daddy better." The preference may be only minimal in degree and inconsequential in the context of the overall strong attachment to both parents. But nonetheless it is there.

Apparently, the child does have an internal need, particularly in the early years, to develop a sense of oneness by having one favorite caretaking figure. With two parents present, the baby still has the capacity to create this for itself, with no untoward consequences, by its own expressed preference, no matter how slight it may be.

The parents themselves will be the first to admit it. Bob's parenting arrangement with his wife at the time of our interview was a 60–40 one, with him on the 40 percent end. When he looked back on his daughter Valerie's early attachments, he explained her proclivity for her mother in traditional parenting terms:

> Somehow I feel my daughter's connection with Audry is more comforting for her, for example, when she's physically hurt. There's a real strong attachment between her and Audry, and also a real strong attachment with me. But given that Audry is with her more I guess I'd have to say Audry and Valerie's attachment is more. It feels fine.

Two-year-old Sam also shows a preference for his mother over his father, because his mother has been around him more. But Nancy, the mother, does not think it is a big deal: "He's an incredibly flexible kid and very attached to his father, too, and the difference is narrowing. When we're both around, he wants both of us. He's so happy when he gets both of us."

Two things surface. If there is a preference within the first year, it tends to be for Mother over Father. On the other hand, when there is a preference, the parents perceive it as subtle rather than extreme, and also malleable over time. That little babies show a preference toward Mother over Father makes us wonder if perhaps the sociobiologists aren't correct: Women are more biologically equipped for mothering than men.

Yet the truth of the matter was that those families who reported a preference by the young baby for Mother over Father were also

those families in which the mother reported spending more time than the father with the baby. Not genes but opportunity is at issue here. Although the new emphasis in popular advice to parents, particularly working parents, is that *quality* of time spent with the child is more important than *quantity,* the parent who spends more time with the child will undoubtedly have more practice in reading and responding to the child's signals, particularly when that child is pre-verbal. That parent may also find him or herself more "invested" in the child. In shared parenting families, if there is any unevenness in time sharing, the parent with more opportunity, particularly in the early months, is more likely the woman.

There is also the factor of the "doing" vs "being" of parenting. If mothers, with their more permeable ego boundaries, are somewhat better at "tuning in" to the children, this will certainly give them a slight edge in baby bonding. Normatively, there is a greater sense of merging in the *early* infant-parent relationship, and it is only later, as the child develops language and becomes a separate being, that such merging becomes less important in the parent-child bond. These fathers, themselves raised by women and therefore less given to such merging, are perhaps not as finely tuned as the women to the early nonverbal cues of the baby. If the baby senses this, its preference will likely be for the parent who can best provide such fine tuning—the mother.

We could say that it is her hormones that make the woman more receptive, except that the increased levels of female hormones in the mother's body remain only briefly after birth. We could say that it was the breast-feeding relationship, except that, although some parents certainly felt that the mother's ability to soothe the young infant through nursing enhanced the mother-infant bond, there were sharing families with children who breast-fed yet displayed a slight preference for Father over Mother. And Dr. Harlow's studies of monkeys have certainly demonstrated that a cuddly, non-lactating mechanical mother will be chosen any day over a cold, hard, wire mother filled with milk.[12]

But most significant, regardless of etiology, was that the preferences reported, in addition to never being extreme, were also never permanent. They shifted from one developmental period to the next, depending on both the gender of the child and the parent (with fathers becoming equally popular as mothers by the second year), and also in response to various life circumstances, such as employment shifts or entry into adolescence.

Over the course of a mere three years of life, a child in an egalita-

rian family may have changed her or his mind several times about who "number one" is, as with this little girl of twenty-one months, described thus by her father:

> When Nadine was breast-feeding, she was more attached to Eileen. Now it changes with whatever activities Nadine wants to do. Now it is pretty equally divided. For example, if Nadine wants to take a walk, she'll come with me. But if she wants to read a story, she'll come to Eileen. In terms of physical comforting, it's equally divided.

Family events, such as the birth of a new sibling, can turn a child from one parent to the other. Joshua was just a little tyke when his mother became pregnant. From his mother's point of view, a shifting of loyalties ensued:

> Toward the beginning and middle of my pregnancy, Joshua was very attached to Ira. I seemed more of a suspect person to him. Joshua became very preoccupied with the baby. Lately, he has a more appropriate concern about the baby and is very attached to me. He'll spend an hour and a half sitting on my lap, talking, playing, getting up to get a book, which is not entirely his style.

One parent begins to change: Her belly swells, she slows down, and she just seems "different." The child navigates back and forth between the two parents as he or she works through the feelings and fantasies stirred up by this event. The "preferred" parent may in fact be the one the child is in the most conflict about, feels anxious toward, or has a bone to pick with.

The psychological "inner" crises that are universally part and parcel of growing up can also turn the child from one parent to the other. One example is the child's gender experiences. Jason is four, and appears to be in the throes of an Oedipal drama. He tells Mommy he does not like Daddy as much because "Daddy's bigger, smellier, hairier than you." He tells Daddy he loves Mommy more because "I came from Mommy." This is no different from the love affair that goes on between child and opposite-sex parent in traditional households, except that Jason up until this point has been very attached to both parents and Father is not a distant rival but the man who has been taking care of him half the time.

Such developmental crises are more easily negotiated when the children can make use of the parent who is most central to the struggle at that particular time. The child with only one available

parent is more "stuck," having to work everything out with that one parent. With strong attachments to two parents, a child has greater liberty to navigate between Mother and Father. The older the child gets, the more the attachment evens out between both parents, as life events lead the child to turn first to one parent and then to the other, and sometimes to both.

There is no evidence of confusion or anxiety for the child in these attachment shifts. I first began to wonder about this when I learned that children of egalitarian families often use the names Mom and Dad interchangeably, and not always appropriately. This could be a sign of confusion, in which the child is having trouble telling Mom and Dad apart and holding onto them as two separate people.

But there is a much more benign explanation for the name switching. As I sat in these families' homes I began to notice a repeatable pattern. Suzie might call, "Mommy," and Daddy answers from the kitchen, "Yes, Suzie, what can I do for you?" Daddy answers either because he is the closest or because he is "on duty." So Suzie learns that when she calls Mommy, any of two people will respond. No wonder, then, that she often looks straight at Daddy and calls him "Mommy" or vice versa. It is a socially reinforced response, rather than a sign of some inner confusion.

The terms "Daddy" and "Mommy" also become social categories for the child rather than proper names for their parents. Recall that Joshua, not yet two, called the parent who was home "Mommy" and the one who was away "Daddy." Brilliant that a child so young could absorb the dominant culture's norms about who mommies are and who daddies are.

Even though attachments to Mother and Father even out over time, a major dilemma for sharing parents at any particular moment is how to handle the child's request for one parent over the other. They can either bend to the child's wishes or hold to the principles of egalitarianism, encouraging the child to accept the other parent as well. Their commitment to doing things equally may be in conflict with respecting their child's wishes as a legitimate developmental need. Dedicated to equality but not wanting to harm their child, what do they do?

Sharing parents have found no easy solution to this dilemma. They might feel somewhat rejected when the other parent was the favored one, a feeling that was as true for the men as for the women, but they were able to take such feelings in stride. Most parents were like Eileen and Bernard. They took the "child-centered" ap-

proach: "Nadine's preferences get honored, in terms of who she wants. If she says "Mommy," then she gets Mommy. It's our belief that she knows exactly what she wants. Whatever Nadine needs or feels more comfortable with, we'll go with that." But if the requested parent is not available, Nadine accepts the other one with little protest.

No parents were so rigid about equality that they would insist on forcing the "rejected" parent on the strongly protesting child. But some felt it was very important to convey to the child that the other parent was also able to comfort the child or meet his or her needs. They were also wary about the child's requests as reflecting a would-be manipulation rather than a real need for one parent over the other.

Julie, who was having sleep problems at age three, would scream at her father when he came in for a nocturnal comforting, "Go away! Get my mother!" Mother and Father, initially committed to the child-centered approach, would comply with Julie's wishes, seeing her as traumatized and in need of Mother. Several days' later, a sleep-deprived mother and a hurt, rejected father looked at each other, laughed, and realized, "This kid is getting away with murder." From then on Julie was told to take the parent who appeared or no one, and the sleep disturbances, remarkably, disappeared. More than truly needing Mommy, Julie had wedged herself in the middle to see how much power she wielded over Mommy and Daddy. The issue was not attachment but early childhood omnipotence: Julie's testing to see if she could make her parents come and go as she pleased. It draws our attention to the potential pitfalls of overindulging the child in the child-centered approach to attachment preferences.

Denise and Stuart came up with a lovely compromise solution to the child's expressed preference for one parent:

> There were times when Anya wanted Stuart to put her to bed. So I was glad when there were nights when Stuart wasn't there, so there wouldn't be any competition. Sometimes when Anya chose Daddy, but I would need to be with Anya, we would both go in to Anya together. We work very cooperatively together.

Here parents' and child's feelings alike were taken care of. Although Anya did not get the exclusivity with Daddy she might have liked, she did get him, along with Mommy as well.

The child in the sharing family emerges firmly attached to two loving parents. This is an important milestone in the child's early life that builds the groundwork for a happy and fulfilling life. Not just families totally committed to 50–50 parenting but any household that expands Father's involvement in the care of the children can enhance the child's development of bonding and attachment, with the equation: The more the involvement, the better the outcomes for the child.

11

Co-parenting and Personality Development

> . . . the central force for change in history is neither technology
> nor economics, but the "psychogenic" changes in personality
> occurring because of successive generations of parent-child
> interactions.
>
> LLOYD DE MAUSE[1]

Attachment is only the *first* major task facing a child in becoming
a person who can cope in the world. As the child grows older, the
accomplishment of new developmental tasks is called into question
when a child has more than one involved parent, including the acqui-
sition of autonomy and independence, social competence, and inter-
personal skills. Success in these areas prepares the child for entry
into the larger world of culture and society. Increasing Father's in-
volvement in childrearing definitely alters the nature of parent-child
interactions. We wonder whether this systematic alteration in the
family will show up, as DeMause predicts, in changes in the chil-
dren's personality, specifically in the areas just mentioned.

Two Parents: A Richer Social Terrain

The parents in sharing families, along with many modern parents
today, put great emphasis on the acquisition of social flexibility
and openness as a goal for their children. They have a notion of

their children growing up to be interested in and open to many aspects of life, rather than taking a straight and narrow path. They believe this will best prepare them for a complicated world that requires high degrees of adaptability to change and differences.

Because of the intimate exposure it offers to two points of view and two personality styles, the sharing family is perceived by the parents as a fine road to achieving this goal. The children learn about variations in human possibility by getting a clear picture of both a mother and a father. They discover that their mom takes care of them one way, their dad another.

They also have the opportunity to incorporate these two adults into their inner sense of self. Children, as people-seeking organisms, absorb the adults around them as part of their inner world. The parent exists not just as a real person in the external world; rather, an image of the parent becomes alive and "real" within the child's psychological life. The child carries the parent around inside, so to speak, and uses that "inner" parent, along with the external one, to develop a sense of self and guide him or her through the terrain of human relationships.

To qualify for entrance into the child's inner domain, the parent must have deep, emotional significance for the child. The more the parent is involved in the child's life, the more likely the parent will achieve that significance and be internalized within the child as a central figure. I am proposing that children are quite capable of internalizing two primary parents, with benefits to their establishment of trust. A related benefit is that the child at a very early age grows sensitized to the variations between Mother and Father, bathes in the richness of having *two* central inner figures, and develops a more variegated and flexible personality style based on an early exposure to difference.

It is not just that the child is exposed to different people, but that the ministrations, emotions, and communications that transpire between each of the parents and the child give the latter slightly different mirrors in which to see him or herself. Little Brandon, a child of one of the families in the study, incorporates within himself an image of a father who is playful and whimsical. He begins to develop an inner picture of himself as a happy-go-lucky little partner to this father, an image first reflected through the eyes of his father. His mother, a rather serious sort, is absorbed within him as the person he brings his innermost worries to. She reflects back to him a sense of himself as a contemplative child. With these two "mirrors

of self" sharing an equal place on his inner walls, Brandon begins to develop a picture of himself as both playful and introspective. As long as these reflections do not contradict each other, putting the child in a bind as to the real nature of his character, the child can evolve with a richly textured sense of self, a self fertilized by two very involved parents.

The parents not only offer variation to the child, in his or her inner and interpersonal life, but they also can balance each other. This is obviously true in any household with two parents, but when those two parents move toward equality in their involvement, the issue of complementarity takes on unique meaning. The child navigates daily between two parents. Even with a preference for one parent over the other, the child's dependency is fairly evenly distributed between Mother and Father. In that case, exposure to two parenting styles helps the child achieve a feeling of equanimity, if the parents complement rather than contradict each other in their personality differences. For example, a mother's intensity can be tempered by a father's more phlegmatic style. The children may not get as ruffled by the mother's bombastic responses if they can also call on the father's slow patience.

The result, according to these parents, is that the children early in life develop the capacity to be open, relate to many different kinds of people, and easily adapt to new situations. In one mother's words, "our son is extremely flexible about who he's with. He uses people to the maximum, whoever is there with him. He also shows positive approach behaviors towards new people."

Learning to Read Social Cues

The flexibility that these mothers and fathers see in their children might be present in *any* child whose parents have a sensitive and nurturing approach to childrearing. What is unique to children with a more involved father, however, is the precocious development of interpersonal acuity and social discrimination skills.

Not even two yet, Nadine already knows that if she wants to try dangerous feats at the playground, she should stick close to Dad, because Mom is too squeamish and overprotective about such things. But if she wants to get help with something while preserving her autonomy so she can do it "myself," her best bet is Mom, because Dad has a tendency to take over and do it himself. With two parents present the children are provided with very early training in these

types of discrimination skills, which are then applied to the outside world with a feeling of competence and assuredness on their part. These skills are what the parents point to when they describe the positive outcomes of shared parenting for their children.

The children at a very early age also learn to pick up on subtleties in the mother-father dynamics. Mother, because she has more difficulties with internal boundaries, can be somewhat more available than Father. Gary and Suzanne are a couple who have struggled for years over the conflicts between his tuning out and her tuning in. Suzanne reports that their daughter, Kira, has always been sharp in picking that up. Like a homing pigeon, she makes a beeline toward the parent who is more available—in this case, Mommy.

Kira, like many children, learns to go where she can get results. When she wants adult attention, Gary may not be a likely target, because he can sit behind his book and say, "Not now, Kira, can't you see I'm reading?" Suzanne, because of her own inner make-up, has no such defenses, nor might she care to respond that way. Kira, in her very early life, learns to navigate and discriminate. With the practice provided by having to negotiate with two involved parents in getting her needs met, the child develops a sharp eye for differences.*

The precocious development of these discrimination skills can be seen in a very positive light: These are children who will grow up adept in reading social cues and highly sophisticated in traversing through a heterogeneous and complicated society. Yet, one cannot help but hear some less attractive labels or attributes applied: facile, manipulative, superficial.

For example, if a child never has to grapple intensely with a stubborn or cantankerous parent, but can instead bounce over to the other parent, who is more malleable and sweet-tempered, will the child be tempted to find easy outs in other relationships? A strong belief among some is that marriages are not working out so well these days because marriage partners are not willing to stick it out

* As the children pick up the subtleties of differences between Mother and Father, they can become the external reinforcer of those differences. For example, each time Kira seeks out Suzanne rather than Gary, she shapes Suzanne's behavior so it continues to be more "tuned in" to the child and less preserving of Suzanne's extra-parenting self. So, ironically, the presence of two involved parents not only stimulates the child early on to make subtle discriminations between two equally present people; it also puts the child in the position of *active* agent, who may reinforce or underline differences that already exist in the parents.

and go through the hard work and pain of ironing out the rough spots and so-called irreconcilable differences.

Supposedly, the early relationship with a mothering figure is the child's first lesson in struggling through an intense, one-to-one relationship where, in essence, there is really no escape. It may be imprinting for monogamy, as Margaret Mead said, but in a society that continues to emphasize the value of a long-term couple relationship, even in the face of its obvious social failures, it may also be preparation for a "good" marriage.

With two equally available parents, we cannot discount the possibility that the child might early internalize a notion that if you are uncomfortable in an intense relationship with one person, there is always another one readily available. Shared parenting, rather than providing an added intensity, depth, and richness to the inter- and intrapersonal experience of the child, could dilute those very qualities. On the other hand, a couple relationship could become less frightening when there is not the impossible expectation of replicating the lost, exclusive mother-child bond from yesteryear.

The real test will, of course, be an investigation of the sharing children's actual intimate relationships as they enter adulthood, but in the meantime there is no evidence in these young people's lives of anything approaching interpersonal superficiality.

100–100 Parenting: Risks for the Child

One legitimate worry that does remain about the co-parenting children's social and emotional development relates to the phenomenon of wall-to-wall parenting. We have two parents who are often involved in "double" parenting. Not just one parent gives the child a bath, but all four parental hands immerse themselves in the soapy water. If there is any place where *more* might actually be *less* for the child, it is in this risk of "overparenting."

One day, when my daughter was three years old, we accidentally left a tape recorder on during a family dinner at my husbands' parents' home. I was devastated to hear what played back to me: two eager, effervescent parents talking a mile a minute, *simultaneously*, in each of Rebecca's ears. Like a nightmare of two out-of-synch stereo speakers blasting in her head. How relieved I was to know she hadn't become catatonic or stone deaf from the experience. Of course, the outcome was hardly that catastrophic. But the incident certainly made me take stock of how much we might be "overfeed-

ing" our child with stimulation and attention as a result of both being so child-focused and "on" all the time.

Paul sat at the dining room table, jiggling his baby and diverting him with a music box to give us some quiet while I conducted the interview. The subject matter was not this cherubic little boy but his older son, Zach, who was now twelve. With a critical, observing eye and the wisdom of many parenting years behind him, Paul described better than anyone else could the toll such overfeeding can take on the child over time:

> We're both so damned involved with him. It happens in praise, happens in inquiring about his day, or about a certain event or interchange. If one of us happens not to be here at the time, he's got to go through it twice. We both have to be filled in. There's no one whose responsibility it is to keep track of what's going on with him day-to-day. Like in my family it was my mother. My father only heard what I chose to tell him. He didn't ask me any of that stuff nor did I care to tell him.
>
> If Zach does something wrong, we're both likely to get on him and discipline him. If he does something we like, we both praise him. Now he doesn't like to get praised. He gets embarrassed. He finds it very hard to accept praise from us.
>
> When he does something well, it's so noticed that he doesn't have any privacy. He's telling us to get off of him, now that he's old enough. Now that he's articulate enough to tell us, we've learned to realize how overinvolved we had become with him. For example, he'll say to me, "I went through all that with Mom already!" When he was younger, he was already letting us know that it was too much for him, but not directly. He would just act it out in some way that made it clear that he couldn't take it anymore. Like, we'd both be praising him about something and all of a sudden he would just get up and leave the room.
>
> Over many years we're much better about it and we try not to do all that double stuff, but it was a number of years before we were even consciously aware that we were doing it.

Paul goes on to admonish those involved in some form of dual parenting, with all their good intentions of providing their children with the best and the most of their emotional presence:

> Not only do you get all the positive stuff from both people. You get the negative stuff from both people. The kid gets twice as

much shit. And you get twice as much parenting if you're not careful. That is, somehow it doesn't feel like there's a finite amount of parenting that needs to be done and that you could sit down and divide it half and half. If you could, then it would be wonderful split parenting. It's like it grows geometrically with the number of people involved in the parenting, so that when there's two parents, the kids have to take almost twice as much.

If we think back to the original shared parenting concept, each adult would take up only half the parenting to add up to the parenting that occurred in the past, when only one parent was primarily responsible. But instead we see, as we have remarked, a phenomenon that at times approaches 100–100 rather than 50–50 parenting between two people. And the potential fallout for the children is an overinvolvement even more extreme than the overinvestment of the 1950s mother who had nothing but her child to live for and was forced to channel all her creative energies into that small human being. The consequence for the co-parented child can be a feeling of emotional suffocation, accompanied by squeamish or avoidant reactions to the parents' loving, but undaunted and perpetual, scrutiny. In no way can this be beneficial for the child's development of autonomy or his or her ability to regulate the level of distance or connectedness to another human being. Attachment may go well for the child. But *detachment* seems quite another matter.

Fortunately, most parents are aware that this kind of smothering is a possibility. Each parent was asked in the interview to identify any negative effects of shared parenting for the children. Next to the confusion resulting from the "changing of the guard" and the ambiguous division of labor between the parents, the most oft-cited potential problem was exactly the phenomenon of overparenting.

And many have attempted to remedy it. For example, a close friend of mine revealed that she has come to realize that the problem in their family is that she and her husband have never known who is supposed to do what, so they both end up feeling responsible and beleaguered by everything when it comes to running the household and raising their two children. Like Paul, she saw the children reeling from this lack of clarity and duplication of efforts. She and her husband have devised a solution, in the form of a more clearly differentiated division of tasks: One will do *all* the cooking, for example, while the other will be responsible for *all* their daughter's music lessons and practice. In that way, my friend hopes both to

make life saner for herself and to eliminate the problems for the children that Paul warned about.

But given that the problem of the all-hands-on-deck approach has not been totally licked yet, there indeed appear to be psychological manifestations for the child of two very involved parents. In the early years, there is a tendency for the sharing child, particularly if it is a first or only child, to have difficulty entertaining her or himself. If they have had the doting attention of *two* primary caretakers in their first months and years, the children certainly do become quite social, to the point that what is interfered with is the very capacity to be alone or call on one's inner resources to sustain oneself.[2]

Instead, the parents are ever-responsive and take advantage of every available opportunity for social interaction with the child. Particularly if both parents work during the day and regroup during evenings and weekends, they are eager for time with the child. Whether because the parents genuinely want more time with the child, feel guilty for not being there enough, or engage in a subtle competition to come in at least neck and neck for the number one position in the child's eyes, the effects on the child are the same. It becomes a rare event for the child to have even a moment to her or himself, or to be asked to be alone.

In the early months, with the joy of a new and happily awaited baby in the home, the showering of attention on the obviously blossoming infant presents no problems or concerns. It is as the child grows older, faced with new developmental challenges, and the novelty of parenting wears off that trouble can erupt. Beginning at the end of the first year and into the second year, when other children are able to play alone for several minutes or occasionally turn to themselves for amusement, the sharing parents begin to notice that their children are either not able or show no desire to sustain or entertain themselves for more than a few moments, if at all. As months or years go on, it doesn't get any better, culminating in the chronic child litany, "There's nothing to do today. What can I do?"

No doubt there are constitutional factors and temperamental styles that contribute to individual differences among children in the capacity to be self-sustaining, regardless of environmental factors or family life. But the style of shared parenting that represents 100–100 rather than 50–50 parenting either exacerbates individual children's problems in acquiring the capacity for self-sustained activity or perhaps

even inhibits their development of this trait where it otherwise might flourish, given a different kind of parenting input.

Where the saliency of parenting style becomes especially obvious is in the difference between first or only and later-born children. Recent studies in sibling differences indicate that in any family, regardless of the style of parenting, the first-born often shows the effects, both positive and negative, of being the doted-upon child. I am suggesting that the problems are aggravated in the sharing family (where overinvolvement is already built into the system), so that the first or only child gets a particularly heavy dose of doting. By the time a second child comes around, a mother and father realize that something has to give, often with the solution of one parent per child, which at least reduces the opportunities for four hands on one child. No surprise, then, that parents repeatedly reported that child number two just happened to be more self-contained and less demanding.

The outcome of 100–100 parenting may not be just a decreased capacity to be alone, particularly if there is only one child, but also a cultivation of entitlement and egocentrism. Suzanne's little girl, Kira, was considered a real handful by both her and her husband. Suzanne also thought that they had not entirely done the best for Kira by their shared parenting patterns:

> We are both so involved with her. She is a very powerful child. The child becomes the center of the universe because of that degree of involvement and focus on her.
>
> Kira wants to be part of our unit. She gets into seeing herself as an adult in the situation. She'll do better with another child. A single child in shared parenting feels she has a right to both parents that will be remedied somewhat when she has to share those parents with another child.

Parents worry that expectations like Kira's can mean trouble. What kind of trouble? In common parlance, maybe a spoiled brat: a person who can tolerate nothing but immediate gratification and anticipates consistent and unfaltering service from others.

There is also the problem of children coming to believe that they are miniature adults. Suzanne hints at this when she refers to her child's expectation that she is just one of the gang, on an equal par with Mom and Dad. With two parents doting on the child, and devoting the vast majority of their time to the child rather than to each other, the child came to expect to be in on a lot of things.

As a result, the child does not make distinctions between adults and children that many of the parents remember themselves making in their own childhoods.

Two parents who work in the same field described an incident during a professional consultation group held at their home in which their two-and-a-half-year-old son "sat in" while his mother and father participated. The little boy listened intently, trying to grasp the words, and unabashedly piped in, "Now, what's a metaphor?" Far from the old motto that children should be seen and not heard, these little ones are precocious and eager and also take it completely for granted that they are entitled to full, equal weight being given to their questions and concerns in any situation, regardless of their age or status.

This sense of child entitlement in an adult world is a problem shared with other modern families in which generational differences are more muted and children are both allowed and encouraged to speak up for themselves. Optimistically, a child raised in this atmosphere can become inquisitive and self-confident. But the potential end product is a child who may be too adult-oriented, perhaps even a bit "odd" or clumsy among peers. The risk is exacerbated in the shared parenting family because of the intensity of intimate family time spent with *two* adults.

A built-in antidote can be the hours that the child spends in day care or school. The child may be the center of attention at home, but in a group situation the child is reduced to one among many, who must learn to share and cooperate with both children and adults alike. The children from sharing households typically spend a good part of their day in such settings and do appear to do very well in both relating to peers and relinquishing center-stage status.

The child develops a fuller sense of self; the child cannot do anything herself. The child learns that two people love and care for him; the child expects to be loved and cared for every minute of the day. When it comes to the development of autonomy and independence, these are the dialectical tensions that exist for the child with two involved parents.

Democracy in Action

When I was little, I would wake up and call for my mother. My father would come in and be upset because I hadn't called Daddy. So I just started calling "Parent, Parent."

RACHEL, AGE 14

Rachel's parents adamantly protested that this was not the case. They insisted she had simply fabricated the story for dramatic effect. Perhaps so. But it almost doesn't matter. Even if Rachel is just spinning a tale, it speaks to a growing child's fantasies of what it is like to have *two* parents so centrally involved in her life.

Rachel certainly had a twinkle in her eye and an upturned smile of mirth as she teased her parents with this story. In no real way had she actually squelched her own emotional needs and desires for the sake of her parents' well-being and commitment to equality. I have watched with great warmth and respect the sensitivity and responsiveness of each of Rachel's parents (both close family friends) to Rachel's needs, which might be better met by Mother or by Father at any particular time. But she certainly has internalized an understanding that equality and fairness to others is extremely important, and that showing favoritism or preferential treatment can be harmful.

When two adults parent together, the children observe and directly experience negotiation, compromise, and conflict resolution. Whatever the social values of the parents who embark on a sharing arrangement, just the process of doing it together breaks down the patriarchal norms of the traditional family. No longer is Father the emotionally absent but socially more powerful figure who controls the purse strings and makes the important life decisions for the family, while Mother keeps the home fires burning.

The children inadvertently develop a sense of democracy in social relationships as they watch their mother and father in action, a phenomenon that is true not just for the strictly 50–50 family but for any family in which Father moves toward more active involvement in the everyday affairs of the household. "He's able to watch us work things out on the spot. See what shared responsibility means."

From a social learning point of view, the sharing parents become a model for the child to follow. Rather than autocratic, unilateral, or arbitrary rulings, the child witnesses parenting by committee. Since one of the touchstones of shared parenting is that no one person is in charge of decision making, decisions by consensus become the norm. If Stacey wants to get a pair of sharp scissors and her mom and dad are not sure she's ready for them, Stacey may very well see Mom and Dad talk it out with each other and come to a decision. In that way, Stacey internalizes a style of negotiation, mutual listening, and conflict resolution that is compassionate and cooperative in tone and will prepare her well for a future life as a democratic citizen. From identifying with her parents and watching

and taking in their process, Stacey herself will emerge with highly developed group process and interpersonal communication skills.

At the same time, the child's participation in the larger social order will be greatly enhanced by experiencing Mom and Dad as a bloc. Stephanie, now an experienced parent with two children, reflects that "one of the things we do best is not get drawn into taking sides." Once a final decision or policy is implemented, the parents reported, they try to make a point of supporting each other. So if Stacey's parents ultimately say No to the sharp scissors, even though Mom may have originally leaned toward saying Yes, it is imperative that Mom not begin to waver or cave in when Stacey whines, "Oh, but that's not fair, and I really want one, and I hate you both."

In that way, the child gets a sense of a firm, stable system in which Mom and Dad work not against but with each other. Subsequently, it is hoped, the child experiences the social world as consistent and dependable and also grows to understand the process of talk and negotiation that occurs between two people as a significant and worthwhile endeavor not to be taken lightly.

Discipline is the area in which mother-father unity came up most repeatedly as an issue for the parents. In open-ended interviews, both mothers and fathers consistently brought up the topic spontaneously when they spoke of the unique issues of raising a child in a shared parenting household.

If there is any area in which the child development research and literature has demonstrated the need for consistency between adults in childrearing, it is that of discipline. Without a reasonable amount of consistency, children have been shown to be hyperactive, anxiety-ridden, aggressive, or depressed in their school functioning. They become a burden to both teachers and parents alike.

"I'm stricter. I have a tendency to want to do things more firmly. I feel an urge to move in. I criticize Barbara for being too wishy-washy." This is the first challenge of discipline enforcement in the shared parenting arrangement. In *any* family there is typically a gap between the father and the mother on the lenient-to-strict spectrum. Hard cops and soft cops just seem to be genetically attracted to each other. In the police investigating room those two styles may well complement each other, but they present a particular problem for the mother and father who are sharing responsibilities and trying to be unified. Discipline becomes one of the toughest measures of a couple's unity, which is why the parents kept raising it as an issue.

Bob is honest that he and his wife Audry have tensions about discipline:

> It has to do with my confusion about what's most appropriate. Sometimes I feel Audry disciplines Valerie as you would an older child. I would do things in a different way. I would focus on redirecting, rather than paying attention to the behavior.

But he and Audry have talked it out and done their best to work out their differences and come out with an approach that feels comfortable to both of them. And for Valerie he thinks that has been a great advantage:

> She sees us as one voice, not a "Wait until your father comes home!" Whoever is there will deal with it. And as consistently as possible.

No longer are fathers menacing giants who return at the end of the day to mete out punishments and just rewards. A child instead experiences a parenting duo in which two people decide democratically how their child should be handled.

In the best of possible worlds, if the parents have not had time in advance to work out an agreement about how to handle a situation, as is often the case with the sudden and unpredictable eruptions that warrant adult intervention, a moral code is invoked: If one parent steps in, the other parent should stay out. As Pete explains it:

> If I'm in conflict with Esther, I put pressure on Stephanie not to intervene. That would be subversion. We're fairly unified around discipline.

And right he is to put such pressure on Stephanie, for she confesses that

> sometimes I think he's too strict with them. I want to defend the kids against this brute man. Sometimes I think he is too hard on Esther.

Instead of stepping in, Stephanie stores up her feelings until later, hashing it out with Pete out of earshot of the children. In that way they avoid confusing Esther, putting her in the middle as they play out their differences.

By observing the parents negotiating and working cooperatively and being the object of that joint endeavor, both in discipline and

in other areas, the child incorporates a respectful way of treating others and of relating in a parallel, rather than hierarchical, fashion. Some parents in sharing arrangements carry this even one step further by including their child in the decision-making process. Again, this is part of the larger ethos of the "enlightened" parenting of this generation, in which children are brought on a more equal plane with adults. The sharing family is a particularly fertile breeding ground for such child-centered "participatory democracy." With two people already actively involved in democratic decision making, it can seem a "natural" extension to also include the child. Many of the parents believed this to be very good for the child, imbuing him or her with a greater sense of social effectiveness and self-respect.

Dr. Diana Baumrind's studies of parents and children buttress the parents' beliefs.[3] Children raised in democratic households, in which the parents were consistent, nurturing, and respectful of their child's input, were found to be both better socialized and independent. They were very competent little people.

But as with other virtues (for the children) of shared parenting, there is an underside to the blossoming of the democratic and socially competent child. Many years ago, while vacationing with our children, we rented a canoe by the hour. Unfortunately, for reasons inexplicable to us, Rebecca, six at the time, developed a sudden aversion to the canoe and refused to get in. Right next to us was another family of four, and as coincidence would have it, they too had a canoe-phobic child in their midst. For twenty minutes we sat on the banks of the river exploring her fears with Rebecca and gently coaxing her to at least try it. Seven dollars of our twenty-dollar rental fee went into the process.

In the meantime, the father in the next family leaped forward and yelled at his boy, "Get in or I'll whop you one!" Twenty minutes later, they were all out on the water having a thoroughly enjoyable time and getting their full money's worth, while we still sat forlornly on the shore. Gazing at the other family happily splashing in the current, I thought to myself, "Is all this democratic process really worth it? Maybe a little more authoritarianism wouldn't be so bad. I mean, who's having the good time on this river, us or them?"

Obviously, two parents who share parenting could be as authoritarian as the family in the next boat. They could be two bosses instead of one. But because so few decisions are made unilaterally, the proneness toward participatory democracy in the co-parenting household

raises some important concerns for "enlightened" parents about "overdemocratizing" the child.

Anyone who has worked in a group that bases its decisions on participatory democracy knows the tedious torture of discussing and negotiating an issue to the *n*th degree before any action can be taken. So it is for the child who must wait around while Mom and Dad go through the painstaking process of parenting by committee on the spot.

Not only do the children have to wait, they may also be exposed to more daily conflict than is good for them. Parenting by committee is sometimes an open floor debate to which the children are privy. The negotiations can get heated if Mom and Dad both have a high stake in the outcome. After all, they are both equally invested in how the parenting will come out. Even after the issues are settled, there may be a residue in the air. Rather than the children imbibing confidence about human relationships cemented through talking things through and deciding together, they can become despondent or aversive to such democracy in action, tired of all the responsibility put on their own little shoulders, and perhaps a little hungry for someone to just tell them what they should do.

As a defense against the parents' seemingly endless negotiations, the child may also resort to playing one parent off against the other. The more two parents try to parent cooperatively, the more we might encounter this, particularly if there is a crack in the system and the parents begin to lose their team spirit.

Kate, age thirteen, sometimes feels suffocated by the lack of clear lines of authority in her family. Tired of having to get an OK from *both* parents, she resorts to the age-old trick of going to Dad for a Yes when Mom just said No. She can never understand how her father and mother can telepathically communicate from the second to the first floor and block her maneuvers. She hasn't figured out their main counterdefense: the speed of her delivery and her flight from their gaze give away her second asking. Kate's manipulative efforts, although thwarted, alert us to the potential of a Machiavellian rather than a democratic child evolving from the shared parenting experience.

From the child's point of view, having two involved parents is beneficial to attachment, more problematic to detachment. Co-parenting provides the child with an opportunity to develop strong

social competence and democratic skills; it runs the risk of breeding egocentrism or self-centeredness in the child. That is the answer to the question, "What happens when *two* people mother a child?" Now we turn to the next question, "What happens to the child when one of those parents is a man and the other a woman?"

12

On Becoming a Girl
or a Boy

What are little boys made of? Dirt, and snails, and puppy dog tails, that's what little boys are made of. What are little girls made of? Sugar and spice and everything nice, that's what little girls are made of.

If each generation were left entirely to its own devices . . . , without even an older generation to copy, sex differences would presumably be almost absent in childhood and would have developed after puberty at the expense of considerable relearning on the part of one or both sexes.

H. BARRY, M. K. BACON, AND I. I. CHILD, 1957[1]

The very first categorization we learn about ourselves as young babies is "I am a girl" or "I am a boy"—even before we know what color we are, what religion we belong to, or what ethnic group we came from. For the rest of our growing years, and even into adulthood, we struggle with what that means, with how we are supposed to act, and with who we are as a male or female self. The nursery rhyme tells us it is simple: Boys and girls are made of different stuff. That's just the way it is. But anthropologists who have traveled throughout the world tell us it is culture and society that dictate what will be a boy and what will be a girl, not the stuff inside the child. We need only alter certain factors in that

culture to see that what is a boy and what is a girl change accordingly. So, gender is perhaps a social category, not an immutable, biological fact.

Regardless of whether one is on the nature or nurture end of this enduring controversy, it is generally agreed upon that one's sense of self as either male or female is both a critical and a universal dimension in all societies. In that context, the worst fear of critics of the shared parenting arrangement is that children will grow up gender-confused: that they will not acquire a clearly demarcated sense of what it means to be male or female. In the words of a prominent psychologist, such confusion in childhood might then result in adolescents or adults who "strive to avoid adopting sex-typed responses because of anxiety over the behaviors that are prescribed for their sex roles. These individuals are typically in conflict and are likely to manifest a variety of psychopathological symptoms."[2]

The critics are right to be concerned that something might happen with respect to gender. As social scientists like Margaret Mead and Barry, Bacon, and Child have demonstrated, genderedness is a culture-bound phenomenon that exists as a universal social category but that varies enormously from one society to the next in its content and meaning. What is "feminine" for women in one culture may be strictly forbidden to women in another. The same is true for men. The only thing about gender that *is* universally true is that women mother infants and young children all over the world. Now there is a small group of parents, whether they are consciously committed to altering gender development or not, who are disturbing that universal norm by including the father in intimate daily caretaking. That departure from the norm makes people either nervous or excited regarding its effects on children's masculinity and femininity.

What Is Gender Anyway?

In a liberalized era—of sex change operations, increased albeit not unproblematic openness about one's sexual preference, and a greater demand for sexual equality—the question of gender alterations still evokes deep-felt and primitive emotions within us. In 1978 in California there was a right-wing campaign to keep homosexual teachers out of the classroom for fear they might either molest children or induce the children to themselves become homosexuals. Studies of homosexuality indicating absolutely no correlation between a par-

ent's sexual preference and their child's made not a dent on the proponents of this campaign. And although the initiative was badly defeated by the voters, it did stir up people's confusions and fears about children, sexuality, and the ingredients that go into making a boy a boy and a girl a girl.

The psychoanalyst Phyllis Tyson has untangled the confusion for us by breaking down gender into three separate categories.[3] Her breakdown will help us identify the issues about children's gender that are really in question when we introduce a man into the mothering arrangement.

It behooves us to be meticulous here, because one core argument in favor of shared parenting is that it is a prerequisite to the alteration of gender-specific personality traits in boys and girls. It is those traits that create the "being" in women, the "doing" in men, and the difficulties for men and women in relating to each other.

The issue is *gender identity:* the compilation of characteristics that make up each person's combination of masculinity or femininity. According to Phyllis Tyson, "these characteristics may be determined not only by biological sex and anatomy, but by psychological factors such as object relations, identifications, intrapsychic conflicts, and bisexual conflicts—not to mention cultural and social influences."[4] In other words, becoming a girl or a boy involves an interaction between the biological, the social, and the meeting of those two within the *intra*personal world of the child.

There are three components of gender identity: core gender identity, gender role identity, and sexual partner orientation. The first, core gender identity, is simply that primitive sense of "I am a girl," "I am a boy." In normal development a child has already consciously acquired this awareness by eighteen months of age, and in fact after twenty-four months it essentially becomes an immutable category in the child's psyche. The second, gender role identity, comprises the child's actual behaviors in the world that are directly related to the child's core gender identity. In other words, it is how one acts, thinks, or feels *because* "I am a girl" or "I am a boy." The third part, sexual partner orientation, which typically does not become relevant until adolescence, refers to the individual's choice of sexual partners, either same-sex, opposite-sex, or both.

The first category, core gender identity, should occur no differently in the co-parenting family than in any other family. Innate biological structures, the child's assignment to one sex or the other at birth, and the child's cognitive capacities and attention to body image,

accompanied by the parent's acceptance and appropriate communication to the infant that it is either male or female, are all the ingredients necessary to bring the child to the sense of "I am a girl (or boy)." Nothing in the restructuring of parenting so it is shared by a man and a woman should in any way significantly alter these necessary ingredients—though we could imagine that it might speed up the process for a boy baby, because he now has a male parent more readily available for comparison, exploration, and identification. But in general the children in shared parenting families seem no different from any other children in their development of core gender identity: They all have a firm sense that they are either male or female by the end of the second year of life.

As for the third category, sexual orientation, psychologists should be humble enough to say that they really do not know how sexual preference develops. We have theories that either contradict each other or do not hold up to empirical test. One theory says that an overbearing, seductive relationship with a mother creates a homosexual son. Yet plenty of men with overbearing, seductive mothers did not become homosexual, and plenty of homosexual men did not have overbearing, seductive mothers. One theory states that lesbianism results from unresolved pre-Oepidal issues with Mother in the first years of life, while yet another states that a difficult or abusive relationship with Father causes the girl to turn away from men and toward women as lovers. Some theorists argue that sexual orientation is at least in part, if not predominantly, constitutionally determined—by hormones, perhaps.

Since we have no reliable theory that consistently explains the development of the third category, sexual orientation, we would be hard pressed to speculate what the impact will be on a child's ultimate sexual orientation of having both a man and a woman involved in daily caretaking.

It is the second category, gender role identity, that is the central concern with respect to the children of shared parenting families. It involves a subjective sense of how people experience themselves as male or female—which is acquired not just through direct teaching, training, and modeling, but also as a result of the subtle, often unconscious exchanges between parent and child in the intimate moments of daily life. Gender role identity encompasses not only culturally learned behaviors and the child's cognitive understandings of what male and female are, but also the relationships with important males and females in the child's world as they are absorbed

into the child's inner life and internalized as part of the child's self.

Both the observable behavior of males and females and the child's relationships with Mother and Father are typically quite different in the shared parenting family than in the traditional household. First, each of the parents is being nontraditional in his or her own sex-role behavior. Secondly, the child now has an intimate "mothering" relationship with both a man and a woman, and therefore that child's internalized world of relationships with men and with women will be different than a family in which a woman mothers and a man takes a back-seat role in parenting. It makes sense, then, that we should look with either eager expectancy, if we are advocates of the revamping of old gender ways, or anticipated disapproval, if we are preservers of traditional gender norms, to the probable alterations in gender role identity in the children of families wherein fathers and mothers share.

A Parent's Dream

The social critics of shared parenting seem much more preoccupied with the gender outcomes for the children of sharing parents than do the parents themselves. Instead, as I mentioned earlier, the couples were much more pressed to talk about the effects of having *two* parents involved in the children's care. But when parents did bring up gender, it was done with self-reflection concerning an area to which they had clearly given considerable thought.

Although it is not a necessary component of shared parenting, a predominant dream of many of the couples who choose to co-parent is to provide for their children freedom from sexual stereotyping and expanded choices based on personal desire rather than on the gender constrictions imposed by the culture. Psychological studies have revealed higher modes of functioning in such areas as creativity and moral development when there is a breakdown of sex-typing and an integration of the masculine and feminine modes in children.[5] It is this enhancement that many sharing parents want for their children.

Eileen, dressed in overalls and a tee shirt, gazes out her apartment window into the morning sun, imagining her small daughter as a grown-up woman. Slowly she turns back toward me and muses:

> She'll grow up knowing that daddies are people, too. They're not god-like figures that come down from on high. It will make

her expectations for a husband different. She'll want someone with more active involvement. She'll learn that mommies go to work. Maybe daddies do, maybe daddies don't. She'll know there's a whole range of options. They're all OK.

It is not just the child's exposure to men who are more involved with their children or women who leave each morning to go to work. The child is also learning and *modeling* actual behaviors of the parents. A father diapers younger sister, and then his three-year-old son runs to feed his own baby doll. My daughter's favorite make-believe game in her play group was "Mommy goes to a meeting." Through direct imitation and by incorporation of new mental images of what men can do and what women can do, the child can actually become less gender-stereotyped.

The parents are particularly captivated by the impact of the father's involvement on their children's experience of men and women. Shared parenting will be a benefit to Marshall's five-year-old son because "he gets to see his father in a different role than breadwinner. He gets to talk to his father. He gets to see his father cry, hug." So in this respect, the most significant aspect of shared parenting vis-à-vis the children is the provision of a close, intimate relationship with a man—a man whom they discover is as sensitive and capable of feeling as a woman. A man who can give baths and feed babies. A man who is actually around as much as the woman in their lives.

For the boy, shared parenting provides a direct model of a new kind of man, a man who has released the "feminine" in himself through active mothering and then gives full permission to the son to do the same. The girl learns that men are not remote and unapproachable, and she grows to expect sensitivity, nurturance, and relatedness from the men in her life.

Clinical psychologist Sam Osherson writes in his book *Finding Our Fathers*[6] that men—and women, too—search throughout their lives for the father they never really had because of his emotional and sometimes physical absence. The shared parenting couple completes the search through offering their own children the presence and availability of the nurturing man they *didn't* have—the finest gift they feel they can give to their offspring, and a gift that simultaneously helps them heal their own old wounds.

The importance of the mother in conveying the message that biology is not destiny and that women can combine work and parenting should not be overlooked. Yet, ironically, Marsha, swollen with

her child-to-be, brings her deviation from traditional motherhood right back to fathers: "I think shared parenting sets an example for my girls that I married someone who respects my desire to have both a career and be a mother." There are many households today in which women both mother and have a career. But even more significant for the child's gender development is the presence of a man who supports that change.[7] There is some implicit understanding that the man, who has more to give up in a male-dominant culture by eschewing the roles and prerogatives of traditional manhood, is the most salient force in communicating to the child that we really are free to be who and what we want to be.

So, many of the parents believe that their children's gender development will be deeply affected by their being raised by both a man and a woman who mother. Are they right?

Shared Parenting and Oedipus

Oedipus, cast out in infancy because of a prophecy that he would kill his own father, indeed returns to his homeland to unwittingly fall in love with his mother and send his father to his death. Upon realizing the horrific nature of his acts, Oedipus gouges out his own eyes. Proceeding from this myth, Freud generated the psychological theory that all boys in young childhood fall in love with their mothers and wish their fathers out of the picture. The resolution of this drama is the son's identification with the aggressor, the father, who might otherwise retaliate against him for the boy's hubris is wanting not only to compete with but to vanquish his father and take away his wife. With that identification also comes the repression of the little boy's desires toward his mother. Consequently, by age five or six, he emerges a little man, repudiating the world of women and fully indentifying with the world of men.

Freud was a bit more shaky in developing a parallel story for the little girl. But she, too, falls in love with her father and dreams of banning mother from the kingdom so as to hook up with Daddy, give him a baby, and live happily ever after. This, too, is a fantasy doomed to failure, and her ultimate resolution is to accept her fate as a woman who will neither have a penis (a highly valued item, according to Freud) nor live among the world of men and activity. By age five or six, she, too, like her brother, will have repressed her desires for her opposite-sex parent and will fully identify with the world of women.

All of this presumed the nuclear family in which women stay home and take care of children and men are the instrumental bread-winners and more distant figures in the home. Social scientists, clinicians, and feminists alike have spent years both poking holes in the theory and creating alternative paradigms for how girls become "feminine" and boys "masculine." But regardless of the theory's validity, Freud alerted us to the crucial significance for becoming male or female of both the real and fantasized relationships of a small child with Mother *and* Father.

Within a psychoanalytic framework, Nancy Chodorow refers to the situation in the traditional nuclear family that dictates how boys will become male and girls female as "Oedipal asymmetries."[8] There is a triangle consisting of man, woman, and child. But in that triangle man is more distant from child than woman, given a household in which only woman mothers. For the girl to head down the road toward womanhood she simply has to ally herself with the adult whom she has already known most intimately from birth, her mother. But for the boy to progress toward manhood, he has a longer road to travel. He must disengage himself from that same intimately known woman, his mother, and become allied with a person he knows far less well, his father. It is because of this uneven triangle for boys and for girls that males and females end up with such different gender role identities, particularly when it comes to personality styles. Boys are more objective, girls more relational. Boys are more separate, girls more connected.

In the sharing family, the asymmetries are corrected. Even if Mother and Father are still somewhat sex-typed in their parenting, the actual presence of both a mother and father is the most salient factor. Because they are both involved, the distance between the child and Mother and the child and Father is exactly equal, both for sons and for daughters.

Also, according to the traditional account, there actually is no triangle until the child's third year of life. Prior to that, only the twosome of Mother and child exists, and Father is just a fuzzy figure in the background. Even those psychoanalytic theorists who have revamped the theory to give more credence to the significance of fathers earlier in life maintain that Father's main contribution is to break into the symbiotic orbit of Mother and child. In doing so he demonstrates to the child that there is a world of culture and activity outside the confines of the family hearth, a world that offers expanded horizons and freedom from the intensity of the mother-

child bond, which the child is eager to pull away from by the second year.[9]

In the sharing family, there is no such knight in shining armor from the outside world who becomes noticeable to the child only in the second year of life, when the child is developmentally ready to emerge from its exclusive relationship with Mother in infancy. Besides a perfectly balanced rather than an asymmetrical triangle, there has also been a triangle from birth. The baby is no more familiar with the world of women than with the world of men, for both a man and a woman are equally present as two counterpoints in its life. Both Mother and Father represent hearth, and both Mother and Father represent culture. The small child grows up in a much more bisexual world than that of the traditional family, and the triangle begins to look very different.

Consider Andrew, age three, a child in a shared parenting household. Mommy: "Hi, are you my little Andrew?" Andrew: "No, I'm Daddy's little Andrew. Nina [his sister] is yours." A new Oedipal configuration. Supposedly, at the age of three, a little boy should be in the full throes of the Oedipal drama, in which he wants Mommy all to himself and Daddy out of the picture. But this three-year-old boy had eyes only for Daddy. That had been consistently true since his infancy and changed only when he reached middle childhood.

A close friend of mine, a therapist, similarly reports that the Oedipal drama is just not happening the way books say it should in her shared parenting family. Her three-year-old son flirts with her husband as well as with her. There is no doubt in her mind that sometimes he competes with Mommy for Daddy's affections and wants Daddy all to himself. The same scenario is also played out at other moments with Mommy as the object of his affections.

The fantasies of aggression and hostility toward the like-sex competitor are now focused also on the opposite-sex parent. So with the little boy Andrew we hear a dialogue like the following:

ANDREW: Where's Mommy?

DADDY: She'll be home soon. She's with Nina.

ANDREW: I'm going to eat Mommy.

DADDY: You're going to eat Mommy?

ANDREW: I'm going to eat Mommy because she's broken.

DADDY: Because she's broken?

ANDREW: Yes, I'm going to fix her.

DADDY: You're going to eat her to fix her?

ANDREW: Yes.

DADDY: How did she break?

ANDREW: Because I bit her.

The hostility toward a competitor, the ensuing guilt, and the need to repair the damage by fixing the hurt are all there in Andrew's fantasy. Except the competitor is his mother, not his father.

Yet two years later, with Andrew now five, Daddy becomes the rejected parent, as in the traditional Oedipal triangle. Andrew sits on the floor attempting to wrap his Mother's Day present, frustrated. His father offers to help. Andrew cries out, "No, I don't want you! Mommy's smaller than you are. And I want a smaller person. I don't want a bigger person like you. So I want Mommy to do it."

There is no doubt that relationships with both the like-sex and opposite-sex parents are much more complicated for the children of sharing parents than for the children in a traditional family. The child is intimately and fairly equally attached to both Mother and Father. Both opposite- as well as same-sex identifications are apparent, identifications which clearly should influence the child's gender role identity, if the theory is correct.

Living in a Gender-Conscious World

Something significant, then, changes in the child's experience just because there is both a mother and a father equally present. And, as the parents themselves point out, their actual behavior in the walls of the home will also affect the child's gender development. Yet they are also aware that the children do not live in a family vacuum, but are deeply influenced by the larger world around them. With all their dreams of expanded options for their children, they are occasionally rudely awakened to the reality of swimming upstream in a culture that is still dominated by gender stereotypes and prescribed role divisions between men and women.

Margaret and her husband share fully in all the household tasks. Yet her twelve-year-old son defends his manhood with, "I don't do dishes!" Sonya, age three, sat on the couch waiting for her cousin to arrive, dressed to the teeth in a long dress, black patent leather shoes, and a shoulder bag. When her mother suggested she might want to go change clothes and dig in the garden to pass the time

until her cousin arrived, she retorted indignantly, "Ladies don't get dirty!"

For me this reality hit home during a mealtime exchange many years ago. I sat at the table, alone with the two kids, tired after a day at work and in a decidedly crabby mood. Rebecca glared at me with fire in her eyes: "You know what this feels like, Mom? It feels like I'm Snow White and you're the wicked stepmother." She got me in the jugular. Then I started thinking, "What similar insult could she have flung against a crabby father about his crabby fathering?" Our folklore makes room only for nonexistent fathers or for men who save their children from the hands of a wicked stepmother—Snow White, Cinderella, Rapunzel.

If we can accept children's folklore as a reflection of the dominant ideology of a culture and its unconscious manifestations, then shared parenting stands outside the reigning patterns within this lore. The child has no parallel mythological concept of a "bad father"—only horrendous images of giants, ogres, and wicked kings, most of whom do not father children at all. In fairy tale lexicon, women's saliency is in their parenting. Men's is not. It is not that I am advocating the creation of new fairy tales that create wicked fathers alongside wicked mothers. But my small daughter's barb brought home to me how deeply embedded in our consciousness and our children's are the traditional understandings of gender and parenting, even when we systematically set about to restructure them.

With all their dreams and aspirations, then, sharing mothers and fathers are still not totally "genderless" in their parenting. It is not simply that men tend to pick up screwdrivers more while women are the first to reach for the sewing needle. For the children, the differences are played out most significantly in the doing vs. being of parenting.

Sam Osherson reports in his book that "I've been impressed by the numbers of men who report being able to talk as children to their mothers but not to their fathers."[10] Women feel the same way. And what of the next generation? Jesse, our son, tells me he finds it easier to talk to me than to his father because, "Well, Mom, you're a psychologist. And you work with kids. So you understand better than Daddy." But is it really my professional status that dictates Jesse's sense of my "better understanding"?

In several families the parents observed that their children, both sons and daughters, tended to talk more about problems or about their inner life to their mothers than to their fathers. And that was

not predicated on the mothers being mental health professionals who worked with children. Karen stares off into a picture on her office wall as she tries to catalogue in her head the ways their son, Joshua, is different with her and her husband:

> Ira [his father] thinks Joshua may talk about his feelings more with me. He's much more likely to come out with his statements and questions that seem pretty significant.

I asked Karen why she thought this should be so.

> He talks to me more about the baby, and about genital differences. I have thought sometimes that I am a bit more tuned in to some of those concerns than Ira.

More tuned in. That is the key variable that makes sons and daughters seek out their mothers more than their fathers, even in these shared parenting families. But I suspect that the discrepancy between children's talking to mothers and to fathers is hardly as great as in the traditional family, if my family and the sharing families with whom I am intimately involved are any indication.

Yet there still remains a difference, more noteworthy in the parents' eyes when they see it with their sons than with their daughters. The whole point of exposing a little boy to an involved father was so that he could identify with a man who is sensitive and understanding. Within the framework that like will be attracted to like, the implicit expectation is that boys will begin to open up to their fathers, particularly about the problems of being male, once those men become available figures rather than distant gods.

But as the man comes closer in the new triangle, that reduced distance between father and child does not erase the reality that the father, because of his own history, enters parenthood with less ability to "open up" than his wife. His children pick that up, so they turn to Mother. When the little boy grows up he himself may be very different, because he has never had to make the internal shift in identification from a present mother to a more distant father that theoretically causes men to become more closed. But in the meantime, both he and his sister know somewhere inside, from their experience with their own parents, that the world of women is somewhat more "tuned in" than the world of men.

The parents' differences in their play styles can also influence their children's understandings of gender. Francine lets out a chuckle when

she realizes that even when she and her husband engage in the same play activity with their son, the gender split still rears its head:

> David is reading Jason *The Hobbit*. I'm reading Jason this sweet story about two mice in the attic. Talk about a male book and a female book!

If a father roughhouses more than a mother, the children quickly learn whose back to jump on if they're looking for a good time. And whom to go to if they want to snuggle up in the hammock. The parents, despite dreams of androgyny, transmit to the child a diluted version of a gender-typed world, one in which men "do" and women "are." How this weighs against the impact of having both a man and a woman present in shaping the child's gender role identity is what we will turn to now.

The Boys and Girls They Become

So gender consciousness for the child of sharing parents is drastically altered because the child now has two equidistant parents in the family triangle, but is similar to other children's experience because the child still grows up in the same world of sexual politics and values and still has parents who remain gender-distinctive in their parenting styles. So we wonder: Are these children really any more androgynous than children from traditional homes? Do the boys seem more nurturant and relational than boys whose fathers do not mother? Do the girls have better abilities to function in the "objective" world traditionally considered men's domain?

One way to answer these questions is to look at the actual like-sex and cross-sex behaviors and identifications in the children. Sonya, the little girl in the patent leather shoes and long dress, was hardly the picture of androgyny. Even though she had no role model of a mother who dressed that way, she absorbed as a young child the cultural dress code of "femininity" in a strongly motivated desire to differentiate herself as female rather than male. This is a developmental task of pre-school-age children, regardless of family type, and it often finds expression in seemingly extreme statements of gender-distinctive behaviors incorporated from the larger culture.

But Sonya long ago discarded her fancy clothes and is now a young teenager who is decidedly into boys and make-up, but is also athletic, assertive, and very clear about her equal status with boys, even in a culture she knows does not fully support that. Those

"masculine" traits were already apparent in her when she was waltz-
ing in her black patent leather shoes. She, like so many other female
children from sharing families, exudes a balance of femininity and
masculinity—of being and doing, so to speak.

When it comes to cross-sex identifications, though, it is the boys
who stand out more remarkably. "Tomboys" have always been ac-
cepted in the culture, but this new breed of boys, who are nurturing
and unabashedly display the feminine within them, takes everyone
by surprise—even mothers and fathers who are purportedly commit-
ted to gender equality and expanded options.

Cross-dressing is a perfect example. David is a father who does
not believe in essential differences between women and men and
hopes his son will grow up to be who he wants to be rather than
what the culture tells him he has to be as a man. Yet he furrows
his brow when he tells this tale about his son Jason:

> Jason really likes one of Francine's nightgowns and took to
> wearing it. So we bought him his own little pink one. Sure
> enough, a neighbor comes over and sees him in the nightgown.
> That might be difficult for Jason. He thinks this is normal. How
> is he going to feel when he finds this is not "normal"? It's a
> contradiction he will have to deal with.

Jason is not the only little boy dressed in frills. One little boy
wanted to be a firefighter for Halloween. His proposed costume: a
pink dress, rubber boots, and a fire hat. A friend talked to me about
the little white dress she and her son went to pick out together at
the local secondhand store. He carried his precious dress to pre-
school each day for dress-up play, much to the consternation of
some of the parents who watched him proudly march in with his
new acquisition. This predilection for dressing up is not an inevitable
outcome of shared parenting, but it is noteworthy that little boys
of my acquaintance who do engage in such fantasy play share one
thing in common: mothers and fathers who parent together. The
phenomenon, when it does occur, raises interesting questions about
gender development.

Observers and parents alike begin to grow squeamish when they
see boys dress up. It is not just what the neighbors think, but also
stirrings within themselves about possible perversions, and images
of transvestism. Homophobic worries surface, such as when one
grandfather warned his daughter to forbid her son from ever wearing
a dress again or he would be in danger of becoming a homosexual.

Yet no similar anxieties erupt when Janie wants to wear her brother's football uniform or be Superman on Halloween.

In fact, boys' donning women's clothes in their fantasy play is not at all related to later sexual identity. It is our own misunderstanding of what the act means that leads to these interpretations. Cross-dressing in boys' play is merely a manifestation of their cross-sex identifications and the ease with which they express the developing feminine aspect within them in their early years.

They are being no different than the little girl who dresses in fairy costumes and Cinderella gowns. Little boys, too, like the ethereal and magical feeling of silky nightgowns and glittery tutus. Except for flowing capes, little boy dress-up clothes in our culture are just not as much fun. In a family structure which fully affords the opportunity to incorporate both the feminine and the masculine from Mommy and Daddy alike, some little boys begin to consciously express what is probably there in all male children but repressed: the desire to play out the feminine aspects of themselves. But they know it is just make-believe—that they are really boys and that they like being boys.

And they also learn as they grow older that such behavior is completely unacceptable in the larger culture. At such time, usually by school age, the nightgowns and the fun furs go underground, to be played with only within the confines of their homes. But the legacy from their early childhood, the freedom to be "feminine" just as little girls are in fantasy life, likely remains embedded within them, not as a "perversion" but as part of an androgynous sense of self which absorbs both Mother and Father in their development of gender role identity.

Not only do the little boys feel comfortable with the feminine within themselves; they also recognize it or at least fantasize it in their fathers. Craig tells a beautiful story about his young son. He describes a fantasy play in which Daniel, then two, would pretend to be breast-feeding from Craig. Recall that breast-feeding is the very first gender obstacle men must overcome in sharing parenting; yet here is Craig's little son wanting to "pretend" that barrier away by embodying in his father the final vestige of basic mothering that he has learned about in his relationship with his mother. Again, in an equidistant triangle with no asymmetries the little boy identifies with not only the masculine but also the feminine in his father.

The boy, like the girl in the sharing family, expresses both a masculine and a feminine side. But we sit up and take more notice when

it is a boy. In a culture which puts greater value on masculine than on feminine traits, we are more taken aback by a male who would leave that more hallowed ground of men for the lesser world of women and femininity. It is not just deeply ingrained prejudices operating, but also our pragmatic understanding that these little boys will meet up with a harder time in life outside the walls of the home if they are too "deviant" or stray too far afield from the cultural norms of masculinity.

And indeed some of these little boys do openly repudiate many aspects of traditional masculinity, an attitude that their own fathers shared in childhood but typically kept under tight wraps. Thinking that age was the key factor, Gregory, a six-year-old acquaintance of mine, bemoaned to his mother, "Oh, Mommy, I don't want to grow up to be a teenager, you know, a ten-year-old. Because then I'll turn into one of those rough, macho boys." The difference between Gregory and his father is that Gregory in his childhood feels no shame for these feelings but rather has a strong, positive self-image about being one of these "new" kind of boys. In fact, he is quite proud of it.

A mother tells the story of one particularly challenging moment as a parent when her son, Justin, was seven. Her commitment to "androgynous" childrearing was truly put to the test: Justin decided he wanted a canopy bed. With all the frills. He had no idea that this was typically a "girl's" bed; he just thought it was neat. Her mind began to race: "What would the other kids on the block say when they saw it? Would they tease him? Would they think he was really weird?"

After much dialogue with friends and colleagues, she decided that if she was really committed to non-sex-typing, he should have his canopy bed. Her greatest shock was picking him up at school that week to find him and a group of the most "macho" boys hovering around the art teacher. What was happening? The teacher was drawing Justin's bed according to his specifications, and all the boys were ooh-ing and ah-ing and begging to be the first to come see it. So be it for this mother's angst about his masculine survival.

The impact of shared parenting on gender development appears more profound for the boy than for the girl. But the facilitation of cross-gender identification in the new, symmetrical family triangle often leaves the family domain as the only really safe arena for the boy to fully express his "girl-like" side. In this day and age a little girl has far greater leeway to be "boy-like" at school, on the play-

ground, and in the neighborhood. Everyone is excited about her aspirations to be a doctor. No one looks askance when she joins a soccer team, even in the most conservative of communities. The airline stewardess would not bat an eye if my daughter skipped aboard the plane wearing her baseball hat. But if Jesse walked on with a baby doll wrapped in a blanket, he would get more than a second glance.

Little boys in sharing families who choose to express the feminine aspects of themselves are in the same predicament as boys from *any* family that attempts to implement some form of nonsexist child-rearing. Unlike their sisters, who are bolstered by outside institutions which tolerate and sometimes even encourage androgynous behavior in girls, the boys' new behavior still goes against the grain of the larger culture they live in.

The new equidistant mother-father-child triangle, with Father as present as Mother, may inevitably reduce the gender differences in the personality make-up of the sons and daughters. One way this becomes apparent is in the children's feelings about their own sex and the opposite sex: "If I were a girl I would be just the same." This, a seven-year-old boy's poem in a poetry assignment, "If I were a girl . . . If I were a boy." He is from a sharing household. He knew full well that his anatomy would change, but his understanding was that the behavior, feelings, and thoughts which, put together, made him the person he was would be completely unchanged if he were to wake up one morning female.

I had the opportunity to read all the children's poetry in this class assignment. The poems intrigued me. I was first appalled to find that even in a school with an emphasis on nonsexist education the youthful misogyny that expresses itself among boys in girl-hating still emerged, as in "If I was a girl/I would hate it" or "If I was a girl/I would be bad./I would not like it./I would go to the zoo/but couldn't see." And if the boys didn't outright condemn the proposition or identify all the constrictions of girlhood, they had fantasies of remaining boy-like even if forced to become a girl. There were no parallel jingles of boy-hating from the girls.

So we know that male-dominant values are still alive and well in children, even within a school that self-consciously implements a nonsexist curriculum. But when I reread the poems I realized that not one boy from a shared parenting family, of which there were more than a few, demonstrated any such negativity toward being a girl. The little boy above thought he would be just the same. Another

little boy wrote that "If I was a girl/I would like to put on lipstick," and another, "If I was a girl/I would have long hair/and would work at a /traveling agency."

A demarcation also existed between the daughters of sharing parents and other girls in the class. A little girl from a traditional household wrote, "If I was a boy/I would not have to wait to/go on the toilet/I could go in the bushes./I would hate girls and play dirty tricks." She assumes that life would be easier if she were a boy, and that she would easily adopt the misogynist attitudes of the other boys.

In contrast, daughters from sharing households indulged in positive fantasies of "male" activities, particularly sports, or of having male physical attributes, such as mustaches. Actually, the very activities they envisioned doing as boys, such as climbing trees, wearing pants, or running races, were things they were already doing every day as girls.

In fact, the strongest impact of having both a mother and a father involved in child care may simply be the communication to the children that the "feminine" components of life are OK. Just as having both a mother and a father involved reinforces the feminine components in boys, it also instills in a little girl the strong sense that being female is good and valuable. She sees her mother parenting while still achieving other things in life, and genuinely feeling positive about being a woman. She sees her father supporting her mother and also adopting traditional "female" behaviors himself. Buttressed by feminist values that might be available to her in the subculture around her, she has the opportunity to develop a feeling that being female is good. And so one little girl in a shared parenting family would hate being a boy only "because I like being a girl." Another little girl, age three, gives herself the name "Dr. Mommy Wonderwoman." Like the boy who is proud of the "new" kind of boy he is, the little girl affirms herself as a "new" kind of female, soft and gentle but also powerful and competent.

With this "new" sense of maleness and femaleness comes an agility in moving back and forth between culturally "masculine" and "feminine" modes of functioning. One obvious way this is manifest is in cross-sex friendships. Many sons and daughters in shared parenting families establish strong bonds with children of the opposite sex. This is particularly striking in some of the boys, who often seek girls to play with because they, like their fathers before them, do not feel comfortable in "macho" culture and enjoy the companion-

ship and relatedness of little girls over the jockeying and rough-and-tumble play of boys. A boy may also gravitate toward other boys like himself, who have a similar masculine-feminine balance and do not dance to the tune of the dominant standards of boyhood.

It is admittedly a burden for these children to find themselves growing up against the cultural grain. There can be a price to pay, as when the dress-up clothes have to remain behind closed doors or a bully teases about the doll brought to school. But in my personal and professional experience, the benefits far outweigh the losses. The girls develop a strong positive self-image. The boys appear quite content in the social world they have made for themselves, even if they lament the lack of availability of more boys like themselves, knowing full well that they are a minority. Because they have integrated a masculine way of being, too, they are also able to adapt to the mores of mainstream boy culture. So it is that I watch the sons play house with their female friends or "gentle" male friends, yet become wild and rambunctious with their more "traditional" boy pals.

Seemingly shared parenting creates little boys and little girls who internalize a more integrated sense of being male and female and who are highly nurturant and empathic in their behaviors. Not only may little boys be given permission to play with dolls; they also will know what to do with them. But more important than the child's playthings, it is the presence of the father in daily caretaking and the willingness of the mother to make room for him that makes this happen. It happens even when the parents choose to be or inadvertently remain gender-typed in their own personality and parenting styles.

A study by Dr. Abraham Sagi in Israel found that both sons and daughters in families with highly involved fathers showed high scores on scales of empathy.[11] The children I know confirm that. Little girls show no significant edge over little boys in the capacity to relate—and that capacity is a central attribute of both the girls and the boys.

13

When I Grow Up

Some day, when Lorraine and Laverne and other girls about six
or so grow up to be free and be themselves and take what
classes they want in PE, and become paper deliverers or
mechanics and newspaper reporters or doctors or astronauts,
partly it will be because of people like me who helped change
the times.

BETTY MILES, *The Real Me*[1]

Our generation was brought up on Golden Books that taught us
that only boys could become astronauts, while girls should stay
home and cook for them. Only a generation later, children now
have access to fictional characters like Barbara Fisher in *The Real
Me,* who communicate not only that women can enter any profession
they want, but that men can be warm and nurturing just like women.

The children are exposed to this material, but this does not mean
that every child will read this material or incorporate it into his or
her own sense of self. We would expect that sons and daughters
from a sharing family, with parents who are actually living out
such a life, would be among those children who would either be
deeply moved by these messages or simply understand them as re-
flecting what they have always thought about their future anyway.

We know, now, that children of both sexes who have a mother
and father involved in their care develop the "feminine" component

239

of their personality, the capacity to be open and relational. But we wonder, too, about the "masculine" side: the ability to be separate, to be objective, to draw boundaries around oneself. These are often harder traits than either nurturance or relational abilities to observe and measure in growing children, because children are normatively subjective and have loose boundaries, regardless of gender. But we can get some measure of them by looking into the children's projections of who they will be in the future, particularly their attitudes about work roles, gender, and combining family and paid work.

Who Will I Be?

If you ask a little girl what she wants to be when she grows up, she will typically include "Mommy" in her listing. But if you ask the same question of a little boy, "Daddy" is often the last thing on his mind. He is destined for bigger things. Even with the recent emphasis on the "new father" in the culture at large, it has not yet penetrated the consciousness of small boys in the playground—unless they have one of those "new fathers" at home who is genuinely involved with them.

Here are some segments from a case history of a boy who has one of those new fathers. At age four, Adam fantasized about his own adulthood:

ADAM (TO HIS MOTHER): When I grow up I'm going to live with you and then there'll be two daddies. And I'll find a mommy and then we'll have babies.

MOTHER: And what else do you think you'll be besides a daddy?

ADAM: Well, I don't know. Maybe just a daddy. Or . . . [after several seconds thought] maybe I'll be a ranger.

[Later] Or maybe I'll go to Sacramento to work [like his father]. Daddy, do you teach big people?

FATHER: Yes.

ADAM: Do you teach about being rangers?

How different Adam was from other boys his age in the focus on fatherhood in his dreams for the future. Parallel to that, if he was going to be something other than a parent, his fantasy was that his own father would be the one to train him, as in the old cottage industry model of a father-son apprenticeship. Rather than

separateness there is a strong fantasy of sustained connectedness with both Mother and Father, as with another four-year-old boy I know from a sharing household, who does not want to get married and have a wife because he wants to grow up and live with his parents. Adam's bondedness is particularly apparent with his like-sex parent, his father: He imagines himself someday linked with him in both his parenting and his professional training.

By age five, Adam's speculations about his future had solidified. He now was clear that he only wanted to be a parent:

ADAM: Mommy, I never want to get married. I wouldn't want one of those big parties. It's too embarrassing. I'd just want to live with a woman and have a baby with her.

MOTHER: Well, Adam, you could do that if you want. Or you could get married and not have a big party. Hey, Adam, have you thought about what you want to be when you grow up?

ADAM: [Pauses.] Well, nothing. I just want to stay home and take care of the baby.

One could say he had gone overboard in asserting the feminine aspects of himself. One could also say that his visions of being a stay-at-home dad evolved directly from his own wishes for connectedness with his parents, as when he proclaimed to his sister: "When I grow up, I'm going to stay home and take care of my children. I'll never send them to day care. I'll just stay home all day and play with them. I loved my own day care. But I'd still never send my kids to day care. Or maybe it's school."

By age seven Adam had repudiated his extreme stance and arrived at a happy medium. He would be a daddy but also run a day care center, a vision which he maintains to the present day.

Contrast this with Adam's sister, Mara. Almost from the time she could walk she knew she wanted to be a dancer. This continues to be her goal and one she works hard at, although she has expanded the possibilities to include historian or journalist. She is very similar to many other girls in the culture today, particularly those with working mothers, in her vision of a future work role outside the home.[2]

What about motherhood? Mara (age nine): "I don't know if I'll have children, because if I'm a dancer I'll be traveling all over the world, and then it would be hard to have children." She has never been as clear as Adam about her commitment to parenthood and

continues to be torn by the potential conflicts between motherhood and a life on stage. In the worst-case scenario, her considered repudiation of motherhood could be seen as a rejection of her own mother's life and choices. But more sanguinely, her leanings toward a life without children can be interpreted as a measure of her own sense of boundaries and separateness, her ability to step back and make objective assessments about her work identity. She is able to conceive of a vision of herself as not necessarily merged with another person.

For each of these children, Adam and Mara, there is a role reversal in a situation with no actual parent role model. Mara's propensities are toward work, which might be so involving that it would preclude parenthood. Adam has fantasies of being a househusband. Each child gravitates toward the traditional opposite-sex gender role. What they will actually become in the future remains to be seen. But in the present, such fantasies likely reflect their affirmation of the opposite-sex side of each of them. Mirroring the proclamation made by their own like-sex parent, Adam says, "*I* can mother"; Mara says, "*I* will have a public identity."

Both Adam and Mara communicate a sobering reality we already know about the difficulties of shared parenting. They must pick up quite keenly how complicated and sometimes overwhelming it is for both their mother and their father to try to juggle it all. In their childhood fantasies they create a simpler world, devoid of precarious work-and-family balancing acts. Ironically, in their quest for simplicity, Adam picks the "feminine" solution, Mara the "masculine" one—perhaps as a reminder to their parents that not for naught have they demonstrated that there is not only one choice for men and another for women.

Mara and Adam are not just isolated case histories. They reflect the larger reality I have observed. Boys in sharing families incorporate a vision of fathering into their future roles, whereas girls are even clearer than their mothers, and far less ambivalent, that they absolutely *will* have an identity outside the home. And the three-year-old daughter of my friend who calls herself "Dr. Mommy Wonderwoman" gives us some idea of how early these children begin to integrate fantastic fantasies of integrating a work and family identity.

Attitudes Toward Gender

Jason is a pre-schooler. He is watching television with his mother. An ad comes on. On the screen, a father tries to hug his son, but can't bring himself to do it. Jason jumps up and protests, "Why

doesn't the father want to hug the boy? Why doesn't he want to be with the boy?" His mother explains that Jason is like this a lot of the time:

> He is always making comments that mommies can do the same things as daddies, and boys and girls can do the same things. He tends not to see sex differences between boys and girls. Jason also asks a lot of questions about equality between women and men.

Jesse's third-grade teacher stopped me after school one day, looking rather bedraggled. "That son of yours . . . ," he began. "Oh no," I thought, "what act of stubbornness has he inflicted on his teacher today?" He went on, "He never misses a beat. If I ever talk about mothers and kids, he's the first to blurt out, 'What about fathers?' If a story is about what boys do, there's Jesse: 'Well, so can girls.' It's great. He's the best challenge to sexism I could ask for in the class."

Similarly, in sixth grade Rebecca returned home outraged that a new physical education teacher would not let the girls play in a touch football game and instead suggested they be cheerleaders. She and her friends organized a militant campaign in protest, and the situation was soon remedied.

These children of sharing parents are part of a larger subculture of children and youth, like the fictional Barbara Fisher, who are aware that old ways of being male and female are changing and that things have not always been so fair to either girls or boys. A psychological study done in 1979 demonstrated that androgynous parents generate in their children a broader perspective of sex roles than do traditional parents.[3] The children of sharing parents reflect that. Some of them not only develop a broad perspective; they become hypervigilant about the issue, actively carrying the torch of confronting sexism.

When a girl challenges prevalent gender practices, it is often to defend a territory of rights and opportunities for herself and to protest her relegation to a secondary status vis-à-vis boys. With a boy it is a bit more complicated. Though of the gender which traditionally is accorded greater status, he nonetheless feels anxious that as a male in the culture he will be prevented or discouraged from engaging in those "feminine" activities he may have cultivated a desire to do, such as playing with dolls or becoming a day care provider.

His father may have thought the same thing, but in his generation

such thoughts were often suppressed or left unspoken. Today the son of a sharing family has a bit more social support behind him, plus a family structure which affirms his feminine aspects. This allows him to speak up more forcefully about what males and females can do. It is not just a moral issue, or a question of ethics and rights. It is also very much an emotional issue touching his innermost desires.

But when a child is so militant, where does that come from? I think its source is more than simply watching their parents in action. Children from families which put a strong emphasis on sexual equality in parenting incorporate quite early an understanding of how important gender issues are to their own parents. Their mother and father have each struggled to disengage from the gender norms of parenting that they were brought up with. They continue to struggle with each other day by day to actually implement equality in their parenting, a feat we have seen is easier proclaimed than executed. The children both comprehend this and internalize it in their own psyches, carrying the demand for equality beyond the walls of their home into their own peer world.

The push for equality may also just "come naturally" because it has become built into the children's psychological make-up as a result of being raised by both a man and a woman. The boys and girls may integrate within themselves a balance of masculine and feminine so thoroughly that it does not make sense to them that the rest of the world should be any different. Not only are they identifying with both a male and a female who are primary caretaking figures; they are also incorporating within themselves two parents who in their own adult development are struggling toward a more equal inner balance of masculine and feminine.

A little boy from a sharing family walks into the local bookstore, surveys the greeting cards on the rack, and exclaims, "Mommy, look at these cards. You see, they're made to show that daddies can take care of children. You see, all these are daddy animals. Every one of them. [This was not obvious to the mother.] I think that's really great that they do this." My son tells me it would be sexist for women to stay home and men to go to work. My daughter tells me it would be boring.

Children from families with father involvement are deeply affected in their attitudes toward family and gender role. They are nonsexist in their attitudes, balk against sexual stereotypes, and envision their own family type as not only viable, but optimal. If they grow up

and raise children, they cannot imagine doing so with an absent father or a mother who stays home.

Does a Mommy Equal a Daddy?

Parents who share the care of their children succeed in inculcating in their children a positive attitude toward an alternative family life in which women and men parent together. But recalling the doing-being distinction that still remained in equal-parenting couples, we wonder whether this dichotomy influences a child's understanding of what is a mother and what is a father.

Just on a role modeling level, we assume that a salient feature of the modeling process is likeness between the model and the observer, and that like gender is a critical form of likeness. In that case, little boys will imitate fathering behavior that is more prone to doing than to being, and little girls will adopt a mothering style that is more prone to being than doing. Boys will continue to be more separate, girls more connected.

But if we take a more psychodynamic approach and also keep in mind that these children exhibit cross- as well as like-sex identification, we get a different perspective. The children will not necessarily imitate the parenting style of their like-sex parent. But they *will* be sensitized to the gender-specific conflicts that go on inside a woman and inside a man.

We have found that the mother is more "tuned in" than the father and that the children pick up on this. The woman's balancing act is also a daily "fact of life" in her psyche. Remember the mother who while at work wants to run to the day care center and scoop up her small son, but while at home with her son sometimes wants to flee to the office and work? A perceptive child will tune into this ambivalence, and may internalize the notion that women are people who are somewhat more relational, but who also stew in a perpetual internal turmoil about where and who they want to be.

Men, too, live with a conflict about their work and family identity. They are quite aware that their devotion to childrearing eats into their time and diminishes their opportunity for work success. There is no doubt that they will experience their children as a drain now and then. These are loving men who do not take these tensions out directly on the children, but they may be a bit less available at times.

The man has a much better ability than his wife to draw boundaries

around his parenting and nonparenting responsibilities. He is not as merged with the children as the mother. His ease in establishing demarcations may serve as a model to his children, both male and female, that it is possible to do that. But from the child's perspective it may also feel like a psychological disappearing act: Now he's here, now he's not. It's the difference between the mother playing blocks with the baby on the floor while she's also trying to prepare tomorrow's assignment and the father buried in his book on the couch. The child's perception of a more distant father, compared with Mother, reproduces itself, albeit in a more subtle way for the children of sharing parents than for the generation before them or for children in more traditional households.

In witnessing the conflicts their mothers and fathers are each going through as they attempt to break down sexual divisions in parenting, the children may be influenced in their attitudes toward and understanding of male-female personality differences. They may argue for gender equality in their lives, but their family experience tells them that women and men are just not the same.

The Feminization of Daily Life

Our discussion of the effects of shared parenting on gender role identity keeps gravitating back to the saliency of a *man* in the children's life and the impact on the *sons* of sharing mothers and fathers. There appears less in the story to unravel for females. As I consider the experience of shared parenting, it strikes me that there is much more of a shift toward the dominance of the "feminine" in the child's daily life than toward a greater infusion of the "masculine" as a result of the choice of a shared parenting arrangement.[4] This shift may have important implications for a child's understanding of gender.

Granted that the child now has a daily exposure to masculinity because of the presence of the father in the home each day. But from the child's point of view, when we look at what the child *sees* the father and mother doing every day, we get a picture of both a man and a woman doing "female" things.

The little girl and the little boy directly witness both their mother and their father cooking, cleaning, and doing child care—that is, doing traditional female household work. They are also aware that both their mother and their father work outside the home. But in a culture where there is typically a strong segregation between the

workplace and the home, the children only rarely observe their mother or father directly in the traditionally "masculine" sphere of the labor market.

Visits to the workplace, extra work brought home, or discussions with the children about one's work certainly help the child develop an understanding of Mommy and Daddy as workers. But this is nowhere as concrete or in depth as the daily performance of household work to which the child is exposed. Psychologist David Lynn formulated that in traditional families the boy has a particularly difficult time developing male identity because both his father and the world of masculine activities remain abstract to him. Daughters have mothers right there to directly imitate and learn from. Because the father is not around very much, the boy has "fewer opportunities than the girl to receive rewards for, in his case, modeling an adult male in a close personal relationship."[5]

The son in the sharing family, along with the daughter, now has a close personal relationship with a man. But the sphere of traditional masculine activity, the workplace, has not changed in its inaccessibility to children in this culture. It has historically been abstract to children since the Industrial Revolution, and particularly since child labor laws removed children from adult workplaces. It remains so to this day, for children in both sharing and traditional families.

But we ask, "Don't the children still get to see their parents doing 'masculine' things at home, like car tune-ups, carpentry, or home repairs?" Furthermore, if the parents are working to break down sex role barriers, the child should get to see both a mother and father with a screwdriver in hand or a ladder beneath them.

The problem is that the parents have put so much primacy on sharing the nurturing activities of parenting that often the sharing of traditionally masculine tasks is not so readily attended to. It is not that these couples think that the division of parenting tasks is more essential than any other task division. After all, remember that these were parents who had typically worked out an equitable division of household tasks well before their children were born. It is more than the "feminine" tasks, of both household labor and childrearing, take up an inordinately greater bulk of family time than the twice-a-year tune-ups or once-a-month household repairs they are called on to do.

Also, just as it has not always been so easy for the women and men to divide up the "feminine" activities, so the parents have the same problems balancing the "masculine" activities, such as car

maintenance or the physical upkeep of the house, when they do come up. If the children's doctor's appointments are more on the mother's mind than the father's, the father is more likely keeping track of changing the oil filter than the mother. The woman has to train herself to take notice of these things. In the meantime, there is a tendency for the father to take over. The child, then, sees that the traditionally masculine tasks in the household are more likely done by the father than the mother.

Yet even if the mothers were better at taking on the "masculine" tasks in the sharing household, there are just not that many of those tasks for the child to observe. If the fathers are doing these activities more than the mothers, they are still not doing them very much, particularly in contrast to the amount of time they put into parenting. Technology has increasingly replaced physical labor in daily life, along with a reliance on consumer services, such as plumbers or electricians. With the wall-to-wall parenting and simultaneous commitment to work identity that is part and parcel of the shared parenting experience, these men and women are particularly prone to buying services from the outside rather than doing things themselves. They just do not have the time.

From the child's point of view, it might be better if mothers committed to gender rearrangements made sure they took the time to pick up that hammer or climb up to the roof. As it stands now, the child directly experiences a wealth of "feminine" activities going on in the home, both by Mother and Father, but very few "masculine" ones. So the child is presented with a difficult challenge in integrating a balanced view of the world when the traditionally "female" realm remains more concrete and the traditionally "male" realm more abstract, even though both realms are now embodied by both a woman and a man, Mom and Dad.

There is a further complicating factor. Some parents who share parenting have a bias toward the feminine. Stephanie, a mother who herself has been very involved in the feminist movement, admits:

> If my daughter wanted to wear dresses, that would be OK. If she wanted to climb trees, that would be OK. But if I had a little boy, I would be afraid. I would be worried that if he started being macho, we'd think he was terrible.

Many fathers feel the same way.

The parents hope that their sons will not embody traditional male behaviors which they condemn, such as bullishness, physical aggres-

siveness, and suppression of vulnerability and feelings. They take for granted that their daughters will be able to adopt the better masculine virtues, such as assertiveness, achievement orientation, and physical prowess. Yet they do not shudder if their daughter also decides to wear a dress. But they would shudder if their son were to become a bully or a tough guy or only wanted to play with toy soldiers. The worst of traditional female traits in their daughters pales in comparison with the dread they feel toward the incorporation by their sons of the destructive male traits they see in the culture around them.

Surely these biases, when felt by the parents, are communicated to the children. In the children's experience, this is one more weight toward the feminine end on the gender scales. The message is, "There is nothing worse than being a traditional male. A very feminine female is surely more palatable than a gruff and insensitive male."

These biases can put a little boy in quite a bind, particularly in the transmission of subtle or even unconscious messages to him. If he moves too much toward the feminine, people begin to worry. Intellectually, we may want to adopt a completely open attitude as to where our sons fall on the gender spectrum; but from our hearts often come different messages, dictated by deeply ingrained sentiments from our past.

But on the other end of the spectrum, his parents communicate to him, lurk the disapproved traits of sexist malehood. The boys David Lynn described may have a harder time than their sisters in constructing an identity because of the physical absence of a personal male role model; but the little boys in the sharing family whose parents spurn the traditionally masculine may also have a hard time, because of the need to find some middle ground of malehood not too close to either end of the spectrum. In contrast, the little girl has a wider band to operate in, as has always been the case.

The Children As Adults

None of the children in these families was old enough to actually demonstrate to us what adult choices they might be making. On this question we can only extrapolate and speculate. What kind of mate will they look for? Will they follow the family model provided by their parents?

We do not yet know whether they will follow the same patterns as in the larger culture in their propensity to choose opposite- or

same-sex partners. As we have seen, because most girls have been mothered by women, we observe a bisexuality in females' experiences of intimacy, with one form of love for women and another for men. This bisexuality should persist in the daughters of sharing parents, but also now be extended to the sons. Given an early and ongoing intimate relationship with a man, his father, the son knows fully the experience of closeness between males. Regardless of who he eventually chooses as a sexual partner, a man or a woman, a boy with an actively involved father will carry into his adulthood the capacity for a deeper loving relationship with men than is afforded most males in this culture who have been mothered only by women.

The son and the daughter who make heterosexual choices will each have a different terrain to traverse. The girl has had a model of a father who is warm, nurturing, and involved in her care. She will have known a daily intimacy with a man that parallels the intimacy she has enjoyed with a woman. It is likely that if she grows up and wants a relationship with a man, she will want a man who is emotionally open and connected. She will also want a man who will respect her autonomy and her desire to work or develop a career. She is lucky, for the possibility of finding such a man will be much greater than when her mother was looking. In this generation a higher value is placed on feeling men, who can both express their emotions and take in those of others and who can give full respect to needs other than their own.

The son from a sharing family will also be in search of a partner some day. In a woman he will want someone who will both accept and appreciate his androgyny and will not be put off by his capacity to cry and feel. He most likely will not be attracted by or be attractive to a woman looking for a Marlboro man. He will also want a woman who fully supports his desire to be actively involved as a father. Likewise, he will support her desire to be more than a mother.

When the children grow up and marry, the cycle begins again. Any child brought up with a father active in the care of his children, whether in a "pure" 50–50 arrangement or not, will grow up with a personality style less gender-typed than that of mother-raised children. When the children have their own offspring, they will face the same struggle as their mothers and fathers before them in implementing gender equality in their parenting. Only this time it will be much easier, because of the sons' and daughters' own upbringing in a family in which both a woman and a man mothered.

14

Parenting Together
A Reality

The unforgettable images on these pages are *Ladies Home Journal*'s salute to today's fathers—loving dads who truly nurture their children.

<div align="right">

Ladies Home Journal, June, 1986[1]

</div>

The times they are a'changin'. The article in the *Ladies Home Journal,* entitled "A New Kind of Father," goes on to tell us that in the last twelve years the percentage of fathers present in the delivery room has made a phenomenal jump, from 27% to 80%. Furthermore, a survey of their readers in 1985 showed that 84.2% of their readers under forty believe that men are just as good with children as women. This is no radical magazine with a left-wing readership. The *Journal* is genuinely tapping a remarkable shift in the attitudes of the American public. Part of that public, shared parenting families, not only bring Father in the delivery room; they make sure he continues his involvement after returning home.

Is parenting together a revolution or an evolution? Probably both. Sixteen years ago, when I and other feminists were demanding equality of the sexes in the home, the idea of a man doing half of the parenting was an outlandish proposition. Then the idea was a threatening and disturbing one, not readily welcomed by the world around us. Now, in 1986, the *Ladies Home Journal* prints in boldface that "what has taken place is not so much a revolution as an evolution—

from rigid roles to today's fluid parenting styles." No longer a feminist demand, but now a mainstream idea, the shift is understood as an erosion, over the last generation, of the norms that kept women primarily in the home and men primarily in the workforce.

The erosion is no more clearly evidenced than in the reports of older fathers with second families or with a latecomer amongst their first flock of children. And so one father reports, in the *Journal,* about his second marriage, "I never read *The Cat and The Hat* the first time around. I never diapered or bathed the babies. I just came home after my wife had them all fed and in their pajamas, and I kissed them good night. It wasn't macho to really mother them. Now the rules have changed. Real men take care of the kids. I like that."[2]

Just in the past twelve months there has been a media splash of men hugging, kissing, or gazing in the eyes of their young children: pictures plastered all over magazines, newspapers, even billboards. Kodak shows us bigger than life a "real" man, muscle-bound and stripped to the waist, lovingly cradling a tiny infant in his strong arms. Second-time-around fathers also see these photographs, and are obviously proud to be one of these "new" men. They are immensely relieved that they made it just under the wire by getting to do in the mid-1980s what they would not have even dreamed of ten years before—mothering a child. Fathers of grown children who never had that opportunity express remorse and sadness that they themselves did not grow up in a generation that would have allowed or encouraged them to have greater contact with their children.

This is a drastic transformation. The underlying forces that have allowed this new family form to unfold, such as changes in the economy or a shift from physical to technological forms of labor, may have been evolutionary, slowly gathering force over time. But the actual acknowledgment of and acclamation given to men and women parenting together is much more sudden.

Those of us who were the pioneers are thrown off-balance: We do not know whether to feel victorious or co-opted. For we know full well that with all the recognition given to babies on men's laps and the visibility of fathers and children on Sunday strolls, the percentage of men and women who genuinely share the tasks of parenting is quite small. But the fact that such a practice is increasingly lauded rather than condemned *is* a large victory, one that will make it decidedly easier to receive social support for this new family style.

Although it is easier said than done, we have learned that men

and women *can* mother together. The stories we have heard document the possibility of a loving, fruitful, and happy life outside the confines of the traditional nuclear family, a model our society until recently took for granted as the benchmark of health. The success of the sharing couples and their children proves that we can stretch the form of the family very far without stretching the people in it out of shape. Further testimony is that the parents themselves end up feeling that shared parenting is not simply a choice, but an imperative. They may have "chosen" it in the beginning, but now they cannot do without it.

Nonetheless it is a slow process. Even with the remarkable shift in public consciousness about gender roles and men's involvement in parenting, the emotional scripts deep within us are not easily discarded. It still makes some people squeamish to imagine a man changing a diaper, even though they would like to admit that wasn't so, and the sharing parents themselves confess that deeply internalized feelings within them sometimes make the experience of parenting together a difficult one.

Along with the emotional resistances, the economic and social realities of the surrounding culture are not changing as rapidly as the culture's new openness toward fathering. Rather than supporting the experiment, the structure of the economy and the workplace has put up barriers to the success of men and women mothering together.

When a sharing arrangement fails or never gets off the ground, financial necessity is often the cause. A man's retreat to the primary breadwinning role is often forced upon the family by the sobering reality that on the whole, working women still earn less than two-thirds as much as working men. If that doesn't make things hard enough, the lack of flexibility in the workplace and the great risks to an individual's advancement if one works less than full time and full steam make it hard to find an arrangement that simultaneously satisfies a family's child care needs and the realities of the parents' work life.

Lack of community support can have a further dampening effect. Just as a little boy might have to hide some of his "girl" toys or activities in order to survive in the neighborhood, fathers may have to leave some of their "mothering" activities underground—as with the man who never took his family's turn as secretary of his children's babysitting co-op because it would be so shocking to the other co-op mothers in his conservative community.

Living comfortably within your own community can often take precedence over the principle of sharing. One survival technique is to search out the few families residing there that *do* have similar parenting arrangements. Yet even with that minority support, the situation of being a "different" kind of family can be a lonely experience.

A rift can occur with old friends who remain more traditional parents. Sharing parents may feel pressed to make a whole new set of friends, more compatible with their family style. The alternative, of course, is to adapt to community norms and go back to the old way. Occasionally, families do this, particularly if goaded on by criticisms or skepticism on the part of close extended family about this new way of doing things.

To parent together, then, takes an exceptionally strong commitment. Not just these external impediments but internal psychological tensions about work and family pull at the parents, tugging the woman toward the mothering end of the balance and the father toward the primary breadwinner end. With the added pressures of intricate scheduling, struggles over gender disparities, and work overload that come with shared parenting, it can be tempting to throw in the towel.

Yet these couples overwhelmingly do not do so. They look over the fence at families in which mothers carry the backbreaking load of both a full-time job and full-time responsibility for the children. That does not seem like an enticing alternative, although it is one faced by more and more women today as over 60% of mothers with children enter the workforce.

They think of a life in which Dad would be denied the intimate relationship with the children that has grown so central to his life. They imagine their sons and daughters denied that daily access to Dad which the children so take for granted. The feelings of loss and sorrow which accompany that fantasy are one of the strongest safeguards of the sharing arrangement. So, in the words of one father, "Would I go back to a traditional parenting situation? Not if I can help it!"

Parenting together can work and does work, and once chosen it is tenaciously held on to by most. But it also has some problems that should not be overlooked in planning for the future. Some worry that one untoward consequence of shared parenting is that the child actually ends up with two *fathers* rather than two *mothers*.

Just as mothering does not reside in a person but rather consists

of a set of socially constructed tasks and obligations, so fathering, in traditional terms, consists of primary breadwinning, being at the helm of the family, and providing *secondary* love to the children. A mother whose career is vitally important to her, as is her husband's, explains to me that she and her husband are not doing anything like the mothering she had known as a child. "We're both mothering, but we're also both fathering. Actually, you could say our little boy has two fathers." Because she and her husband both work long hours and have their small son in full-time child care, she imagines her son's parenting to be provided by two fathers—except that a father would not be the one to have arranged that child care or to pick up baby, bring him home, and give him a bath.

More realistically, in social terms children in such families have two working mothers: parents who go out during the day to earn a living and, equally, devote their evening and weekend time to their child. But this mother's point, that the child with *no* parent who is primarily responsible runs the risk of being a child with two secondary parents, is well taken. Traditional fathers were not intended to bring up children on a daily basis. So *two* of them will never do when it comes to raising a child.

To avoid this potential risk of diluted parenting, some sharing families with heavy work schedules opt for the split-shift arrangement. When one parent is on, the other is off. But this solution generates another set of risks. A parent from a sharing family told me this funny story. When he and his wife sat down together for a meal one day, their three-year-old daughter let out a gleeful shriek. "Oh, is this a holiday?"

The point of shared parenting, obviously, was not to make family meals a rare occasion. But with two parents overloaded and strapped for time, the children and adults alike can be deprived of a familial communal experience. The times with everyone together become few and far between. Better social and economic supports for the sharing family, such as flextime jobs and job sharing, could alleviate those stresses, and must be worked toward as we plan for the future of the family.

The moment is ripe for this planning. Presently the Family and Medical Leave Act is being brought before the Congress, legislation which would guarantee both men and women the right to take a leave of absence from their jobs to care for a newborn, adopted, or seriously ill child or for a seriously ill parent. Employees would be allowed to take an unpaid leave of up to eighteen weeks and

would be guaranteed the same job or an equivalent one upon return-
ing to work. Although the bill would not apply to everyone in the
workforce, but only to those in workplaces with fifteen or more
employees, the significance of the bill, if passed, is that the United
States would now be implementing a program in which *both men
and women* could take time out from their jobs for family reasons.
We would be joining all the other major Western industrial countries
in having a national policy on parental leave.

The bill is regarded as a "pro-family" bill, and its supporters
are indeed strange bedfellows, including, for example, the National
Organization for Women, the National Conference of Catholic
Bishops, and the American Life League, a "pro-life" education
organization. It has become a bipartisan issue, and its original spon-
sor, Representative Patricia Schroeder (D—Colo.) explains it simply:
"Our problem is that the people of my generation still think the
best of all worlds is children staying home with Mommy while Daddy
is out slaying dragons. That is not the real world."[3]

Many expect the bill to pass in some form. That does not mean,
of course, that people will take advantage of it. An *unpaid* parental
leave is not much of a boon to most working families, who will
hardly be able to sustain the loss of family income for such an
extended period. Also, if Sweden, one of the pioneering countries
with respect to parental leave, has anything to teach us, it is that
only a small handful of *men* actually stay home for any significant
time with their children. Because Swedish men still fear the repercus-
sions for job advancement of taking parental leave and because the
belief that women are made to mother is still in place, it is typically
Mom, not Dad, who takes extended time from work to care for
the baby.

Not until financial incentives are offered or attitudes about these
issues change could the bill have a significant effect. But in the mean-
time it is symbolically important as a national statement that men
as well as women have crucial parental roles.

The introduction of this bill is truly a signal of the erosion of
old ways. Until the dust settles, there is seeming confusion and disar-
ray. When it comes to the family, Peter Morrison, the director of
the Rand Corporation's Population Research Center, tells us that
"people think they are seeing departures from the norm, but depar-
tures now are 75% of the norm."[4] Parents who mother together
are part of that departure.

They have opened a new frontier. When the first sharing couples

embarked on their journey, they were looked at with either trepidation or excitement, as is true of any pioneering venture. The old ways of raising a family, in which Mom stayed home and Dad earned a living, may have been crumbling, but people were left with no clear vision of where to go next.

A decade or more later, we now have reports back from the frontier. We find that there are few of the feared harmful consequences to either parents or children when mothers and fathers share the care of the children—that it is safe out there. We can even invite others to follow. They may not choose to move out all the way into the new terrain, doing a full 50–50 arrangement; but the benefits of any shift toward having men more involved in childrearing and women freer to develop identities outside motherhood far outweigh any of the drawbacks—for the parents, the children, and the marriage.

As in any pioneer movement, as time goes on the settlers are no longer mavericks, but become part of the mainstream. So it is that men and women who parent together ushered in a new arrangement that has now been, at least in part, absorbed into the culture: not necessarily egalitarian parenting, but the expectation that fathers be more involved in family life while their wives combine work and mothering.

The shared parenting family is also truly a social laboratory, teaching us much about the interface of culture, gender, and personality. If given the opportunity, men can mother. Gender roles are not immutable categories. Theories that say that only women can mother are merely culture-bound, a product of their time, rather than objective scientific fact. But at the same time, the inner experience that is so different for the man and for the woman who parent together alerts us to the reality that gender shifts involve more than an alteration of roles or changes in behavior. It involves a restructuring of personalities, a shift in the balance of the masculine and feminine components of our psyches.

What we are as men or as women is deeply embedded within us, not because of biology but because of our very earliest experiences in our own families and the internalization of the beliefs, mores, and practices of the culture we grew up in. We can chip away at the personality differences between men and women that make both parenting and female-male relationships such a disjunctive affair, but the personalities we came with will in many respects be the ones we leave with. It is the *children* of sharing parents, entering

adulthood with a different family history and in the context of a changing set of cultural beliefs, mores, and practices, who will show the personality integration most conducive to women and men mothering together.

It is not, then, simply a one-generation transformation. Things are drastically different, yet something of the old still remains. The male-female personality differences that make parenting a lopsided affair will fade with each new generation, but will take at least one or two to really disappear. The sons and daughters will exhibit a better balance of doing and being than their parents. And their children, if they are also offspring of sharing parents, will show an even better one. That balance, in two parents, is the harbinger of a man and a woman truly parenting together.

My greatest hope is that the mothers and fathers who read this book will draw strength from the realization that they're not the only women and men struggling with the daily tensions of parenting. The enlightenment from discovering that their conflicts stem not from individual personality differences but from the same gender distinctions visible in thousands of households across the country should be tremendously relieving. For sharing couples, it will make their experience more understandable and bolster their confidence that it is not personal failure or poor mate selection that creates tension for them, but socially constructed personality differences between men and women accompanied by a social and economic climate that does not fully support their arrangement.

Recall the three threads that, woven together, create the tapestry of the shared parenting experience: the external realities of the job market and the extra-familial world; the values and beliefs of the culture; the psychological make-up of the woman and the man. Depending on the texture and resiliency of each of the yarns, the design will or will not get worked up into true equality in parenting. The creation of *any* family type, not just the sharing household, is dependent on these three threads. There is no *one* correct or natural childrearing model, but changing ones that interweave the needs of a society and the needs of the individual at any particular time in history, into either a pleasing tapestry or a bed of knots.

The couples I studied who have opted for a shared family arrangement *have* been able to create a weaving that, with all its difficulties, is a harmonious and well-integrated one. I do not expect its colors to fade with time but rather to grow more vibrant in hue as the three threads—public life, belief systems, and individual psychology—are pulled in the direction of gender equality.

Notes

CHAPTER ONE: THE NEW MOTHERING DUET

1. See J. Robinson, 1977, *How Americans Use Time: Social-Psychological Analysis* (New York: Praeger); J. Pleck and M. Rustad, 1980, "Husbands' and Wives' Time in Family Work and Unpaid Work in the 1975–76 Study of Time Use" (Unpublished manuscript, Wellesley College); M. Kotelchuck, 1976, The infant's relationship to the father: Experimental evidence, in M. E. Lamb, ed., *The Role of the Father in Child Development* (New York: Wiley).

2. Robert Hanley, TV program prompts missing man to return, *The New York Times*, August 22, 1984.

3. D. Ehrensaft, 1980, When women and men mother, *Socialist Review*, no. 49.

CHAPTER TWO: CANDIDATES FOR SHARING

1. David Wessel, Working fathers feel new pressures arising from child-rearing duties, *Wall Street Journal*, September 7, 1984.

2. C. P. Cowan, P. A. Cowan, L. Coie, and J. D. Coie, 1978, Becoming a family: The impact of a first child's birth on the couple's relationship, in W. B. Miller and L. F. Newman, eds., *The First Child and Family Formation*. Chapel Hill, N.C.: Caroline Population Center.

3. See Samuel Osherson, 1986, *Finding Our Fathers* (New York: Free Press), for an excellent discussion and analysis of the disappointment of

American men with respect to their own fathers, who, they felt, really did not come through for them emotionally in their growing-up years.

CHAPTER THREE: "UNTO US A CHILD IS BORN"

1. See D. W. Winnicott, 1965, *The Family and Individual Development* (London: Tavistock) for a thorough explication of Winnicott's concept of "good enough mothering."

2. Nancy Chodorow, 1978, *The Reproduction of Mothering: Psychoanalysis and the Sociology of Gender* (Berkeley: University of California Press).

3. See Graeme Russell, 1983, *The Changing Role of Fathers* (St. Lucia, Queensland: University of Queensland Press), for a thorough review of contemporary social science findings on role sharing.

4. It is interesting to note, however, that the recent interest in flextime, on-site child care, and maternity and paternity leaves may not be as much a product of increasing numbers of mothers entering the work force as of men getting involved in child care. In the United States, women have been in the work force for a long time. It is only recently that the influx of career men into involved fathering has occurred. As the attention has zoomed in on men involved with their children and as men have made more noises concerning its effects on their work and family lives, so American industry and government have given increased attention to the needs of working "parents." As in many other spheres, only when the more powerful male gender is affected is a social problem given public recognition.

CHAPTER FOUR: DAY-TO-DAY SHARING

1. Nancy Chodorow, 1978, *The Reproduction of Mothering.*

2. Dorothy Dinnerstein, 1976, *The Mermaid and the Minotaur* (New York: Harper and Row).

3. Rick Sapp, 1984, "A Study of Role Sharing Fathers" (Ph.D. diss., The Wright Institute, Berkeley, Ca.).

CHAPTER FIVE: THE ROOTS OF THE SHARING EXPERIENCE

1. Ilse-Margaret Vogel, 1968, *When I Grow Up* (New York: Golden Books).

2. Samuel Osherson, 1986, *Finding Our Fathers.*

3. See David Lynn, 1970, *Parental and Sex-Role Identification* (Berkeley, Ca.: McCutchan).

4. See Jessie Bernard, 1973, *The Future of Marriage* (New York: Bantam Books), for a full discussion of this pattern.

CHAPTER SIX: DOING VS. BEING IN PARENTING

1. Nancy Chodorow, 1978, *The Reproduction of Mothering*, p. 169.

2. D. W. Winnicott, 1971, *Playing and Reality* (London: Tavistock).

3. *Ibid*, p. 87.

4. Gloria L. Lawrence, 1985, "The Mother's Differential Cathexis and Treatment of the Male and Female Preoedipal Child" (Ph.D. diss., The Wright Institute, Berkeley, Ca.).

5. Lillian Rubin, 1983. *Intimate Strangers* (New York: Harper and Row), pp. 92, 95.

6. See D. W. Winnicott, 1965, *The Maturational Processes and the Facilitating Environment* (London: Hogarth Press and the Institute for Psychoanalysis).

7. The statistics are from a *New York Times* poll reported in the *San Francisco Chronicle* on December 12, 1983.

8. See D. W. Winnicott, 1971, *Playing and Reality*, for a full discussion of this expanded notion of play.

9. See Michael Lewis, Candice Feiring, and Marsha Weinraub, 1981, The father as a member of the child's social network, in M. E. Lamb, ed., *The Role of The Father in Child Development*, 2nd ed. (N.Y.: John Wiley), for a review of psychological findings on mother-father differences in play.

10. Gloria Lawrence, 1985, "The Mother's Differential Cathexis and Treatment."

11. Talcott Parsons, 1955, The American family: Its relations to personality and social structure, in T. Parsons and B. F. Bales, eds., *Family, Socialization, and Interaction Processes* (Glencoe, Ill.: Free Press).

12. Simone de Beauvoir, 1961, *The Second Sex* (New York: Bantam).

CHAPTER SEVEN: HOW DO I LOVE THEE?

1. See, for example, Lillian Rubin, 1983, *Intimate Strangers* (New York: Harper and Row); Harriet Goldher Lerner, 1986, *The Dance of Anger: A Woman's Guide to Changing the Patterns of Intimate Relationships* (New York: Harper and Row).

2. See Nancy Chodorow, 1978, *The Reproduction of Mothering*, chapters six and ten, for a thorough discussion of this.

3. Margaret S. Mahler, Fred Pine, and Anni Bergman, *The Psychological Birth of the Human Infant* (New York: Basic Books).

4. See D. W. Winnicott, 1971, *Playing and Reality*, chapter nine, for a full discussion of the maternal holding environment.

5. See M. Ainsworth, 1969, Object relations, dependency, and attachment: A theoretical review of the infant-mother relationship, *Child Development*,

40, 969–1026; R. Schaffer, 1977, *Mothering* (Cambridge: Harvard University Press); M. Weinraub, T. Brooks, and M. Lewis, 1977, The social network: A reconsideration of the concept of attachment, *Human Development, 20,* 31–47.

6. Nancy Chodorow, 1978, *The Reproduction of Mothering,* p. 206.

7. Jane Lazarre, 1976, *The Mother Knot* (New York: Dell), p. 52.

8. See E. L. Abelin, 1971, The role of the father in the separation-individuation process, in J. B. McDevitt and C. F. Settlage, eds., *Separation-Individuation* (New York: International Universities Press).

9. A. Gurwitt, 1976, Aspects of prospective fatherhood, *The Psychoanalytic Study of the Child, 31,* 237–70.

10. Christopher Lasch, 1977, *Haven in a Heartless World* (New York: Basic Books).

11. A recent national survey revealed that while career was once the main preoccupation of men, 75% of the men polled said being a father was their most satisfying activity. Only 5% said their work was (See Robert McCall, The importance of fathers, *Parents Magazine,* July 1985, for a report of this survey). These attitudes seem to be translated into actual increased attention and time to parenting. Gail Gregg reports in *The New York Times Magazine* ("Putting kids first," April 13, 1986) that "once it was just mothers. Now, it's also fathers trying to balance the demand of careers and children."

12. Steve Villano, writing about his experiences as a primary parent for the magazine *Working Mother,* explains: "Other experiences pale by comparison. Other fathers, born in other times, or unable to escape the expectation that men must always choose career over family, are not as fortunate." (A father's story, *Working Mother,* November 1985, p. 130).

CHAPTER EIGHT: DUAL PARENTING AND THE DUEL OF INTIMACY

1. See Dorothy Dinnerstein, 1976, *The Mermaid and the Minotaur,* and Lillian Rubin, 1983, *Intimate Strangers.*

2. Ira Wolfson, The closer you get, the faster I run. *Ms.,* September 1985, p. 36.

3. Nancy Chodorow (1978) addresses this in *The Reproduction of Mothering.*

4. Ira Wolfson, The closer you get, the faster I run.

5. D. W. Winnicott, 1965, *The Family and Individual Development.*

6. Lillian Rubin, 1983, *Intimate Strangers,* p. 60.

7. See Lillian Rubin, *ibid.*, for a thorough analysis of this phenomenon in adult male-female relationships.

8. Joanne Kates, Hers (column), *The New York Times,* October 9, 1986.

9. See Nancy Chodorow, 1978, *The Reproduction of Mothering,* chapters eleven and twelve.

10. Lillian Rubin, 1983, *Intimate Strangers,* p. 65.

11. D. W. Winnicott refers in one of his papers to the corrective emotional experience as "some environmental happening, perhaps a friendship, [which] may provide a correction of a failure of basic provision, and may unhitch the catch that prevented maturation in some respect or other" (Dependence in infant-care, in child-care, and in the psycho-analytic setting, *International Journal of Psychoanalysis,* 1963, 44, p. 344).

CHAPTER NINE: HOW THE MARRIAGES FARE

1. See Gayle Kimball, 1983, *The 50–50 Marriage* (Boston: Beacon Press), appendix four, for a thorough review of studies of housework and work responsibilities in dual-work families.

2. Jessie Bernard, 1973, in *The Future of Marriage* (New York: Bantam Books), cites statistics that women do worse *in* marriage than outside of marriage in terms of mental health factors, while the reverse is true for men.

3. In *Intimate Strangers,* Lillian Rubin (1983) describes the situation as follows: "Nurturance can be used as a defense against intimacy in a relationship—a cover to confuse both self and other, to screen the fact that it doesn't exist. It can be used manipulatively as a way to stay in control, as a way to bind another, and ensure against the pain of loneliness" (p. 90).

4. See Joel Crohn, 1986, *Ethnic Identity and Marital Conflict* (New York: American Jewish Committee, Institute of Human Relations), for a discussion of childrearing differences in interethnic marriages.

5. George Gilder, 1981, *Wealth and Poverty* (New York: Basic Books), p. 15.

6. Rhona and Robert Rapaport, 1976, *Dual-Career Families Re-examined* (New York: Harper), p. 302.

7. Faye Crosby, The juggling act: Why so many women thrive on the hectic life, *Working Mother,* August 1983.

8. This instrument was adapted from Philip and Carolyn Cowan's research method, used in the Becoming a Parent project at the University of California, Berkeley.

9. See *The General Mills Family Report,* 1980–1981 (Minneapolis, Minn: General Mills, 1981).

10. See Lillian Rubin, 1979, *Women of a Certain Age* (New York: Harper and Row), for a discussion of the empty nest syndrome in middle-aged people after the children leave home.

11. Quoted from a subject in Lillian Rubin, 1979, *Women of a Certain Age,* p. 38.

CHAPTER TEN: THE CHILD WITH TWO MOTHERS

1. Margaret Mead, 1954, Some theoretical considerations on the problem of mother-child separation, *American Journal of Orthopsychiatry, 24,* no. 3., 471–83.

2. J. Nash, 1965, The father in contemporary culture and current psychological literature, *Child Development, 36,* 26–92.

3. D. Ehrensaft, 1971, The all-important mother-child duet (Unpublished manuscript, University of Michigan).

4. John Bowlby, 1969, *Attachment and Loss,* vol. I: *Attachment* (New York: Basic Books).

5. See H. R. Schaffer and P. E. Emerson, 1964, The development of social attachments in infancy, *Monographs of Social Research in Child Development, 29,* no. 3., 1–77; H. R. Schaffer, 1977, *Mothering* (Cambridge: Harvard University Press); Elizabeth Irvine, 1966, Children in kibbutzim: thirteen years later, *Journal of Child Psychology and Psychiatry, 7,* 167–78.

6. Bruno Bettelheim, 1969, *Children of the Dream* (New York: Avon), p. 323.

7. See Melanie Klein, 1932, *The Psychoanalysis of Children* (London: Hogarth Press).

8. R. Rosenthal and L. Jacobson, 1966, Teachers' expectations: Determinants of pupils' I.Q. gains, *Psychological Reports, 19,* 115–18.

9. See John Bowlby, 1969, *Attachment and Loss,* vol. I: *Attachment.*

10. H. R. Schaffer and P. E. Emerson (1964) are the clearest about this, in their study of Scottish youngsters. See The development of social attachments in infancy.

11. M. S. Mahler, F. Pine, and A. Bergman's 1970 study, *The Psychological Birth of the Human Infant* (New York: Basic Books), is probably the most well-respected piece of empirical research that integrates behavior and intrapsychic factors in assessing the infant's early months.

12. H. F. Harlow, 1958, The nature of love, *American Psychologist, 13,* 673–85; H. F. Harlow, 1961, The development of affectional patterns in infant monkeys, in *Determinants of Infant Behaviour, vol. I,* ed. B. M. Foss (New York: John Wiley).

CHAPTER ELEVEN: CO-PARENTING AND PERSONALITY
DEVELOPMENT

1. Lloyd DeMause, 1975, *The History of Childhood* (New York, Harper
Torchbooks), p. 3.

2. See D. W. Winnicott, 1965, *The Maturational Processes and the Facilitating Environment,* for a discussion of the critical importance, in the maternal environment, of allowing the young infant to be able to call on his or
her own inner resources. Without that occurring, the child is blocked from
developing what Winnicott calls the "true self," which is one's own individuality.

3. Diana Baumrind, 1967, Child care practices anteceding three patterns
of preschool behavior, *Genetic Psychological Monographs, 75,* 43–88.

CHAPTER TWELVE: ON BECOMING A GIRL OR A BOY

1. H. Barry, M. K. Bacon, and I. I. Child, 1957, A cross-cultural survey
of some sex differences in socialization, *Journal of Abnormal and Social
Psychology, 55,* p. 329.

2. These words were written by Jerome Kagan in 1964 (J. Kagan, Acquisition of sex-tying and sex role identification, in M. Hoffman and L. W.
Hoffman, eds., *Review of Research in Child Development,* vol. I [New
York: Russell Sage], p. 145). Whereas mores and attitudes regarding sex
role behavior have changed markedly in the last twenty years, the attitude
expressed by this prominent psychologist twenty years ago is still very
prevalent in the concerns of many lay people and professionals alike when
it comes to the question of tampering with Mother Nature regarding gender
development.

3. See Phyllis Tyson, 1982, The role of the father in gender identity, urethral
eroticism, and phallic narcissism, in S. H. Cath, A. R. Gurwitt, and J.
Munder Ross, eds., *Father and Child* (Boston: Little, Brown).

4. *Ibid.,* p. 175.

5. See Jeanne Block, 1973, Conceptions of sex role: Some cross-cultural
and longitudinal perspectives *American Psychologist, 6,* 512–526, for a
study of gender and moral development, and H. B. Biller and D. L. Singer,
1971, Sex-role development and creative potential in kindergarten-age boys,
Developmental Psychology, 1, 291–96, for a study of gender and creativity.

6. Samuel Osherson, 1986, *Finding Our Fathers.*

7. See Linda Gunsberg, 1982, Selected critical review of psychological investigations of the early father-infant relationship, in S. H. Cath et al.,
Father and Child, for a discussion of the significance of the father in the
child's gender development.

8. Nancy Chodorow, 1976, Oedipal asymmetries and heterosexual knots, *Social Problems, 23,* no. 4, 454–68.

9. E. Abelin, 1975, Some further observations and comments on the earliest role of the father. *International Journal of Psychoanalysis, 56,* 298–302; J. Munder Ross, 1982, In search of fathering, in S. H. Cath et al., *Father and Child.*

10. Samuel Osherson, 1986, *Finding Our Fathers,* p. 25.

11. A. Sagi, 1982, Antecedents and consequences of various degrees of paternal involvement in child-rearing: the Israeli project, in M. Lamb, ed., *Nontraditional Families* (Hillsdale, N.J.: Lawrence Erlbaum Associates).

CHAPTER THIRTEEN: WHEN I GROW UP

1. Betty Miles, 1975, *The Real Me* (New York: Avon Books).

2. See Anita Shreve, The working mother as role model, *The New York Times Magazine,* September 9, 1984.

3. J. De Frain, 1979, Androgynous parents tell who they are and what they need, *The Family Coordinator, 28,* 237–43.

4. My thanks to Dr. Nancy Chodorow for her thoughts on this subject of the feminization of the household, offered in a personal communication to me.

5. David Lynn, 1969, *Parental and Sex Role Identification* (Berkeley, Ca.: McCutchan), p. 36.

CHAPTER FOURTEEN: PARENTING TOGETHER: A REALITY

1. Sondra Forsyth Enos, A new kind of father, *Ladies Home Journal,* June 1986, p. 43.

2. *Ibid.,* p. 47.

3. Quoted in Parenthood leave bill: Effects on men, *New York Times,* August 27, 1986.

4. Quoted in If you see families making a comeback, it's probably a mirage, *Wall Street Journal,* September 25, 1986.

Index